Contemporary E
Art Guide

Edited by
Mark Gordon

**HATJE
CANTZ**

*2.99
W14
C69

What Is Europe?

An ideological construct, rather than a fixed place, the borders and definitions of Europe have undergone substantial changes over the centuries. During the last few decades, Europe has seen its form change as the European Union has absorbed more of the former satellite republics of the USSR and as countries endeavor to join the economic and political union of the western European states. For the purposes of this book, the long-held ideological form of Europe as having its boundaries being defined by the Atlantic Ocean in the west, the Mediterranean Sea in the south, the Turkish state in the southeast, and the Russian state in the east, will be held to. Geographically and geologically, it is agreed that Europe is basically a peninsula of the larger Eurasian landmass although we leave it to others to argue the case for an enlarged European context.

What Is Contemporary?

If the issue of what defines Europe is contentious and fraught with political connotations, the issue of what is contemporary is just as arbitrary and open for debate. Many, including auction houses for the purposes of sales, have defined the contemporary as "post-war" or, in the case of art theory, as "post-Pop." The merits of seeing the modernist project as having ended with the rise of American and European Pop Art in the early sixties has much to recommend it for the theoretical reasons that the break is easy to map and easy to identify. It is for this reason that *Contemporary Europe* posits that contemporary includes all work from the rise of Pop to today.

Institutions, Galleries, Auction Houses, and Collections

The present volume of *Contemporary Europe* concentrates on contemporary art institutions, as defined by their non-profit status. With the rapid increase in contemporary art galleries and with the volatile nature of the art business that features galleries opening, moving, and closing, based on the demands of the art market, is a reason for the non inclusion of the for-profit galleries. The contemporary art enthusiast, though, is thought of in that for the major art centers such as London, Paris, and Berlin, there are synopses of the relevant gallery areas.

The guide features a wide range of institutions that were selected on the following basis: quality of exhibitions, quality of collections, future plans, and location. For instance, a small space in a country with few art centers is judged less rigorously than it would

be in a country that is well endowed with contemporary art facilities. It is hoped that institutions that did not make the final version of the present volume will increase their commitment to international programming and be included in the next volume.

East vs. West

A major feature of *Contemporary Europe* is the relative positions of the former Eastern Bloc states in relation to the cold war definition of Western Europe. The term "east" itself is loaded with cultural and political connotations. The countries formerly in the "east" have not had the opportunities to engage with the contemporary that the "west" has had so therefore in many instances they are judged by a different scale. It would be unfair to the "east" to expect that in almost twenty years there would be parity between the two spheres.

Public vs. Private

With the rise of the art market in the last decade, a large number of private collectors have emerged who rather than following the traditional path of donating works to the local museum or cultural institution have instead embarked on opening their own spaces to display works as they see fit. Many German museums have suffered through onerous agreements with collectors only to see the collections removed for sale at auction. While both museum professionals who should have foreseen these issues and collectors who strong-arm museums into disadvantageous agreements are to blame, the outcome has been that collectors are now going it alone, without the structure of the museum. What this means for the future is open for debate. Will these private collections close when the collector loses interest, the value of the works rises or falls, or the heirs of the original collector have different agendas? The audience, for now, is the beneficiary of this change in emphasis as collectors have opened spaces throughout Europe.

Mark Gordon
Berlin 2009

If you wish for your event or institution to be covered in the next edition or have questions or comments in regard to the content of this book contact the author at contemporaryeurope@yahoo.com

Albania

Since the Tirana Biennale held its third edition in 2006, Albania has suffered from the many issues that plague this volatile region. With the Biennale currently in limbo and a lack of investment in contemporary art spaces, or cultural investment in general, Albania is in many ways an emerging nation on the cultural stage.

Headquartered in Tirana, the TICA—Tirana Institute of Contemporary Art (www.tica-albania.org) is a new arts organization currently without a permanent location but with plans to offer artists' residencies as well as organizing temporary exhibits.

Austria

Allowing for its size, Austria has a broad range of challenging arts institutions spread throughout the country offering a diverse range of international contemporary art. The vibrancy of Austria is led by the energetic and active curatorial leadership at many Austrian venues. Since the sixties and the emergence of the Viennese Actionists, the Austrian art scene has produced many of the leading artists in Europe, a fact which is reflected in the strength of the gallery scene in Vienna as well as the world-class art schools in the capital. Vienna, as it has throughout its history, continues to exert a strong pull on the arts in central and south Eastern Europe.

Austria Resources

www.kulturleben.at
culture news with exhibit information
www.kunstnet.at
exhibition information
Spike Art Quartely, www.spikeart.at
Austria-based German/English
language arts magazine
Kunstradio, www.kunstradio.at
online radio station devoted to art
www.publicart.at
Art in Public Space Lower Austria, orga-
nization based in St. Pölten that organi-
zes public art projects throughout
Lower Austria by artists such as Clegg
& Guttmann, Tony Cragg, and Olafur
Eliasson
www.lac.coop
Lower Austria Contemporary site
with information in German on
events in Lower Austria
www.mtk.at
Medien.Kunst.Tirol, Innsbruck-based
organization presents projects

Austria Events

May
Architektur Tage
October
Lange Nacht der Museen

Vienna

A casual art tourist visiting Vienna cannot
help but be impressed by the range of insti-
tutions and galleries devoted to cutting-
edge contemporary work. Long known
for its engagement with the current, from
the days of Jugendstil and the Vienna Se-
cession to the Viennese Actionists, Vienna
continues to feature a flourishing art
scene based in the 1st and 4th districts.

Vienna Resources

www.basis-wien.at
German and English language
Vienna art information

wien.art49.com
German and English-language
exhibition information and news
www.koer.or.at
Kunst im öffentlichen Raum Wien,
organizes public art projects since 2007
www.spikeart.at
Austrian art magazine includes guide to
Vienna galleries

Vienna Events

April
Vienna Fair, The International
Contemporary Art Fair
April & November
Vienna Art Week
2009
curated by _vienna 09 (6 May–6 June)
2010
ViennaBiennale; Frederick Kiesler Prize
for Architecture and the Arts; Oskar-
Kokoschka-Preis

MuseumsQuartier

How to get there Set across the Ring-
strasse from the Kunsthistorisches Mu-
seum, the MuseumsQuartier is one of the
largest cultural complexes to have been
built in post-war Europe.
Museumsplatz
www.museumsquartier.at
Kunsthalle Wien
Daily 10–7, Thu 10–10
Tel +43 1 52 1890
www.kunsthallewien.at
Leopold Museum
Daily 10–6, Thu 10–9
Tel +43 1 52 5700
www.leopoldmuseum.org
MUMOK
Museum Moderner Kunst
Daily 10–6, Thu 10–9
Tel +43 1 52 500
www.mumok.at
AzW Architekturzentrum Wien
Daily 10–7
Tel+43 522 3115

www.azw.at
(all sites German and English)
Exhibitions & Collections The Kunsthalle Wien was opened in 1992 in a temporary location in the Karlsplatz and subsequently moved to the Museums-Quartier in 2001. Exhibits such as ones by Louise Bourgeois, Raymond Pettibon, and William Kentridge further the brief of the Kunsthalle Wien to present international contemporary art and encourage discourse.

Designed to house the collection of Austrian art of Dr. Rudolf Leopold, the Leopold Museum has a singular collection of the works of Schiele as well as Klimt and other Austrian modernists. Two works by Schiele from the collection were contested as Nazi-era loot during a 1998 touring exhibition at MOMA.

Forming the basis of the MUMOK collections are works from the Austrian State as well as the 1981 gift of works from the German industrialist Peter Ludwig. The museum itself began as the Museum of the 20th Century in 1962 and thereafter became affiliated with the Museum of Modern Art in the Palais Liechtenstein. The collection is especially well known for its collection of Vienna Actionist artists and exhibits have featured Ryan Gander, John Baldessari, and Mike Kelley.

The AzW is the home for Austrian architecture of the twentieth and twenty-first centuries and presents exhibits on a wide variety of themes related to building. Founded in 1993, the museum moved to the former Messepalast site in 2001. AzW opened a satellite location for emerging architecture in 2007 but was forced to close the space in early 2008 due to budget cuts.

Buildings Designed by Ortner & Ortner, the MuseumsQuartier encompasses the eighteenth-century Royal Stables of Fischer von Erlach plus several purpose-built modernist-derived museum buildings. The museum complex uses a variety of contrasting shapes and materials, including the gray stone cube of the MU-MOK and the white box of the Leopold Museum as well as existing structures to create a collage of form and urban design.

Directors Director Kunsthalle Wien Gerald Matt 1996 –, chief curator Kunst-

halle Wien Sabine Folie – 2007, director MUMOK Edelbert Köb 2001 –

Selected solo exhibitions MUMOK Omer Fast, Keren Cytter, Sigmar Polke, Markus Huemer, Harun Farocki, Ryan Gander, Erwin Wurm, Franz Gertsch **Selected solo exhibitions Kunsthalle Wien** Raymond Pettibon, Dara Birnbaum, Chen Zhen, Marcel Dzama, Louise Bourgeois

MAK
How to get there Set on Vienna's historic Ringstrasse, the MAK or Museum of Applied Art is accessible via the Stubentor U-Bahn/tram stop.
Stubenring 5
Tue 10–Mid, Wed–Sun 10–6
Tel +43 171 1360
www.mak.at (German and English)
Exhibitions & Collections Founded in 1864 as the Imperial and Royal Austrian Museum of Art & Industry, the MAK is currently driven by the energies of its director, Peter Noever. During Noever's tenure the museum has engaged with con-

temporary art in initiatives exemplified by the re-installation of the museum collection by artists such as Donald Judd, James Turrell, and Franz West.

From May to November, MAK also displays selections of their contemporary art collection at a former flak tower in the Arenbergpark, **CAT Contemporary Art Tower** (Gefechtsturm Arenberg, Danenbergplatz 6, Sun 2–6, Tel +43 1711 36 231, www. mak.at).

Building Constructed in 1871 in a neo-renaissance style by Heinrich van Ferstel, this was the first museum to be built on the ring. With the redesign of the interior in 1993 by contemporary artists the museum entered a new phase, highlighted by a meeting of contemporary and historical trends.

Director Peter Noever 1986–

Selected solo exhibitions Victor Burgin, Alfons Schilling, Elke Krystufek, Arnulf Rainer

Secession
Friedrichstrasse 12
Tue–Sun 10–6, Thu 10–8
Tel +43 1 587 5307
www.secession.at

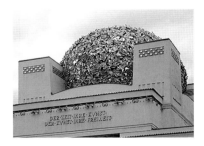

Since its founding in 1897, the Secession engages with international art trends as well as with Austrian art in a historic Jugendstil building near the Karlsplatz. The Association of Visual Artists is one of the oldest in the world and operates on a democratic basis. The first president of the Secession was Gustav Klimt whose iconic Beethoven Frieze can be glimpsed in the basement. Following extensive Second World War damage, the Secession was rebuilt in 1963 to mirror its original Joseph M. Olbrich design. Over the last decade, the Secession has produced many important exhibitions and remains one of the most forward-looking artists associations in Europe.

President András Pálffy

Selected solo exhibitions Korpys/ Löffler, Piotr Uklanski, Tue Greenfort, Jens Haaning, Antje Schiffers, Tom Burr

Generali Foundation
Wiedner Hauptstrasse 15
Tue–Sun 11–6, Thu 11–8
Tel +43 1 504 9880
www.foundation.generali.at

The Generali Foundation is a private non-profit foundation financed by the Generali insurance firm and which opened in 1995 in a space designed by Jabornegg /Palffy. Exhibiting a focused program of contemporary art in temporary exhibits, the Generali has built a reputation as an innovative institution. The Generali also collects artists such as Dan Graham, Hans Haacke, and Andrea Fraser. On January 1, 2008 the Generali merged with the BAWAG Foundation to create a new organization, Foundation(s) Quartier, and it remains to be seen what the curatorial vision for this new organization will entail.

Director Sabine Folie 2008–, curator Bettina Spoerr

Selected solo exhibitions Anna Oppermann, Edward Krasinski, Gustav Metzger

Kunsthaus Wien
Untere Weissgerberstrasse 13
Daily 10–7

Tel +43 1 712 0491
www.kunsthauswien.com
Kunsthaus Wien is, depending on one's view, the home to the kitsch of Hundertwasser or the home of the unique organic work of the same. Built in 1991 in a former furniture factory this is a privately run institution.

Kunsthalle Wien (Karlsplatz)
Treitstrasse 2
Tue–Sat 4–midnight, Sun–Mon 1–7
Tel +43 1 521 89 1201
www.kunsthallewien.at
Kunsthalle Wien Karlsplatz is a branch of the MuseumsQuartier Kunsthalle and was opened as a temporary structure in 1992 while the Kunsthalle was being constructed. Originally composed of a yellow container and a glass box resembling a cargo container and designed by Adolf Krischanitz, the architecture was singularly inventive and the programming has been of a high level since its inception.
Selected solo exhibitions Nathalie Djurberg, Luca Faccio, Paul Albert Leitner

BAWAG Foundation
Wiedner Hauptstrasse 15
Mon–Sat 10–6
Tel +43 1 504 98 8015
www.bawag-foundation.at
BAWAG Foundation is a project of the BAWAG bank and was founded in 1974. The foundation has focused on contemporary art since 1995. In 2008, the BAWAG merged with the Generali Foundation to create a new organization the Foundation(s) Quartier located in the Generali's space on Wiedner Hauptstrasse. The BAWAG continues to host exhibits by the likes of Susan Hiller and Christian Jankowski.

Kunsthalle Exnergasse
Währingerstrasse 59, Stiege 2, first floor
Tue–Fri 2–7, Sat 10–1

Tel +43 1 401 2141
www.kunsthalle.wuk.at
The Kunsthalle Exnergasse is located in the WUK Werkstätten und Kulturhaus that is set in a converted factory and which presents thematic exhibitions based in contemporary practice. The WUK was formed in 1981.

Augarten Contemporary
Scherzergasse 1a
Thu–Sun 11–7
Tel +43 79 5570
www.atelier-augarten.at
Augarten Contemporary opened in 2001 in the Augarten park grounds and is run by the Belvedere. The Belvedere, while focusing mainly in the historical collections of Prince Eugene, has significant contemporary holdings by artists such as Gelitin, Rudolf Schwarzkogler, and Heimo Zobernig. The Augarten also offers artist residency programs.
Selected solo exhibitions Markus Schwinwald, Martin Schnur

T-B A21 Thyssen-Bornemisza Art Contemporary
Himmelpfortgasse 13
Tue–Sun noon–6
Tel +43 1 513 9856
www.tba21.org
T-B A21 Thyssen-Bornemisza Art Contemporary was founded in 2002 by Francesca von Habsburg who is the fourth generation of the Thyssen family to support the arts. Formerly the curator of her father's impressive art collection in Lugano (now housed in Madrid), von Habsburg is noted for commissioning unconventional projects and sitespecific works such as the pavilion in Croatia by Adjaye and Eliasson.

Künstlerhaus
Karlsplatz 5
Daily 10–6, Thu 10–9

Tel +43 1 587 9663
www.k-haus.at

With its origins in the 1861 founding of the artists association, the Künstlerhaus is set in a historic building from 1868 on the Karlsplatz. While still run as a private association, the focus is on current trends in the arts with an accent on regional artists.

Mahnmal für die 65.000 ermordeten österreichischen Juden und Jüdinnen der Shoah
Judenplatz

British artist Rachel Whiteread's *Mahnmal für die 65.000 ermordeten österreichischen Juden und Jüdinnen der Shoah* opened in 2000 and represents an empty library and functions as a anti-memorial with a steel-and-concrete casing that is a powerful statement of loss and has links with the themes of death and loss so prevalent in Whiteread's work.

Museum auf Abruf
Felderstrasse 6–8
Tue–Fri 11–6, Thu 11–8, Sat 11–4
Tel +43 1 4000 8400
www.musa.at

Museum auf Abruf is termed a "museum on demand" and houses the contemporary art collection of the city of Vienna, presenting exhibits by emerging artists as well as selections from the substantial collection of the city.

Vienna Art Areas

In the areas surrounding the Karlsplatz are located a substantial number of contemporary art galleries, especially in the Schleifmühlgasse (4th district) and Eschenbachgasse (1st district). An area also featuring a large selection of contemporary spaces is the Seilerstätte located in the 1st district.
www.seilerstaette.com

Bregenz

Kunsthaus Bregenz

How to get there Situated on Lake Constance on the border of Switzerland, Germany, and Austria, Bregenz is 1 1/2 hours from Zurich.
Karl-Tizian-Platz
Tue–Sun 10–6, Thu 10–9
Tel +43 557 448 5940
www.kunsthaus-bregenz.at
(German and English)

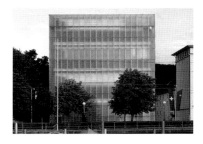

Exhibitions & Collections The Kunsthaus Bregenz is unique in forging no permanent collection while instead relying on its minimalist aesthetic to provide depth and scope to what are meticulously curated exhibitions.
Building Peter Zumthor's Kunsthaus Bregenz opened in 1997 and immediately won praise throughout the architectural press for its sumptuous minimalism. A deceptively simple design allows the art to stand for itself within a building that has eliminated all superfluous detail.
Director Eckhard Schneider 2000–08
Selected solo exhibitions Cerith Wyn Evans, Jean-Marc Bustamante, Michael Craig-Martin, Tino Sehgal

Dornbirn

Dornbirn Events
July/August
Art Bodensee art fair

Kunstraum Dornbirn

Jahngasse 9
Tue–Sun 10–6
Tel +43 5572 55 044
www.kunstraumdornbirn.at

Set in a former assembly hall the Kunst-raum Dornbirn is the city gallery of Dornbirn and presents exhibits dealing with art and nature. The gallery's bare hall faced with bricks provides a unique setting for contemporary works.

Selected solo exhibitions Michel Blazy, Olaf Nicolai, Mark Dion

Graz

A provincial capital south of Vienna, Graz is by tradition intensely conservative. This has been belied by the construction in 2003 of two innovative structures that seem out of place in the historic fabric of the baroque city. This is a prime exam-ple of what being the Cultural Capital of Europe as designated by the European Union and the money allocated to this designation, can bring to a city.

Graz Resources

www.aktuellekunst-graz.at
German and English-language guide to exhibitions

Graz Events

April
Galerientage

Kunsthaus Graz

How to get there On the banks of the River Mur, the Kunsthaus Graz stands out amongst the Baroque architecture of this central Austrian city. Reachable via tramlines 1, 3, 6, and 7 or a 15-minute walk from the train station.

Lendkai 1
Tue–Sun 10–6
Tel +43 316 8017 9200
www.kunsthausgraz.at

(German and English)

Exhibitions & Collections As with many another Austrian Kunsthaus, there is no permanent collection and the exhibition spaces do not lend themselves to displays of a wide variety of media. Exhibitions have regularly featured major internatio-nal artists. Idiosyncratic in the extreme, what is on show here is the architecture.

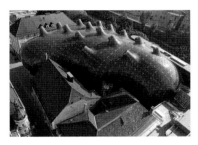

Building Peter Cook, member of seminal British architectural group Archigram, and Colin Fournier (as Spacelab Cook Fournier) have constructed what they term a "friendly alien" that emphasizes biomorphic form over utility value. A throbbing blue skin gives the Kunsthaus its distinctive appearance and is especial-ly stunning when seen at night. Since its opening in 2003 the Kunsthaus has re-ceived considerable attention to its inno-vative design.

Director Peter Pakesch 2003–
Selected solo exhibitions Martin Kippenberger, Werner Reiterer, Kenneth Anger, Cerith Wyn Evans, John Baldessari

Die Insel in der Mur

www.inselindermur.at

Vito Acconci's Die Insel in der Mur (Is-land in the Mur) was constructed as part Graz's 2003 year as the Cultural Capital of Europe and stands in the middle of the river Mur. While functionally it is meant to serve as a café and amphitheater

the main value appears to be its sculptural and aesthetic role. The Insel is one of the major pieces of Acconci's architectur-

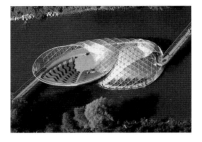

al work which involved a significant shift from his engagement with performance and video art.

Neue Galerie Graz
Sackstrasse 16
Tue–Sun 10–6
Tel +43 316 82 9155
www.neuegalerie.at
Founded in 1811 as the Landesbildgalerie, the Neue Galerie Graz am Landesmuseum Joanneum is located in the baroque Palais Herberstein and, in addition to its collection of nineteenth- and twentieth-century works, offers an engaging program of contemporary exhibits.

Grazer Kunstverein
Palais Thinnfeld,
Mariahilferstrasse 2
Tue–Sat 10:30–6
Tel +43 316 83 4141
www.grazerkunstverein.org
The Grazer Kunstverein presents mainly emerging Austrian artists since its inception in 1986. Moving into new premises in the renovated Palais Thinnfeld in January 2008, the Kunstverein features regional artists.
Director Soren Grammel 2006
Selected solo exhibitions Bernd Krauss, Nina Könnemann

Haus der Architektur Graz
Palais Thinnfeld, Mariahilferstrasse 2
Tue–Sun 10–6
Tel +43 316 32 3500
www.had-graz.at
Haus der Architektur Graz opened in 1988 to encourage dialogue amongst architects, students and those interested in contemporary architecture and urban planning. The house is located in the recently renovated Palais Thinnfeld (since early 2008) and presents changing exhibitions.

Innsbruck

Innsbruck Resources
www.innsbruckcontemporary.at
English and German language information on galleries and institutions in Innsbruck and Tyrol region

Innsbruck Events
February
Art Innsbruck

Kunstraum Innsbruck
Maria Theresien Strasse 34
Tue–Fri 11–6, Sat 11–6
Tel +43 512 58 4000
www.kunstraum-innsbruck.at
Kunstraum Innsbruck opened in 1996 in a space renovated by Hans Peter Petri. The Kunstraum is known for its commitment to international contemporary art.
Director Stefan Bidner
Selected solo exhibitions Jonathan Meese, John Bock, Franz West, Hubert Kiecol, Michael S. Riedel

Galerie im Taxispalais
Marie Theresien Strasse 45
Tue–Sun 11–6, Thu 11–8
Tel +43 512 508 3170
www.galerieimtaxispalais.at
Originally founded in 1963, the Galerie im Taxispalais re-opened in 1999 in a

renovated baroque building and features temporary exhibits.

Director Silvia Eiblmayr
Selected solo exhibitions Heidrun Holzfeind, Maria Hahnenkamp, Georg Urban, Charlotte Salomon, Roman Ondak

Klagenfurt

MMKK
Museum Moderner Kunst Kärnten
Berggasse 8 / Domgasse
Tue–Sun 10–6, Thu 10–8
Tel + 43 50 536 30542
www.verwaltung.ktn.gv.at
Museum Moderner Kunst Kärnten is located in a collegiate castle from 1586 with significant additions made during the baroque era. Long the seat of the provincial governor of Carinthia, the museum was only opened in renovated rooms in 1965. The collection features work by contemporary artists Heimo Zobernig, Hans Schabus, and Erwin Wurm.
Selected solo exhibitions Donald Baechler, Maria Lassnig

Klosterneuberg

Sammlung Essl
An der Donau 1
Tue–Sun 10–7, Wed 10–9
Tel +43 08 008 3200
www.sammlung-essl.at
Sammlung Essl is a collection of twentieth- and twenty-first-century art housed in the northern suburb of Vienna, Klosterneuberg, and reachable via S-Bahn. While leaning heavily on Austrian art, the collection of Karlheinz & Agnes Essl also includes artists such as Jannis Kounellis, Shirin Neshat, Nam June Paik, and Cindy Sherman. Opened in 1999 to a design by Austrian architect Heinz Tesar, the collection was originally planned to be placed in the center of Vienna in the new

MuseumQuartier where the Leopold Collection is now located.
Head Andreas Hoffer

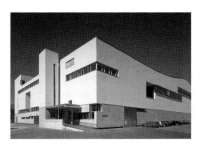

Selected solo exhibitions Jonathan Meese, Markus Prachensky

Krems

Kunsthalle Krems
Franz Zeller Platz 3
Daily 10–5
Tel +43 27 3290 8010
www.kunsthalle.at
Set in an Adolf Krischanitz renovated tobacco factory, the Kunsthalle Krems has presented international artists since opening in 1995.
Selected solo exhibitions Wolfgang Denk, Markus Wilfing, Yves Leresche, Brigitte Kowanz

Linz

Well-known internationally as the home to the annual ARS Electronica Festival, Linz has invested heavily in culture including a Kulturmeile, or culture mile, along the Danube. In 2009 Linz will be one of the European Capitals of Culture and during this time period special art exhibitions and events will take place. Linz is not new to urban culture planning. During the nineteen-thirties, Hitler had planned for Linz to be the major focal point for arts in the greater Reich, with

museums and extensive refashioning of the historical center.

Linz Events

2009
Linz European Capital of Culture; new ARS Electronica Center Museum of the Future opens (2 Jan); Festival of Regions (9 May–1 June 09); ARS Electronica (3–8 Sept 09)
2010
ARS Electronica (Sept 10)

Lentos Kunstmuseum Linz

Ernst-Koref-Promenade 1
Wed–Mon 10–6, Thu 10–9
Tel +43 732 70 70 3600
www.lentos.at

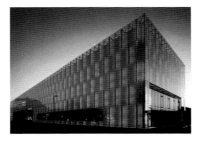

In 2003, the Lentos Kunstmuseum Linz was inaugurated as the new art gallery of the city of Linz. The innovative architecture by Weber+Hofer has garnered praise for its sensitive approach to design. While the museum collection encompasses work from the modern to contemporary period, the emphasis is on the extensive modern collection with the donation of the Berlin art dealer Wolfgang Gurlitt. The contemporary is represented in the collection by works from Tony Cragg, Maria Lassnig, Valie Export, amongst others.
Director Stella Rollig
Selected solo exhibitions Ursula Meyer, Marko Peljhan, Peter Köllerer, Michaela Melián

OK Offenes Kulturhaus Oberösterreich

OK Platz 1
Mon–Thu 4–10, Fri 4–midnight
Sat 10–midnight, Sun 10–10
Tel +43 732 784 1780
www.ok-centrum.at
OK Offenes Kulturhaus Oberösterreich or OK Center for Contemporary Art, has developed a reputation for presenting challenging temporary exhibitions since its founding in the late nineteen-eighties. Set in a thirties building renovated in 1998 by Peter Riepl, the center is one of the leading venues for international art in Austria.
Director Martin Sturm
Selected solo exhibitions Luca Vitone, Šejla Kameric, Victor Amplev

Landesgalerie Oberösterreich

Museumstrasse 14
Tue–Fri 9–6, Sat–Sun 10–5
Tel +43 732 77 44820
www.landesgalerie.at
Landesgalerie Oberösterreich has its origins in the 1855 founding of the Landesgalerie and has been located in current building since 1895. Pursuing contemporary art for the collection as well as contemporary exhibitions since 1985, the Landesgalerie concentrates on Austrian artists with a special focus on graphic work and photography.
Selected solo exhibitions Hans-Peter Feldmann, Robert Jelinek

Mistelbach

MZM
Museumszentrum Mistelbach

Waldstrasse 44–46
Tue–Sun 10–6
Tel +43 025 722 0719
www.mzmistelbach.at
The MZM Museumszentrum Mistelbach opened in renovated factory whose ren-

ovation was designed by Johannes Kraus and Michael Lawugger. A major feature of the museum is the Hermann Nitsch museum opened here in 2007 and featuring works of this Viennese Actionist.

Neuhaus

Museum Liaunig
by appointment May to October
Tel +43 4356 211 15
www.museumliaunig.at
Museum Liaunig opened in August 2008 and presents the collection of the Carinthia-based collector Herbert Liaunig. The collection is focused on post-1945 Austrian art and includes works by Walter Pichler, Arnulf Rainer, and Erwin Wurm. Originally to be partly financed by the province, this fell through and Liaunig originally chose Odile Decq to design the structure that was eventually built by the design firm querkraft.

Salzburg

Museum der Moderne Salzburg Mönchsberg
Mönchsberg 32
Tue–Sun 10–6, Wed 10–9
Tel +43 662 84 22 20403
www.museumdermoderne.at
Designed specifically to meet the demands of installing modern and contemporary work the Museum der Moderne Salzburg Mönchsberg opened in 2004 and was designed by Munich-based architect Friedrich Hoff Zwink. The museum is set high above Salzburg on the Mönchsberg and commands spectacular views of the surrounding area.
Selected solo exhibitions Anselm Kiefer, Lawrence Weiner, Stephan Balkenhol

Museum der Moderne Salzburg Rupertinum
Wiener Philharmonikergasse 9

Tue–Sun 10–6, Wed 10–9
Tel +43 662 84 22 20451
www.museumdermoderne.at
Housing the modernist collections of the city of Salzburg, the Museum der Moderne Salzburg Rupertinum is located in a baroque palace and was originally opened in 1983. With a large collection of works of Expressionism from the collection of art dealer Friedrich Welz, the Rupertinum also has a continuing focus on the contemporary with works by, amongst others, Bruno Gironcoli, Elke Krystufek, and Maria Lassnig.
Selected solo exhibitions Tina Barney, Nabila Irshald, Herbert Scheibl

St. Pölten

NOe Landesmuseum
Kulturbezirk 5
Tue–Sun 9–5
Tel +43 2742 9080 90100
www.landesmuseum.net
An encyclopedic museum encompassing natural history as well as fine art, the NOe Landesmuseum opened in 2002 to a design by noted deconstructionist architect Hans Hollein. The museum houses the extensive collections of the Niederösterreichische (Lower Austria) province and includes contemporary works by Elke Krystufek, by Hermann Nitsch, and Arnulf Rainer.
Selected solo exhibitions Ona B, Makis E. Warlamis

The arts in Belgium are dominated by the Flemish north (Ghent and Antwerp) and Brussels while the rest of the country is hindered by a lack of investment and therefore the Wallonian institutions, despite government intervention, are mainly of provincial character. Belgium has had a long history of engagement with the contemporary especially during the conceptual art nineteen-seventies. In light of their more prosperous neighbors France and the Netherlands, Belgium offers a distinctly different art experience based on regionalism. This situation may change, though, as Brussels has recently added the Wiels, a forward-looking contemporary arts institution, to the cultural fabric.

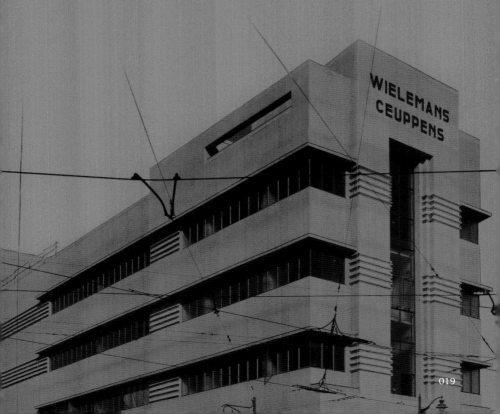

Belgium Events

May
Le Printemps des Musées

Antwerp

Long a center for contemporary art in Western Europe, Antwerp saw a particularly strong period of activity in the nineteen-seventies when Gordon Matta-Clark created his famous Opéra Baroque, now destroyed, in the city.

Antwerp Resources

www.antwerpart.be
Dutch and English-language list of exhibitions

Antwerp Events

August
Museumnacht
September
Antwerp Art Weekend
2009
Museum aan de Stroom opens, Neutelings Riedijk architects

MukHa
Museum van Hedendaagse Kunst

Leuvenstraat 32
Tue–Sun 10–5
Tel +32 3 260 9999
www.muhka.be
(Dutch only)

How to get there Sited in the south of Antwerp near the Royal Museum, MukHa can be reached via bus 23 from Antwerp Central Station.

Exhibitions & Collections An initiative of the Flemish community, MukHa is particularly involved with collecting and exhibiting Belgian art. Discussions to create a contemporary art museum began following the Second World War, although due to financial circumstances only in 1987 was the building inaugurated. This delay caused the museum to miss out on Gordon Matta-Clark's *Office Baroque* created in Antwerp in 1977, which is still a loss felt by the local arts community. The collection, though, does have significant holdings of the works of Matta-Clark as well as other prominent international artists.

Building Housed in a converted grain silo from 1926 in the southern port area, MukHa's renovation was entrusted to Antwerp architect Michel Grandsard. The post-modern design is emblematic of its time and has engendered some criticism for its use of form. Further conversions by Grandsard in 1992 and then of the lobby in 2003 by Robbrecht & Daem have brought the museum additional features.

Director Bart de Baere 2002–
Selected solo exhibitions Luc Tuymans, Atelier Panamarenko, Jan Fabre

Middelheimmuseum

Middelheimlaan 61
Oct–March Tue–Sun 10–6,
April & Sept Tue–Sun 10–8,
May & Aug Tue–Sun 10–9,
June & July Tue–Sun 10–10
Tel +32 3 827 1534
www.museum.antwerpen.be/
middelheimopenluchtmuseum

Located on the outskirts of Antwerp, the Middelheimmuseum is an Open Air Sculpture Museum featuring works by Guillaume Bijl, Tony Cragg, Per Kirkeby, Jessica Stockholder, amongst others. The museum first housed an international sculpture show in 1950 and from 1951 to 1989 it held the well regarded international sculpture biennial. Continuing to add space, the park has continued to serve as one of the most important centers for outdoor sculpture in Europe.

Extra City Center for Contemporary Art

Klamperstraat 40
Thu–Sun 2–8

Tel +32 4 442 1070

www.extracity.org

Extra City Center for Contemporary Art features temporary exhibits and opened in 2004 in a former grain silo. The center offers an artist in residence program that has featured Terence Koh.
Selected solo exhibitions Luke Fowler, Joachim Koester

objectif_exhibitions

Kleine Markt 7–9

Tel +32 3 288 4977

www.objectif-exhibitions.org

objectif_exhibitions hosts mainly group thematic exhibitions and has had a tradition of innovative curatorial leadership.
Artistic director Mai Abu ElDahab, former director Philippe Pirotte

deSingel

Desguinlei 25

Mon–Fri 10–7, Sat 4–7

Tel +32 3 248 2828

www.desingel.be

deSingel architecture center opened in 1985 and also offers dance, music, and theater events. Located in a building by Léon Stynen from 1968, the center has plans to transform itself into an arts campus with additional buildings and facilities to open in 2010.

Brussels

The home of the European Union, Brussels is an international city that has until recently been focused on regional issues dominated by its position at the center of the divide between the Flemish north and the French Wallonian south. As a result of its increased visibility in the international arena, Brussels has seen a marked rise in the cultural investment, with private collections, galleries, and museums opening in the last several years.

Brussels Events

March

Museum Night Fever

April

ARTBrussels, contemporary art fair

October

Nuit Blanche

2010

Brussels Biennial

Musées Royaux des Beaux Arts de Belgique

Rue de la Régence 3

Tue–Sun 10–5

Tel +32 2 508 3211

www.fine-arts-museum.be

The Musées Royaux des Beaux Arts de Belgique encompasses two institutions, The Museum of Ancient Art and The Museum of Modern Art, in a building designed by Alphonse Balat in 1887. Contemporary art is exhibited in the extension built in 1984 by Roger Bastin and features works from the collection by Francis Bacon, Marcel Broodthaers, and Dan Flavin. Originally opened in 1803, the Musées Royaux were transferred to the Belgian state in 1842 by King Leopold II and are currently undergoing extensive renovations as well as frequently closing certain galleries.

Wiels, Contemporary Art Center

Av. Van Volxemlaan 354

Wed–Sat 12–7, Sun 11–5

Tel +32 2 347 3033

www.wiels.org

A major addition to the art scene, Wiels, Contemporary Art Center opened in May 2007 and is located in the former Wielemans-Ceuppens brewery building from 1930 and is a prime example of modernist industrial architecture. The center presents single-artist exhibitions by international art figures and has no plans to collect.
Artistic director Dirk Snauwaert

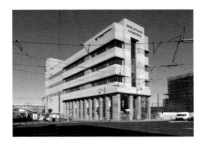

Selected solo exhibitions Yayoi Kusama, Marcel Berlanger, Simon Starling, Luc Tuymans

CCNOA
Centre for contemporary
non-objective art
Boulevard Barthélémylaan 5
Fri–Sun 2–6
Tel +32 2 502 6912
www.ccnoa.org
CCNOA, centre for contemporary non-objective art opened in 1998 and is dedicated to showing abstract work in a variety of mediums. While exhibits are centered on Belgian artists, international artists are also frequently featured.
Selected solo exhibitions Gerwald Rockenschaub, Matthieu Mercier, Alan Ugow

Vanhaerents Art Collection
Rue Anneessens 29
by appointment only
Tel +32 2 511 5077
www.vanhaerentsartcollection.com
Vanhaerents Art Collection houses the collection of local property developer Walter Vanhaerents and is located in a nineteen-twenties' building renovated by Robbrecht and Daem. Accessible to the public via appointment since 2006, the collection includes works by Bruce Nauman, Cindy Sherman, Barbara Kruger, Jenny Holzer, Allan McCollum, amongst others.

Argos
Werfstraat 13, rue du Chantier
Tue–Sat 12–7
Tel +32 2 229 0003
www.argoarts.org
Argos was founded in 1989 to investigate the convergence of art and media. A unique feature of the center is the extensive media library.

Fondation pour l'architecture
55 rue de l'Ermitage
Tue–Fri 12–6,
Sat–Sun 10:30–6
Tel +32 26 42 2480
www.fondationpourlarchitecture.be
Fondation pour l'architecture was founded in 1986 in an early twentieth-century power station in the Louise district. The center was a project of architect Philippe Rotthier and presents changing exhibits on urban planning and architectural themes.

Charleroi

B.P.S. 22
22 boulevard Solvay
Thu–Sun 12–6
Tel +32 71 27 2971
www.bps22.hainaut.be
The contemporary art space for the province of Hainaut, B.P.S. 22, was founded in 2000 and focuses on art that engages with society. Sited in an industrial building from 1911, the center hosts focused temporary exhibits.
Director Pierre-Oliver Rollin
Selected solo exhibitions Wang Du, Kendell Geers

Duffel

Thierry De Cordier's Kapel
van het Niets
Stationsstraat 22C
Mon–Fri 12:30–4:30

Tel +32 15 30 4030
www.pz-duffel.be
Thierry De Cordier's Kapel van het Niets (Chapel of Nothing) is a concrete box with a white interior that operates as a sacred space and which opened in 2008. Located on grounds of the Psychiatric Hospital St. Norbert this restful place is meant as a retreat for patients and visitors.

Ghent

Ghent Events
December
Gent Museumnacht & Gentse Kunstweek

S.M.A.K.
Stedelijk Museum voor
Actuele Kunst
How to get there Located near the Museum of Fine Arts, S.M.A.K. is south of the historic center of Gent.
Citadelpark
Tue–Sun 10–6,
first Friday of month 10–10
Tel +32 9 221 1703
www.smak.be
(Dutch, French, English)

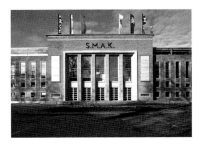

Exhibitions & Collections Opened in 1999, S.M.A.K. incorporates works from the Contemporary Arts Association and the Museum voor Hedendaagse Kunst. The museum bears strongly the imprint of founding director Jan Hoet and the international focus he brought to the institution. Exhibited artists include David Hammons, Juan Muñoz, and Luc Tuymans. Unfortunately since Hoet's departure the museum has lost much of its impetus and has seen its international standing fall.
Building Located in the 1948 Casino building, a renovated public ballroom and social center, S.M.A.K. was designed by Belgian architect Koen Van Nieuwnhuyse.
Director Philippe van Cauteren 2005
Selected solo exhibitions Paul McCarthy, Kendell Geers, Anton Henning, Matthias Beckmann

Hasselt

Z33
Zuvelmarkt 33
Tue–Sat 11–6, Sun 2–5
Tel +32 11 295960
www.z33.be
Z33 presents temporary exhibits that focus on art and design. New media is also a part of the program that includes films and events.
Director Jan Boelen

Hornu

Musées des Arts Contemporains
rue Sainte-Louise 82
Tue–Sun 10–6
Tel +32 65 65 2121
www.mac-s.be
Musées des Arts Contemporains was opened in 1991 as the art museum for the region of Mons Borinage and the province of Hainault. The museum is housed in an old industrial mining complex from the nineteenth century renovated and extended by Pierre Hebbelinck, and is noted for being one of the foremost museums of Wallonian Belgium.
Director Laurent Busine
Selected solo exhibitions Beat Streuli, Anish Kapoor

Leuven

Leuven Events
Fall
Playground-Live Art Festival,
annual event

STUK Kunstuncentrum
Naamsestraat 96
Wed–Thu 2–9, Fri–Sun 2–6
Tel +32 16 320 320
www.stuk.be
In the capital of Flemish Brabant, the
STUK Kunstuncentrum was founded in
1977 as part of student initiatives and
came under Flemish governmental support
structure in 1986. Moving into a
new facility in 2002 the center features
art, dance, theater, and performance as
well as temporary contemporary art exhibits.
Selected solo exhibitions Erwin Wurm,
Keren Cytter, Hans Op De Beeck

Liège

Musée d'Art Moderne et d'Art Contemporain
Parc de la Boverie
Tue–Sat 1–6, Sun 11–4:30
Tel +32 4 343 0403
www.mamac.be
Set in the Boverie park in a building
from the universal exhibition of 1905,
the Musée d'Art Moderne et d'Art Contemporain
has a collection of mainly
French and Belgian art that concentrates
on modernism.

Mechelen

Mechelen Events
2009
Contour 2009—Fourth Biennial
for Video Art (21 March–21 June 09)

Created during the Balkan conflicts of the nineteen-nineties, Bosnia and Herzegovina suffered terribly in the wars and the region is only slowly recovering some of its pre-war vitality. Sarajevo, as capital, has seen international efforts to reconstruct elements of the city damaged during the siege of the city. Currently there are plans to have noted architect Renzo Piano design a new home for a contemporary art museum.

Bosnia and Herzegovina

Sarajevo

Sarajevo Events

TBD: ARS AEVI Museum of Contemporary Art, Renzo Piano architect

ARS AEVI Museum
of Contemporary Art

www.arsaevi.ba

An anagram of Sarajevo, ARS AEVI Museum of Contemporary Art is a project inaugurated in 2007 and conceived during the siege of the city in the nineteen-nineties. Plans are in development for Renzo Piano to design a new museum although a collection is already being formed with donations from artists such as Jannis Kounellis, Joseph Kosuth, and Michelangelo Pistoletto.

Sarajevo Center
for Contemporary Art

Obala Maka Dizdara 3

Tel +387 33 66 5304

www.scca.ba

Sarajevo Center for Contemporary Art was originally part of the George Soros funded eastern European art centers and since 2000 has been an independent organization with offices located at Sarajevo Academy of Fine Art. Projects and exhibitions are staged in venues around Sarajevo while a permanent home is sought.

Bulgaria is a newcomer to the contemporary art world and has yet to develop a significant commitment to developing an arts infrastructure. The country has in many ways struggled to find its way in the expanded Europe, with many choosing to leave the country due to the high levels of corruption. This has hurt the arts community as many who otherwise would have been a nascent arts audience have decided to seek their futures elsewhere.

Bulgaria

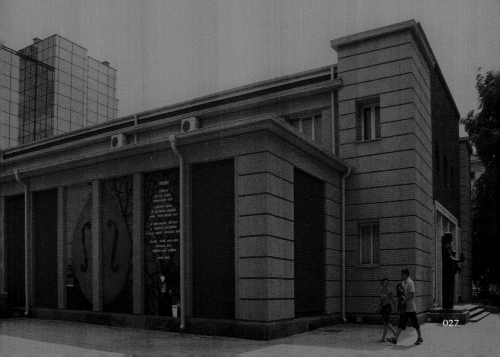

Sofia

Sofia Art Gallery
1. Gen. Gurk Str.
Tue–Sat 1–7, Sun 11–6
Tel +359 2 987 2181
www.sghg.cult.bg

Focused on Bulgarian art, the Sofia Art
Gallery was originally established in
1928 and opened in present location in
1977 with an additional space at 15 Yanko
Sakazov Boulevard. This is the institu-
tion with the highest commitment to
contemporary art in Bulgaria, although
the contemporary art department was
only recently established in 2004.

ICA
Institute of Contemporary Art
Tel +359 887 51 0585
www.ica.cult.bg
ICA Institute of Contemporary Art was
formed in 1995 and association of artists
and art professionals has mounted exhib-
its and held events throughout Sofia.
Many of the leading Bulgarian cultural
workers, including its director Iara Boub-
nova, have been involved with the proj-
ect although its current status is in limbo.

Plovdiv

Plovdiv Events
September
Night of Museums and Galleries

Croatia

Croatia has emerged from the Balkan conflicts of the nineties to see rapidly expanding tourism numbers although this has yet to fully impact the contemporary art sector. New contemporary art museums are scheduled to open in Zagreb in autumn 2007 (significantly delayed) and in Rijeka in 2010, which will bring some focus to what is now a barren landscape for contemporary art enthusiasts. The difficulty faced by Croatia, as for other parts of the former east, is the need to start from the ground up in building collections and forging institutions while also encouraging collectors, artists, and arts enthusiasts to support and engage with the arts.

Croatia Resources
www.culturenet.hr
English and Croatian-language guide to
Croatian cultural events and institutions

Zagreb

Zagreb Events
Autumn 2007(delayed)
Museum of Contemporary Art opens,
architect Igor Franic

Muzej Suvremente Umjetnosti Zagreb
www.msu.hr
Muzej Suvremente Umjetnosti Zagreb
(Museum of Contemporary Art Zagreb)
was founded in 1954 as the City Gallery
of Contemporary Art and the museum
was scheduled to re-open in autumn
2007 with a new building designed by
Igor Franic that takes the step of moving
from the historic center to a location
across the Sava River. The new location
houses areas for the well-regarded collec-
tion of Croatian and Balkan-based con-
temporary art as well as temporary exhi-
bition rooms. Check on the website for
opening dates, hours, and further infor-
mation as the project has encountered
numerous delays since its projected 2007
opening date.
Curator Branka Stipanic 1983–93

Dubrovnik

Museum of Modern Art Dubrovnik
Put Frana Supila 23
Tue–Sun 10–8
Tel +385 20 42 6590
www.ugdubrovnik.hr
Museum of Modern Art Dubrovnik was
designed in the nineteen-thirties as a
mansion for a ship owner and only opened
in 1950 as a museum. Recognized as
housing a significant collection of Balkan-
based art, the museum is known for its
modernist focus.

Selected solo exhibitions Slaven Tolj,
Oskar Herman, Jan Fabre

Lopud Island

Your black horizon Art Pavilion
open May & October Daily 11–5,
June–September Daily 11–7
www.tba21.org
One of the more intriguing collaborations
of recent years, *Your black horizon* Art
Pavilion features London-based architect
David Adjaye & artist Olafur Eliasson in
a project organized by Thyssen Bor-
nemisza Art Contemporary. Originally
presented at the 2005 La Biennale di
Venezia, the pavilion opened on this is-
land near Dubrovnik in summer 2007. A
deceptively simple box, the pavilion
houses a black box space in which a hori-
zon of light totally surrounds the viewer.
The black horizon refers to the image on
the retina that is left for a few seconds af-
ter exiting the pavilion.

Rijeka

Muzej Moderne
I Suvremente Umjetnosti
Dolac 1, 2nd floor
Tue–Sun 10–2 & 5–8
Tel +385 33 4280
www.mmsu.hr
Muzej Moderne I Suvremente Umjetnos-
ti, Museum of Contemporary and Mod-
ern Art is a museum founded in 1948
that exhibits on a Kunsthalle schedule
due to lack of space to exhibit their per-
manent collection of artists from the Bal-
kan region. Plans are in place to renovate
an existing structure in the harbor area
for the museum to move into in 2010.
Director Branko Francèschi

Divided into Greek and Turkish sectors,
Cyprus has had a limited connection to
the contemporary art world as it operates on the periphery of the European situation. This was one of
the attractions for scheduling Manifesta in Nicosia,
the capital of the Greek section, in 2006. This was
eventually canceled as the political situation became
untenable and the island has reverted to a lack of
engagement with contemporary art. It is perhaps too
much to ask for this situation to change until the
political climate has been improved.

Cyprus

Nicosia

Pharos Centre for Contemporary Art
24 Demosthenis Severis Avenue
Tue–Fri 10–1 & 3–5
Tel +357 22 66 3871
www.pharosart.org
Pharos Centre for Contemporary Art was
founded in 2005 to present temporary
exhibitions as well as offering a residen-
cy program.

Czech Republic

Seemingly the best-placed country of the former Eastern Bloc to embrace the contemporary situation based on the Czechs' long history of engagement with topical themes and underground movements, the Czech Republic has instead focused on the revitalization of its heritage industry with its accompanying accent on tourism and a vision of Habsburg-era central Europe.

Prague

One of the most stunningly attractive cities in Europe, Prague serves as a magnate for Czech art and culture. While most of the energy in the Czech art scene is centered here, including the lively Prague Biennale, the city does groan under the weight of the massive amounts of tourists crammed into its historic quarters. The Czech capital has yet to see significant commitment from its leaders to create new contemporary art institutions to rival what is rightly seen as one of Europe's premier heritage attractions.

Prague Events

June
Museum Night
September/October
Tina B, The Prague Contemporary Art Festival
2009
Prague Biennale 4 (14 May–26 July 09)
TBD: Sculpture Grande Prague, open air sculpture festival last held in 2007

Czech Museum of Fine Arts

Husova Street
Tue– Sun 10–6, 7–9
Tel +420 22 222 0218
www.cmvu.cz
Focusing on regional art, the Czech Museum of Fine Arts is located in a medieval house adapted for use in 1971. The museum concentrates on modernist art including work from the communist era.

Veletržní Palace

Dukelských hrdinu 47
tram 17, 12, 14 stop Veletržní
Tue–Sun 10–6
Tel +420 224 30 1111
www.ngprague.cz
A masterpiece of functionalist architecture, The Trade Fair Palace or Veletržní Palace houses the national gallery's collection of modern and contemporary art. Originally built in 1928 by Oldrich Tyl and Josef Fuchs, this is a striking building which, despite fire damage in 1974, retains its ability to impress. While the strength of the museum is in its collection of Czech modernism there are holdings on view of contemporary work by artists such as Michelangelo Pistoletto, Hermann Nitsch, and Tony Cragg. Exhibits concentrate on trends in modernism and regional Czech art.

Galerie Rudolfinum

Alšovo nábreži 12
Tue–Sun 10–6
Tel +420 222 31 9293
www.galerierudolfinum.cz
The neo-renaissance Galerie Rudolfinum building opened in 1884 and was originally designed to be a House of Artists

featuring a picture gallery and a concert hall. The name stems from its patron, crown prince Rudolf Hapsburg and it was here that the Czech parliament sat during the nineteen-twenties. In 1994, the Galerie was opened as a space for temporary exhibits of contemporary art, with the large decorated rooms so indicative of the late nineteenth century forging a unique dialogue with art more used to the traditional white gallery spaces so prevalent in most institutions.
Director Petr Nedoma
Selected solo exhibitions Neo Rauch,

Rineke Dijkstra, Václav Jirásek, Gregory Crewdson

Dox Centre for Contemporary Art
Osadní 34
Wed–Fri 11–7, Sat–Mon 10–6
Tel +420 224 930 927
www.doxprague.org

Dox Centre for Contemporary Art was founded in 2002 to present both international and Czech artists. Completed in October 2008, the home for the center opened in the Holešovice area. The center is a welcome addition to the Czech contemporary arts landscape and it is hoped will engage with the larger European contemporary art context.
Director Leoš Válka

**Foundation
for Contemporary Art Prague**
www.fca.fcca.cz
Opened in 1992, Foundation for Contemporary Art Prague is the successor to the Soros Center for Contemporary Arts which closed in 1998 and offers grants and support to contemporary Czech artists.

Tranzit and Tranzit Display
Tranzit
Fricova 11
Tel +420 222 562 031
www.cz.transit.org
Tranzit Display
Dittriochova 9 / 337

Tel +420 777 154 864
www.tanzitdisplay.cz
Tranzit and Tranzit Display are projects begun in 2001 to address contemporary art in the Eastern European context through exhibitions and programs. Frequent exhibits engage with current trends and have featured artists such as Eija Liisa Ahtila.

Brno

Brno Events
May
Museum Night

Brno House of Art
Malinovského nám. 2
Daily 10–6
Tel +420 54 221 1808
www.dumb.cz
The Brno House of Art built in 1910 in Secessionist style and is operated by the city of Brno. The city's reputation for world-class modernist architecture is emphasized by Bohuslav Fuchs' remodeling of the house in functionalist style following the Second World War. The exhibition strategy and collections here are more of a regional nature although there is an effort to expand into international contemporary work.
Selected solo exhibitions Mark Lüders, Aktivni Konstelace

**Brno House of Art
House of Lords at Kunstat**
Dominikánská 9
Daily 10–6
Tel +420 542 423 4405
www.dumb.cz
The Brno House of Art, House of Lords at Kunstat is part of the Brno House of Art organization and is located in a renaissance building in the historic center. Also located here is Gallery G99 and exhibits here of a temporary nature.

Selected solo exhibitions
Katarzyna Kozyra, Otto Placht

Ceský Krumlov

Egon Schiele Art Centrum
Široká 71
Daily 10–6
Tel +420 380 704 011
www.schieleartcentrum.cz
Egon Schiele Art Centrum began as a private initiative in 1993 and is set in a brewery complex dating from the sixteenth century. The center offers a permanent installation of the work of former resident, the modernist Egon Schiele, as well as changing international exhibitions.

Pilsen

Galerie Města Plzně
Dominikánská 2
Tue–Sun 10–12 & 1–6
Tel +420 37 803 5310
www.galerie-plzen.cz
The municipal art gallery, Galerie Města Plzně was formerly called the X-Centre from 1991 to 2001 and exhibits mainly Czech artists.

Denmark

Known for its progressive social character, Denmark shows a surprisingly conservative approach to contemporary art. Copenhagen exerts a substantial influence on Danish contemporary art although the museum in Aarhus, the Kunsthalle in Odense and the Louisiana in Humlebæk are in many ways the most vibrant contemporary art centers in the country. Denmark has produced, though, one of contemporary art's most influential figures in Olafur Eliasson who characteristically has chosen to locate his studio in Berlin.

Denmark Resources

www.artnet.dk
Danish-language art news and
exhibition information
Øjeblikket, www.øjeblikket.net
Danish art magazine

Copenhagen

A vibrant and energetic city with a com-
mitment to innovative architecture, Co-
penhagen's arts institutions are surpris-
ingly inward-looking and regional in
focus. It is rather north of Copenhagen in
Louisiana that one finds an international
focus on contemporary art. With the
opening in 2008 of the new Arken mu-
seum in the suburbs of Copenhagen, it is
hoped that a more energetic contempo-
rary scene can emerge.

Copenhagen Resources

www.mik.dk
Danish-language guide to museums
www.artbag.dk
Danish-language exhibition information
www.kunstkalenderen.dk
Danish-language exhibition information

Copenhagen Events

September
Art Copenhagen, The Nordic Art Fair
October
Kulturnatten
2009
Alt Cph: Platform for Nordic Non-Profit
Art Spaces, Copenhagen, Denmark
2012
U Turn Quadrennial for Contemporary
Art, Copenhagen

Arken Museum for Moderne Kunst

Skovvej 100
Tue–Sun 10–5, Wed 10–9
Tel +45 43 54 0222
www.arken.dk (Danish and English)
How to get there Situated in the Western
suburbs of Copenhagen, Arken can be ac-
cessed from Copenhagen central station
by taking S-line A or E to Ishøj Station
then bus 128 to museum. This journey
takes approximately 25 minutes.

Exhibitions & Collections Opened in
1996, Arken is devoted to presenting
post-1945 art from Danish, Nordic, and
international artists. While the collection
focuses on post-1990 work, exhibitions
feature a wide range of artists and recent-
ly have focused on more conservative re-
alist work and modernist styles.
Building A new extension by C. F. Møller
Architects opened in January 2008 and is
meant to add more traditional exhibition
spaces to this striking museum set by the
sea. Using nautical themes and referring
to landscape motifs, Søren Robert Lund
designed the museum while still an ar-
chitectural student. The museum has
since become a striking addition to the
Danish architectural landscape.
Director Christian Gether 1997–
Selected solo exhibitions Duane Han-
son, Peter Bonde

GL Strand

Gammel Strand 48
Tue–Sun 11–5, Wed 11–8
Tel +45 33 36 0260
www.glstrand.dk

GL Strand was founded in 1875 and is de-
voted to presenting the works of emerg-
ing Danish artists as well as art historical

themed exhibits. This privately run institution is located across from the Royal Palace complex in a 1750 building designed by Philip de Lange.

Selected solo exhibitions Randi & Katrine, Mogens Andersen

Kunsthallen Nikolaij

Tue–Sun 12–5, Thu 12–9

Tel +45 3318 1780

www.kunsthallennikolaj.dk

The city-run contemporary art center Kunsthallen Nikolaij is housed in the Nikolaij Church in the center of Copenhagen. While there is no permanent collection, temporary exhibits of contemporary art focus on Danish and international art trends. The former Nikolaij Church, one of the oldest in Copenhagen, was first used as an art center in 1957 and in the sixties hosted Fluxus events. The Kunsthallen was opened here in 1981 and can be reached via the metro station Kongens Nytorv.

Selected solo exhibitions Peter Callessen, Annette Merrild, Peter Brandt

Statens Museum for Kunst

Sølvgade 48–50

Tel +45 3374 8494

Tue–Sun 10–5, Wed 10–8

www.smk.dk (Danish and English)

How to get there Set just northwest of the city center, the Statens Museum occupies a splendid park location.

Exhibitions & Collections Comprising the Royal Collections begun in 1750, the Statens Museum has a large array of primarily Danish contemporary art in the permanent collection. As well as an active collection policy, the museum also shows emerging artists such as Matthew Buckingham and Jonathan Meese as part of its X-Rummet, or X-Room, series.

Building Designed by Vilhem Dahlerup in 1896 as a sober and classical building meant to project the power and status of the Royal Collections. The historic building had to be renovated extensively in the sixties by Nils Hoppel to meet twentieth-century needs. A further extension opened in 1998 built by C. F. Møller Architects and is home to the modern and contemporary collections. This extension has caused some controversy by its seeming bland white spaces that contrast markedly with the original structure.

Selected solo exhibitions Ann Lislegaard, Jeppe Hein, Tal R & Jonathan Meese

Dansk Arkitektur Center DAC

Strandgade 27B

Daily 10–5, Wed 10–9

Tel +45 3257 1930

www.dac.dk

Dansk Arkitektur Center DAC is dedicated to presenting exhibits on architecture and urban planning in a 1880 warehouse in Christianshavn that was renovated and re-opened as home of DAC in 1986.

Overgaden Institute of Contemporary Art

Overgaden Neden Vandet 17

Tue–Sun 1–5, Thu 1–8

Tel +45 3257 7273

www.overgaden.org

Founded by local artists in 1986, the Overgaden Institute of Contemporary Art exhibits mainly emerging Danish artists in a nineteenth-century printing factory.

Selected solo exhibitions Daniel Svarre, Jakob Kolding, Seimi Norregaard

Kunsthal Charlottenborg

Nyhavn 2

Tue–Sun 12–5

Tel +45 3313 4022

www.kunsthalcharlottenborg.dk

Kunsthal Charlottenborg re-opened in summer 2008 after being closed for renovations. The center aims to present in-

ternational contemporary art in four yearly exhibitions.

Charlottenlund (Copenhagen)

Ordrupgaard
Vilvordevej 110 (train to Klampenborg or Lyngby Station then bus 388)
Tue, Thu, Fri 1–5, Wed 10–6,
Sat–Sun 11–5
Tel +45 39 64 1183
www.ordrupgaard.dk
Zaha Hadid's 2005 extension to the Ordrupgaard collection of French Impressionism incorporates many of the ideas present in her other designs. To complement the country residence built by Gotfeld Tvede in 1918 in the outskirts of Copenhagen, Hadid built an elegant elongated exhibition hall and café that is sensitive to the natural environment. The Hadid extension is meant to provide a forum for temporary exhibitions which include contemporary art.
Selected solo exhibition Michael Kvium

Aalborg

Utzon Center
Slotspladsen 4
Tue–Sun 10–5
Tel +45 7690 5000
www.utzoncenter.org
Sited in the home town of noted architect Jørn Utzon, the Utzon Center opened in 2008 to a design by Jørn and Kim Utzon and presents exhibits on architecture and design. Included at the center are the archives of Jørn Utzon, including his designs for the internationally known Sydney Opera House.

Nordyllands Kunstmuseum
Kong Christians Allé 50
Tue–Sun 10–5
Tel +45 98 13 8088
www.nordjyllandskunstmuseum.dk

A striking building designed by Finnish architect Alvar Aalto (with Elissa Aalto and Jean-Jacques Baruël), the Nordyllands Kunstmuseum opened in 1972 and houses a striking collection of mainly Danish modern and contemporary art. A sculpture park has additional works by Danish artists.
Selected solo exhibitions Poul Gernes, Tage Andersen

Aarhus

Aarhus Events
October
KulturNat Aarhus
2009
ArosS Aarhus Kunstmuseum extension, architect Olafur Eliasson, opens in August/September

AroS Aarhus Kunstmuseum
Aros Allé 2
Tue–Sun 10–5, Wed 10–10
Tel +45 8730 5500
www.aros.dk
Housing one of the largest collections of contemporary art in Denmark, the AroS Aarhus Kunstmuseum opened in 2004 and was designed by Schmidt Hammer & Lassen. Prior to the opening the museum had two previous locations since its founding in the mid-nineteenth century. The collection focuses on Danish art but also has significant holdings of installation and video, including works by Ola-

fur Eliasson, Tony Oursler, and Bill Viola. In 2009, a skywalk on the roof by Danish artist Olafur Eliasson entitled *Your rainbow panorama* is due to open.
Selected solo exhibitions Robert Rauschenberg, Michael Kvium, Bill Viola, Olafur Eliasson

Esbjerg

Esbjerg Kunstmuseum
Havnegade 20
Daily 10–4
Tel +45 7513 0211
www.eskum.dk
Esbjerg Kunstmuseum focuses on art from 1920 to today with Danish modernist artists stressed. Included in the collection are works by Per Kirkeby and Michael Kvium.

Herning

Herning Events
TBD: Herning Center for the Arts opens, architect Steven Holl, begun 2007

Herning Center of the Arts
www.herningcenterofthearts.dk
The new Herning Center of the Arts is being constructed by American architect Steven Holl, well-known for his synthesis of landscape and design especially in the well-regarded Kiasma in Helsinki. Housing exhibition galleries as well as other features and institutions, this is a multi-use center and builds on the current Herning with its significant Arte Povera and Pietro Manzoni collections.

Humlebæk

Louisiana—Museum for Moderne Kunst
How to get there Located on the North Zeeland coast with a stunning view across to Sweden, Louisiana is 35 km north of Copenhagen and reachable via

train in 36 minutes (Kystbanen station) and then a 10 minute walk to the museum.
Gl. Stranvej 13
Daily 10–5, Wed 10–10
Tel +45 4919 0719
www.louisiana.dk (Danish and English)
Exhibitions & Collections Founded by Danish publishing head Knud W. Jensen, Louisiana is one of the foremost contemporary institutions in the Nordic countries. With a preeminent collection of European post-war modernism, Louisiana also collects and exhibits contemporary art by artists such as Cindy Sherman, Anselm Kiefer, and Per Kirkeby.
Building With a brief to give equal weight to landscape, art, and architecture, Jørgen Bo and Vilhelm Wohlert created one of the most unique settings for modern art with their 1958 design. The original villa built in 1856 provides the center point for exhibition buildings that incorporate a sensitive approach to modernist architecture. Subsequent additions by the architects added additional space appropriate for the display of contemporary work.
Director Poul Erik Tojner 2000–
Selected solo exhibitions Lucian Freud, Tal R, Richard Avedon, Candice Breitz, Per Kirkeby

Toreby (Lolland)

Fuglsang Kunstmuseum
Nystedvej 71

Tue–Thu 9–2, Fri–Su 11–5
Tel +45 54 78 1414
www.fuglsangkunstmuseum.dk
Fuglsang Kunstmuseum opened in January 2008 as part of a manor home complex to a design by Tony Fretton Architects. The collection is composed of art from 1700 to today although the concentration is on nineteenth-century Nordic artists.

Odense

Kunsthallen Brandts

Brandts Torv 1
Tue–Sun 10–5, Thu 12–9
Tel +45 62 40 7000
www.brandts.dk
Kunsthallen Brandts is located in a former eighteen-century textile factory complex that today houses several museums and cultural centers. Known for innovative contemporary art exhibits, this is one of the liveliest centers of art in Denmark. With a renovation accomplished by Kristian Isager, the Kunsthallen opened in 1987 and was formerly known as Kunsthallen Brandts Klædefabrik. In 2004 a new space was opened in the Passage Building.
Director Lars Grambye 2008–
Selected solo exhibitions Ian McKeever, Bernard Frize, Jesper Rasmussen

Roskilde

Museum of Contemporary Art

Staendertorvet 3D
Tue–Fri 11–5, Sat–Sun 12–4
Tel +45 46 31 6570
www.samtidskunst.dk
Set in the historic 1733 Baroque Roskilde Palace, the Museum of Contemporary Art does not collect but instead operates on a Kunsthalle system. The exhibits hosted by the Museum vary greatly in focus.

Silkeborg

Silkeborg Kunstmuseum

Gudenåvej 7–9
Nov–Mar Tue–Fri 12–6, Sat–Sun 10–5,
April–Oct Tue–Sun 10–5
Tel +45 8681 5131
www.silkeborgkunstmuseum.dk
Silkeborg Kunstmuseum opened in 1982 with the donation of the collection of Danish artist Asger Jorn and was designed by Niels Frithiof Truelsen. The museum was further enlarged in 1998 and although exhibitions are conservative in nature the museum does continue to collect Danish artists such as Per Kirkeby.

Tranekær, Langeland

Tickon-Tranekær International Centre for Art and Nature

Ostergade 10
Daily sunrise–sunset
Tel +45 62 51 3505
www.langeland.dk
With a strong connection between art and nature, the Tickon-Tranekær International Centre for Art and Nature includes works by David Nash, Alan Sonfist, Herman de Vries, and Giuliano Mauri, on grounds of a castle set on the Danish island of Langeland.

Vejle

Vejle Kunstmuseum

Flegborg 16–18
Tue–Fri 11–4, Sat–Sun 10–5
Tel +45 7572 3135
www.vejlekunstmuseum.dk
Vejle Kunstmuseum originally opened in 1923 with an exhibition hall that featured modernism and related movements. Reopening in 2006 with additional spaces designed by Kim Utzon Architects the museum stresses Danish art in its collections and exhibitions.

The heart of the British art scene, London, offers a wealth of institutions, galleries, auction houses, and private collections, all of which reward a lengthy exploration. By having such a strong center as London, though, the arts in other regions of England have suffered, only emerging from London's shadow in the last decade. With new institutions opening in Liverpool, Gateshead, and Middlesbrough, England is beginning to develop a more diverse and intriguing art climate. It will remain to be seen whether this will continue to expand to include other regions that remain dominated by the heritage industry.

UK Resources

www.24hourmuseum.org.uk
listings and articles on UK museums
and heritage sites

www.artangel.org.uk
Artangel organizes and commissions art,
worked with Matthew Barney,
Francis Alÿs, Steve McQueen, etc.

www.artrabbit.com
UK listings of events and exhibitions

www.artscouncil.org.uk
national arts organization,
funds art projects

www.commissionseast.org.uk
Visual arts agency that puts together
public arts projects

www.newexhibitions.com
listings of UK and Ireland exhibitions

www.artrumour.co.uk
gossip of UK art scene

www.forma.org.uk
organization that presents arts and
media projects throughout Europe

www.artguide.org
UK listings of Britain and Ireland
includes historical art

UK Events

2010
The British Art Show BAS7, traveling to
three venues in UK

London

For all intents and purposes the contemporary arts capital of Europe, London is a lively and energetic place in which to see the best in international art. London's art institutions, galleries, and auction houses are dispersed from the East End to Soho to more diverse locales which require the art traveler to manage time, especially with the notorious London traffic and transport a factor. The London art scene of today stems from the massive appeal and investment that followed in the wake of the rise of the YBA, or Young

British Artist, movement of the late nineteen-eighties and early nineties. Along with new museums, today many private collectors are joining the worldwide trend to open up spaces for their collections in a move pre-figured by the doyen of British collectors, Charles Saatchi. It is this mix of public and private that has helped established London's deserved reputation as an international art city.

London Resources

www.guardian.co.uk/artanddesign/art
listing of links from The Guardian

www.saatchi-gallery.co.uk/
london_gallery_guide.htm
London gallery listings

London Events

Monthly events
TimeOut First Thursdays: East London
Art Galleries and Museums
Annual Events
Summer Exhibition: Royal Academy
of Arts—held annually with Charles
Wollaston Prize given
Summer: Serpentine Gallery Pavilion
October
Frieze Art Fair; The Cartier Award—
annual prize given during Frieze;
Bridge Art Fair; Zoo Art Fair; Scope
London; The Affordable Art Fair
December
Turner Prize winner announced—
annual prize at Tate Britain
January thru December 2009
Santiago Sierra's *Death Clock*,
Hiscox Building: 1 Great St. Helen's
2009
Tate Triennial, Tate Britain (3 Feb–26
April 09, Whitechapel Art Gallery
opens 5 April
2010
David Roberts Art Foundation opens in
Camden
2012
Tate Modern extension, Herzog + de

Meuron architects; Royal Academy of Arts, Burlington annex, renovation by David Chipperfield

Tate Britain

How to get there Tate Britain is located at Millbank on the Thames five minutes' walk from the Pimlico Underground (Victoria Line). A boat also runs every forty minutes between Tate Britain and Tate Modern.

Millbank
Daily 10–5:50,
first Friday of the month 10–10
Tel +44 20 7887 8888)
www.tate.org.uk/britain
(English with limited information in thirteen other languages)

Exhibitions & Collections The home of British art since its opening in 1897, Tate Britain has a pre-eminent collection of work from 1500 to post-second world war. With the 2000 opening of Tate Modern, Tate Britain has effectively positioned itself as the voice of art in Britain via its annual staging of the Turner Prize and exhibits on a wide range of British art history. In addition, every three years a Tate Triennial is staged that focuses on recent trends in British art. Regular exhibits entitled Art Now focus on emerging cutting edge art.

Building Sidney R. J. Smith's 1897 Tate Gallery building on the Millbank has undergone many alterations and changes over the last century, adapting itself to changes in political and exhibition directives. Additions such as those financed by noted art dealer Joseph Duveen in the thirties (and executed by John Russell Pope) provide unique spaces to view historic British art. The 1987 opening of the Clore Gallery, designed by James Stirling and Michael Wilford, to house the Turner Bequest is seen as a landmark in postmodern museum architecture. Recently, Alan Colquhoun and John Miller have in-

tegrated the various designs into a more harmonious whole, while also constructing the new Centenary Wing.

Directors Nicholas Serota (Tate) 1988–, Stephen Deuchar (Tate Britain) 1988–
Curators Contemporary Chief Judith Nesbitt, Andrew Wilson, Clarrie Wallis **Selected solo exhibitions** Seb Patane, Goshka Macuga, Christina Mackie, Peter Peri, Kate Davis, Jake and Dinos Chapman, Mark Wallinger, Raqib Shaw, Howard Hodgkin

Tate Modern

How to get there Situated on the South Bank of the Thames near the Southwark Underground (Jubilee Line) and Blackfriars Underground (District and Circle Lines), Tate Modern is also close to the Embankment with the construction of the Millennium Bridge. It is also possible to take a boat to Tate Britain, which leaves every forty minutes from Bankside Pier.

Bankside
Sun–Thu 10–6, Fri–Sat 10–10
Tel +44 20 7887 8888
www.tate.org.uk/modern
(English with limited information in thirteen other languages)

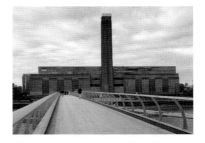

Exhibitions & Collections A major collection of post-war art, Tate Modern offers an extremely diverse range of work from Abstract Expressionism to Surrealism to cutting-edge contemporary. The permanent collection exhibition has en-

couraged controversy since its installation on a thematic program although this was recently changed on director Nicolas Serota's initiative. Exhibitions are centered on international art figures spanning the post-war period as well as the Unilever series in the main turbine hall which stages dramatically staged single artist projects.

Building The Bankside Power Station, designed by Sir Giles Gilbert Scott in 1946, is located on a commanding site on the south bank of the Thames. The conversion by Herzog + de Meuron retains many of the power station's unique features including the stunning turbine hall while also continuing the duo's minimalist aesthetic concerns. In 2012 a highly theatrical extension will be completed by Herzog + de Meuron that will vastly increase gallery space and create a contemporary ziggurat in the London skyline.

Directors Nicholas Serota (Tate) 1988–, Vicente Todolí (Modern) 2003–

Curators chief Sheena Wagstaff, Tanya Barson, Juliet Bingham; film Stuart Comer, Matthew Gale, Mark Godfrey, Jessica Morgan; performance Catherine Wood.

Selected solo exhibitions

Louise Bourgeois, Doris Salcedo, Hélio Oiticica, Gilbert & George, Fischli & Weiss, Carsten Höller, Pierre Huyghe, Martin Kippenberger

The Hayward
Belvedere Road
(Tube Waterloo or Embankment)
Daily 10–6, Fri–Sat 10–10
Tel +44 87 1663 2501
www.southbankcentre.co.uk

The Hayward, part of the Southbank Centre complex, is a major venue for temporary exhibitions that have recently focused almost exclusively on contemporary art. Opened in 1968 and a prime example of Brutalist architecture, designed by the Greater London Council's Department of Architecture and Civic Design, The Hayward has encountered much criticism and undergone successive attempts at rebranding. A 2003 renovation by Haworth Tompkins added a café designed by artist Dan Graham. The Hayward was managed by the Arts Council of England from 1968 to 1987 and remains in charge of handling the Arts Council's collection of post-war art.

Director Ralph Rugoff 2006–

Selected solo exhibitions Antony Gormley, Atelier van Lieshout, Dan Flavin, Rebecca Horn, Roy Lichtenstein, Sam Taylor Wood, Ann-Sofi Sidén

ICA
The Mall
(Tube Charing Cross or Piccadilly)
Daily 12–7:30, Thu 12–9
Tel +44 20 7930 0493
www.ica.org.uk

Established in 1947, the ICA (Institute of Contemporary Arts) has long been one of the most innovative arts institutions in the UK. Featuring exhibits, film screenings, talks, symposia, and music events, the ICA is especially renowned for presenting imaginative themed exhibits as well as, until recently, the annual Becks Futures Art Prize. The ICA is set since 1968 in the heart of London on The Mall, in a terrace house designed by John Nash.

Director of exhibitions Mark Sladen 2007–, Jens Hoffmann 2003–06

Selected solo exhibition Peter Hujar

Royal Academy of Arts
Burlington House
Daily 10–6, Fri 10–10
Tel +44 87 0848 8484
www.royalacademy.org.uk

Founded in 1768, the Royal Academy of Arts engages with contemporary art through thematic shows and their annual summer open exhibition. Located since

1867 in the historic Burlington House, near Piccadilly, the Royal Academy limits their membership to eighty of the most prestigious artists and architects of the day. As befitting their location in the Palladian confines of James Gibbs designed Burlington House, the Royal Academy can sometimes seem conservative although this is belied by exhibits such as 1997's *Sensation* show of YBA artists. Burlington House was renovated extensively by Norman Foster in 1991 and is now known as The Sackler Wing. Plans were announced in 2008 for David Chipperfield to renovate the Burlington annex which will be completed in 2012.
Exhibitions secretary Charles Saumarez Smith 2008–, Norman Rosenthal 1976–2008
Selected solo exhibition Georg Baselitz
Other Exhibits *USA Today: New American Art from the Saatchi Collection*

Serpentine Gallery

Kensington Gardens (Tube Knightsbridge, Lancaster Gate, and South Kensington)
Daily 10–6
Tel +44 20 7402 6075
www.serpentinegallery.org
Serpentine Gallery in Kensington Gardens is one of the most challenging venues for contemporary art in Britain. Founded by the Arts Council in 1971, the Serpentine Gallery has featured artists Matthew Barney, Thomas Demand, and Ilya Kabakov, as well as presenting the annual temporary Serpentine Pavilion constructed by architects such as Zaha Hadid, Daniel Libeskind, and Álvaro Siza. The 1934 Tea Pavilion home of the Serpentine was originally built by Henry Tanner and since renovated by John Miller + Partners in 1998.
Directors Julia Peyton-Jones 1986–, co-director exhibitions & programming arts Hans Ulrich Obrist 2006–, chief curator Kitty Scott 2006–

Selected solo exhibitions Anthony McCall, Matthew Barney, Hreinn Friðfinnson, Paul Chan, Allora & Calzadilla, Karen Kiliminik, Runa Islam, Thomas Demand

Camden Arts Centre

Arkwright Road
Tue–Sun 10–6, Wed 10–9
Tel +44 20 7272 5500
www.camdenartscentre.org
Camden Arts Centre. Accessible via tube: Finchley Road (Jubilee and Metropolitan Lines) and Hampstead (Northern Line) 850 meters or by rail: Finchley Road and Frognal (Silverlink line) is a publicly funded venue for contemporary art in the north of London that offers a broad range of activities and events, from exhibitions to readings to artists' residencies. Begun in the seventies, Camden Arts Centre is located in a Victorian building that was restored in 2005 by Tony Fretton Architects.
Director Jenni Lomax
Selected solo exhibitions Mamma Andersson, Siobhan Hapaska, Aernout Mik, David Thorpe, Matthew Buckingham

Barbican Art Gallery

Barbican Centre, Silk Street, Level 3
Daily 11–8, Tue–Wed 11–6,
first Thu 11–10
Tel +44 20 7638 4141
www.barbican.org.uk/artgallery/
Set within the confusing precincts of the multi-functional Barbican Centre, the Barbican Art Gallery has emerged as a major venue for international contemporary art through exhibitions geared to cutting-edge work. The Barbican itself is a legacy of seventies design that, while roundly criticized at its opening in 1982, today evokes a post-dystopian world. Exhibits at The Curve explore contemporary art with artists such as Hans Schabus and Huang Yong Ping.

Whitechapel Art Gallery

77–82 Whitechapel High Street
(Tube Aldgate East)
Tue–Sun 11–6, Thu 11–9
Tel + 44 20 7522 7888
www.whitechapel.org

Founded in 1901, the Whitechapel Art Gallery has long been a leading venue for temporary-focused international contemporary art exhibits. The Gallery's location in the East End prefigured today's profusion of galleries in Shoreditch and Hoxton. During its long history the gallery has been the scene of many seminal exhibits, such as with the only showing of Picasso's *Guernica* in Britain in 1939 as well as hosting many of the leading British art figures of the last half century. The gallery was expanded by the Belgian architects Robbrecht and Daem and reopened in April 2009.

Director Iwona Blazwick 2001–, curator Anthony Spira
Selected solo exhibitions Margaret Salmon, Albert Oehlen, David Adjaye, Ugo Rondinone, Paul McCarthy

Saatchi Gallery

Duke of York's HQ, King's Road
Daily 10–6
www.saatchi-gallery.co.uk

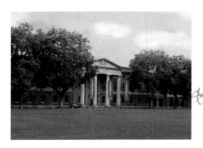

Noted mega-collector and driver of the art market for many years, advertising mogul Charles Saatchi founded the Saatchi Gallery for the presentation of his collection in 1985 in a former paint factory renovated by Richard Gluckman. Moving to new facilities in 2003 in County Hall on the South Bank, Saatchi ran into problems with his landlord, thereupon necessitating the creation of a new home for the Gallery that opened in October 2008 in Chelsea. Saatchi has been a major figure in the careers of Damien Hirst, Tracey Emin, Jake and Dinos Chapman, amongst others, and the collection, although suffering major loses in a 2004 fire, is one of the most important of late-twentieth century. The new space in the Duke of York's Headquarters is a rather antiseptic space designed by Paul Davis + Partners and it will be intriguing to see how the collection makes optimum use of the facility.
Director Rebecca Wilson

The Louise Blouin Foundation

3 Olaf Street
Tue 10–8:30, Wed–Sun 10–6
Tel +44 20 7985 9600
www.ltbfoundation.org

The Louise Blouin Foundation is an initiative of the noted Canadian-born publisher of *Art + Auction* and *Modern Painters,* Louise T. Blouin MacBain. The institute presents primarily single artist exhibits in a Borgos Dance-renovated industrial coachworks from the twenties and which opened to the public in 2006.
International director Henry Timms
Selected solo exhibitions James Turrell, Richard Meier

David Roberts Art Foundation

111 Great Titchfield Street
Tue–Fri 10–6, Sat 11–4
Tel +44 20 7637 0868
www.davidrobertsfoundation.com

In 2007, Roberts opened Gallery One now known as the David Roberts Art Foundation to show projects from his collection and this will remain open with

a focus on projects by external curators.
Curator Vincent Honoré

**David Roberts Art Foundation
Camden**
15A & 37 Camden High Street
www.davidrobertsfoundation.com
Scheduled to open in 2010, the David
Roberts Art Foundation Camden will
present temporary exhibitions from the
collection of Roberts, a property devel-
oper, in a space designed by Seth Stein.
This collection is one of the strongest in
Britain with artists such as Antony Gorm-
ley, Damien Hirst, and Marc Quinn.

176
176 Prince of Wales Road
Thu–Fri 11–3, Sat–Sun 11–6
Tel +44 20 7428 8940
www.projetspace176.com
176 presents selections from the exten-
sive Anita & Poju Zabludowicz Collec-
tion that was founded in 1995 and in-
cludes substantial works by Albert
Oehlen, Sarah Lucas, and Jonathan Meese
amongst others. 176 is set in a former
Methodist chapel from 1867 and reno-
vated for art by Allford Hall Monaghan
Morris. The venue hosts three annual ex-
hibitions and plans are also in the early
stages for a venue in Finland to display
the permanent collection.
Curator Elizabeth Neilson

**Parasol unit
foundation for contemporary art**
14 Wharf Road
Tue–Sat 10–6, Sun 12–5
Tel +44 20 7490 7373
www.parasol-unit.org
A private institution, the Parasol unit,
opened in 2004 and presents three to
four exhibitions per year in a space in the
heart of London's borough of Islington.
Claudio Silvestrin, who has designed
many arts venues in the UK, designed the

space itself, which also includes the not-
ed gallery Victoria Miro in a spectacular
space on the top floor.
Founder and curator Ziba de Weck

Selected solo exhibitions Darren Al-
mond, Yutaka Sone, Armen Eloyan,
Johannes Kahrs, Matthew Ronay

westlondonprojects
2 Shorrolds Road
Fri–Sat 12–6
Tel +44 20 3080 0708
www.westlondonprojects.org
One of the many privately founded non-
profits to emerge in recent years, west-
londonprojects was founded by Madda-
lena and Paolo Kind to present inter-
national artists to the UK audience.
Selected solo exhibitions Charline von
Heyl, Joan Jonas, Wade Guyton

Rivington Place
Rivington Place
Tue–Fri 11–6, Thu 11–9, Sat 12–6
Tel +44 20 7749 1240
www.rivingtonplace.org
With a brief to educate the public in con-
temporary art, David Adjaye's Rivington
Place was established in late 2007 and
hosts Iniva, the UK-based contemporary
arts exhibition organizers, in addition to
an arts and photographic library. The cen-
ter is mainly known for its innovative ar-
chitecture that fuses minimalism with a
contemporary aesthetic.

South London Gallery
65 Peckham Road
Tue–Sun 12–6
Tel +44 20 7703 6120
www.southlondongallery.org

Set in Peckham south of the River Thames, the South London Gallery has its origins in the 1868 founding of South London Working Men's College and is located since 1891 in Portland House. With a permanent collection strong in British art as well as a commitment to showing contemporary art, this has been a leading venue since the early nineties.
Director Margot Heller, curator Kit Hammonds –2008
Selected solo exhibitions John Armleder, Chris Burden, Mark Dion

Design Museum
Shad Thames
Daily 10–5:45
Tel +44 87 0833 9955
www.designmuseum.org

Focusing on a wide range of applied art with a focus on presenting shows by leading international architects, the Design Museum was founded by designer and retailer Terence Conran in 1989 and was originally housed in the V&A. Since 1989 the museum has been located in a brick warehouse on the south bank of the Thames. The museum presents architecture and design shows by the likes of Zaha Hadid and Jean Prouvé.
Director Deyan Sudjic 2006–

Matt's Gallery
42–44 Copperfield Road
Tube Mile End stop
Wed–Sun 12–6
Tel +44 20 8983
www.mattsgallery.org

Matt's Gallery was founded in 1979 by Robin Klassnik and named for his dog, Matt. Since 1993 located in Copperfield Road, the gallery is known for its engagement with artists and sensitivity to the artistic process and has presented many leading figures from the British art scene in one-person shows.
Selected solo exhibitions Willie Doherty, Michael Curran, John Russell

Chisenhale Gallery *Later*
64 Chisenhale Road
Wed–Sun 1–6
Tel +44 20 8981 4518
www.chisenhale.org.uk

In north-eastern London, the Chisenhale Gallery hosts temporary exhibitions of contemporary art in the former forties-era Chisenhale Works building. The gallery was founded in 1986.

London Art Areas
The West End covers roughly the area from Oxford Circus to Piccadilly Circus and is west of Charing Cross. In this area many of the most established galleries are located as well as the Royal Academy. While the term "West End" has become more of a brand than a specific geographic term, the art scene here remains a major location in the European art context.

In contrast to the tonier West End, Hoxton and Shoreditch in the East End emerged in the nineties as major centers for the YBA artists and their galleries. The southern area of Hoxton, centered on Hoxton Square, and its neighboring Shoreditch area were home to many abandoned industrial buildings that serve to house artists' studios and galleries. This area was notoriously difficult to access with the lack of tube service, although this is set to change in 2010 with the extension of the East London Line.

In north east London, London Fields in the borough of Hackney is home to many cutting-edge galleries and artists' spaces, including The Hothouse gallery complex.

Close to the tube stop of Bethnal Green, this area rose to prominence in the mid-nineties as an alternative to Hoxton, which had gradually began to gentrify.

Birmingham

Ikon Gallery
1 Oozells Square, Brindleyplace
Tue–Sun 11–6
Tel +44 121 248 0708
www.ikon-gallery.co.uk
One of the more engaged British contemporary art centers, the Ikon Gallery opened in the sixties in the neo-gothic Oozells Street School. Temporary exhibits feature international established artists as well as emerging artists.
Director Jonathan Watkins
Selected solo exhibitions Alice Cattaneo, Sofia Hulten, Richard Deacon, Claudia Losi, Jacques Nimki, Arturo Herrera

Brighton

Brighton Events
2010
Brighton Photo Biennial

Bristol

Arnolfini
16 Narrow Quay
Daily 10–8, Thu 10–6
Tel +44 117 917 2300
www.arnolfini.org.uk
Hosting exhibitions and events on the harbor in Bristol, the Arnolfini opened in 1961 and was started by Jeremy and Annabel Rees. Moving to a former tea warehouse in 1975 which David Chipperfield renovated in 1987, the Arnolfini is known for its focused exhibition program of contemporary art.
Selected solo exhibitions Michael Curran, Hans-Peter Feldmann

Spike Island
133 Cumberland Road
Tue–Sun 12–6
Tel +44 117 929 2266
www.spikeisland.org.uk
Offering artist studios as well as temporary exhibitions, Spike Island is set in a former tea factory from the sixties that was renovated for art by Caruso St. John in 2007.

Cambridge (Bourn)

Wysing Arts Centre
Fox Road, Bourn, located one mile from Bourn bus stop, check website for details
Daily 12–6
Tel +44 195 471 8881
www.wysingarts.org
Wysing Arts Centre houses artists' studios as well as having a well-regarded international artists' residency program at a former farm 9 miles west of Cambridge. In January 2008 the center re-opened with the addition of buildings by Hawkins Brown architects. The center has featured temporary exhibitions in addition to its artists' facilities since its founding in 1989.

Cardiff, Wales

Cardiff Events
2010
Artes Mundi 4 Prize, Cardiff–biannual prize

East Winterslow, Salisbury, Wiltshire

NewArtCentre
Roche Court
Daily 11–4
Tel +44 1980 862 244
www.sculpture.uk.com
Founded in 1958 and originally located in London, the NewArtCentre is set in

the historic nineteenth-century Roche Court. With galleries designed by Richard Marshall, the center re-opened in 1998 to present works by artists such as Antony Gormley, Richard Long, and Gavin Turk.

Exeter

Spacex
45 Preston Street
Tue–Sat 10–5
Tel +44 139 243 1786
www.spacex.co.uk
Opened in 1978, Spacex presents mainly emerging artist in temporary exhibitions in a nineteenth-century warehouse building.
Selected solo exhibitions Cory Arcangel, Geoffrey Farmer, Orshi Gersht

Folkestone

Folkestone Events
2011
Folkestone Triennial

Gateshead

BALTIC
Gateshead Quays
South Shore Road
Mon–Sun 10–6
Tel +44 191 478 1810
www.balticmill.com
Since its founding in 2002, BALTIC, centre for contemporary art has developed a reputation for alternately offering engaged contemporary art exhibits as well as having operational difficulties with changes in leadership and staff turmoil. The former flour mill was converted by Ellis Williams Architects and offers a stunning location on the River Tyne.
Directors Godfrey Worsdale 2008–, Peter Doroshenko 2005–07
Selected solo exhibitions Kendell Geers,

Kader Attia, Ant Macari, Mark Titchner, Suky Best, Fabien Verschaere

Angel of the North
near A1 and A167 roads
into Tyneside
www.gateshead.gov.uk
The steel angel atop a hill facing southern England and the A1 and A167 roadways, Antony Gormley's *Angel of the North* has developed into a major symbol for the revitalization of Northern England since its installation in 1998. Meant to symbolize hope, the angel is one of British sculptor Gormley's signature works.

Hampshire

Artsway
Station Road, Sway
Tue–Sun 11–5
Tel +44 1590 68 32260
www.artsway.org.uk
Artsway is a venture of local artists with a gallery opened in 1997 to design by Tony Fretton. The location in the New Forest with a pavilion was featured at La Biennale di Venezia in 2005.
Selected solo exhibitions Nathaniel Mellors, Ma Yongfeng

Leeds

Henry Moore Institute
74 The Headrow
Mon–Sun 10–5:30, Wed 10–9

Tel +44 113 234 3158
www.henry-moore-fdn.co.uk
Run by the foundation of the modernist British sculptor Henry Moore, Henry Moore Institute opened in 1993 and is dedicated to presenting and supporting contemporary and modernist sculpture. The institution has sponsored exhibits at many venues in the UK and abroad as well as hosting temporary exhibits by leading international art figures.
Director Alan Bowness 1988–, curator Penelope Curtis
Selected solo exhibitions Thomas Schütte, Imi Knoebel, Ettore Spalletti

Leeds Art Gallery
The Headrow
Mon–Tue 10–8, Wed 12–8,
Thu–Sat 10–5, Sun 1–5
Tel +44 113 247 8256
www.leeds.gov.uk/artgallery/
Leeds Art Gallery originally opened in 1888 in a purpose-built structure by W. H. Thorp that is adjacent to municipal buildings in the center of Leeds. The gallery has recently begun to focus on contemporary art, including in 1998 hosting the inaugural Northern Art Prize.

Liverpool

As the 2008 European Cultural Capital, Liverpool has seen a determined effort to regenerate areas previously affected by urban blight. With new museum openings, the city is continuing on the course established with the Albert Docks restoration in the early eighties of using culture to improve the urban fabric. Contemporary art has been used as part of this ongoing effort in urban regeneration.

Liverpool Resources
www.artinliverpool.com
listings of exhibitions as well as information on public art works

Liverpool Events
2009
Light Night Liverpool
(9 Jan 09)
2010
Liverpool Biennial 6th edition, fall;
John Moores exhibition and prize

Tate Liverpool
How to get there Set in the historic Albert Docks, Tate Liverpool is within walking distance of Lime Street Station.
Albert Dock
Tel +44 151 702 7400
Daily 10–5:50, closed Mondays from September to May
www.tate.org.uk/liverpool
(English with limited information in thirteen other languages)

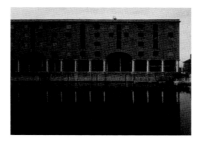

Exhibitions & Collections A Tate in the North, Tate Liverpool opened in 1988 with the brief of bringing the Tate's extensive collections to the north of England. While this has, in some senses, happened, a more distinctive feature of the Tate Liverpool is its engagement with contemporary art. As well as hosting the Liverpool Biennial, Tate Liverpool has recently featured exhibits by Jake & Dinos Chapman, Sarah Lucas, and Richard Wentworth.
Building Closed in 1972, the historic 1841–48 Albert Docks by Jesse Hartley were part of an urban regeneration project begun following the Toxteth riots in the

early eighties. The James Stirling and Michael Wilford renovation of the industrial buildings of the Albert Docks assigned Tate Liverpool a visually subordinate role. With no bold signature, Tate Liverpool instead relies on a sensitive utilization of the industrial space for maximum effect. A further renovation was carried out in 1998 by Michael Wilford to increase the galleries available for exhibition.

Director Christoph Grunenberg 2001–
Curator Laurence Sillars
Selected solo exhibitions Niki de Saint Phalle, Peter Blake, Ellen Gallagher, Jake and Dinos Chapman, John Armleder, Sarah Lucas, assume vivid astro focus, Richard Wentworth

complex of former industrial buildings in the old port area.
Selected solo exhibitions Brian Griffiths, Catherine Sullivan, Goschka Macuga

Bluecoat Arts Centre
School Lane
Tel +44 151 702 5324
www.thebluecoat.org.uk
Bluecoat Arts Centre is a multi-arts venue that re-opened in 2008 in the city center of Liverpool. The building dates from the eighteenth century and is the oldest building remaining in the center and has presented exhibits since 1958. Currently, the exhibition program focuses on thematic subjects with a focus on regional artists.

Liverpool Public Art
Crosby Beach: Antony Gormley *Cast Iron Men*

Manchester

Manchester Events
2011
Asia Triennial Manchester
TBD: FC MoCA Manchester, delayed from 2007

Manchester City Gallery
Mosley Street
Tue–Sun 10–5
Tel +44 161 235 8888

FACT
The Foundation for Art
& Creative Technology
88 Wood Street
Mon–Fri 10–6, Sat–Sun 11–6
Tel +44 151 707 4450
www.fact.co.uk
Concentrating on commissioning and exhibiting film, video, and new media art, FACT, the Foundation for Art & Creative Technology was founded in 1988 and previously called Moviola. FACT offers exhibits and a range of cultural activities in building constructed by Austin-Smith Lord that was a factor in Liverpool's successful bid to be European Cultural Capital.
Selected solo exhibitions Anna Lucas, Vito Acconci, Candice Breitz

A Foundation
67 Greenland Street
Wed–Sun 12–6
Tel +44 151 760 0600
www.afoundation.org.uk
A Foundation is an arts center established in 1998 by the major philanthropist John Moores to support contemporary visual art. The foundation organizes the Liverpool Biennial and relocated in 2006 to a

www.manchestergalleries.org

Manchester City Gallery is a museum founded in the nineteenth-century to house the city's art collection. While infrequent contemporary art exhibits are held, the permanent collection includes work by Mona Hatoum, David Hockney, and Richard Deacon. A new expansion opened in 2002.

Selected solo exhibition Pae White, Paul Morrison

FC MoCA Manchester

www.fcmoca.co.uk

Originally scheduled to open in 2007, FC MoCA Manchester will house the substantial collections of Frank Cohen and will be one of the largest private museums in the UK. With a large selection of YBA artists, Cohen is sometimes called the Saatchi of the North. Currently selections from the collection are on view at Cohen's Initial Access space in Wolverhampton.

Cornerhouse

70 Oxford Street
Tue–Sat 11–6, Thu 11–8,
Sun 2–6
Tel +44 161 228 7621
www.cornerhouse.org

A feature of Manchester's cultural scene since opening in 1985, Cornerhouse offers a well regarded film program and well as hosting temporary exhibits in former carpet shop that was unoccupied for long period during seventies.

Selected solo exhibitions Paul Ramirez-Jonas, Richard Healy, Victor Burgin

Margate (Kent)

Margate Events

2010

Turner Contemporary Gallery (www.turnercontemporary.org) opens, David Chipperfield architect

Turner Contemporary

www.turnercontemporary.org

Dedicated to noted British nineteenth-century artist J. M. W. Turner and visitor to the South Coast town of Margate, Turner Contemporary will feature contemporary work in a space designed by British Minimalist David Chipperfield. The art center will host temporary exhibits by international artists and currently displays work in a project space at 53–57 High Street (Tue–Sun 10–5) until the opening of the center in 2010.

Middlesbrough

Middlesbrough Events

TBD: Anish Kapoor's Tees Valley Giants (also in Stockton, Redcar, Hartlepool and Darlington) announced July 2008

MIMA Middlesbrough Institute of Modern Art

Centre Square
Tue–Sat 10–5, Sun 12–4
Tel +44 164 272 6720
www.visitmima.com

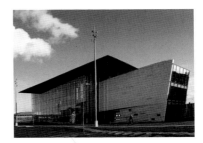

Since its founding in 2007, MIMA Middlesbrough Institute of Modern Art, this Erick van Egeraat Architects designed complex has hosted temporary exhibits with an accent on the union of craft and fine art. Currently not displayed are the holdings that include all of the city's art collections.

Director Godfrey Worsdale, curator
Gavin Delahunty
Selected exhibitions MIMA Collection,
Modern British Sculpture

Milton Keynes

MKG Milton Keynes Gallery
900 Midsummer Boulevard
Tue–Sat 10–5, Sun 11–5
Tel +44 190 867 6900
www.mk-g.org
The first public art gallery in England in
over twenty years, the MKG—Milton
Keynes Gallery opened in 1999 to a de-
sign by Blonski Heard Architects. Since
opening, the gallery has shown a long-
term commitment to engaging with in-
ternational contemporary art in focused
one-artist exhibitions.
Selected solo exhibitions Adrian Paci,
Pae White, Phil Collins

Newcastle

Laing Art Gallery
New Bridge Street
Mon–Sat 10–5, Sun 2–5
Tel +44 191 232 7734
www.twmuseums.org.uk
Founded in 1901 by Scottish wine mer-
chant Alexander Laing, the Laing Art Gal-
lery is particularly strong in British works
from the nineteenth and twentieth cen-
turies. Added to this is a recent accent on
contemporary art.

Norwich

Sainsbury Centre for Visual Arts
Earlham Road University
of East Anglia
Tue–Sun 10–5, Wed 10–8
Tel +44 160 359 3199
www.scva.org.uk
On the grounds of the University of East
Anglia, the Sainsbury Centre for Visual

Arts stems from the gifts of supermarket
founder Robert Sainsbury in 1973 and is
noted for being one of the signature ear-
ly buildings of Norman Foster. Since its
opening in 1978 the collection has grown
to include works from ancient art to con-
temporary as well as presenting occa-
sional thematic exhibits on current topi-
cal subjects.

Nottingham

Nottingham Events
2009
Caruso St. John's CCAN Centre for
Contemporary Art Nottingham opens
in spring

CCAN
Centre for Contemporary
Art Nottingham
www.ccan.org.uk
Due to open in the spring of 2009, Not-
tingham Contemporary will house tem-
porary exhibits by international artists in
a purpose-built structure by Caruso St.
John in the heart of Nottingham.

Oxford

Modern Art Oxford
30 Pembroke Street
Tue–Sun 12–5
Tel +44 186 572 2733
www.modernartoxford.org.uk
Formerly known at the Museum of Mod-
ern Art Oxford, Modern Art Oxford was
founded on the grounds of Oxford Uni-
versity by Oxford dons. Originally meant
to house a modern art collection to be
built in conjunction with the University,
instead Modern Art Oxford has devel-
oped into one of the foremost and for-
ward looking of British venues for pre-
senting international contemporary art.
Director Andrew Nairne 2000–
Selected solo exhibitions Trisha

Donnelly, Daniel Buren, Callum Innes, Stella Vines, Kerry James Marshall

River Irwell (from Quays to Bacup) near Manchester

Irwell Sculpture Trail
www.irwellsculpturetrail.co.uk
(currently not available)
Devoted to public art with environmental themes, the 30 mile (48 kilometer) long Irwell Sculpture Trail was completed in 1997 and includes works by Rita McBride *(Arena* located on south bank of river, at back of Salford's Littleton Road playing fields), Tim Norris *(Lookout* in Clifton Country Park Salford), and Ulrich Rückriem *(Untitled* in Outwood Colliery Radcliffe). River Irwell is located in Lancashire and the Manchester area of Northern England and the river was a major conduit for factories during the Industrial Revolution.

St. Ives

Tate St. Ives
Porthmeor Beach St. Ives, Cornwall
Mar–Oct Daily 10–5:20, Nov–Feb
Tue–Sun 10–4:20
Tel +44 173 679 6226
www.tate.org.uk/stives
Long a home to British artists, St. Ives is located in Cornwall and overlooking Porthmeor Beach is the home of Tate St. Ives. Focused on modernist Barbara Hepworth and her circle, all of whom worked extensively in St. Ives, the gallery was designed by modernist-influenced architects Eldred Evans and David Shalev and opened in 1993. While exhibits are mainly devoted to modernism the contemporary is also part of the program as well as artist residencies.
Artistic director Martin Clark 2007–
Selected solo exhibitions Francis Bacon, John Hoyland, Ellsworth Kelly

Sheffield

Sheffield Resources
www.artsheffield.org
operated by Sheffield Contemporary Art Forum and has gallery listings

Sheffield Events
TBD: Art Sheffield festival
(last held in 2008)

Site Gallery
1 Brown Street
Wed–Sat 11–5:30
Tel +44 114 281 2077
www.sitegallery.org
Devoted to emerging artists, Site Gallery presents changing exhibitions since its opening in 1998.

Millennium Galleries
Arundel Gate
Mon–Sat 10–5, Sun 11–5
Tel +44 114 278 2600
www.sheffieldgalleries.org.uk/coresite/html/millennium.asp
With a focus on craft and applied art, the Millennium Galleries opened in 2001 in a purpose-built structure designed by Pringle Richards Sharratt. The galleries regularly host traveling exhibitions.

Sudeley Castle Winchcombe (Cotswolds)

Sudeley Castle
Tel +44 124 260 3308
www.reconstrction.org.uk
The Elizabethan Sudeley Castle holds an annual exhibition from July to October entitled Reconstruction devoted to contemporary sculpture. This historic house in the Cotswolds has hosted exhibits featuring artists such as Ghada Amer, Keith Coventry, and Carsten Höller, since 2006. Part owner Mollie Dent-Brocklehurst also currently serves as curator for the new

Abramovich-owned art center in Moscow. Curators Mollie Dent-Brocklehurst and Eliot McDonald

Sunderland

Northern Gallery of Contemporary Art
City Library and Arts Centre,
Fawcett Street
Mon & Wed 9:30–7:30, Tue,
Thu–Fri 9:30–5, Sat 9:30–4
Tel +44 191 514 1235
www.ngcs.co.uk
Presenting focused exhibits since its founding in 1995, the Northern Gallery of Contemporary Art is part of a library and arts center complex and is especially engaged with promoting emerging artists.
Selected solo exhibitions Cory Arcangel, Tim Brennan, Daniel Silver

Wakefield

Wakefield Events
2010
The Hepworth opens, architect David Chipperfield

The Hepworth
www.hepworthwakefield.com
Located on the waterfront, The Hepworth will be devoted to the work of modernist sculptor Barbara Hepworth, the Hepworth is the work of David Chipperfield and the design expresses his spare and restrained style that is well suited to the tradition of British modernism.

Walsall

New Art Gallery
Gallery Square
Mon–Sat 10–5, Sun 11–4
Tel +44 1922 637 575
www.artatwalsall.org.uk
New Art Gallery houses a wide-ranging historical art collection that includes con-

temporary works by artists such as Gavin Turk and Yinka Shonibare. The gallery itself was opened in 1999 to a design by Caruso St. John and is set on Gallery Square that was designed by artist Richard Wentworth.

Warwickshire

Compton Verney
March–Dec Tue–Sun 11–5
Tel +44 1 926 64 5560
www.comptonverney.org.uk
Compton Verney is located in an historic Robert Adam designed mansion from the seventeen-sixties. Opened as an art center in 2004 the house presents exhibits on a wide variety of art themes and styles.
Selected solo exhibitions James Coleman, Richard Billingham, Luc Tuymans

West Bretton Wakefield

Yorkshire Sculpture Park
April–Oct 10–5 Daily,
Nov–Mar Daily 10–4
Tel +44 192 483 2631
www.ysp.c.uk

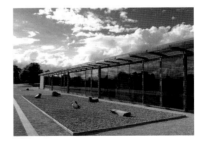

One of Europe's foremost outdoor sculpture parks, Yorkshire Sculpture Park is set on 500 acres of grounds created as a private pleasure ground in the eighteenth century and known as Bretton Hall. Opened to the public in 1977 the park hosts changing exhibitions as well as per-

manent installations by James Turrell, Mark di Suvero, Ulrich Rückriem, and others.

Woking

The Lightbox

Chobham Road, Woking Surrey
Tue–Sat 10–5, Sun 11–5
Tel +44 148 373 7800
www.thelightbox.org.uk

Marks Barfield's The Lightbox has won awards for its simple yet classic spaces for changing exhibitions and design collections. Opened in September 2007 the institution plans to engage with contemporary art although predominately exhibits with craft basis are planned.

Wolverhampton

Initial Access

Units 19 & 20 Calibre Industrial Park,
Laches Close, Off Enterprise Drive
Tue–Fri 11–4, Sat 10–4
Tel +44 190 279 8999
www.initialaccess.co.uk

Initial Access houses a selection from the collection of DIY entrepreneur Frank Cohen known as the "Saatchi of the North" for the breath and quality of his collection. In 2007 the space opened in an industrial park with three exhibits a year curated by David Thorp. Cohen also has been planning to open FC MoCA Manchester that will house his collection although it has been delayed from its scheduled opening date of 2007.

Estonia

This Baltic country was controlled by the USSR until 1991 and has strong allegiances with its neighbor across the Gulf of Finland, Finland. The engagement with contemporary art has faced many of the same issues that confronted the former Eastern Bloc after the fall of Communism and the dissolution of the USSR. The construction of the KUMU Art Museum in Tallinn and the forthcoming Tallinn Capital Culture year in 2011 are signs that the country is engaged on the cultural front.

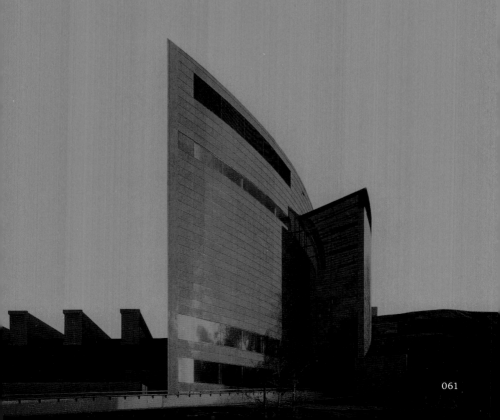

Estonia Resources

www.muuseum.ee

information on Estonian museums in English and Estonian

Tallinn

Tallinn is a stunning city that has seen a rapid rise in tourism over the last decade. This, and the forthcoming investment involved in the hosting of the 2011 European Capital City, will further the process of cultural renewal following the years of Soviet domination.

Tallinn Events

2011

Tallinn European Capital of Culture

KUMU Art Museum

Weizenbergi 34/Valge 1

May–Sept Tue–Sun 11–6,

Oct–April Wed–Sun 11–6

Tel +372 602 6000

www.ekm.ee

KUMU Art Museum designed by Finnish architect Pekka Vapaavuori and opened in 2006, Kumu stands for KUnstiMUseum and houses the Estonian art collections as well as hosting temporary exhibits. While a strong Baltic and Nordic emphasis is stressed, there are also occasional shows by international art figures.

Director Sirje Helme

Selected solo exhibitions Paul McCarthy, Jaan Toomik, Mark Raidpere

Tallinn Art Hall

Vabaduse Square 6

Wed–Mo 12–6

Tel +372 644 2818

www.kunstihoone.ee

Tallinn Art Hall was built in the thirties by functionalist architects Anton Soans and Edgar Johan Kussik and was an initiative of Estonian artists. Restored in 1995, the center hosts exhibits on a Kunsthalle basis.

Selected solo exhibitions Orlan, Andrei Monastorski

Tartu

Tartu Events

2011

Estonian National Museum opens, architects Dorell, Ghotmeh & Tane

To be built on the site of a former airfield, the new Estonian National Museum will house ethnographic objects from Estonia and the region. The new space is designed by the Paris-based team of Dorell Ghotmeh and Tane and means to engage with the historically charged location as well as the issues surrounding the troubled twentieth-century history of Estonia.

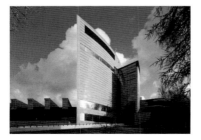

Long under the sway of Sweden and Russia, Finland has seen a limited engagement with contemporary trends in fine art although conversely architecture has been the scene of much innovation in the modern period. It is Helsinki that dominates the art scene here with the Kiasma museum opening in 1998 a major focal point for the rise in interest in the art of today. It is perhaps indicative of countries that began nation building in the twentieth century that foremost was a search for indigenous traditions rather than embracing an international art world.

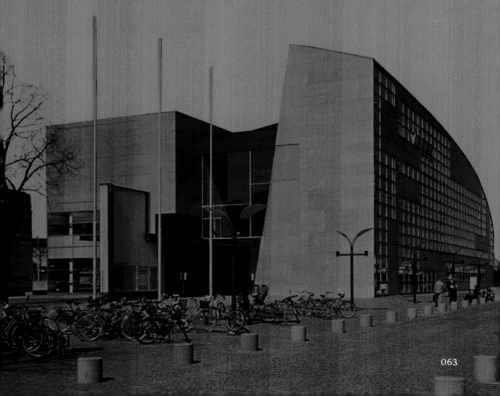

Finland Resources

www.museot.fi
Finnish/English-language information
on museums in Finland
Arkkitehti, www.ark.fi
Finnish architecture publication
Pro Arte Foundation,
www.proartefoundation.fi
launched in 2008 this organization will
organize art events as well as the annual
IHME Project in Helsinki
Framework, www.framework.fi
Finnish art review in English

Helsinki

A major center of modern architecture in
the form of Alvar Aalto and related archi-
tects, Helsinki's commitment to the con-
temporary can be glimpsed in the con-
struction of Kiasma, the contemporary
art museum in a highly charged area of the
capital. While this signifies Helsinki's am-
bition to be a force on the international
art calendar, it has yet to see significant in-
frastructure for contemporary art created
by the local and national government.

Helsinki Resources

www.visithelsinki.fi
Finnish, Swedish and English-language
events and exhibitions

Helsinki Events

August
Night of the Arts
January 2009
Helsinki Photography Festival,
HPF09 (21–24 Jan 09)
March 2009
IMHE Project Antony Gormley
(20 March–13 April 09)

Kiasma

Museum of Contemporary Art Kiasma
How to get there Kiasma is located a few

minutes' walk from the central train sta-
tion.
Mannerheiminaukio 2
Tue 10–5, Wed–Sun 10–8:30
Tel +358 9 17 3361
www.kiasma.fi
(Finnish, Swedish, and English)
Exhibitions & Collections The Kiasma
collection is based on works from Pentti
Kouri's international contemporary art
collection. Featuring artists such as Chris-
tian Boltanski, Dan Flavin, and Richard
Serra, the collection augments the exhi-
bition policy, which focuses on Finnish
and Nordic contemporary art.

Building Designed by Steven Holl, Kias-
ma (from chiasm and referring to inter-
sections of optic nerves) is a striking
building that features a curving ramp
leading to exhibition spaces that turn and
slope creating a disorienting feel. Opened
in 1998 Kiasma is a striking counterpoint
to the historic modernism of Helsinki.
Director Director 1990– & director of
National Art Galleries 2000– Tuula
Arkio, senior curator Maaretta Jaukkuri
Selected exhibition *Evil Eye Narrative
and Gaze in Post Soviet Art*

Kunsthalle Helsinki
Nervanderinkatu 3
Tue–Fri 11–6, Wed 11–8, Sat–Sun 12–5
Tel +358 9 454 2060
www.taidehalli.fi
Kunsthalle Helsinki, an initiative of the

Finnish Art Society, opened in 1928 to a design by Hilding Ekelund with interiors by Jarl Eklund. Focusing on contemporary Finnish art as well as international art, the Kunsthalle is one of the pre-eminent examples of nineteen-twenties' Finnish neo-classicism.

Ateneum Art Museum
Kaivokatu 2
Tue, Fri 9–6, Wed–Thu 9–8,
Sat–Sun 11–5
Tel +358 9 17 3361
www.ateneum.fi
Ateneum Art Museum is the Finnish National Gallery and as such contains a broad selection of international and Finnish art up until 1960 as well as exhibiting works from contemporary artists. The building opened in 1887 to a design by Theodor Höijer and meant to be a house of the arts, including craft and design. Following the opening of Kiasma, the contemporary collections moved to that institution.

Espoo

EMMA
Espoo Museum of Modern Art
WeeGee House
Ahertajantie 5, Tapiola
Tue 11–6, Wed–Thu 11–8,
Fri–Sun 11–6
Tel +358 98 165 7512
www.emma.museum
EMMA Espoo Museum of Modern Art opened in the WeeGee house, a former printing factory designed by Arno Ruusuvuori, in 2006. While the museum presents exhibits both modern and contemporary, there are also three separate collections housed in the EMMA that reflect the history of modernism in Finland.
Selected solo exhibitions
Antoni Tàpies, Raimo Utrainen, Shirin Neshat

Pori

Pori Art Museum
Etelaranta
Tue–Sun 11–6, Wed 11–8
Tel +358 2 621 1080
www.pori.fi
Pori Art Museum is set in a nineteenth-century customs warehouse which opened in 1981 as museum restored and extended in 2000 by Arkkitehdit Ky. The collections of the municipality are located here as well as a representative selection of works of Finnish modernism.
Selected solo exhibitions Oscar Muñoz, Fiona Tan

Turku

Turku Events
2011
Turku European Capital of Culture

Turku Art Museum
Aurakatu 26
Tue–Fri 11–7, Sat–Sun 11–5
Tel +358 2 262 7100
www.turuntaidemuseo.fi
Founded in 1904 and designed by Gustaf Nyström, the Turku Art Museum presents primarily Finnish and regional art of the modern period. The museum was restored and re-opened in 2005.
Selected solo exhibitions Paul Osipow, Jarno Harakkamäki

The arts in France are dominated by the Parisian art world. Based in tradition and with a wealth of governmental support, Paris has recently recovered from years of stagnation to once again be at the heart of European contemporary art practice. What this means for the provinces is that, despite the establishment of FRAC cultural institutions in the eighties, they remain under-funded and without a dedicated artist and collector base. The FRAC system, although highly varying in quality amongst its member institutions, has amassed a significant collection of artwork at the regional level as well as providing a venue for emerging artists. It is emblematic, though, of France that the government and politics play such a pivotal role in the allocation of support and the setting of priorities at all levels of the French system.

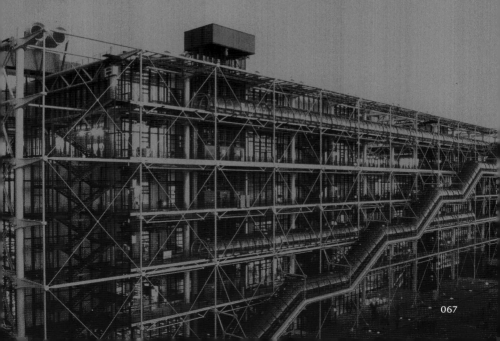

France Resources

www.culture.fr/sections/themes/art_
contemporain/
French-language contemporary art info
www.dca-art.com
useful data bank of French art centers,
English and French language
www.patrimonie-en-isere.fr
art in Isère region only
www.artnet.fr
launched in 2008, French-language art
and auction news

Paris

In recent years Paris has re-emerged as a
major international art center, with vi-
brant and lively alternative art centers as
well as a revitalized Pompidou, which has
recovered from years of disengagement
with contemporary work. Even the Lou-
vre has dedicated a portion of their space
to contemporary art and, with a wealth
of top-level galleries and major art events,
Paris is once more a force in the interna-
tional art world.

Paris Resources

www.museums-of-paris.com
French/English-language
museum information
www.paddytheque.net
French-language blog
about Parisian art world
www.paris-art.com
French-language exhibition information
www.parismusees.com
French-language museum information
www.tram-idf.fr
French-language information
for art on tramway project

Paris Events

Annual Events
April
Art Paris, Foire d'art Moderne +
Contemporain
May
Nuit des Musées
September
Festival d'Automne à Paris
October
Nuit Blanche (night of contemporary art);
FIAC, Foire Internationale d'art contem-
porain; Slick, art fair; Art Elysees, art fair;
Show-Off, art fair; Marcel Duchamp
Prize, annual prize announced during
FIAC; Prix Fondation d'enterprise Ricard,
annual prize announced during FIAC
November
Paris Photo art fair
2009
Monumenta, Grand Palais, artist Chris-
tian Boltanski; Paris Triennial, Grand
Palais
2010
Monumenta, Grand Palais ; Fondation
Louis-Vuitton opens, architect Frank
Gehry
TBD: Centre Pompidou, Alma branch
opens; Contemporary European
Creation Centre & Sculpture Park,
Île Seguin

Centre Pompidou
Musée National d'Art Moderne
How to get there Located in the center of
Paris, the Centre Pompidou can be reached
via the Metro stops Rambuteau, Hôtel de
Ville, and Rer Châtelet-les-Halles.
Place Georges Pompidou
Wed–Mon 11–9
Tel +33 1 4478 1233
www.centrepompidou.fr
(French, English, and Spanish)
Exhibitions & Collections One of the
foremost European modernist and con-
temporary collections, the Musée Natio-
nal d'Art Moderne occupies a central role
in the arts in France. Due to its strong
support from the French state, the muse-
um is able to mount exhibitions and ex-
pand its focus. This is evidenced by the
satellite Pompidou currently under con-

struction in Metz as well as the plans to expand into the Alma complex directly under the Palais de Tokyo. While originally envisioned as an open plan museum with few walls and with an exhibition program oriented to the most challenging art and exhibition techniques, the museum has in recent times become more conventional and traditional in its approach. In 2008, the Pompidou announced highly controversial plans to open a site at the Palais de Tokyo to be called the Centre Pompidou-Alma. This new center will focus on mid-career French artists.

Building A landmark of contemporary architecture, the Centre Pompidou by Renzo Piano & Richard Rogers opened in 1977 and has since become a cultural icon and silenced early critics of its design. With its striking exterior of pipes and tubes, the Pompidou revolutionized the approach of urban planners and architects to issues of urban regeneration. The Pompidou was originally seen as more of a cultural laboratory with music, art, and performance occupying central roles. The Pompidou remains a unique document of its time and retains its ability to impress.

Director Alfred Pacquement 2000–

Selected solo exhibitions David Claerbout, Annette Messager, Yves Klein, Vija Celmins, Robert Rauschenberg, Hiroshi Sugimoto

Jeu de Paume
Concorde, 1 place de la Concorde, metro Concorde
Tue 12–9, Wed–Fri 12–7, Sat–Sun 10–7
Tel +44 1 4703 1250
www.jeudepaume.org
The 1851 Napoleon III building, the Jeu de Paume, meaning a form of tennis in the nineteenth century, is the current home of photography exhibitions. From 1922 to 1986 the Jeu de Paume was the Museum of Impressionism but following the Musée d'Orsay's opening the Jeu de Paume underwent renovations by Antoine Stinco and reopened in 1991. An amalgamation of the Centre National de la Photographie, the Patrimoine Photographique and the Galerie Nationale du Jeu de Paume and created in 2004, the Jeu de Paume has recently hosted exhibits by Cindy Sherman and Joel Meyerowitz. Satellite exhibits are also held at the Hôtel de Sully.

ARC / Musée d'Art Moderne de la Ville de Paris
How to get there Can be reached via metro Alma-Marceau or Iléna.
11, avenue du Président Wilson
Tue–Sat 10–6, Wed 10–10
Tel +33 1 5367 4000
www.mam.paris.fr (in French only)
Exhibitions & Collections The city of Paris' modern and contemporary art collection developed out of the perceived need in the thirties for a museum solely devoted to modernism. With the subsequent donations of collectors Emanuele Sarmielmo, Mathielde Ames, and Ambroise Voillard, an early core of the museum was formed. It is the stated goal of the museum to pursue an energetic collection policy and recent exhibits have featured Pierre Huyghe, Gabriel Orozco, and Steve McQueen. The initials ARC refer to the contemporary collections of the museum.

Building Built for the World Fair of 1937 Jean-Claude Dundel and Andre Albert's Palais de Tokyo was intended to partially house the Musée d'Art Moderne following the conclusion of the fair. Due to lack of funds, the classical and sober Palais was not opened to the public until 1961. From 1961 to 1989 the museum was then forced to deal with a large variety of institutions housed in the Palais, which has hampered the museum's ability to forge a unique identity.
Director Fabrice Hergott 2006–
Selected solo exhibition Mathieu Mercier

Palais de Tokyo
site de création contemporaine
How to get there Can be reached via metro Alma-Marceau or Iléna.
13, avenue du Président Wilson
Tue–Sun 12–12
Tel +33 1 4723 5401
www.palaisdetokyo.com
(French and English)
Exhibitions & Collections Established by Nicolas Bourriaud and Jérôme Sans, the Palais de Tokyo engages with contemporary art through exhibitions and events geared to challenge the viewer and encourage discourse. Exhibits have featured a high level of curating initiative and have brought an edge to the Parisian art scene. The changes in leadership at the Palais due to French government political interference are symptomatic of the centralizing role of politics in the arts in France although the institution remains an even mixture of public and private support.
Building Housed in the same building as the Musée d'art Moderne de la Ville de Paris, the Palais de Tokyo is a remnant of the 1937 World Fair. At the behest of the Ministry of Culture, in 2002 Anne Lacaton and Jean-Phillippe Vassal remodeled the wing housing the Palais de Tokyo

with minimal intervention to allow an unobtrusive display of art.
Directors Marc Olivier Wahler 2006–, Nicolas Bourriaud & Jérôme Sans founding directors 2002–05

Selected solo exhibitions Steven Parrino, Joe Coleman, Michel Blazy, Zilvinas Kempinas

Louvre
99 rue de Rivoli
Wed–Mon 9–6,
Wed & Fri 9–10
Tel +33 1 4020 5020
www.louvre.fr
I. M. Pei's Grand Louvre pyramid opened in 1989 and is the most visible part of Mitterand's Grand Projets. Although changing the sense of the Louvre as a royal palace in favor of an experience that references mall culture, the pyramid is a masterstroke of contemporary museum design. This hallowed institution known for its conservative leanings has in recent years embraced contemporary art with, for instance, in 2007 work by Anselm Kiefer installed in the nineteenth-century staircase at the north end of Perrault's Colonnade. In addition, the Counterpoint series inaugurated in 2005 gives a contemporary artist free reign to create an installation in the museum, which is augmented by exhibits by contemporary photographers such as Candida Höfer and Patrick Faigenbaum.

Selected solo exhibitions Jan Fabre, Mike Kelley

La Maison Rouge
10 boulevard de la Bastille
Wed–Sun 11–7, Thu 11–9
Tel +33 1 4001 0881
www.lamaisonrouge.org
La Maison Rouge opened in 2004 and is home to the Foundation Antoine de Galbert. The art center is an initiative of the former gallery owner Antoine de Galbert and is housed in a factory converted by Jean-Yves Clément of Amplitude with the artist Jean-Michel Alberola designing the reception areas. The unique feature of the institution is that exhibitions focus on private collections and are handled by independent curators.
Managing director Paula Aisemberg
Selected solo exhibitions Patrick van Caeckenbergh, Tetsumi Kudo, Henry Darger, Michael Borremans

Fondation Cartier
261 boulevard Raspail
Tue 10–10, Wed–Sun 10–8
Tel +33 1 4218 5650
www.fondation.cartier.com

Run by the noted jewelry and watch-making firm Cartier, Fondation Cartier opened in 1994 in a building designed by Jean Nouvel. While presenting temporary exhibits of an international caliber the center is housed in a transparent glass structure meant to safeguard a cedar tree planted by French nineteenth-century author Chateaubriand. This has created a challenging space in which to present the meticulously curated exhibits.
Director Hervé Chandès
Selected solo exhibitions Robert Adams, Lee Bull, David Lynch, Gary Hill, Juergen Teller

Fondation d'entreprise Ricard
12 rue Boissy d'Anglas
Tue–Sat 11–7
Tel +33 1 5330 8800
www.fondation-entreprise-ricard.com
Fondation d'entreprise Ricard is the foundation of the Pernod Ricard alcohol-producing firm and has included a modest space designed by Jakob et MacFarlane since 2007. Exhibitions focus on emerging French artists as well as hosting the annual art prize of the foundation, the Prix Fondation d'enterprise Ricard.
Selected solo exhibitions Guy Limone and Laurent Grasso

Le Plateau
Place Hannah Arendt, intersection of Rue des Alouettes and Rue Carducc
Sat & Sun 12–8
Tel +33 1 5319 8810
www.fracidf-leplateau.com
One of the more innovative and engaged of the spate of new centers opened for contemporary art, Le Plateau was created in 1983 as the Regional Fund for Contemporary Art of the Île-de-France which included a brief to amass a collection of contemporary art. The center opened in 2002 in a former television studio and has since developed a reputation for its focused programming.
Director Xavier Franceschi, chief curator Caroline Bourgeois,
Selected solo exhibitions Nicole Eisenman, Jean-Michel Sanejouand, Joan Jonas

Cité de l'architecture
& du Patrimoine
1 place du Trocadéro
Tue–Wed, Fri 12–8, Thu 12–10,
Sat–Sun 11–7
Tel +33 1 5851 5200
www.citechaillot.fr

The world's largest architecture museum, the Cité de l'architecture & du Patrimoine opened in September 2007 in the Art Deco Palais de Chaillot. With discussions to create an architecture museum lasting over two centuries, the current institution stems from plans drawn up in the early nineties. Exhibitions and collections run the gamut of current and historical French architecture tradition and innovation.

Kadist Art Foundation
19–21 rue des Trois
Thu–Sun 2–7
Tel +33 1 42 5183
www.kadist.org

Housing a large private collection, the Kadist Art Foundation was founded 2001 to present selected exhibitions as well as providing artist residencies.

Coordinators of exhibitions Elodie Royer and Sandra Tardjman
Selected solo exhibitions Mario Garcia Torres, John Fare, Mungo Thomson, Wilfredo Prieto

Espace Claude Berri
8 rue Rambuteau
Wed–Sat 11–7
Tel +33 1 44 54 8800

Espace Claude Berri opened in March 2008 in space designed by Jean Nouvel to highlight the collection of French film director Claude Berri with changing exhibits from his modern and contemporary collection of artists such as Bruce Nauman, Paul McCarthy, and Robert Ryman. It remains to be seen how the death of Claude Berri in January 2009 will impact the institution.

Selected solo exhibition Gilles Barbier

Le Laboratoire
4 rue du Buloi
Fri–Mon 12–7
www.lelaboratoire.org

Le Laboratoire opened in 2007 and presents temporary exhibits featuring artists and designers in collaboration with scientists.

Selected solo exhibition Shilpa Gupta

Île Seguin
Announced in 2006 by the government of Jacques Chirac, the Contemporary European Creation Centre & Sculpture Park, Île Seguin, is meant to house a public art center that will concentrate on contemporary work. The Île Seguin has been host to a series of failed projects, from the abortive attempt to build a museum for the Francois Pinault Collection that eventually went to Venice, to this project that has yet to see support from the current administration. Former host to the Renault car factory, the island has already seen several projects canceled by the new municipal government.

Fondation Louis-Vuitton
The Frank Gehry-designed Fondation Louis-Vuitton is set to open in 2010 and will house exhibits as well as original commissions and research facilities. Amongst the most extensive in France, the contemporary collection of LVMH and its chairman Bernaud Arnault include many of the leading figures of the international art scene. The new museum will be located next to the Bois de Boulogne and early plans by Gehry showed a particularly striking biomorphic form.

Artistic director Suzanne Page

Le Pavillon de l'Arsenal
21 boulevard Morland

Tue–Sat 10:30–6:30, Sun 11–7
Tel +33 1 4276 3397
www.pavillon-arsenal.com

Le Pavillon de l'Arsenal opened in 1988 as a center for Parisian architecture and urban planning. Designed by Clement in 1879, the building originally served as a *musée populaire* and then in turn as a factory, a restaurant, and a home to the archives of Paris. Exhibitions focus on contemporary architecture and the website offers a useful database of contemporary Parisian architecture.

Paris Art Areas

Surrounding the Centre Pompidou on the Right Bank in the 3rd and 4th arrondissements is the hip area of Le Marais. This area became a protected quarter in 1969 and is home to leading Parisian galleries.

In the 13th arrondissement on the Left Bank is the rue Louise Weiss (www.louise13.fr) that hosts many cutting-edge Parisian galleries. With a large population of Asian immigrants this area has a unique flavor.

Home to the École des Beaux Arts, the Faubourg Saint-Germain is located on the Right Bank and is a residential district dotted with contemporary galleries.

In the 19th arrondisement a former state funeral parlor has been turned into art spaces from 2008 that will house artists' studios and other facilities and will be open to the public.

On the Right Bank, the 20th arrondissement is home to a large population of Arab and Chinese immigrants as well as the most challenging new contemporary art galleries. This area features the art center Le Plateau.

Amiens

Musée de Picardie
40 rue de la République

Tue–Sun 10–12:30, 2–6
Tel +33 3 2297 1400
www.amiens.fr/musees

Musée de Picardie has been under renovation and re-opened in April 2008 featuring a large collection of archeological and historical art as well as a rotunda from 1992 designed by Sol LeWitt. Constructed in the mid-nineteenth century the museum is a prime example of Second Empire architecture.

Annecy

Fondation pour l'art contemporain Claudine et Jean-Marc Salomon
Chateau d'Arenthon
Mar–June Thu–Sun 2–7,
July–Oct Wed–Sun 2–7
Tel +33 4 5002 8752
www.fondation-salomon.com

Fondation pour l'art contemporain Claudine et Jean-Marc Salomon is set in the historic sixteenth-century Château d'Arenthon since its founding in 2001. Jean-Marc Salomon is a major manufacturer of skis and skiing equipment who sold his family firm in 1997 and now concentrates on collecting contemporary art. Especially of interest are the gardens which include works by Antony Gormley, Jan Fabre, amongst others.
Selected solo exhibitions Jacques Monroy, Peter Wüthrich

Arles

Arles Events
2009
Les Rencontres d'Arles Photographie, annual event (7 July– 13 Sept 09)
TBD: Fondation Luma, architect Frank Gehry, plans announced December 2007

Fondation Luma
Announced in December 2007, plans for a new purpose-built home for the Fon-

dation Luma and the annual photography festival, Les Rencontres d'Arles Photographie, to be designed by Frank Gehry on the site of an abandoned railway yard. The Fondation Luma is the private foundation of Swiss philanthropist and heir to Hoffmann La Roche pharma empire Maja Hoffmann. Already controversial, the initial plans would substantially alter the existing railway architecture.

Aubervilliers

Les Laboratoires d'Aubervilliers
41 rue de l'Ecuyer
Tel +33 153 56 1590
www.leslaboratoires.org
Les Laboratoires d'Aubervilliers was established in 1994 and has become one of the more active of cultural facilities in the Paris region. Producing special projects as well as hosting artists, the center is located in a former ball bearings factory northeast of Paris.

Avignon

Collection Lambert
5 rue Violette
Sept–June Tue–Sun 11–6,
July–Aug Daily 11–7
Tel +33 4 9016 5620
www.collectionlambert.com
Housing the collections of noted Parisian gallerist Yvon Lambert, the Collection Lambert en Avignon, Musée d'Art Con-

temporain opened in 2000 in the eighteenth-century hôtel de Caumont. The collection includes 350 works on loan to the museum as well as site specific works by Lawrence Weiner, Jenny Holzer, and Niele Toroni. Lambert is one of the most respected of French dealers who has shown many of the leading contemporary artists since first opening in Paris in 1966. The museum had a rather odd incident of vandalization then in 2007 a visitor kissed a work by Cy Twombly leaving a large red stain on the canvas.
Director Eric Mezil
Selected solo exhibitions Cy Twombly, Andres Serrano, Francis Alÿs

Bignan

Domaine de Kerguéhennec
Centre d'art contemporain
Sept–June Tue–Sun 10–6,
July–Aug Tue–Sun 10–7
Tel +33 2 9760 4444
www.art-kerguehennec.com
Domaine de Kerguéhennec, centre d'art contemporain is located 12 miles north of Vannes in southern Brittany in an eighteenth-century villa and gardens with a sculpture park. The gardens include works by Richard Long, Richard Artschwager, Ulrich Rückriem, as well as many other contemporary artists. Having opened in 1986 the center also offers residencies.
Selected solo exhibitions Ceal Floyer, Mel Bochner, Steven Pippin

Bordeaux

CAPC Musée d'Art Contemporain de Bordeaux
7 rue Ferrère
Tue–Sun 11–6, Wed 11–8
Tel +33 5 5600 8150
www.bordeaux.fr
Set in a nineteenth-century warehouse once used to store foodstuffs from the

colonies of France, the CAPC Musée d'Art Contemporain de Bordeaux opened in 1983 and houses a collection that concentrates on developments over the last thirty years with conceptual art, land art, and Arte Povera especially well represented.
Director Charlotte Laubard 2006–
Selected solo exhibitions Pascal Broccolichi, Chohreh Feyzdjou

Arc en Rêve
Centre d'architecture
7 rue Ferrère
Tue–Sun 11–6, Wed 11–8
Tel +33 5 5652 7 836
www.arcenreve.com
Arc en Rêve, centre d'architecture was founded in 1981 and presents exhibits on architecture and urban planning.
Selected solo exhibition Yona Friedman

Brétigny sur Orge

CAC Brétigny
Centre d'art contemporain
de Brétigny
Espace Jules Verne
rue Henri Douard
Tue–Sat 2–6
Tel +33 1 6085 2076
www.cacbretigny.com
Beginning in 2000 in this suburb of Paris, the CAC Brétigny, Centre d'art contemporain de Brétigny has offered exhibitions and projects with a recent accent on film with, since 2004, the commissioning of projects from several leading international artists such as Artur Zmijewski, Clemens von Wedemeyer, and Sania Ivekovic. This is of one the leading venues for contemporary art in the Paris environs.
Selected solo exhibitions Nicolas Chardon, Rainer Oldendorf, Markus Schinwald

Chamarande, Essonne

Domaine de Chamarande
38 rue du Commandant Arnoux
Tel +33 1 60 82 5201
www.essone.fr
Domaine de Chamarande was established in 2001 by Dominque Marchès on the grounds of the seventeenth-century Château de Chamarande. The permanent collection includes mainly French artists with a large sculpture park on the grounds of the estate.

Clermont-Ferrand

Clermont-Ferrand Events
May
Nuit des Musees
2009
VideoFormes, XXIVe manifestation internationale d'art vidéo et nouveaux medias; Clermont-Ferrand, annual festival (10–14 March 09)

Espace d'Art Contemporain La Tôlerie
10 rue du Bien Assis
Tue–Sun 3–7
Tel +33 4 73 42 6376
www.clermont-ferrand.fr/
La-Tolerie.html
Espace d'Art Contemporain La Tôlerie is located in a former garage and opened in 2003 by the city of Clermont-Ferrand. Yearly projects are presented by a guest curator.

Delme

Centre d'art Contemporain
la Synagogue de Delme
33 rue Poincaré
Wed–Sat 2–6, Sun 11–6
Tel +33 3 8701 3561
www.cac-synagoguedelme.org
In a synagogue from 1881 is the Centre d'art Contemporain la Synagogue de

Delme which, in addition to temporary exhibits, also offers artist residencies. The center opened in 1998.
Selected solo exhibitions Peter Downsbrough, Toby Paterson, Dan Walsh

Dijon

Le Consortium
16 rue Quentin
Tue–Sat 2–6
Tel +33 3 8068 4555
www.leconsortium.com

Le Consortium founded in 1977 in a former electrical appliances store, and is run by a team of three curators: Xavier Douroux, Franck Gautherot, and Eric Troncey. This is one of the more engaged of regional French contemporary art institutions and the center also hosts dance, theater, and musical events.
Director Eric Troncey 1995–
Selected solo exhibitions Mark Leckey, Simon Linke, Carsten Höller, Piero Gilardi, Angela Bulloch

FRAC Bourgogne
49 rue de Longvic
Mon–Sat 2–6
Tel +33 3 8067 1818
www.frac-bourgogne.org

FRAC Bourgogne was established in 1983 as part of the FRAC network and has earned a reputation for the quality of its collection, which unfortunately is not on view.
Selected solo exhibitions Rita McBride, Frances Stark, Matthew Buckingham

Dunkerque

Dunkerque Events
TBD: new FRAC Nord Pas de Calais opens

FRAC Nord Pas de Calais
930 avenue de Rosendaël
Tue–Sat 2–6
Tel +33 3 28 65 8420
www.fracnpdc.fr

FRAC Nord Pas de Calais one of the foremost FRAC collections in France especially strong in Minimal and Conceptual Art with Bruce Nauman, Donald Judd, and Dan Flavin, as well as some works from the collection of Hans Neefkens, a Dutch collector. The institution is in the process of relocating to l'AP2 a former shipyard site to house both collection and temporary exhibits.

Epinal

Musée Departmental d'Art Ancien et Contemporain
1 place de Lagarde
April–Oct Wed–Mon 10–6,
Oct–Mar Wed–Mon 10–12:30 & 1:30–6
Tel +33 3 2982 2033
www.vosges.fr

Since opening in a renovated hospital from the seventeenth century, the Musée Departmental d'Art Ancien et Contemporain the museum has been renovated several times over, the latest being in 1992. Its location on the island on the Moselle is striking and the museum houses a substantial collection of historical painting as well as works from minimalism and Arte Povera. A special accent is placed on works by female artists, as evidenced by the Fondation Camille donation of works from Louise Nevelson, Sophie Calle, amongst others.

Grenoble

Magasin, Centre National d'Art Contemporain
How to get there Located 1 hour from Lyon in Grenoble, Magasin is 10 minutes by foot from the Gare SNCF or 5 minutes via tram A.
Site Bouchayer-Viallet, 155 cours Berriat
Wed–Sun 2–7

Tel +33 4 7621 9584
www.magasin-cnac.org
(in French only)
Exhibitions & Collections Opened in
1986 as one of the Grands Projets of Fran-
çois Mitterand, Magasin works on a Kunst-
halle system with no permanent collec-
tion. Temporary exhibits regularly feature
challenging art and a vigorous curatorial
vision has allowed Magasin to remain a
major venue for two decades.

Building The industrial building, Maga-
sin (Store), was built in 1900 by Gustav
Eiffel to shelter machines. In the conver-
sion by Patrick Bouchain the large central
hall was preserved. Further renovations
in 2005–06 brought the center addition-
al exhibition spaces.
Director Yves Aupetitallot
Selected solo exhibitions Troy Braun-
tuch, Latifa Echakhch, Gavin Turk,
Lothar Hempel, Franck Scurti, Kader
Attla, Jonathan Meese

Musée de Grenoble
5 Place Lavalette
Wed 11–10, Thu–Sun 11–7
Tel +33 4 76 63 4444
www.museedegrenoble.fr
Founded in 1796 in the wake of the
French Revolution, the Musée de Greno-
ble houses a substantial collection of his-
torical and contemporary art. For over a
century the museum was housed in a
nineteenth-century building but in 1994

moved into a new home designed by lo-
cal architects Olivier Félix-Faure, An-
toine Félix-Faure, and Philippe Macary.
The contemporary collection stresses
French art with Christian Boltanski and
Bernard Lavier as well as major Minimal-
ist and Conceptualist works from Richard
Long, Sol LeWitt, and Carl Andre.
Selected solo exhibition Wolfgang Laib

Hérouville Saint-Clair

Wharf
Centre d'Art Contemporain
de Basse-Normandie
7 passage de la Poste
Tue–Sat 2–6:30
Tel +33 2 3195 5087
www.herouville.net/CAC.html
Wharf, Centre d'Art Contemporain de
Basse-Normandie opened in 1990 and is
a modest space for the presentation of
contemporary art in Normandy.

Île de Vassivière

Centre International d'art
et du Paysage
Vassivière Island, 60 km
east from Limoges
Tue–Fri 2–6,
Sat–Sun 11–1 & 2–6
Tel +33 5 5569 2727
www.ciapiledevassiviere.com
Located on an island in the center of an
artificially created lake in the province of

Limousin, the Centre International d'art et du Paysage is noted for its international quality sculpture park and art building designed by post modernist Aldo Rossi and which opened in 1987. The sculpture park is open year round and includes works by Andy Goldsworthy, Olivier Mosset, Ilya Kabakov, and Michelangelo Pistoletto. The distinctive conical-shaped center is one of the major built works of Rossi.

Ivry-sur-Seine

Centre d'art contemporain d'Ivry—le Crédac
93 avenue Georges Gosnat
Tue–Fri 2–6, Sat–Sun 2–7
Tel +33 1 49 60 2506
www.credac.fr
In the southeastern suburbs of Paris, the Centre d'art contemporain d'Ivry—le Crédac houses temporary exhibits by contemporary artists with an emphasis on emerging art.

Le Havre

Le Havre Events
2010
Arts Le Havre 10,
biennale d'art contemporain

Le Spot
centre d'art contemporain
du Havre
32 rue Jules Lescesne
Tue–Sat 2–6
Tel +33 8 7230 3066
www.le-spot.org
Le Spot, centre d'art contemporain du Havre has a brief to encourage artistic creation through projects and experimentation since opening in 1997. A major feature of the center is the organizing of the Arts Le Havre biennial, begun in 2006. **Selected solo exhibition** Philippe Cam

Lens

Lens Events
2010
Louvre II opens, architects SANAA

Le Louvre Lens
The new satellite space for the Louvre, Le Louvre Lens (or Louvre II), is to open in the industrial city of Lens in 2010. To be designed by the innovative Japanese architects SANAA known for their spectacular New Museum in New York, the former mining site will be transformed into a center housing temporary exhibits as well as selections form the Louvre collections of historical art.

Les Mesnuls

Fondation d'art contemporain Daniel et Florence Guerlain
5 rue de la Vallée
Thu–Mon 11–6
Tel +33 1 3486 1919
www.cg78.fr
Fondation d'art contemporain Daniel et Florence Guerlain houses the collections of the Guerlains on the family estate 40 km from Paris. With three yearly exhibitions the center focuses on drawings, which is also a major focus for the collection. Opened in 1996 this private collection includes works by Tatiana Trouvé, Gerard Galouste, and Silvia Bächli.

Limoges

FRAC Limousin
2 Place des Charentes
Tue–Fri 10–6, Sat 2–6
Tel +33 5 5577 0898
www.fraclimousin.fr
Since 1991, FRAC Limousin has been a part of the regional FRAC system and is set in a former grocery warehouse from the nineteenth century. While the collec-

tion concentrates on photography and sculpture, the four yearly exhibitions are international in scope.

Selected solo exhibitions Alain Sechas, Thomas Bayrle

Lyon

The capital of the Rhône region and a UNESCO Heritage Site, Lyon has developed a reputation for its Biennale de Lyon which has become a stop on the international art circuit. With world class museums, Lyon has a deserved reputation for culture and engagement with contemporary art.

Lyon Resources

www.adele-lyon.com
French-language listing of Lyon region venues for contemporary art
www.culture.lyon.fr
French-language exhibition information

Lyon Events

September
Docks Art Fair, biannual art fair (2009)
2009
Biennale de Lyon

Institut d'art Contemporain

11 rue Docteur Dolard
Wed–Fri 1–6, Sat–Sun 1–7
Tel +33 4 7803 4700
www.i-art-c.org
Founded in 1997 the Institut d'art Contemporain (Villeurbanne) is a division of the organization of regional art centers in France, FRAC, and presents challenging exhibitions featuring emerging artists. At the site of the former Nouveau Musée art center and opened in 1978, IAC administers other regional art centers of the Rhônes-Alpes area as well as managing the collection of this region and partnering as co-hosts of the Lyon Biennial. Vil-

leurbanne is in the eastern suburbs of Lyon and is a 15 minute walk from the Gare SNCF Lyon.

President Jean-Pierre Michaux
Selected solo exhibitions Leonel Moura, Rita McBride, Peter Friel, Jordi Colomer

MAC
Musée d'Art Contemporain de Lyon

How to get there Sited in the north of the city in the Cité Internationale, the Musée d'Art Contemporain can be reached via bus lines C1, 4, and 58.

Cité Internationale,
81 quai Charles de Gaulle
Wed–Sun 12–7
Tel +33 4 7269 1717
www.mac-lyon.com
(French and English)

Exhibitions & Collections Created in 1984 as an offshoot of the Musée des Beaux Arts de Lyon, the museum outgrew its position in the Beaux Arts museum complex. With a collection that is modest in scale, the museum is noted mainly for challenging exhibits and for co-organizing and presenting the Biennale de Lyon.

Building Built as part of the Cité Internationale project by Renzo Piano, the museum occupies the former Palais de la Foire de Lyon, a façade of which survives. The 1918 fair grounds were moved to a new exposition site in 1984 allowing the

construction of the new buildings, which opened in 1995.

Director Thierry Raspail, associate director Thierry Prat

Selected solo exhibitions Erwin Wurm, Fabien Verschaere, Yona Friedman, Kendell Geers

Marseille

Marseille Events
2013
Marseille, European Capital of Culture

MAC
Musée d'Art Contemporain
69 avenue de Haifa
Oct–May Tue–Sun 10–5,
June–Sept daily 11–6
Tel +33 4 9125 0107
www.marseille.fr
MAC, Musée d'Art Contemporain opened in 1994 in a building designed in the nineteen-seventies with a collection that spans the movements Nouveau Réalisme, Fluxus, and Arte Povera. With a sculpture garden featuring works by Jean-Michel Alberola, Fabrice Gygi, amongst others, the MAC also hosts temporary exhibits by international art figures.

Metz

Metz Events
2010
Centre Pompidou Metz opens, architects Shigeru Ban & Jean de Gastines

49 Nord 6 Est-FRAC Lorraine
1 bis, rue de Trinitaires
Wed–Sun 12–7, Thu 1–8
Tel +33 3 8774 2002
www.fraclorraine.org
49 Nord 6 Est-FRAC Lorraine founded in 1983 as part of FRAC system and since 2004 has been housed in a medieval building known as the Hôtel St. Livier.

Centre Pompidou Metz
www.centrepompidou-metz.fr
In 2010, the branch of the Parisian Pompidou Centre will open in Metz as the Centre Pompidou Metz to a design by the Japanese architect Shigeru Ban. The center's light-filled structure is flexible, allowing for a variety of installation strategies for the exhibition of works from the permanent collection of the Pompidou. Set near the Belgian and German border, this new museum is evidence of an increased desire to broaden the scope of French commitment to contemporary art outside of the Parisian center. Also of note is the inability of the Pompidou in Paris to adequately display its collection, necessitating the creation of a new structure to house its world-class modern and contemporary works.

Milly-la-Forêt

Le Cyclop de Jean Tinguely
open May to end of October,
guided tours Sat 2–5, Sun 11–5:45
Tel +33 1 6498 9518
www.art-public.com/cyclop
The Swiss kinetic artist Jean Tinguely created the *Le Cyclop de Jean Tinguely* with work begun in 1969 in collaboration with Niki de Saint Phalle, Daniel Spoerri, Arman, and Larry Rivers, and which officially was opened by the French government in 1994. Tinguely is especially well-known for his large mechanical sculptures that comment on industrial society.

Monaco

Nouveau Musée National de Monaco
NMNM
www.nmnm.mc
The principality has, considering its wealth, a surprisingly lackluster commitment to contemporary art. With plans for

a new building to house the Nouveau Musée National de Monaco NMNM currently on hold there is little prospect for the situation to change. Originally the new museum was to house the collections of the principality that include art from the nineteenth century to contemporary. This would be the successor to the Musée des Beaux Arts Monaco that closed in 1958 when its collections were ceded to France.

Mouans–Sartoux

L'Espace de L'Art Concret
Château de Mouans
Sept–June Tue–Sun 11–6,
July & Aug 11–7, Thu 11–8
Tel +33 4 9375 7150
www.espacedelartconcret.fr
Founded by Sybil Albers and Gottfried Honegger in 1990, L'Espace de L'Art Concret houses a substantial collection of primarily modern artists although conceptualists in the form of Joseph Kosuth, Richard Serra, and Daniel Buren are well represented. The space in the sixteenth-century Château de Mouans houses the art collection and the surrounding estate provides a suitable setting for outdoor works. The collection was donated to the state in 2000.

Nantes

Nantes Events
2009
Loire Estuary 2007 2009 2011 Nantes to Saint Nazaire (6 June–16 Aug 09)
2009
Memorial to the Victims of Slavery, artist Krzysztof Wodiczko opens in autumn

Nice

Villa Arson
20 avenue Stephen Liégeard
Oct–June Wed–Mon 2–6,
July–Sept Wed–Mon 2–7
Tel +33 4 9207 7373
www.villa-arson.org
With a brief to educate as well as provide space for art, the Villa Arson opened in a nineteenth-century villa of the Arson banking family in 1970. The villa is well known for its international art school and residency program in addition to presenting temporary exhibits.
Artistic director Eric Mangion,
Selected solo exhibitions Gerald Panighi, Fabrice Hyber, Stephen Wilks, Véronique Boudier

**Musée d'Art Moderne
et d'Art Contemporain MAMAC**
Promenade des Arts
Tue–Sun 10–6
Tel +33 4 9713 4201
www.mamac-nice.org
Musée d'Art Moderne et d'Art Contemporain MAMAC with its distinctive arc design by Yves Bayard and Henri Vidal has a collection rich in contemporary art beginning with Pop and including work by Jean-Michel Alberola, Nam June Paik, and Keith Haring. Since opening in 1990, the museum has presented a wide variety of modern and contemporary exhibitions.
Selected solo exhibitions Michelangelo Pistoletto, Bernard Pages, Jean Pierre Raynaud, Robert Rauschenberg, Alain Jacquet

Nîmes

Carré d'Art
16 Place de la Maison Carreé
Tue–Sun 10–6
Tel +33 4 6676 3570
www.carredart.org
One of the more noteworthy buildings of Norman Foster, the Carré d'Art forges a dialogue with the surrounding Roman ruins in the center of the old city. Evidencing Foster's contemporary take on

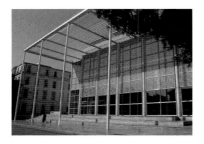

modernism, with glass and clean aesthetic lines, the center was inaugurated in 1993 and includes a collection of artists such as Christian Boltanski, Gunther Förg, and Sigmar Polke.
Selected solo exhibitions Rebecca Horn, Giuseppe Penone

Noisiel

La Ferme du Buisson
allée de la Ferme
Tel +33 1 60 37 7878
www.lafermedubuisson.fr
In the Marne la Vallee Cedex, the art center La Ferme du Buisson is set on a former farm that was part of an industrial complex from the nineteenth century. The center is a multi-use cultural venue and theater as well as music has its place here. Contemporary exhibits have been staged since 1992.

Noisy-le-Sec (Paris)

La Galerie
Centre d'art Contemporain
1 rue Jean–Jaurés
Tue–Fri 2–6, Sat 2–7
Tel +33 1 4942 6717
www.noisylesec.fr
Set in the suburbs of Paris, La Galerie, Centre d'art Contemporain opened in 1999 and operates a curator-in-residence program as well as exhibits on a Kunsthalle system.

Poitiers

Le Confort Moderne
185 rue du Faubourg du Pont Nef
Wed–Sun 2–7
Tel +33 5 49 46 0808
www.confort-moderne.fr
Le Confort Moderne was established in 1985 and presents temporary exhibits as well as music events.

(Cergy) Pontoise

Axe Majeur
Dani Karavan's Axe Majeur, part of Mitterand's Grand Projets and located in the suburbs of Paris, is surely one of the most odd of public monuments and the forgotten remnant of the French President Mitterand's projects to transform culture in France. Installed in 1989, and as of yet uncompleted, the major axis runs for three kilometers and includes several viewing points. Meant to symbolize the harmony between man and nature, there are many overt references to alchemy and astrology as the location was the home to alchemist Nicolas Flamel.

Rennes

La Criée
Place Honoré Commeurec
Tue–Fri 12–7, Sat–Sun 2–7
Tel +33 2 2362 2510
www.criee.org
La Criée, Centre d'Art Contemporain hosts temporary exhibits as well as providing spaces for events such as dance and performance.
Selected solo exhibitions Roderick Buchanan, Latifa Laabissi, Paola Pivi

Rochechouart

Musée départemental
d'art contemporain de Rochechouart

Place du Château
Wed–Mon 10–12:30 & 1:30–6
Tel +33 5 55 03 7777
www.musee-rochechouart.com

Musée départemental d'art contemporain de Rochechouart located in a historic thirteenth-century French castle in Haut-Vienne district. The castle includes permanent installations by artists such as Richard Long as well as works by Gerhard Richter, Giuseppe Penone, and Gabriel Orozco, and opened as contemporary art museum in 1985.

Saint Étienne

**Musée d'Art Moderne
Saint Étienne Métropole**
La Terrasse, tram 5 from the center
Wed–Mon 10–6
Tel +33 4 7779 5252
www.mam-st-etienne.fr

Musée d'Art Moderne Saint Étienne Métropole established in 1947 and by the end of the fifties was one of the first museums in France devoted to art of the twentieth century. With a move to a permanent home designed by Didier Guichard in 1987 in the outskirts of the industrial center of Saint Étienne, the Musée d'Art Moderne has presented exhibits by Jannis Kounellis, Txumin Badiola, and Orlan, amongst others. In 2001 the museum was transferred from the municipality of Saint Etienne to the greater Saint Étienne Métropole region.

Director General Lorand Hegyi
Selected solo exhibitions Hwang Young-Sung, Soonja Han, Zeng Fanzhi, Michelangelo Pistoletto, Orlan

Saint-Louis

**Espace d'Art Contemporain
Fernet Branca**
2 rue du Ballon
Wed–Mon 2–6
Tel +33 3 8969 1077
www.museefernetbranca.org

The former distillery of aperitif maker Fernet–Branca, Espace d'Art Contemporain Fernet Branca has housed an art space since 2000 and presents temporary exhibits in an early-twentieth-century factory.

Selected solo exhibitions Lee Ufan, Paul Rebeyrolle, Antoni Clave, Olivier Mosset

Saint Nazaire

Saint Nazaire Eventws
2009
Loire Estuary 2007 2009 2011 Nantes to Saint Nazaire (6 June–16 Aug)

Le Grand Café
Place des Quatre z'horloges
Tue–Sat, Sun 3–6
Tel +33 2 4473 4400
www.grandcafe-saintnazaire.fr

In a distinctive setting in a historic café from the nineteenth century, Le Grand Café, Centre d'Art Contemporain has since 1997 housed an art center with artist residencies also offered. The center is known for its engagement with contemporary international art in well-curated one person exhibits.

Selected solo exhibitions Ivan Grubanov, Allora & Calzadilla, Minerva Cuevas, Elisabeth Ballet, Zilvinas Kempinas

Strasbourg

Strasbourg Resources
www.musees-strasbourg.org
French-language information
on museums in Strasbourg

Strasbourg Events
May
Nuit des Musées
November
St-art, European contemporary
art fair

Musée d'Art Moderne
et Contemporain MAMCS
1 place Hans Jean Arp
Tue–Wed, Fri–Sat 11–7, Thu 12–10
Tel +33 3 8823 3131
www.musees-strasbourg.org
Musée d'Art Moderne et Contemporain
MAMCS opened in 1998 and was de-
signed by French architect Adrien Fain-
silber. The museum is especially well
known for its holdings of German con-
temporary art that is the largest in France
and includes works by Georg Baselitz,
Jörg Immendorff, and Markus Lüpertz.
Meant to symbolize openness and trans-
parency, the museum design has been a
source of controversy.
Chief curator Emmanuel Guigon

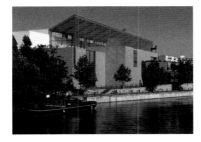

Selected solo exhibitions Piotr Uklan-
ski, Daniel Depoutot, Franck Nitsche,
Christopher Wool, Jean-Luc Parent

Toulouse

Toulouse Events
September
Printemps de Septembre, annual event

Les Abattoirs
76 allées Charles-de-Fitte
Tue–Sun 11–7
Tel +33 5 6248 5800
www.lesabattoirs.org

Les Abattoirs is located in the former
slaughterhouse from 1831 and which
opened as an art center in 2000 by An-
toine Stinco and Rémi Papillaut. With
spaces for the permanent collection,
which includes the Parisian gallery own-
er Daniel Cordier's bequest of primarily
modern and contemporary French art, as
well as the meticulously curated exhibits,
this center is one of the more lively re-
gional French art institutions.
Selected solo exhibitions Antonio
Saura, Ilya & Emilia Kabakov, Wang Du,
Charles Simonds

Tourcoing

Le Fresnoy
22 rue de Fresnoy,
metro from Lille 15 minutes
Wed–Thu 1–7, Fri–Sat 2–9, Sun 2–7
Tel +33 3 2028 3800
www.fresnoy.net
Designed by Bernard Tschumi, Le Fres-

noy, studio national des arts contemporains is a multi-use facility that includes a school, cinema, and exhibition center. Primarily focusing on video and new media, temporary exhibits have featured Chantal Akerman, Christian Boltanski, and Chris Marker. The existing complex of Fresnoy was an entertainment and market center for the textile industry workers in this region. Following its closure in 1984, the site was developed by Tschumi with a large shed placed over the existing structures and it re-opened in 1998. The design incorporates many of the deconstructivist elements so familiar in Tschumi's work.
Selected exhibitions *Territoires de l'image, Panorama8, Histoires Animées*

Tours

CCC Centre de Creation Contemporaine de Tours
53–55 rue Marcel-Tribut
Wed–Sun 2–6
Tel +33 2 4766 5000
www.ccc-art.com
Since its inauguration in 1985, CCC Centre de Creation Contemporaine de Tours has developed a reputation for presenting challenging art by emerging artists. The center was one of the first of the *centres d'art* to be created by the Ministry of Culture that preceded the FRAC system.
Selected solo exhibitions Agnès Thurnauer, Noel Dolla, Malachi Farrell, Nicole Tran Ba Vang

Versailles

Versailles Events
Fall
Château de Versailles-Versailles Off, annual event (Sept - Dec 09)

Château de Versailles
April–Oct Tue–Sun 9–6:30
Nov–Mar Tue–Sun 9–5:30
Tel +33 1 3083 7620
www.chateauversailles.fr
Château de Versailles, the historic royal residence, hosts, during the month of October, the annual Versailles Off, which is a two-day contemporary art fest with artists such as Jeff Koons, Bernard Lavier, and Michel Blazy.

Le Marcéchalerie
5 avenue de Sœaux
Sat–Mon 2–6
Tel +33 1 3907 4027
www.versailles.archi.fr
The modest Le Marcéchalerie, Centre d'Art Contemporain presents primarily French emerging art.
Selected solo exhibitions Laurent Pariente, Jacques Julien, Michel Blazy, Jakob Gautel

Vitry-sur-Seine (Paris)

MAC/VAL Musée d'Art Contemporain du Val-de-Marne
Carrefour de la Libération
Tue–Sun 12–7, Thu 12–9
Tel +33 1 4391 6420
www.macval.fr
One of the largest contemporary projects in France in the last twenty years, the MAC/VAL Musée d'Art Contemporain du Val-de-Marne was designed by Jacques Ripault, twenty years before actually constructing the museum, in the Val de Marne region in the southern suburbs of Paris and which opened in 2005. Holding the collections of the FRAC, whose artworks number in the thousands, the MAC/VAL concentrates on art from 1950 to today. The major accent here is on French artists or artists who work in France, which is natural since the FRAC collection is built on French art.
Selected solo exhibitions Jacques Monory, Claude Lévêque

Germany

A country especially rich in contemporary art institutions and art infrastructure, Germany rewards an extended exploration. The system of arts in Germany, whereby Kunstvereins take the lead in exhibiting emerging artists and which take more chances in showing challenging work, allows for a diverse range of art experiences. Added to this is an acceptance and encouragement for innovative architecture, especially in Berlin, with museums and galleries leading the way. An intriguing element of this cultural matrix is the flight of German artists and arts professionals from all regions to Berlin.

Germany Resources

www.artnet.de
art news in German
www.kulturstiftung-des-bundes.de
German-language art information
Texte zur Kunst, www.textezurkunst.de
Berlin-based German/English magazine

Berlin

Over the last decade Berlin has rapidly emerged to be a major center for international art. With a diverse range of progressive galleries, an innovative architectural fabric, and dynamic cultural institutions, Berlin has much to reward the arts enthusiast. Coupled with these assets, Berlin has seen an influx of artists, curators, and arts professionals, giving the city a unique atmosphere and enriching the cultural landscape.

Berlin Resources

www.indexberlin.de
German-language exhibition
information
www.berliner-galerien.de
German-language exhibition
information
www.galerien-berlin-mitte.de
German-language exhibition guide
for Mitte
www.artery-berlin.de
bi-monthly German/English-language
publication
Kunstmagazin Berlin,
www.kunstmagazineberlin.de
German/English-language arts
coverage
www.heidestrasse-galleries.com
information and map on gallery area
Heidestrasse
www.zitty.de/kunst
art coverage in Berlin magazine *Zitty*
www.berlin.art-info.de
German-language information on art
scene in Berlin

www.artupdate.com/berlin
map of Berlin galleries and museums

Berlin Annual Events

January & August
Lange Nacht der Museen (unfortunately not all contemporary institutions participate in the event)
May
Gallery Weekend
September
ABC Art Berlin Contemporary;
art forum berlin
Fall
Preview Berlin: The Emerging Art Fair;
Bridge Art Fair
2009
Preis der Nationalgalerie für Junge Kunst, biannual prize presented during
art forum berlin
Spring 2010
MICAMOCA Collection, Kühn Malvezzi architects; Berlin Biennale 6
TBD: Sammlung Olbricht; Humboldthafen, private contemporary art museum, announced September 2008

Hamburger Bahnhof
Museum für Gegenwart

How to get there Located near the new Hauptbahnhof in Mitte, the Hamburger Bahnhof is easily accessible.
Invalidenstrasse 50/51
Tue–Fri 10–6, Sat 11–8,
Sun 11–6
Tel +49 30 397 8340
www.hamburgerbahnhof.de
(German and English)
Exhibitions & Collections An international-quality museum, the Hamburger Bahnhof is devoted to showing challenging works in dynamic exhibition designs. The collection brought together works owned by the state as well as bringing to Berlin the important Sammlung Marx, which has been highly controversial in its Berlin installation as well as the histori-

cally charged but extensive and forward-looking Flick Collection.

Building Opened in 1996 with galleries partially designed by Josef Paul Kleihues, the Bahnhof has been a landmark in Berlin since its original opening as a railway station in 1846–47. Serving many functions since its inception, the current design is a sensitive conversion allowing ample space for a variety of institutional and exhibition roles. A new wing, the Rieck Hall designed by Kühn Malvezzi, was added and funded by the industrialist Flick to house his collection as well as temporary exhibits.

Directors Chief curator Eugen Blume, senior curator Britta Schmitz, curators Joachim Jägr, Friedegund Waldemann, Gabriele Knapstein, Anette Hüsch

Selected solo exhibitions Roman Signer, Brice Marden, William Kentridge, Claude Lévêque, Felix Gonzalez-Torres, The Atlas Group

KW
Institute for Contemporary Art
Auguststrasse 69
Tue–Sun 12–7, Thu 12–9
Tel +49 30 243 4590
www.kw-berlin.de

KW Institute for Contemporary Art is one of the leading contemporary art venues in Germany in its location in what used to be a margarine factory in a former DDR neighborhood, Mitte. Begun by Klaus Biesenbach in the early nineties,

Kunst-Werke has no collection and instead exhibits temporary shows by international artists such as Sue DeBeer, Francis Alÿs, and Katharina Sieverding. In 1999 a renovated and expanded KW was opened with a Dan Graham-designed café and an exhibition space by Hans Düttmann. KW launched and runs the well-regarded Berlin Biennale.

Director Gabriele Horn 2006–, founding director Klaus Biesenbach 1990–2006, **Curator** Susanne Pfeffer 2007–

Selected solo exhibitions Joe Coleman, Mika Rottenberg, Keren Cytter, Katharina Sieverding

Akademie der Künste
Pariser Platz 4
Tue–Sun 11–8
Tel +49 30 20 0570
www.adk.de

Akademie der Künste is located in the historically charged Pariser Platz and presents contemporary exhibitions in a building designed and renovated by Günter Behnisch. The original Arnim Palace building housed the Akademie from 1907 until 1937 when Albert Speer moved his offices here. After significant war damage and years of DDR-era neglect, the Akademie returned to the site in 1993 and, after a tortuous eleven-year process, the new Akademie opened in 2005.

Selected solo exhibition Hans Haacke

Deutsche Guggenheim
Unter den Linden 13 /15
Daily 11–8, Thu 11–10
Tel +49 30 202 0930
www.deutsche-bank-kunst.com/
guggenheim

Since its opening in 1997 Deutsche Guggenheim, a joint venture between Deutsche Bank and the Solomon R. Guggenheim Foundation, offers temporary exhibitions and selection from Deutsche Bank's collections. While the exhibitions

of renowned artists are frequently challenging, the underlying structure of the institution and therefore the satellite branding philosophy of the Guggenheim's Thomas Krens has received much criticism. The Deutsche Bank Collection, though, is one of most well-regarded corporate collections in Europe. The space itself was designed by Richard Gluckman and is located on the ground floor of Deutsche Bank's twenties-era building. **Selected solo exhibitions** Jeff Wall, Phoebe Washburn, Cai Guo-Qiang

Martin-Gropius-Bau
Niederkirchner Strasse 7
Wed–Mon 10–8
Tel +49 30 20 4860
www.gropiusbau.de
Originally the home of the Museum of Industrial Arts & Crafts, the Martin-Gropius-Bau was designed by Martin Gropius and Heino Schmieden in 1881. Numerous changes to content as well as substantial war damage led to a decision in the late seventies to restore the Martin Gropius Bau. The building's position at a key juncture of the Berlin Wall and next to the ruins of the former SS headquarters has lent the building a particular political poignancy. At one time the center of contemporary art, the Gropius Bau currently hosts rotating exhibitions on a wide variety of themes from ancient art to today and has lost much of the vibrancy it was known for.
Selected solo exhibitions Dani Karavan, Hermann Nitsch

N.B.K.
Neuer Berliner Kunstverein
Chausseestrasse 128/129
Mon–Fri 12–6, Sat–Sun 2–6
Tel +49 30 280 7020
www.nbk.org
N.B.K. Neuer Berliner Kunstverein in Berlin's Mitte exhibits contemporary art with a focus on central and Eastern Europe. **Selected solo exhibitions** Matthias Weischer, Artur Mijewski, Ira Schneider, Via Lewandowsky

Neue Nationalgalerie
How to get there Set at the Kulturforum in former West Berlin, the Neue Nationalgalerie was placed directly facing the Wall and East Berlin as an overt statement of western values.
Postdamer Strasse 50
(U-Bahn Potsdamer Platz)
Tue–Sun 10–6, Thu–Sat 10–10
Tel +49 30 266 2951
www.neue-nationalgalerie.de
(German and English)
Exhibitions & Collections Established in 1861 with J. H. W. Wagener's gift of international art to the Prussian state. After 1867 the collection was exhibited in the Nationalgalerie on Museumsinsel and over the decades established significant holdings of Expressionism, Cubism, and other modernist movements. Devastated by National Socialist collection policies, the museum gradually began to re-establish significant holdings in the post-war era. In 1945 the museum became the Gallery of Twentieth Century Art and only in 1968 was a new building, which united the collections of the Alte Nationalgalerie and the Gallery of Twentieth Century Art, opened on the Kulturforum. Today, following restructuring in the wake of unification, the Neue Natio-

nalgalerie collection spans modern art from early modernism to the sixties. Exhibits, though, regularly feature contemporary artists and architects.

Building One of the most significant buildings by Mies van der Rohe, as well as a triumphal return to Germany for the former Bauhaus head, the Neue Nationalgalerie opened in 1968. Designed originally for Schweinfurt and rejected on cost grounds, Mies here shows the austerity and beauty associated with the best of the International Style.

Director General Director of State Museums Udo Kittelman 2008–

Selected solo exhibitions Jannis Kounellis, Jörg Immendorff, Ronald Bladen, Günther Uecker

One of the premier private collections of contemporary art in Germany, the **Sammlung Hoffmann** (Sophie-Gips Höfe, Aufgang C, Sophienstrasse 21, guided tours only, by appointment, Sat 11–4 ,Tel +49 30 2849 9120, www.sammlung-hoffmann.de) is the result of the energetic collecting activities of Erika and Rolf Hoffmann. Located since 1994 in a former factory space renovated by the Hoffmanns, the collection focuses on challenging new work as well as established figures such as Isa Genzken, A. R. Penck, and Frank Stella. Since her husband's death, Erika Hoffmann is the guiding force behind both the curating of yearly exhibits at the Sammlung and an engaged collection policy. The Hoffmanns were the driving force behind the aborted creation of a Kunsthalle Dresden to be designed by Frank Stella. Prior to relocating to Berlin, Rolf Hoffmann ran the clothing firm Van Laack based in Cologne.

Housed in a bunker from the Nazi era, the **Sammlung Boros** (Reinhardstrasse 20, tours by appointment on Saturdays and Sundays, www.sammlung-boros.de) displays selections from the extensive collection of Wuppertal-based advertising mogul Christian Boros. Especially strong in installation art with many works from Olafur Eliasson, Tobias Rehnberger, and Wolfgang Tillmans, the bunker's collections were installed with the assistance of many of the artists themselves as well as working in conjunction with the architectural firm Realarchitektur. The opening of the collection is emblematic of the worldwide trend, especially strong in Germany, of private collectors opening spaces to display their works. A stunning and rewarding art experience, the bunker used to host techno parties in the nineties as well as housing fruit from Cuba during the fifties.

In addition to the Hoffmann and Boros Collections, many private collectors have opened project spaces in Berlin over the last several years as well as many leading European collectors planning to open spaces in Berlin in the coming years. This profusion of private collections belies many of the problems encountered in German museums, especially in Berlin, with the demands of private collectors clashing with the expectations of museum professionals. While this bodes ill for the museums, it has allowed for a more diffuse and varied art system.

A project space run by Düsseldorf-based Axel Haubrok (**haubrokshows,** Sat 12–6, Strausberger Platz 19, Tel +49 39 806

19287, www.sammlung-haubrok.de), who opened on the DDR era Strausberger Platz in the heart of the Karl Marx Allee in 2007, has the most intriguing location although former photography professor Wilhelm Schürmann's **Schürmann Berlin** (Weydingerstrasse 10, Fri–Sat 4–7, www.schuermann-berlin.de) also boasts a unique space in the gallery area surrounding Rosa Luxembourg Platz.

Another collector to emerge is Munich-based Christiane zu Salm who opened the **About Change Collection** (Am Kupfergraben 10, Sat 11–4 by appointment, www.aboutchangecollection.com) of collage-based works in the new David Chipperfield-designed gallery building on Kupfergraben across from the Pergamonmuseum. This building contains selections from the collection of Berlin dealer Heiner Bastian who also was the driving force behind the construction of the spaces and was former curator of the Marx Collection at the Hamburger Bahnhof. Berlin-based property developer and former gallerist Reinhard Onnasch has also joined the list of collectors by opening **El Sourdog Hex** (Zimmerstrasse 77, Tue–Sat 11–6, Tel +49 0 20 60 9160, www.elsourdoghex.org) in 2007.
Skulpturenpark Berlin_Zentrum (Kommandantenstrasse & Alte Jakobstrasse, www.skulpturenpark.org) is an artist run collective started in 2006 that presents temporary exhibits.

A major collector of photography, Frenchman Arthur de Ganay has moved from Paris to a site overlooking the Spree in 2006 (Köpenicker Strasse 10A, by appointment, www.collectionarthurdeganay.com). In the forthcoming years the major collector Thomas Olbricht from Essen will open a large venue next to the KW Institute for Contemporary Art in

Auguststrasse to house his substantial contemporary collection. From Milan, Mariano Pichler will bring his collection, entitled **MICAMOCA**, to an industrial space in Wedding, an area that already features many artists' studios. And finally, Hanns-Peter Wiese from Munich is relocating his collection to a building on Rosa Luxemburg Platz to be designed by Roger Bundschuh.

Haus der Kulturen der Welt
John-Foster-Dulles-Allee 10
Tue–Sun 10–9
Tel +49 30 39 78 7175
www.hkw.de
In a building dubbed the "pregnant oyster," the Haus der Kulturen der Welt offers an engaging program of art events and exhibits geared to presenting cultures from outside Europe. This had led to exhibits centered on New York and the Middle East. The newly refurbished Congresshalle by Hugh Stubbins is a stunning vision of fifties' modernism, with its shell construction and gravity-defying structure (which did indeed succumb to gravity in 1980). The ideology of the construction of the Congresshalle by the US government and its strategic placement near the historic Reichstag is a fascinating story in its own right. This atmosphere adds a unique element to the current program devoted to world art and culture.
Chief curator Valerie Smith 2008–

Berlinische Galerie
Alte Jakobstrasse 124–128
Wed–Mon 10–6
Tel +49 30 78 90 2600
www.berlinischegalerie.de
The municipal art gallery of Berlin, the Berlinische Galerie was founded in 2004 and designed by Jörg Fricke at the site of a fifties' warehouse. While frequent exhibits of contemporary art merge with a

substantial modern art collection, a noted feature of the gallery is the courtyard art design of Fritz Balthaus.

Haus Am Waldsee
Argentinische Allee 30
Daily 11–6
tel +49 30 801 8935
www.hausamwaldsee.de
Opened in 1946 as an art venue, the Haus Am Waldsee presented exhibits by modernists during the fifties and sixties and became one of the foremost exhibit venues during the cold-war era. Located in a historic villa from the twenties, the institution is set in a leafy suburb on the outskirts of Berlin.
Selected solo exhibitions Via Lewandowsky, Olav-Christoph Jensen, Norbert Bisky

Temporäre Kunsthalle
Schlossplatz
Daily 11–6, Mon 11–10
Tel +49 30 4373 9121
www.kunsthalle-berlin.com
Opened in late October 2008, the Temporäre Kunsthalle lies in front of the former Palast der Republik that is currently being torn down to make way for the Schloss to be rebuilt. With a design by Adolf Krishanitz and an exterior by artist Gerwald Rockenschaub that references cloud imagery, the Kunsthalle will stay in place until 2010 and, as with many projects in Berlin, has been beset by controversy. The institution has scheduled several leading artists in one-person exhibitions and it will be interesting to note how the building integrates with the surrounding area, much of which remains a construction site.
Selected solo exhibitions Candace Breitz, Simon Starling

Deutsches Architektur Zentrum DAZ
Köpenicker Strasse 48–49

Tue–Fri 12–6, Sat–Sun 2–6
Tel +49 30 278 79928
www.daz.de
Deutsches Architektur Zentrum DAZ opened in 2005 as the exhibition space of the German Architects BDA and presents changing exhibits and programs on architecture and urban planning.

Announced in September 2008, a new private contemporary museum is to begin construction in 2010 in the Humboldthafen area near the Hamburger Bahnhof. The project is still in the formative stages of planning and the exact nature of the museum remains at this stage unresolved.

Berlin Art Areas

Mitte
Auguststrasse
The home to KW Institute of Contemporary Art as well as being one of the major centers of established Berlin galleries, Auguststrasse was one of the first locations to see substantial gallery activity in the nineties. While it has lost some of its luster, the area continues to host a thriving art scene.
Kochstrasse 60
Kochstrasse 60, now known as Rudi-Dutschke-Strasse (Checkpoint Charlie) This industrial building from the twenties housed a variety of manufacturing firms before conversion into art gallery spaces beginning in 2001.
Zimmerstrasse 90–91
This gallery complex is housed in an early twentieth-century building formerly housing a propaganda-publishing house and rumored to have a former Nazi torture facility in the basement. In 1996, the first gallery to move into the complex was Max Hetzler.
Lindenstrasse 34
Gallery complex opened in 2007 in a former Kaufhaus (German for department

store) from 1912 and features many top galleries.

Heidestrasse

www.heidestrasse-galleries.com

Located in the area surrounding the Hamburger Bahnhof, this busy area has seen many galleries open in the last several years led by the internationally renowned Haunch of Venison.

Halle am Wasser

www.halleamwasser.de

Standing behind the Hamburger Bahnhof, this gallery building opened in May 2008 and features several leading galleries.

Brunnenstrasse

(north from Rosenthaler Platz)

This gallery row has seen emerging and established galleries opening over the last several years since the first galleries moved here in 2004.

S-Bahn Bogen

www.holzmarktstrasse.com

Set in the spaces situated under the S-Bahn station Jannowitz Brücke on the Holzmarktstrasse, this has been the scene for several important galleries over the years. Currently the location is undergoing somewhat of a crisis as galleries enter and leave this rather isolated and difficult-to-access site.

Strausberger Platz and Karl Marx Allee

Built between 1951 and 1953, this historic example of East German architecture has begun to attract private collectors and galleries to join a burgeoning scene on the Karl Marx Allee itself.

Berlin Public art

Resources

www.bildhauerei-in-berlin.de/_html/_ katalog/chronologisch-Gegenwart.html

list of Berlin public sculpture with photos and address

www.sammlung.daimlerchrysler.com/ sculpt/potsdamerplatz/skulpt_index_ e.htm

list of works in Potsdamer Platz in collection of Daimler

Aachen

Aachen Events

August

Lange Nacht der Museen

Ludwig Forum für Internationale Kunst

How to get there The Ludwig Forum is set in the historic town of Aachen near the Dutch border and can be reached via bus lines 1, 11, 16, 21, 46, or 52 from the center of the town.

Jülicher Strasse 97–109

Tue–Fri 12–6, Thu 12–8, Sat–Sun 11–6

Tel +49 241 180 7104

www.ludwigforum.de

(in German only)

Exhibitions & Collections Based on the collection of Peter and Irene Ludwig, founders of museums from Budapest to Cologne, and focused on Pop Art, the Ludwig Forum has made its reputation with engaging exhibitions featuring young artists such as Erwin Wurm and Franz Gertsch as well as established figures like Chuck Close.

Building Set in a Bauhaus-style building from 1929, the Schirmfabrik Emil Brauer, built in 1928 by Josef Bachmann and renovated by the city of Aachen for the Sammlung Ludwig. Fritz Eller, an ar-

chitect based in Aachen, was in charge of the restoration of the building, which reopened in 1991.

Directors Harald Kunde –2008, Brigitte Franzen 2009–

Selected solo exhibitions Edwin Zwackman, Erwin Wurm, Matthias Hoch, Franz Gertsch

N.A.K.
Neuer Aachener Kunstverein
Passtrasse 29
Tue–Sun 2–6
Tel +49 241 50 3255
www.heimat.de/nak

N.A.K. is one of a string of fine Kunstvereins in North Rhine-Westphalia. The NAK offers diverse exhibits by a range of emerging artists.

Director Melanie Bono 2004–

Selected solo exhibitions Jonathan Monk, Rodney McMillan, Diego Hernandez, Sophie von Hellerman

Arnsberg

Kunstverein Arnsberg
Königstrasse 24
Wed–Fri 5:30–7pm, Sun 11–3
Tel +49 2931 21122
www.kunstverein-arnsberg.de

Near the city of Dortmund in North Rhine-Westphalia, the Kunstverein Arnsberg was founded in 1987 and is located on the historic Neumarkt.

Selected solo exhibitions Erwin Wurm, Karin Sander, Marko Lulic

Baden-Baden

Museum Frieder Burda
Lichtentaler Allee 8b
Tue–Sun 11–6
Tel +49 72 21 39 8980
www.museum-frieder-burda.de

Opened in 2004 to a design by Richard Meier, the Museum Frieder Burda is lo-

cated in the belle epoque center of Baden-Baden. The modern and contemporary collection of Frieder Burda is noted for its emphasis on German and Austrian art, particular marquee names such as Gerhard Richter and Sigmar Polke. Meier's modernist building retains many of the design elements known from his Frankfurt museum while also contrasting heavily with the neo-classical Kunsthalle that sits next to the Burda. In 2008 the Burda announced it will exhibit works from the collection of the Pompidou in Paris as part of an ongoing arrangement.

Director Klaus Gallwitz 2005–

Selected solo exhibition Sigmar Polke

Selected exhibitions *Die Sammlung Erich Marx in Baden Baden, Arnulf Raine—Gustave Doré*

Staatliche Kunsthalle Baden-Baden
Lichtaler Allee 8a
Tue–Sun 11–6, Wed 11–8
Tel +49 7221 30 0763
www.kunsthalle-baden-baden.de

The Staatliche Kunsthalle Baden-Baden was opened in a purpose-built structure in 1909 designed in a modernist manner by Hermann Billing and Willem Vittali. The Kunsthalle has established a name for itself since its turn to contemporary art in 1956. Within the landmark building, exhibits concentrate on cutting-edge contemporary work and form a counterpoint to its neighbor, the Museum Frieder Burda.

Director Karola Grässlin
Selected solo exhibitions Marlene Dumas, Dirk Skreber, Stephan Balkenhol

Bedburg Hau

Museum Schloss Moyland
Am Schloss 4
(accessible via bus 44 from either Kleve or Xanten railway stations)
April 1–Sept 30 Tue–Fri 11–6, Sat–Sun 10–6, Oct 1–March 31 Tue–Sun 11–5
Tel +49 28 249 5100
www.moyland.de
Museum Schloss Moyland is located in the rural countryside near the border with the Netherlands, and the medieval-era Schloss houses the largest collection of works by Joseph Beuys as well as the Beuys Archive. In addition to these assets, the Museum has selections of modern and contemporary art from the Van Der Grinten Collection.
Selected solo exhibitions Antoni Tàpies, Joseph Beuys, Markus Lüpertz

Bielefeld

Bielefeld Events
April
Bielefeld Nacht der Museen, Kirchen und Galerien

Kunsthalle Bielefeld
Artur–Ladebeck–Strasse 5
Tue–Fri, Wed 11–9, Sat 10–6, Sun 11–6
Tel +49 521 3299 9500
www.kunsthalle-bielefeld.de
Housing a modern and contemporary art collection, the Kunsthalle Bielefeld is located in a purpose-built construction designed by American modernist Philip Johnson in 1968 and is the architect's only European museum design. Since being renovated in 2002, the Kunsthalle's collection focuses on seventies' and eighties' works while the adjacent sculpture

park includes pieces by Olafur Eliasson, Thomas Schütte, and Richard Serra.
Director Thomas Kellein
Selected solo exhibitions George Condo, George Maciunas, Louise Bourgeois

Bochum

Situation Kunst
Nevelstrasse 29c im Parkgelände von Haus Weitmar
Wed 2–6, Fri 2–6, Sat–Sun 12–6
Tel +49 234 298 8901
www.situation-kunst.de
Situation Kunst (für Max Imdahl), Ruhr-Universität houses artworks by Dan Flavin, Maria Nordman, Richard Serra, Gottfried Graubner, amongst others and is dedicated to the founder of the Art Institute in Bochum, Max Imdahl. Opened in 1990 in buildings designed by Peter Forth, a new wing was inaugurated in 2006 and designed by Gido Hülsmann and Dirk Boländer. Other exhibits at the Situation Kunst feature artifacts from Asia and other historical objects which, together with the modern and contemporary works, form the basis for the Ruhr University art collections.

Bonn

Kunstmuseum Bonn
How to get there The Kunstmuseum Bonn is part of the Museumsmeile and sits next to the Kunst und Ausstellungshalle der BRD.
Friedrich-Ebert-Allee 2
Tue–Sun 11–6, Wed 11–9
Tel +49 228 77 6260
www.kunstmuseum.bonn.de
(German and English)
Exhibitions & Collections While stressing German art from the post-war era, the collection also includes large holdings of Rhenish Expressionism. Artists such as Hanne Darboven, Blinky Palermo, and

Anselm Kiefer are all represented. The regional prizewinner of the city of Bonn is shown regularly during the summer months. Also a regular feature of the museum is the well-regarded Videonale which began in 1984.

Building Opened in 1992, Axel Schultes's design for the Kunstmuseum Bonn emphasizes light and openness in its gleaming white spaces. Together with the Art & Exhibition Hall this is a powerful tandem of buildings signifying the commitment to culture in this former capital city.

Director Stephan Berg

Selected solo exhibitions Alex Largo, John Baldessari, Douglas Swan, Jean Tinguely

Kunst- und Ausstellungshalle der Bundesrepublik Deutschland

Friedrich-Ebert-Allee 4, Museumsmeile
Sun–Thu 9–7, Fri–Sat 9–10
Tel +49 228 917 1200
www.bundeskunsthalle.de

The Kunst- und Ausstellungshalle der BRD designed by Viennese architect Gustav Peichl as a multi-use facility that includes an exhibition hall, conference center, and music venue. Located next to the Kunstmuseum, the Art & Exhibition Hall hosts temporary exhibits on a variety of themes which recently included the Guggenheim traveling exhibition. The genesis of the Art & Exhibition hall dates to discussions in the immediate post-war period for a Kunsthalle to be created in Bonn. Eventually opened in 1992, the Art & Exhibition Hall exhibits many of the traits of the architecture of the former West Germany, including a trend towards the impersonal and bureaucratic.

Bonner Kunstverein

August-Macke-Platz
Hochstadenring 22
Tue–Sun 11–5, Thu 11–7
Tel +49 228 69 3936
www.bonner-kunstverein.de

Established in 1963, the Bonner Kunstverein opened in 1987 in a building designed by Hans-Rucker & Co. and has developed a reputation for the quality of its exhibition program.

Director Christina Vegh 2005–

Selected solo exhibitions John Baldessari, Julian Rosefeldt, Leiko Ikemura

Braunschweig (Brunswick)

Braunschweig Events

July
Braunschweiger Kulturnacht

Kunstverein Braunschweig

Haus Salve Hospes am Lessingplatz 12
Tue–Sun 11–5
Tel +49 53 14 9556
www.kunstverein-bs.de

An especially noteworthy Kunstverein, the Kunstverein Braunschweig is located since 1946 in the nineteenth-century Villa Salve Hospes in the Lessingsplatz. Recent exhibitions have featured artists such as Mark Wallinger and Georg Baselitz.

Artistic director Janneke de Vries 2006–

Selected solo exhibitions Mark Wallinger, Claire Barclay, Tobias Buche, Georg Baselitz

Bremen

Bremen Events

May/June
Lange Nacht der Bremer Museen
2009
Rolandpreis award

Kunsthalle Bremen

Am Wall 207
Tue 10–6, Wed–Sun 10–5
Tel +49 421 32 9080
www.kunsthalle-bremen.de

Run by the Bremen Kunstverein, the Kunsthalle Bremen holds an important collection of European modernism as well as Old Masters and a limited contemporary collection. Founded in 1823, the Kunstverein constructed the present building in 1849 and was extended in 1899 by Eduard Gildemeister. Recent additions in 1982 and 1998 have seen added space for shows by the likes of Yoko Ono and William Kentridge.
Director Wulf Herzogenrath 1994–

Weserburg
How to get there The Weserburg, formerly known as Neues Museum Weserburg, is sited on an island in the center of the Weser River.
Teerhof 20
Tue–Fri 10–6, Thu 10–9, Sat–Sun 11–6
Tel +49 421 59 8390
www.weserburg.org
(German and English)

Exhibitions & Collections The Weserburg opened in 1991 with the unique concept of presenting contemporary art through the lens of collectors. The focus on collectors and major artists such as Gerhard Richter, Georg Baselitz, and Donald Judd has enriched the quality of the art on offer and is a unique experiment in presenting contemporary work.
Building The Weserburg is located in the warehouses of a former coffee-roasting company.

Director Carsten Ahrens
Selected solo exhibitions
Jörg Immendorff, Thomas Demand & Georg Schneider

G.A.K.
Gesellschaft für Aktuelle Kunst
Teerhof 21
Tue–Sun 11–6, Thu 11–9
Tel +49 421 50 0897
www.gak-bremen.de
G.A.K.—Gesellschaft für Aktuelle Kunst is a Kunstverein located next to the Neues Museum Weserburg that shows international emerging artists as well as presenting lectures and other events.
Director Gabriele Mackert 2005–
Selected solo exhibitions Nikki S. Lee, Simon Lewis, Ana Torfs

Cologne

Before the fall of East Germany, Cologne was the major center for art in West Germany. With the subsequent rise of Berlin to a global art center, Cologne has seen its status fall with artists, galleries, and art professionals leaving in numbers for the capital. In spite of this, Cologne has retained a large number of prominent institutions with substantial collections and innovative exhibitions.

Cologne Resources
www.koeln-galerien.de
German and English
exhibition information
www.museenkoeln.de
German and English
museum information

Cologne Events
April
Art Cologne, International Fair for Modern & Contemporary Art;
Art Cologne Prize,
annual prize

Summer
Projekt Stommeln Synagogue,
annual exhibition
October
Art.Fair, Fair for 21st Century Art
November
Lange Nacht der Kölner Museen

Kölnischer Kunstverein

Kölnischer Kunstverein is located in the Brücke, constructed by Wilhelm Riphahn in 1949 for the British Council, where it regularly exhibits international artists as well as providing a platform for emerging artists through their visiting programs. The Kölnischer Kunstverein has a major reputation throughout Europe as one of the foremost Kunstvereins in Germany.

Directors Anja Nathan-Dorn & Kathrin Jentjens

Selected solo exhibitions Boris Sieverts, Sanja Ivekovic, Jutta Koether, Trisha Donnelly

Museum Ludwig

How to get there The Museum Ludwig sits next to the Cathedral in the center of Cologne.

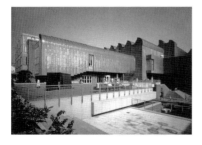

Am Dom/Hbf, Bischofsgartenstrasse 1
Tue–Sun 10–6, one Friday per month
10–10, closed during carnival
Tel +49 22 12 212 6165
www.museum-ludwig.de
(German and English)

Sites nearby Cologne Cathedral, Kolumba Museum

Exhibitions & Collections Founded in 1976 with the donation of the post-war art collection of Peter and Irene Ludwig as well as the Haubrich Collection of Expressionism. The collection is one of the strongest devoted to twentieth-century art in Germany and exhibitions are drawn from the collections as well as from international art figures.

Building Peter Busmann and Godfried Haberer's 1986 building was originally designed to house the Ludwig, Wallraf-Richartz-Museum, and the Philhamonie, although since 2001 the Wallraf-Richartz has vacated for new premises. This has left the Ludwig with one of the largest spaces in Europe to present modern and contemporary art. It is unfortunate, though, that the museum design seems dated and very much of its time.

Director Kaspar König 2000–, curator Barbara Engelbach 2004–

Selected solo exhibitions Corinna Schmidt, Georg Herold, Jeanne Faust

Cologne Cathedral

Domplatz
Daily 6–7:30
www.koelner-dom.de

One of the more interesting commissions of recent years, Gerhard Richter's window *Zufall* for Cologne Cathedral's south transept was installed in 2007 and the window, which replaces one destroyed during the Second World War, is based on the artist's seminal *4096 Colors* work from 1974. In this piece, Richter used a 64 by 64-square grid and a mathematical combination of three primary colors and gray. The window in Cologne echoes this in its 11,500 pixels and is a stunning addition to this most famous of German cathedrals. In another of Cologne's cathedrals, Sankt Andreas Kirche (Daily 8:30–6, Komödienstrasse 4–8, www.dominiker-

koeln.de), Markus Lüpertz designed the windows in the southern transept on themes of redemption and creation. The windows were inaugurated in 2005.

Artothek

Am Hof 50
Mon–Thu 1–7, Fri 10–5
Tel +49 2212 2332
www.museenkoeln.de

Located in a fifteenth-century house, Artothek is part of the Kölnisches Stadtmuseum and stands in the center of Cologne. Since its opening in 1973 Artothek has acted as a catalyst for arts in Cologne by offering adventuresome Cologne-based artists the chance to exhibit.
Selected solo exhibitions Maximilian Erbacher, David Simpson

European Kunsthalle

Tel +49 221 569 6140
www.eukunsthalle.com

European Kunsthalle is a venture originally organized by German curator Nicholas Schafhausen in 2005 that is currently only virtual but there are plans to open a physical site once a suitable location is found. In 2008 the Kunsthalle begins a temporary project at the Ebertplatz and discussions continue to give the Kunsthalle a permanent location.

Cottbus

Kunstmuseum Dieselkraftwerk Cottbus

Uferstrasse / Am Amtsteich 15
Tue–Sun 10–6, Thu 10–8
Tel +49 355 4949 4040
www.museum-dkw.de

In 2008 the Kunstmuseum Dieselkraft–werk Cottbus was opened in a former diesel electric power station from the twenties in the industrial city of Cottbus. Originally founded as the city museum in the seventies, the present institution

plans to engage with the wider European and international context with the presentation of contemporary art exhibits as well as presenting the permanent collection that focuses on landscape and artists from the former East Germany. The brick building was converted by Anderhalten Architekten and is a sensitive approach to what is a prime example of industrial expressionist architecture.

Darmstadt

Darmstadt Events

September
Lange Nacht der Museen

Hessisches Landesmuseum Darmstadt

Friedensplatz 1
Tue–Sat 10–5, Wed 10–8, Sun 11–5
Tel +49 61 5116 5703
www.hlmd.de

Featuring the collections of the Grand Duke of Hessen-Darmstadt, the Hessisches Landesmuseum Darmstadt was established in the nineteenth century and originally located in the Neues Schloss. Moved to a purpose-built structure designed by innovative Berlin architect Alfred Messel in 1906, the building suffered damage in the Second World War and was only re-opened in 1955. An extension opened in 1984 and is dedicated to art of the twentieth century and features the Pop Art collection of the Darmstadt industrialist Karl Ströher. Part of the Ströher extended loan was the Beuys Block, a seven-room installation created by the artist in 1970 and constantly reorganized by Beuys until his death in 1986. One of the most important examples of Beuys's work, this installation has degraded significantly due to its materials and lack of funding to maintain the piece. Its future remains uncertain but it is a strong statement by Beuys on the no-

tion of what is authentic in artwork and allows for a variety of readings.

Kunsthalle Darmstadt

Steubenplatz 1
Tue–Fri 11–6, Sat–Sun 11–5
Tel +49 61 51 89 1184
www.kunsthalle-darmstadt.de
Begun in the nineteenth century as an initiative of the local arts association, the Kunsthalle Darmstadt offers a program that is based on regional themes and is less adventurous than other German Kunsthalles. Having suffered major damage to its Secession-era structure, the new Kunsthalle opened in 1951 and has undergone further expansion in the eighties to increase its exhibition areas.

Institut Mathildenhöhe

Oberwaldhaus, from the Hauptbahnhof F-bus direction Oberwaldhaus
Tue–Sun 10–6, Thu 10–9
Tel + 49 61 51 13 3738
www.mathildenhoehe.info
Set in a Jugendstil-era art colony, the Joseph Maria Olbrich-designed Institut Mathildenhöhe was opened in 1908 and restored to its present condition in 1974–76. The exhibition hall hosts temporary exhibits and regularly features contemporary artists.
Selected solo exhibitions Henk Visch, Janet Cardiff & George Bures Miller, Andreas Gursky

Dortmund

Dortmund Events

September
DEW21 Museumsnacht

Museum am Ostwall

Ostwall 7
Tue–Fri, Sun 10–5, Thu 10–8, Sat 12–5
Tel +49 231 502 3247
www.museumamostwall.dortmund.de

Museum am Ostwall is located in the industrial city of Dortmund in the heart of the Ruhrgebiet. The Museum am Ostwall was opened in 1952 and offers regional contemporary art while the collection is particularly strong in Fluxus artists.
Selected solo exhibitions Ilya & Emilia Kabakov, Adrian Paci

Hartware MedienKunstVerein

Phoenix Halle, Hochofenstrasse, Dortmund-Horde
Thu–Fri 11–10, Sat–Sun 11–8
Tel +49 231 82 3106
www.hmkv.de
Hartware MedienKunstVerein was founded in 1996 by the curatorial team Iris Dressler and Hans D. Christ and has developed a reputation for its work with experimental media art.
Director Inke Arns 2005–
Selected solo exhibition Thomas Köner

Dresden

Dresden Resources

www.dresden.de/museen
German and English information on museums

Dresden Events

July
Museums-Sommernacht Dresden
2009
Albertinum re-opens

Kunsthaus Dresden

Rähnitzgasse 8
Tue–Fri 2–7, Sat–Sun 12–8
Tel +49 351 804 1456
www.kunsthausdresden.de
Set in a building from 1730, the state-controlled Kunsthaus Dresden has its origins in the 1984–90 DDR Center for Art Exhibitions. Undergoing a fundamental change after unification, the Kunsthaus

Dresden came into its present form only in 1997 with the Galerie Rähnitzgasse merging into the new organization. Exhibitions on contemporary art with mainly thematic exhibits are presented.

Albertinum
Brühlsche Terrasse
Tel +49 351 49 14 2000
www.skd-dresden.de

Closed for restoration in 2006 and due to re-open in 2009, the Albertinum is the home to the Gerhard Richter Archive, which was donated by the artist to his hometown in 2005. With forty works in the collection this is one of the largest permanent installations of his work in the world. The Albertinum was constructed in the sixteenth century as a royal armory and underwent significant additions in a high renaissance style by Karl Adolf Canzler in the eighteenth century. Composed of the extremely rich Saxon Sculpture Collection, in the early twentieth century the building was named in honor of King Albert of Saxony. While damaged significantly in the Second World War, the Albertinum was quickly rebuilt to serve as an exhibition venue.

Duisburg

Duisburg Events
2010
MMK Museum Küppersmühle für Moderne Kunst extension, Herzog + de Meuron architects
2011
Wilhelm Lehmbruck Preis award

MMK
Museum Küppersmühle für Moderne Kunst
How to get there Set in the inner harbor of Duisburg, the Küppersmühle is reachable via bus 934 to Hansegracht.
Philosophenweg 55

Tel +49 203 3019 4811
Wed 2–6, Thu 11–6, Sat–Sun 11–6
www.museum-kueppersmuehle.de
(German and English)

Exhibitions & Collections Originally renovated in 1999 to house the collection of real estate magnate Hans Grothe, the MMK now houses the New Ströher Collection, which includes work by Hanne Darboven, Anselm Kiefer, and Imi Knoebel. The ethical issues surrounding the withdrawal of the Grothe Collection and its subsequent sale at auction raises serious issues for museums in general and their arrangements with private collectors. Currently the museum is run from the Bonn-based Stiftung für Kunst und Kultur.

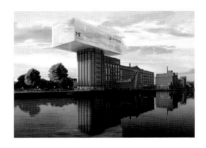

Building Built in 1908–16 the warehouse is part of the historic inner harbor being renovated to a master plan by Norman Foster. The Herzog + de Meuron MMK renovation has much in common with their work for London's Tate Modern and retains many elements of the historic structure. In 2009 the museum will begin work on an extension by Herzog + de Meuron that will house the collections of Sylvia and Ulrich Ströher.

Director Walter Smerling (also Chairman Stiftung für Kunst und Kultur Bonn)

Selected solo exhibitions Jörg Immendorff, Bernar Venet, Peter Brüning, Stephan Balkenhol

Wilhelm Lehmbruck Museum

Friedrich-Wilhelm-Strasse 40
Tue–Fri 11–5, Sat 10–6
Tel +49 203 282 2630
www.lehmbruckmuseum.de

Originally the Duisburg Museum of Art established in 1934, the Wilhelm Lehmbruck Museum features one of the most significant collections of modern and contemporary sculpture in Germany. In 1954 the museum secured the works of modernist Wilhelm Lehmbruck and in 1964 a purpose built museum was opened constructed by Manfred Lehmbruck in Kant Park and re-christened the Wilhelm Lehmbruck Museum. A 1987 extension and a sculpture park were added to the modernist design of Lehmbruck. Contemporary sculpture includes work by Mario Merz, Nam June Paik, and A. R. Penck.
Selected solo exhibition Rachel Whiteread

Düsseldorf

Düsseldorf has been the scene of many singular events of recent German contemporary art history. The central role that the Kunstakademie plays in the arts is key, as this fosters a unique atmosphere which is further augmented by leading institutions and a commitment to showing challenging work. The legacy of Joseph Beuys and his tenure at the Kunstakademie is an engagement with German history and the role of Germany in the wider European context.

Düsseldorf Resources
www.artcity-duesseldorf.de
German-language online guide, organizes Quadriennale

Düsseldorf Events
May
Nacht der Museen Düsseldorf

November
Düsseldorf Kunstpreis, awarded annually
2010
Quadriennale 10 (Fall 2010 at venues throughout Düsseldorf)

Kunsthalle Düsseldorf
Grabbeplatz 4
Tue–Sat 12–7, Sun 11–6
Tel +49 211 899 0243
www.kunsthalle-duesseldorf.de

Since its inception in 1967 the Kunsthalle Düsseldorf has been located on the Grabbeplatz in Konrad Beckmann's concrete brutalist building. The exhibition brief of the Kunsthalle has been to present challenging contemporary art and has featured exhibits by Dan Graham, Hans Rogalla, and Allen Ruppersberg.
Director Ulrike Gross 2002–

K20 & K21
Kunstsammlung Nordrhein Westfalen
How to get there Housed in two separate buildings, K20 is located near the old town center while K21 is sited in an isolated position although accessible via tram (lines 703, 706, 712, 713, and 715). K20 is closed for restoration until autumn 2009.
K20 Grabbeplatz 5
K21 Ständehausstrasse 1
Tue–Fri 10–6, Sat–Sun 11–6
first Wed of month 10–10
K20 Tel +49 211 838 1130
K21 Tel +49 211 838 1600
www.kunstsammlung.de
(German and English)

Exhibitions & Collections The Kunstsammlung NRW was established in 1961 as a private foundation with a large donation of the works of Paul Klee. For the next several decades the museum slowly built a major collection with an emphasis on twentieth-century painting. The holdings were bolstered by Düsseldorf's

pre-eminent role in West German art education, with the Düsseldorf Academy's Joseph Beuys a strong part of the museum's collection. In 2002 the K21, devoted to post-1980 art, was opened and has featured exhibits by Rebecca Horn, Martin Kippenberger, and Juan Muñoz.

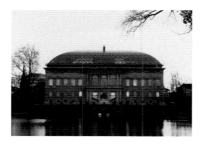

Building Originally housed in a rococo palace, the Schloss Jägerhoff, the Kunstsammlung only moved to a purpose-built museum building in 1986. This building was designed by the Danish architects Hans Dissing and Otto Weitling as an unwelcoming structure of polished black rock although with an inside that opened up onto white rooms designed to fit the modernist works of the Kunstsammlung. In 2002 K21 was opened in the historic Ständehaus, built by Julius Raschdorff in 1876–80 to house the Nord Rhein-Westfalen Parliament. This Neo-renaissance structure was vacated in 1988 and Uwe Kiessler was engaged to renovate the structure. K21 has a stunning steel and glass dome that covers the Ständehaus's large exhibition rooms that also encompass wall and ceiling paintings by Jorge Pardo.
Directors Director Marion Ackermann 2009–, artistic director K21 Julian Heynen 2001–, curator K21 Doris Krystof 2001–
K21 Selected solo exhibitions Joe Scanlan, Gregor Schneider, Juan Muñoz, Martin Kippenberger

K22 Selected solo exhibitions Hiroshi Sugimoto, Francis Bacon

Kunstverein für die Rheinlande und Westfalen
Grabbeplatz 4
Tue–Sat 12–7,
Sun 11–6
Tel +49 211 32 7023
www.kunstverein-duesseldorf.de
The Kunstverein für die Rheinlande und Westfalen in addition to being one of the oldest art associations in Germany is also a major supporter of emerging contemporary art. Housed in a 1967 Konrad Beckmann brutalist building that also houses the Kunsthalle Düsseldorf, on the Grabbeplatz across from the Kunstsammlung, the Kunstverein offers an engagement with current trends in the arts.
Director Vanessa Joan Müller 2006–
Selected solo exhibitions Blinky Palermo, Gerald Byrne, Teresa Margolles, Guillaume Leblon

Museum Kunst Palast
Ehrenhof 4–5
Tue–Sun 11–6
Tel +49 211 892 4242
www.museum-kunst-palast.de
Opened in 2001, Museum Kunst Palast is located in the Ehrenhof, a monumental part of the cultural center of Düsseldorf developed by Wilhelm Kreis in 1929 and since renovated by Oswald Mathias Ungers. Exhibiting a wide range of art from the Düsseldorf City art collection, the Museum Kunst Palast was originally part of the Kunstmuseum and has endured many changes to its location and exhibition brief. The Museum Kunst Palast collects primarily German post-war artists such as Bernd and Hilla Becher, Thomas Schütte, and Gerhard Richter and also presents exhibits devoted to contemporary art. In recent times, the museum has seen its reputation hurt due

to allegations it let private sponsors influence the museum's programming.

NRW–Forum Kultur und Wirtschaft
Ehrenhof 2
Tue–Sun 11–8
Tel +49 211 892 6690
www.nrw-forum.de
NRW–Forum Kultur und Wirtschaft is located in the same complex as the Museum Kunst Palast and offers temporary exhibits on a wide variety of contemporary themes with an emphasis on the union of art and media.
Selected solo exhibitions Philip Treacy, Bruce Connor, Bruce Nauman

Julia Stoschek Collection
Schanzenstrasse 54
Sat 11–4
Tel +49 211 585 8840
www.julia-stoschek-collection.net
Since it was founded in 2007, the Julia Stoschek Collection has been located in a former nineteenth-century frame factory building renovated by Kühn Malvezzi. The accent here is on media art, with Doug Aitken, Monica Bonvicini, and Olafur Eliasson part of the extensive private collection.

KIT
Kunst im Tunnel
Mannesmannufer 1b
Tue–Sat 12–7
Tel +49 211 899 6256
www.kunst-im-tunnel.de
KIT, Kunst im Tunnel lies beneath the promenade of the Rhine Embankment in an unused tunnel and opened in 2007 to present mainly group exhibitions by Germany-based artists.

KAI10, Raum für Kunst
Kaistrasse 10, im Medienhafen
Tel +49 211 99 434 130
www.kaistrasse10.de

KAI10, Raum für Kunst is home to the Arthena Foundation since 2008 and is set in the Rhine Harbor that has been under redevelopment as the Medienhafen.

Eberdingen-Nussdorf

Sammlung Klein
Siemensstrasse 40
Wed & Sun 11–4
Tel +49 7042 376 9566
www.sammlung-klein.de
Opened in 2007, the Sammlung Alison und Peter W. Klein features contemporary work as well as aboriginal art in this location near Stuttgart. Contemporary works from Sigmar Polke, Jane Hammond, and Li Luming are a feature of the collection of Klein, a former partner in Berlin gallery Spesshardt & Klein.

Essen

Essen Events
2010
Museum Folkwang extension opens, architect David Chipperfield
2010
Essen (Ruhr) European Capital of Culture

Museum Folkwang
Kahrstrasse 16
Tue–Sun 10–6, Fri 10–9
Tel +49 201 88 45 301
www.museum-folkwang.de
Museum Folkwang was created in 1902 in the city of Hagen by noted curator and early proponent of modernism Karl Ernst Osthaus. Following the death of Osthaus the museum moved to the city of Essen in 1922 and has remained one of the leading venues for modernism, in spite of the collection being decimated by the Nazis' degenerate art policy. Located since 1956–60 in a building by Kreutzberger Hoesterey and Loy, the museum

is undergoing an expansion by David Chipperfield to open in 2010. While the emphasis of the museum is modernism, frequent exhibitions engage with the contemporary and, until the new museum opening, rotating exhibits only will be presented at the site.

Selected solo exhibitions Simon Starling, Takashi Murakami, Darren Almond,

Kokerei Zollverein Essen

Arendahls Wiese,
entrance Mischanlage
Tue–Sun 10–8
Tel +49 201 279 8330
www.zollverein.de

The large industrial colliery in the north of Essen provides the site for the Kokerei Zollverein Essen built in 1958–61 and which is undergoing conversion to a cultural landmark with planning and design by Rem Koolhaas/OMA. Since closure in 1993, the complex has been designated as a UNESCO World Heritage Site. The coking plant is now home to art installations and exhibits, such as Ilya Kabakov's installation in the former salt house, Maria Nordman's installation at Zollverein Shaft XII Kesselachebunker, and Ulrich Rückriem's installation of twenty-four blocks in the plant grounds. In addition to installations, the Red Dot Design Museum (Tue–Thu 11–6, Fri–Sun 11–8, Gelsenkirchenstrasse 181, tel +49 201 30 1040) was designed in 1997 by Norman Foster in the former boiler house and houses a unique design collection.

Essen-Altenessen

Located on top of coal deposits and mining debris from the surrounding industrial area of the Ruhr, Richard Serra's *Bramme for the Ruhr District* (Nordsternstrasse, directions at www.uni-essen.de/~gpo202/land/schuren.htm) was installed in 1998. Known as the Schuren-bachhalde the mound has views of the area and can be visited via steps that lead to Serra's rolled-steel minimalist sculpture. This is one of the more impressive sites for Serra's work.

Esslingen am Neckar

Esslingen Events
2010
8th International Photo Triennial

Villa Merkel
Pulwerwiesen 25
Tue 11–8, Wed–Sun 11–6
Tel +49 711 3512 2640
www.villa-merkel.de

Villa Merkel, Galerie der Stadt Esslingen was built in 1873 for industrialist Oskar Merkel and is home to the municipal gallery that features exhibits by regional artists.

Fellbach

Fellbach Events
2010
11th Triennale Kleinplastik 2010 (June 2010–)

Frankfurt

A major world financial center, Frankfurt has the feel of an international city sometimes known as Bankfurt that is belied by its wealth of cutting-edge institutions and museums. During the eighties the city instituted a project on the Museumsufer on the bank of the River Main to make Frankfurt the capital of German museums and to that end invited world-renowned architects to design landmark buildings. To some extent, the bloom has gone off the rose, but Frankfurt remains a major contemporary art center that houses more cutting-edge institutions that almost any city in Germany.

Frankfurt Resources
www.frankfurt-gallerien.de

Frankfurt Events
April
Nacht der Museen
2011
Das Städel extension, architects
Schneider + Schumacher

Museum für Moderne Kunst MMK
How to get there In the center of Frankfurt, the MMK can be reached via U4 or U5 U-Bahn (Römer stop).
Domstrasse
Tue–Sun 10–5, Wed 10–8
Tel +49 69 21 23 0447
www.mmk-frankfurt.de
(German and English)
Exhibitions & Collections Art since 1945 forms the core of the collection, which is based on the Ströher Collection donated to the museum in the eighties. Particularly strong in Pop Art and German post-war art with works by Andy Warhol, Roy Lichtenstein, Joseph Beuys, and Jasper Johns.

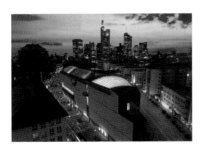

Building Designed by innovative Austrian architect Hans Hollein, the unique triangular-shaped building is a prime example of Hollein's post-modern sensibilities. Sharing design similarities with the architect's museum in Mönchengladbach, the MMK was opened in 1993.
Directors Susanne Gaensheimer 2008, Udo Kittelmann 2002–08

Selected solo exhibitions Taryn Simon, Maurizio Catellan

Deutsches Architekturmuseum
Schaumainkai 43
Tue–Sun 11–6, Wed 11–8
Tel +49 69 2123 6313
www.dam.inm.de
Deutsches Architekturmuseum designed by Oswald Mathias Ungers in 1984 as part of the Museumsufer project of the city of Frankfurt. Renovating an existing nineteenth-century mansion, Ungers courted controversy by creating a house within a house. While exhibitions have become more challenging, the DAM has undergone difficult times including discussions to bring the institution to Berlin in 2001.

Frankfurter Kunstverein
Markt 44
Tue–Sun 11–7
Tel +49 69 219 3140
www.fkv.de
The Frankfurter Kunstverein is committed to exhibiting challenging contemporary art in the historic Steinernes Haus. Established in 1829 this municipal art association offers a platform for emerging art near the reconstructed Römer district. The Kunstverein has maintained a position as one of the most vibrant of contemporary art centers.
Director Chus Martinez 2006–08
Selected solo exhibitions Gardar Eide Einarsson, Arturas Raila

Schirn Kunsthalle
How to get there In the heart of downtown Frankfurt, Schirn Kunsthalle is reachable via tram 11 or 12 from the Hauptbahnhof to Römerberg.
Tue, Fri–Sun 10–7, Wed–Thu 10–10
Tel +49 69 299 8820
www.schirn-kunsthalle.de
(German and English)

Exhibitions & Collections The Schirn exhibits a wide range of work, from art-historically themed exhibits to cutting-edge exhibitions of contemporary art. It is known in particular for presenting in-depth looks at modern and contemporary artists. Over the last several years it has been engaged in repairing its image following the theft of two works by Turner and one by Caspar David Friedrich during an exhibition in 1994.

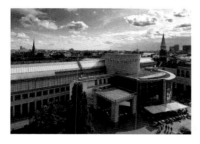

Building Opened in 1986, the Schirn is housed in what was, until the Second World War, Schirn Street. This area was not rehabilitated until the eighties and the Schirn was part of the larger cultural project that Frankfurt undertook to make it the capital of German museums. The architecture by Bangert, Jansen, Scholz, and Schultes, although functional, has difficulty in matching other efforts in the city that create vibrant influential architectural statements.
Director Max Hollein 2001–
Selected solo exhibitions Eva Grubinger, John Bock, A. R. Penck, Bazon Brock, Jan de Cock

Das Städel
Schaumainkai 63
(U1, U2, U3 to Schweizer Platz)
Tue–Sun 10–6, Wed–Thu 10–9
Tel +49 69 60 509 8200
www.staedelmuseum.de
Frankfurt's main art museum, Das Städel

exhibits and collects work from the early renaissance to contemporary art. While contemporary work is not their focus exhibits are regularly held by artists such as William Kentridge and Martin Kippenberger. Selections from the collection by Gerhard Richter, A. R. Penck, and Blinky Palermo are regularly on view in the wing designed for twentieth-century art by Gustav Peichl. The museum was founded in the early nineteenth century with the donation of Johann Friedrich Städel to the city of Frankfurt and thereafter went through many changes including the destruction of the 1878 building in the Second World War. Reopened in 1963, Das Städel anchors Frankfurt's nineties' Museumsufer project on the bank of the Main and will add an extension for contemporary work set to open in 2011 and which will feature works on permanent loan from the Deutsche Bank art collection.
Director Max Hollein 2006–
Selected solo exhibitions Martin Kippenberger, William Kentridge

Kunsthalle Portikus
Alte Brücke 2 Maininsel
Tue–Sun 11–6, Wed 11–8
Tel +49 69 96 24 4540
www.portikus.de
Kunsthalle Portikus opened in 1987 in a building behind a portico from the destroyed public library. The Portikus presents international contemporary art as well as being associated with the well-regarded Städelschule art academy. With the original building by Marie-Theres Deutsch and Klaus Dreissigacker and with a temporary home from 2003 to 2006 in spaces designed by Tobias Rehberger, the Kunsthalle developed a reputation for its programming and vision. A new building opened in 2006 to a design by Christoph Mäckler on an island in the River Main and has immediately gar-

nered praise for its integration of medieval Frankfurt and the modern institution. As part of the new institution Olafur Eliasson has created a light installation in the glass roof.
Director Daniel Birnbaum
Selected solo exhibitions Ben van Berkel, Maurizio Catellan, Paul Chan, Francis Alÿs, Dan Perjovschi

Freiburg im Breisgau

Freiburg Events
June
Fest der Innenhöfe und Museumsnächte

Museum für Neue Kunst
Marienstrasse 10a
Tue–Sun 10–5
Tel +49 761 201 2581
www.museen.freiburg.de
Museum für Neue Kunst is a city-run museum opened in 1985 in an early-twentieth-century girls' school with exhibits that focus on historical art and with a modest collection of contemporary work.

Gera

Gera Events
May
Geraer Museumsnacht

Kunstsammlung Gera
Küchengartenallee 4
Tue 1–8, Wed–Fri 10–5, Sat–Sun 10–6
Tel +49 365 832 2147
www.kunstsammlung-gera.de
Set in a Baroque orangery, the Kunstsammlung Gera is well-known for its collection of expressionist Otto Dix while also housing art from the Middle Ages to contemporary. Since 1972 the Kunstsammlung has been to host to the collection and has recently begun focusing on contemporary-themed temporary exhibits.
Selected solo exhibitions Rosa Loy

Goslar

Goslar Events
Kaiserring
annual award presented by city of Goslar

Mönchehaus
Museum für Moderne Kunst
Mönchestrasse 1
Tue–Sun 10–5
Tel +49 53 212 9570
www.moenchehaus.de
In the heart of Lower Saxony, Goslar is home to the prestigious Kaiserring award, which is presented at the Mönchehaus Museum für Moderne Kunst. The Museum was created at the end of the seventies and is located in a sixteenth-century monk's house. This unique setting for contemporary art is in contrast to the clean white cubes so prevalent in today's museums. Permanent installations by former Kaiserring recipients Anselm Kiefer, Günther Uecker, and Rebecca Horn are located on the premises. In addition, in other areas of Goslar can be found works by Richard Serra, Max Bill, and Dani Karavan, although these works are not well maintained and are defaced with graffiti as well as showing signs of age. Maps obtainable at the museum.
Selected solo exhibition
Matthew Barney

Hamburg

Hamburg Resources
www.galerien-in-hamburg.de
German-language exhibition information
Kunst in Hamburg
bi-monthly German-language free publication

Hamburg Events
May
Lange Nacht der Museen

2011
5th Triennale der Photographie

Deichtorhallen
How to get there In the center of Hamburg, the Deichtorhallen can be reached via U1 to Steintrasse stop.
Deichtorstrasse 2
Tel +49 40 32 1030
Tue–Sun 11–6
www.deichtorhallen.de
(German and English)

Exhibitions & Collections The Deichtorhallen is one of the most vibrant exhibition venues for contemporary art in Germany. Since its inception in 1989 with an exhibition curated by the renowned Harald Szeemann, the Deichtorhallen has presented challenging one-person exhibits by artists such as Jason Rhoades, Elizabeth Peyton, and Jonathan Meese. The recently opened Haus der Photographie houses the F. C. Gundlach Collection as well as the *Der Spiegel* collection of photography and presents both themed and one-artist exhibits.

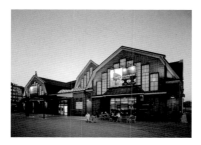

Building The former market halls were opened to the public in 1989 after being donated by the Körber Foundation and renovated by Josef P. Kleihues.
Director Robert Fleck 2004–08
Selected solo exhibitions Erwin Wurm, Hans Haacke, Jonathan Meese, Michel Majerus, Peter Fischli & David Weiss, Stephan Balkenhol

Hamburger Kunsthalle
How to get there Located in the center of Hamburg, a block away from the Hauptbahnhof.
Glockengiesserwall
Tue–Sun 10–6,
Thu 10–9
Tel +49 40 428 13 1200
www.hamburger-kunsthalle.de
(German and English)

Exhibitions & Collections Opened in 1869 and one of the foremost collections of art in Germany, the Hamburger Kunsthalle is divided into two separate institutions, one focused on art before Pop, the other one on contemporary work. The contemporary section encompasses a wide range of work and features site-specific works created for the Kunsthalle by Ilya Kabakov, Jannis Kounellis, Richard Serra, and others.
Building The original Hamburger Kunsthalle building from 1919 is a landmark of museum design in Germany and is joined to the contemporary wing by a plaza. The new building by Oswald Mathias Ungers opened in 1997 and, with its simplicity of design, is a major contrast to the existing Kunsthalle.
Director Hubertus Gassner, director Galerie der Gegenwart: Sabrina van der Ley 2008–
Selected solo exhibitions Sigmar Polke, David Hockney, Daniel Richter, Thomas Demand

Kunsthaus Hamburg

Klosterwall 15

Tue–Sun 11–6

Tel +49 40 33 5803

www.kunsthaushamburg.de

Part of the Hamburg art mile, Kunsthaus Hamburg is located since 1993 next to the Kunstverein in the old market hall on the Klosterwall. Founded in 1962, the Kunsthaus Hamburg has six to eight temporary exhibits per year.

Director Claus Mewes

Selected solo exhibitions Candida Höfer, Daniel Richter, Roman Signer

Kunstverein in Hamburg

Klosterwall 23

Tue–Sun 11–6, Thu 11–9

Tel +49 40 33 8344

www.kunstverein.de

Kunstverein in Hamburg, established in 1817, has long been one of the leading Kunstvereins in Germany. Engaged with the most vital contemporary art, the Kunstverein forms part of the Hamburg museum mile which includes the Kunsthaus and the Deichtorhallen.

Director Florian Waldvogel 2008–

Selected solo exhibitions Darren Almond, Gunther Förg, Cerith Wyn Evans, Tatiana Trouvé,

Dieter Roth Museum

Abteistrasse 57

open by appointment

Tel +49 40 41 9990

www.dieter-roth-museum.de

Dedicated to the Swiss artist Dieter Roth, this is a private museum housing Roth's archive. Roth (1930–1988) was a major figure in the post-war period and is noted for his concern with time and decay in work in a wide variety of media. The museum was started by Roth himself, working in conjunction with the private collector Philipp Buse.

Hamburg-Harburg

Sammlung Falckenberg

Wilstorfer Strasse 71, Tor 2

by appointment only on Saturdays

Tel +49 40 3250 6762

www.sammlung-falckenberg.de

Sammlung Falckenberg, Phoenix Kulturstiftung features the private collection of Harald Falckenberg who has assembled one of the most important of contemporary collections in private hands in Germany. Opened in 2001 in a former factory hall of the Phoenix Works in the industrial Harburg area, the spaces were recently extended by architect Roger Bundschuh to now house five floors of exhibition space. The collection includes works by Franz Ackermann, Mike Kelley, and Martin Kippenberger, amongst others.

Hanover

Hanover Resources

www.kunstplan-hannover.de

German-language exhibition information

Hanover Events

June

Nacht der Museen

Sprengel Museum

How to get there A 20-minute walk from the Hauptbahnhof or via bus 131.

Kurt-Schwitters-Platz

Tue 10–8, Wed–Sun 10–6

Tel +49 511 1684 3875

www.sprengel-museum.de

(in German only)

Exhibitions & Collections The core of the collection is from the 1969 donation of Dr. Bernhard Sprengel who also endowed the museum. Mainly featuring European Modernism with an especially rich selection from Kurt Schwitters and El Lissitzky, the collection also includes

important pieces from the late sixties on, including works from Sol LeWitt, Bruce Nauman, and Georg Baselitz.

Building The city of Hanover operates this museum which was opened in 1979 to a design by Peter and Ursula Trint. The seventies design is of its time with corners, angles, and oblique spaces creating a virtual art maze. An extension was opened in 1992 to update the museum's facilities.
Director Curator photography & media art Inka Schube 2001–

Kestner Gesellschaft
Goseriede 11
Tue–Sun 10–7, Thu 10–9
Tel +49 511 70 1200
www.kestner.org

An impressive melding of Jugendstil design and contemporary form, the Kestner Gesellschaft is located since 1997 in a former swimming pool hall from the early twentieth century. The Kunstverein has established itself as a leading center for international contemporary art exhibits. Kai-Michael Koch, Anne Panse, and Christian Hühn renovated the structure and made it suitable for contemporary work and the energetic leadership of the center has continued to give focus to what is a well-curated program.
Director Veit Görner 2003–
Selected solo exhibitions Bettina Rheims, Eric Fischl, Bruce Nauman, Tim Walker, Wang Du, Raymond Pettibon

Kunstverein Hannover
Sophienstrasse 2
Tue–Sat 12–7, Sun 11–7
Tel +49 511 32 4594
www.kunstverein-hannover.de

One of the largest of German Kunstvereins with over 1200 members, the Kunstverein Hannover was founded in 1832 and has been located in the Künstlerhaus since 1856. Exhibits here are international in focus.
Director René Zechlin
Selected solo exhibitions Aernout Mik, Mark Manders, Julie Mehretu, John M. Armleder

Heilbronn

Kunstverein Heilbronn
Allee 28
Tue–Sun 1–5, Thu 1–8
Tel +49 71 318 3970
www.kunstverein-heilbronn.de

Kunstverein Heilbronn was founded in 1879 and is a lively center for the arts in Baden-Württemberg.
Artistic director Matthia Löbke
Selected solo exhibitions Thomas Locher, Gert und Uwe Tobias, Marko Lulic

Herford

MARTa Herford
How to get there Herford is located in the center of North Rhine-Westphalia, MARTa is 2-1/2 hours from Berlin and 2 hours from Düsseldorf via train and then 5 minutes from the Herford train station.
Goebenstrasse 4–10
Tue–Sun 11–6, first Wed of month 11–9
Tel +49 52 21 994 4300
www.marta-herford.de
(German and English)

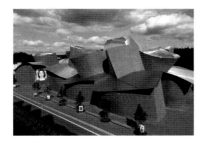

Exhibitions & Collections Currently building a collection, MARTa emphasizes the dialogue between art and design in intriguing exhibitions of international contemporary art. The Gehry-designed spaces lend themselves to design and installation-based work that further informs the collection policy. Since opening, though, issues have developed with funding an extended exhibition strategy as well as with collection building.

Building Designed by Frank Gehry and opened in 2005, MARTa continues Gehry's investigation of organic form and space and is quite reminiscent of similar solutions found in his design for Guggenheim Bilbao. The isolated location of the city of Herford is a constant challenge to the institution.

Director Jan Hoet founding director 2005–08

Selected solo exhibitions Andreas Hofer, Max Bill

Karlsruhe

Karlsruhe Resources

www.spektrum-karlsruhe.de
German-language exhibition information

Karlsruhe Events

March
Art Karlsruhe Internationale Messe für Klassische Moderne und Gegenwartskunst (art fair)

August
Karlsruher Museumsnacht

ZKM
Zentrum für Kunst und
Medientechnologie Karlsruhe
How to get there Situated in the center of Karlsruhe at Lorenzstrasse 19.
Wed–Fri 10–6, Sat–Sun 11–6
Tel +49 721 8100 1200
www.zkm.de
(German and English)

Exhibitions & Collections Composed of two separate institutions, the Museum für Neue Kunst and the Medienmuseum, the ZKM's split identity causes some confusion as well as with its stated role as a "digital Bauhaus." Both institutions have their own physical space but struggle within the overall structure to create and forge their own identity. These limitations aside, the ZKM's Peter Weibel has forged a center for media art that is respected in the international context.

Building The IWKA industrial building designed by Philip Jakob Manz in 1914 was the planned site of the ZKM's origi-

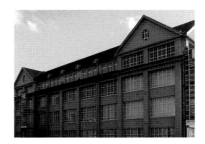

nal conversion to be undertaken by Rem Koolhaas. Koolhaas's design was innovative and is still the object of discussion in the architectural press. Unfortunately, due to political and budget considerations this plan was shelved and a design by Peter Schweger & Partner was implemented in 1997.

Director Peter Weibel 1999–, head Museum für Neue Kunst Gregor Jansen ZKM 2005–
Selected solo exhibitions Michael Kunze, Paul Thek

Badischer Kunstverein
Waldstrasse 3
Tue–Fri 11–7,
Sat–Sun 11–5
Tel +49 7212 8226
www.badischer-kunstverein.de
Badischer Kunstverein, Baden Art Association, was founded in the nineteenth century and is located in a purpose-built house since 1900. Exhibits here regularly engage with the larger international art community.
Director Anja Casser 2006–
Selected solo exhibitions Matts Leiderstam, Daniel Roth, Collier Schorr

Platz der Grundrechte
Platz der Grundrechte, Jochen Gerz's Fundamental Rights Square, was installed in 2005 and evidences Gerz's longtime concerns with involving the public in his works. In this work, twenty-four metal plates are placed atop flagpoles and have statements in response to questions from the artist. Karlsuhe was the post-war seat of justice in West Germany and this piece commemorates that fact.

Kassel

Kassel Events
Arnold-Bode-Preis, annual prize
September
Kassseler Museumsnacht
2012
documenta XIII (9 June–16 Sept 2012)

Documenta
www.documenta.de
Documenta, one of the signature events

in the international art calendar, occurs every five years and its generally high level of curating and site-specific artworks draws visitors to this provincial town from around the world. Begun in 1955 by Arnold Bode as a part of the German Horticultural Show, Documenta became an instrument of cold-war politics due to Kassel's location on the East-West German divide. Successive Documentas have occurred in 1959, 1964, 1968, 1972, 1977, 1982, 1987, 1992, 1997, 2002, and 2007, and took on the name of the "museum of 100 days." Documenta is scheduled from June to September and is held in a variety of locations around Kassel including the Fridericianum and the Neue Galerie.

Kunsthalle Fridericianum
Friedrichsplatz 18
Wed–Sun 11–6
Tel +49 561 707 2720
www.fridericianum-kassel.de
The first museum on the Continent of Europe, the Kunsthalle Fridericianum opened in 1779 and thereafter was severely damaged during the Second World War. Rebuilt for the first Documenta in 1955, the Kunsthalle is no longer a museum but hosts temporary exhibitions since its name change to Kunsthalle Fridericianum in 2001.
Directors Rein Wolfs 2008–,
Rene Block –2007
Selected solo exhibitions Marina Abramovic, Jalal Toufic, Endre Tot

Kiel

Kiel Events
August
Kieler Museumsnacht

Kunsthalle zu Kiel
Düsternbrooker Weg 1
Tue–Sun 10–6, Wed 10–8

Tel +49 431 880 5756
www.uni-kiel.de/kunsthalle/
Kunsthalle zu Kiel is located in a building from 1909 with an extension created in 1986 housing a collection based on the 1855 creation of the Schleswig–Holsteinischer Kunstverein. The collection, which includes art from the nineteenth-century Romantic period to today, of contemporary work is strong and includes works by Marlene Dumas, Gerhard Richter, and Thomas Schütte.
Director Dirk Luckow
Selected solo exhibitions A. R. Penck, Per Kirkeby, Eija-Liisa Athila, Tal R, Tania Bruguera

Kleve

Museum Kurhaus
Tiergartenstrasse 41
Tue–Sun 11–5
Tel +49 28 217 5010
www.museumkurhaus.de
Museum Kurhaus Kleve/Ewald Matare Sammlung stands a few minutes from the Dutch border in a former cure house built in the nineteenth century. The museum, operated by the city of Kleve, includes work from the sixteenth century to today with contemporary art represented by Richard Long, Guiseppe Penone, and On Kawara, amongst others. Designed by Anton Weinhagen in 1845–46, the cure house was added to in 1872–73 and after the First World War its original function changed and it underwent a period of disuse. Re-opened in 1997 to a design by Walter Nikkels and Heinz Wrede the museum occupies an area surrounded by landscaped gardens and site-specific art.
Director Guido de Werd
Selected solo exhibitions Robert Indiana, Giuseppe Penone, Denise Green, Lothar Baumgarten, Brice Marden, Alex Katz

Koblenz

Koblenz Events
September
Lange Nacht der Museen

Ludwig Museum
Danziger Freiheit 1
Tue–Sat 10:30–5, Sun 11–6
Tel +49 261 30 4040
www.ludwigmuseum.org
Stressing French art of the twentieth century, the Ludwig Museum im Deutschherrenhaus opened in 1992 with gifts from the collection of Peter and Irene Ludwig, who funded and endowed five museums in Europe and whose collections were one of the most important in post-war Germany. Located in the former home of German cavaliers, the collection includes works by Jean-Michel Alberola, Daniel Buren, and Jean Tinguely.
Selected solo exhibitions Michael Sailstorfer, Ulrike Ottinger, Artavazd Peleschjan

Kraichtal

Ursula Blickle Stiftung
Mulhlweg 18
Wed 2–5, Sun 2–6
Tel +49 7251 69019
www.ursula-blickle-stiftung.de
In an isolated location in Baden-Württemberg, the Ursula Blickle Stiftung was founded by Ursula Blickle in 1991 and presents four exhibits per year in this rural German location. Exhibits focus on new artistic trends and the foundation has engaged with many leading curators who have presented themed exhibits at the space.

Krefeld

Kaiser Wilhelm Museum
Karlsplatz 35

Tue–Sun 11–5
Tel +49 215 197 5580
www.krefeld.de/kommunen
Constructed to honor the first Kaiser of
the resurgent German state, the Kaiser
Wilhelm Museum opened in 1893 to a
design by Hugo Koch. With a brief to ex-
hibit arts and crafts and with links to the
burgeoning design movement in Germa-
ny, the Kaiser Wilhelm survived the up-
heavals of the twentieth century with lit-
tle damage. In the late sxities the museum
began to stage innovative exhibitions in-
cluding a seminal show curated by Harald
Szeemann in 1969. With the long-term
loan of the Lauffs Collection the museum
came into possession of a strong collec-
tion of American Pop as well as a wide
range of artworks from Arte Povera to
kinetic work. The museum received ad-
verse publicity with its plans in 2006 to
sell a striking Claude Monet painting in
order to finance much-needed repairs and
a further blow when in late 2007 Helga
Lauffs notified the museum that she in-
tended to remove her collection much of
which has now been sold at auction.
Selected solo exhibition Georg Polke

Haus Esters and Haus Lange
Wilhelmshofallee 91 & 97
(Bus 54 to Haus Lange stop)
Tue–Sun 11–5
Tel +49 215 197 5580
www.krefeld.de/kommunen/
The architecturally significant villas creat-
ed by Mies van der Rohe in the twenties
in the suburbs of Krefeld, the Haus Esters
and Haus Lange are run by the Kaiser Wil-
helm Museum and feature uniquely ad-
venturesome programming devoted to
contemporary art. Opened in 1981 after
extensive renovations, the villas have seen
exhibits by Sol LeWitt, Daniel Buren, and
Richard Serra in the early years and recent-
ly Gregory Crewdson, John Wesley, and
Anton Henning have shown here.

Leipzig

The catalyst for the peaceful revolution
which brought down the East German
State, Leipzig has seen a remarkable
growth in contemporary art with galler-
ies, museums, and artists all coming to
prominence here. Known international-
ly for the Leipzig School of Expressionist
painting, which includes Neo Rauch,
Tim Eitel, and Martin Kobe, the city has
become a must stop for collectors and art
enthusiasts as its nearness to Berlin has
proved a major asset.

Leipzig Events
April
Nachtschicht, Leipziger Museumsnacht

Museum der bildenden Künste
How to get there A few minutes' walk
from the Hauptbahnhof, the MDBK is lo-
cated at Katharinenstrasse 10.
Tue, Thu–Sun 10–6, Wed 12–8
Tel +49 34 121 6990
www.mdbk.de (in German only)

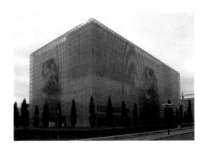

Exhibitions & Collections Established
in 1836, the municipal collection of Leip-
zig was founded by wealthy burghers and
rapidly expanded to include a significant
collection heavy in Expressionism. Sub-
sequent losses due to the Nazis' degener-
ate-art policy and bombing in 1943 led
to the collection being significantly re-
duced. The collection now includes sig-

nificant holdings of the Leipzig School of painters, including many works by Neo Rauch and Daniel Richter.

Building The first major new museum built in the former DDR since 1945, Hufnagel Pütz Rafaelien designed the MDBK in 2004 as a modernist cube composed of concrete and glass. The museum, while simple, has received praise for this very quality and for its exhibition spaces, which allow for a sensitive presentation.

Director Hans-Werner Schmidt

Selected solo exhibitions Christine Baumgartner, Günther Thiele, Matthias Weischer

GfZK
Galerie für Zeitgenössische Kunst
Karl-Tauchnitz-Strasse 9–11
Tue–Sun 12–7
Tel +49 341 140 810
www.gfzk-online.de

The Galerie für Zeitgenössische Kunst GfZK opened in 1998 in Peter Kulka's renovated Villa Rücksicht after having been established by the city of Leipzig in 1991. In 2004 a second building was opened which features exhibits on a Kunsthalle system. The gallery has engendered debate in the arts community by its decision to cede curatorial control to outside collectors and companies from 2008 to 2010.

Spinnerei
Spinnereistrasse 7
Tel +49 341 498 0270
www.spinnerei.de
www.spinnereigalerien.de

The Spinnerei stands in a large factory complex for cotton spinning developed from 1884. This area was turned into a large complex for arts, including galleries and studio spaces, following the closure of the factory in the mid-nineties. Many of the galleries that spawned the Leipzig School can be found here.

Leverkusen

Museum Morsbroich Leverkusen
Gustav-Heinemann-Strasse 80
Tue 11–9, Wed–Sun 11–5
Tel +49 214 855 5644
www.museum-morsbroich.de

Located in an eighteen-century Schloss, or castle, at the center of a park landscape, the museum was founded in 1951 and renovated by Oswald Matthias Ungers in 1985. While especially strong in modernism, works from the Informel and Zero Groups from the sixties and seventies are included in the collections.

Director Markus Heinzelmann 2006–

Lingen

Kunsthalle Lingen
Kaiserstrasse
Tue–Fri 10–5, Thu 10–8, Sat–Sun 11–5
Tel +49 59 15 9995
www.kunsthalle-lingen.de

Kunsthalle Lingen is housed since 1997 in Halle IV of a nineteenth-century industrial factory that was previously used for train repairs.

Selected solo exhibitions Anastia Khoroshilova, Mai Yamashita, Annelise Coste

Ludwigshafen am Rhein

Wilhelm Hack Museum
Berliner Strasse 23
Tel +49 621 504 3045
www.wilhelm-hack-museum.de

Based on the 1973 donation of Cologne-based collector Wilhelm Hack, the Wilhelm Hack Museum, closed for renovation until November 2008, opened in a purpose-built home in 1979 in this industrial city in the Rhineland. The museum focuses its energies on modernism due to Hack's collection, which includes a specially commissioned Miró mural, of Pop Art

and post-war European art movements.
Selected solo exhibitions Imi Knoebel,
Denis Pondruel, Clinton Storm

Mönchengladbach

Städtisches Museum Abteiberg
How to get there Located in the center
of Mönchengladbach at Abteistrasse 27.
Tue–Sun 10–6
Tel +49 216 125 2637
www.museum-abteiberg.de
(in German only)
Exhibitions & Collections The city his-
torical collection was begun in 1901 and
through the decades became known for
expressionist holdings, which were dis-
persed during the Second World War.
Following the end of the war, the muse-
um gradually began to focus on contem-
porary art. With the loans of the Samm-
lung Osnach and Sammlung Marx the
museum became known for internation-
al quality contemporary art. Since the
withdrawal of these collections the mu-
seum has struggled to find its voice.

Building Constructed in 1982 by Aus-
trian architect Hans Hollein the museum
is one of the landmarks of post-modern
architecture. The exhibition rooms were
constructed to uniquely fit artworks sub-
sequently withdrawn has created spaces
that do not entirely work with the art on
view. The museum remains, though, a
unique statement of architectural vision.

A recent refurbishment has restored an
amount of the original luster of the mu-
seum.
Director Susanne Titz 2004–
Selected solo exhibitions Rita McBride,
Olivier Foulon, Manuel Graf, Monica
Bonvicini, Michael Stevenson

Munich

The capital of Bavaria is host to major
museums and institutions as well as sev-
eral internationally regarded galleries.
With support from collectors as well as
the state of Bavaria, Munich has invested
heavily in creating this cultural matrix
that stakes its claim as one of the major
centers for contemporary art in Germa-
ny. It has managed this, even as other re-
gions of Germany have struggled with
the rise of Berlin as the cultural capital of
the Continent.

Munich Resources
www.die-museen-in-muenchen.de
www.m-radar.de
German-language magazine based
in Munich, articles and exhibition
information

Munich Events
October
Lange Nacht der Münchner Museen
2009
Museum Brandhorst opens in spring,
architects sauerbruch hutton

Haus der Kunst
Prinzregentenstrasse 1
Mon–Fri 10–10, Sat–Sun 10–8
Tel +49 89 21 12 7113
www.hausderkunst.de
Haus der Kunst enjoys an ignominious
history. It began as the Haus der Deut-
schen Kunst designed by Paul Troost at
the direction of Adolf Hitler and opened
in 1935. Thereafter it hosted the infa-

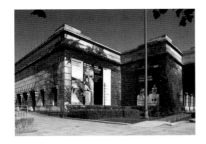

mous *Degenerate Art* exhibition. Following the Second World War the allies rehabilitated the venue and today the Haus der Kunst presents international quality art exhibitions as well as lectures and events. The institution is one of the leading venues in presenting major exhibitions by international contemporary artists.
Director Chris Dercon 2003–, chief curator Thomas Weski 2003–
Selected solo exhibitions Anish Kapoor, Gilbert & George

Kunstverein München
Galeriestrasse 4
U-Bahn Odeonsplatz
Tue–Sun 11–6, Thu 11–9
Tel +49 89 22 9352
www.kunstverein-muenchen.de
The Kunstverein München was founded in 1823 and quickly became a rival to the Munich Art Academy. When the Kunstverein's building was destroyed in the Second World War, it moved into the galleries of the Hofgarten in which formerly was displayed the museum's cast collection. Until the mid-seventies the Kunstverein was a model of insignificance due to its reliance on an outdated membership structure. Subsequent directors and a change in focus has brought the Kunstverein to prominence and led to its claim to be one of the more culturally vital of German Kunstvereins.
Director Stefan Kalmar, curator Daniel Pies

Selected solo exhibitions Wolfgang Tillmans, Cyril Blazo, General Idea, Jeremy Deller

Lenbachhaus/Kunstbau
Luisenstrasse 33 (U2 to Königsplatz, tram 27 to Karolinenplatz)
Tue–Sun 10–6
Tel +49 892 333 2000
www.lenbachhaus.de
Lenbachhaus/Kunstbau is housed in the Lenbach Villa designed by Gabriel von Seidl and conceived by artist Franz von Lenbach in 1891. The center is a city-run institution that exhibits primarily modernism but also has a substantial holding of contemporary art featuring, amongst others, Blinky Palermo, Sigmar Polke, and Joseph Beuys. Permanent installations by Lawrence Weiner and Maurizio Nannucci add to the Villa's artistic vision. A new addition, the Kunstbau, was completed in 1994 by Uwe Kiessler in order to house temporary exhibitions.
Manager and curator of collection for contemporary art Susanne Gänsheimer 2001–
Selected solo exhibitions Dan Flavin, Willie Doherty, Cerith Wyn Evans

Pinakothek der Moderne
How to get there Subway U2/U8 to Königsplatz and then a 5–10-minute walk.
Barer Strasse 40
Tue–Sun 10–6, Thu 10–8
Tel +49 89 2380 5360
www.pinakothek-der-moderne.de
Exhibitions & Collections Part of the Bavarian Art Collections, this twentieth- and twentyfirst-century museum houses the Staatsgalerie Modern Kunst, the Neue Sammlung design collection, the print and drawing collections and architecture collection of the Technical University of Munich. Bringing these disparate collections together, the Pinakothek

der Moderne attempts to create what the institution terms "a MOMA for Munich." Strong in twentieth-century art from the Brücke and Blauer Reiter groups the contemporary section is less extensive with Georg Baselitz, Joseph Beuys, and Sigmar Polke predominating.

Building Opened in 2002, Stephan Braunfels's Pinakothek der Moderne is placed in the historic museum quarter near the Alte and Neue Pinakotheks, thereby creating a nexus of art history in this area. The building itself relies on a central rotunda around which the galleries and collections are situated. Within the layout of the museum the four collections struggle to forge a dialogue.

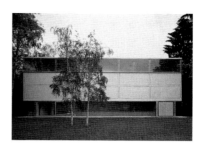

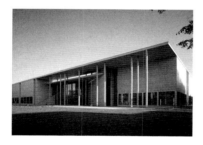

Directors Director Neue Sammlung Florian Hufnagel, director for photography and new media Inka Gräve Ingelmann 2002–

Selected solo exhibitions Francesco Vezzoli, Roman Ondák, Johan Grimonprez, Georg Baselitz, Fischli & Weiss, Thomas Hirschhorn

Sammlung Goetz

Oberföhringer Strasse 103
by appointment
Tel +49 89 959 39 6901
www.sammlung-goetz.de

Sammlung Goetz was constructed in 1992 especially for the private collection of art dealer Ingvild Goetz. Set in a suburb of Munich, the collection is open by appointment only during exhibitions. The Herzog + de Meuron-designed building is known for its subtle use of light and space, which were partly dictated by zoning concerns. In addition, the interior was built in collaboration with the contemporary artist Helmut Federle.

Selected solo exhibitions Matthew Barney, Thomas Schütte, Andrea Zittel

Museum Brandhorst

Theresienstrasse 35a
Tue–Sun 10–6, Thu 10–8
www.museum-brandhorst.de

Opened in May 2009 the Museum Brandhorst features the post-war art collections of Udo Brandhorst, the heir to the Henkel trusts. The new museum was designed by Sauerbruch Hutton architects and is covered with over 30,000 ceramic rods. Brandhorst has assembled a unique collection of over seven hundred works with an especially large selection of pieces by Mike Kelley, Cy Twombly, Franz West and Andy Warhol. The mu-

seum will be located near to the Pina-
kothek der Moderne and the museums
quarter which awaits an overall master
plan to harmonize the area.
Director Armin Zweite 2008–

Münster

Münster Events
September
Nacht der Museen und Galerien
2017
Skulptur Projekte Münster 17

Skulptur Projekte Münster
www.skulptur-projekte.de
Held every ten years during the summer,
Skulptur Projekte Münster is one of the
most important exhibits of internation-
al sculpture in Europe. Since the first ex-
hibit in 1977, the Skulptur Projekte
Münster has increased in prominence
due to the quality of the installations
spread around this university town. The
curators Klaus Bussmann and Kasper
König are the original guiding forces be-
hind the project which in its 2007 ver-
sion included works by Pawel Althamer,
Tue Greenfort, Mike Kelley, amongst oth-
ers. For those visiting in off years, many
of the works remain in place as perma-
nent installations. These include works
by Donald Judd and Claes Oldenburg.

Westfälischer Kunstverein
Domplatz 10
Tue–Sun 10–6
Tel +49 25 14 6157
www.westfaelischer-kunstverein.de
Westfälischer Kunstverein was created in
the nineteenth century and has been set
since 1972 in the complex of buildings
forming the Westfälisches Landesmuse-
um.
Director Carina Plath 2001–
Selected solo exhibitions Gustav
Metzger, Dieter Kiessling, Sigmar Polke

Naumburg

Kathedrale Naumburg
Domplatz
March–Oct: Mon–Sat 9–6, Sun 12–6,
Nov–Feb: Mon–Sat 10–4, Sun 12–4
The thirteenth-century Naumburg Ca-
thedral commissioned Leipzig School
artist Neo Rauch to design a stained-glass
window triptych for the St. Elizabeth
Chapel and which was installed in late
2007. This is a unique work for Rauch
and joins what has seemed to become a
trend of German religious organizations
commissioning contemporary artists to
design windows.

Neuenkirchen

Kunstverein Springhornhof
Tue–Sun 2–6
Tel +49 5195 933 963
www.springhornhof.de
Administering an extensive outdoor
sculpture project, the Kunstverein Spring-
hornhof located on the Lüneburg Heath
began in the late sixties and continues
to add works to the collection by artists
such as Michael Asher, Tony Cragg, and
Rainer Ganahl. Originally, the Kunst-
verein was founded by gallery owner
Ruth Falazik and, following her passing
in 1997, the Kunstverein has come under
state support. The main exhibit building
itself is a former farmstead, appropriate
for this area that relies on agriculture.
Director Bettina von Dziembowski 2000–

Neuss

Neuss Events
May
Kulturnacht in Neuss

Langen Foundation
Raketenstation Hombroich 1
Tue–Sun 10–6

Tel +49 0218257010
www.langenfoundation.de
The Langen Foundation is founded on
the Viktor and Marianne Langen Collec-
tion of Japanese art and European mod-
ernism and which opened to a design by
Tadao Ando in 2004. Built on a former
NATO military base near the Museum
Insel Hombroich, the Langen Foundation
presents both shows from the permanent
collection and curated exhibitions. The
highlight of a visit, though, is the archi-
tecture of Tadao Ando and the way he has
brought his light touch and grace to this
rural setting.

Selected solo exhibitions Alex Katz,
Günther Uecker

Museum Insel Hombroich
How to get there Located in the out-
skirts of Neuss at Hombroich Island in
the Erft River, the Insel can be reached via
bus 869 or 877 from the center of the
city.
Minkel 2
Apr–Sept Tue–Sun 10–7,
Nov–Mar Tue–Sun 10–5
Tel +49 2182 2094
www.inselhombroich.de
(in German only)
Exhibitions & Collections Originally
started as a nature preserve, the noted
collector Karl-Heinrich Müller turned
this location into a virtual wunderkam-
mer with signature buildings created to

house his collection. With work from the
Khmer period to contemporary work by
Gotthard Graubner, Mark di Suvero, and
Norbert Tadeusz on view, the Insel is a
unique setting for viewing this union of
art and nature.
Building Created by sculptor Erwin
Heerich, the original buildings were
opened in 1983 (with more following at
regular intervals during the eighties and
nineties) and they forge a dialogue be-
tween art and nature. The stark modern-
ist-derived structures contrast well with
the wide variety of artistic styles on view
and further offer a different experience
from the traditional museum experience.
Further buildings by Raimund Abraham
in 1997 and Per Kirkeby in 2000 fol-
lowed the purchase by Müller of an adja-
cent abandoned NATO rocket base, as
well as an additional expansion being en-
visioned with sixteen artists having sub-
mitted designs for buildings.

Nuremberg

Nuremberg Events
May
Die Blaue Nacht

Kunsthalle Nürnberg
Lorenzer Strasse 32
Tue–Sun 10–6, Wed 10–8
Tel +49 911 23 1240
www.kunsthalle.nuernberg.de
Originally meant to house the municipal

art collections upon opening in 1913, the Kunsthalle Nürnberg has been known as a Kunsthalle since 1967 and, with the transfer of the fine-art collections to the Neues Museum, concentrates on temporary exhibitions.

Director Ellen Seifermann 1999–
Selected solo exhibitions Peter Zimmermann, Rachel Harrison, Ina Weber

Neues Museum Nürnberg
Klarissenplatz
Tue–Fri 10–8, Sat–Sun 10–6
Tel +49 91 12 4020
www.nmn.de
The last large city in Germany to construct a contemporary art museum, Nuremberg's Neues Museum Nürnberg was built by Volker Staab and opened in 2000. Collections here focus on post-war at, with an accent on Germany and artists from Franconia, with Gotthard Graubner, Thomas Ruff, and Nam June Paik all part of the city's collections.

Director of exhibitions Melitta Kliege 1998–, director Angelika Nollert 2007–
Selected solo exhibitions Christian Möbus, Thomas Schütte, Tony Cragg

Oberhausen

Landmark Art
www.route-industriekultur.de
Landmark Art (visitor center at Kleines Schloss Oberhausen in the Ludwig Galerie Schloss Oberhausen) is a route of artwork in nature featuring artists such as Richard Serra, Dani Karavan, Ulrich Rückriem, Dan Flavin, amongst others, and endeavors to point to the Emscher area's industrial heritage. The Emscher itself is a river once known as the dirtiest in Europe and which was a major transit point for the industry of the Ruhr region.

Ludwig Galerie Schloss Oberhausen
Konrad–Adenauer Allee 46

Tue–Sun 11–6
Tel +49 208 412 4928
www.ludwiggalerie.de
Built in the nineteenth century, the Schloss Oberhausen houses the Ludwig Galerie Schloss Oberhausen that presents mainly thematic exhibits. The schloss opened in 1998 as an initiative of the collectors Peter and Irene Ludwig with renovations by Fritz and Phillip Eller although the schloss has been the site for a municipal gallery ever since 1947. Also administering the Landmark Art sculpture park, the Schloss's collection includes work from the former East Germany as well as applied art.

Selected solo exhibition Valery Koshlyakov

Oldenburg

Oldenburg Events
September
Lange Nacht der Museen

Oldenburger Kunstverein
Damm 2a
Tue–Fri 2–5, Sat–Sun 11–5
Tel +49 444 12 7109
www.kunstverein-oldenburg.de
Founded in the nineteenth century, the Oldenburger Kunstverein was located in the former Duke's gallery of art until moving to a permanent location in 1968. With a long history of presenting exhibits, the Kunstverein stresses emerging art as well as being one of the first western institutions to engage with art from the former socialist east.

Selected solo exhibitions Marko Lulic, Marc Brandenburg, Katharina Sieverding

Edith Russ Haus
für Medienkunst
Katharinenstrasse 23
Tue–Fri 2–5, Sat–Sun 11–5

Tel +49 441 235 3208
www.edith-russ-haus.de
Created by an endowment in the will of Edith Russ, the privately run Edith Russ Haus für Medienkunst hosts artist residencies as well as presenting exhibitions related to new media.
Director Sabrine Himmelsbach

Osnabrück

Osnabrück Events
2009
European Art Media Festival, annual event
(22–26 April 09)

Passau

Museum Moderner Kunst Stiftung Wörlen
Bräugasse 17 Donaukanal
Tue–Sun 10–6
Tel +49 851 383 8790
www.mmk-passau.de
Due to its unique setting near the Czech and Austrian borders, Passau's Museum Moderner Kunst—Stiftung Wörlen dedicates itself to forging a dialogue between the east and the west. Since opening in an historic old house in 1990, the museum has focused on the works of local artist Georg Philipp Wörlen as well as modernist trends.
Selected solo exhibitions Andreas Bindl, Klaus Fussmann

Recklinghausen

Kunsthalle Recklinghausen
Grosse-Perdekamps Strasse 25–27
Tue–Sun 11–6
Tel +49 2361 50 1935
www.kunsthalle-recklinghhausen.de
Kunsthalle Recklinghausen stands since 1950 in a former bunker opposite the Hauptbahnhof. A major factor in the museum schedule is participation in the Ruhr Festivals. The Kunsthalle also has a collection that is based on mainly German artists from the fifties and sixties.
Selected solo exhibitions Michael Jäger, Tatsuo Miyajima

Rolandseck

Arp Museum
Hans-Arp-Allee 1
Tue–Sun 11–6
Tel +49 22 288 4250
www.arpmuseum.org

Richard Meier's modernist-inspired Arp Museum, dedicated to the Dada artist Hans Arp, is housed at the former Bahnhof Rolandseck on the Rhine that was built in 1856 and turned into the Arp Museum in 2001. American architect Meier's new building opened in September 2007 and tries to integrate the architect's classical modernist-inspired spaces with the historic railway station. The Bahnhof also features a bistro with interior design by Anton Henning, a washroom by Maria Nordman, as well as other works by contemporary artists. Exhibitions here often remain for one year.
Director Oliver Kornhoff
Selected solo exhibitions Joseph Beuys, Anselm Kiefer, Michael Craig-Martin, Richard Deacon, Jonathan Meese

Schwäbisch Hall

Schwäbisch Hall Events
October
Lange Kunstnacht

Kunsthalle Würth
Lange Strasse 35
Daily 10–6
Tel +49 791 94 6720
www.kunst.wuerth.com
Begun in the sixties the collections of the
Germany-based Würth firm (who make
fasteners, screws, as well as other con-

struction-fitting equipment) forms the
basis for the Kunsthalle Würth opened
in 2001 to a design by the Danish archi-
tect Henning Larsen. The collection was
begun by Reinhold Würth and spans the
twentieth and twenty-first centuries,
with contemporary works from Markus
Lupertz, Anselm Kiefer, and Jörg Immen-
dorff, as well as many other German art-
ists. The Würth firm also travels parts of
the collection to the various regional cor-
porate offices across Europe. Exhibits
mostly concentrate on modernism.

Schweinfurt

Museum Georg Schäfer
Brückenstrasse 20
Tue–Sun 10–5, Thu 10–9
Tel +49 97 215 1917
www.museumgeorgschaefer.de

Well known for its collection of nine-
teenth-century art that was part of the
donation of local ball-bearing plant own-
er Georg Schäfer, the Museum Georg
Schäfer was designed by Volker Staab and
inaugurated in 2000. Originally the mu-
seum was to be the work of Mies van der
Rohe but his 1964 project never came to
fruition (a version of which is now the
Neue Nationalgalerie in Berlin). The mu-
seum presents mainly historical themed
shows.

Siegen

Siegen Events
2012
Rubens Prize

Museum für Gegenwartskunst Siegen
Unteres Schloss 1
Tue–Sun 11–6
Tel +49 271 40 5770
www.kunstmuseum-siegen.de
The Museum was designed by Josef P.
Kleihues and displays the architects char-
acteristic elegance and clarity in the refur-
bishment of the existing 1894 telegraph
office. In 2004 the museum building was
inaugurated and houses the private col-

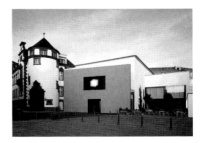

lection of the Lambrecht-Schadeberg
family who control the Krombacher
brewery, and which is based on post-war
painting by artists such as Cy Twombly,

Lucian Freud, and Maria Lassnig. The museum administers the Rubens Prize that is awarded every five years.
Director Eva Schmidt 2004–
Selected solo exhibitions Sigmar Polke, Stephen Willats, Maria Lassnig, Blinky Palermo

Sindelfingen

Sindelfingen Events
March 2010
Senator Peter Schaufler Stiftung opens

Senator Peter Schaufler Stiftung
Eschenbrünnlestrasse 15
Tel +49 7031 932 5900
www.stiftung-schaufler.com
The private Senator Peter Schaufler Stiftung is due to open in 2010 to house the collections of local entrepreneur Schaufler, head of the Bitzer Group. The collection is based on works from the Zero Group, as well as Minimal Art and international contemporary art.

St. Georgen, Schwarzwald

Kunstraum Grässlin
Museumstrasse 2
Sat–Sun 12–6
Tel +49 7724 859 8297
www.sammlung-graesslin.eu
The Grässlin family has developed a reputation as one of the more engaged of German collectors of recent times and operates the Kunstraum Grässlin since 2006. All members of the family are collectors as well as cultural practitioners, although Dieter and Anna Grässlin began the collection in the seventies and which today includes Fischli & Weiss, Isa Genzken, and Cosima von Bonin, amongst others. The Grässlins were also one of the main supporters of Martin Kippenberger who was regularly a guest with them in the Black Forest.

Stuttgart

Stuttgart Resources
www.kunst-in-stuttgart.de

Stuttgart Events
April
Lange Nacht der Museen
October
Stuttgarter Kulturnacht

Kunstmuseum Stuttgart
How to get there Set on the historic Schlossplatz, the Kunstmuseum Stuttgart is a 5 minute's walk from the Hauptbahnhof.
Kleiner Schlossplatz 1
Tue–Sun 10–6, Wed & Fri 10–9
Tel +49 711 216 2188
www.kunstmuseum-stuttgart.de
(German and English)
Exhibitions & Collections The foundations were laid for the Gallery of the City of Stuttgart in the twenties but it was not until 1961 that the gallery opened. Focusing on art from the end of the eighteenth century to today, the Kunstmuseum Stuttgart's collection includes an exemplary collection of works by Otto Dix as well as contemporary art from Wolfgang Laib, Rebecca Horn, and others.

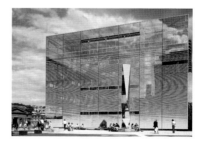

Building Since 1981 efforts were underway to construct a new home for the gallery. In 1999 Hascher & Jehle won an international competition with their bold

design of a glass shell enclosing a stone cube. Opening in 2005 the building has won praise from the architectural press.
Director Marion Ackermann 2003–08
Selected solo exhibitions Josephine Meckseper, Carsten Nicolai, Pia Maria Martin

Staatsgalerie

How to get there A few minutes' walk from the Hauptbahnhof, the Staatsgalerie is set on the busy Konrad-Adenauer-Strasse 30–32.
Tue–Sun 10–6, Thu 10–9
Tel +49 711 4704 0250
www.staatsgalerie.de (in German only)
Exhibitions & Collections Opened in 1843 the Alte Staatsgalerie encompassed the royal collections of Baden-Württemberg as well as the Royal Academy. Re-opened in 1958, the Alte Staatsgalerie outgrew its building and a new building was commissioned to house the modern and contemporary collections. A wide range of contemporary art is included in the collection including work from the Fluxus artists, Arte Povera, and a particularly large number of works by Gerhard Richter. Exhibitions are mostly themed and concentrate on modernism.
Building The Alte Staatsgalerie was designed by George von Barth but virtually completely destroyed during the Second World War. Designed by James Stirling and Michael Wilford, the Neue Staatsgalerie is one of the signature buildings of the postmodern movement. Containing references to prior architectural epochs and forms, including the rotunda and atrium forms, the Neue Staatsgalerie opened to acclaim in 1984. The bright colors of the interior balance the striking use of exterior stone modeling creating a unique setting for contemporary art. A further extension designed by Wilfrid and Katharina Steib opened in 2002 to house the graphic collection as well as additional exhibition spaces.

Württembergischer Kunstverein

Schlossplatz 2
Tue–Sun 11–6, Wed 11–8
Tel +49 711 22 33 7014
www.wkv-stuttgart.de
Württembergischer Kunstverein offers intriguing exhibitions by contemporary artists. This well regarded Kunstverein is located in the Kunstgebäude, built by Theodor Fischer in 1910–13 but destroyed in the Second World War. Rebuilt in 1961 the Kunstgebäude also housed the municipal art collections until they were moved in 2005 to the Kunstmuseum.
Directors Hans D. Christ and Iris Dressler 2005–
Selected solo exhibitions Stan Douglas, Peter Bogen, Anna Oppermann

Ulm

Ulm Events

June
Lange Nacht der Museen

Kunsthalle Weishaupt

Tue–Sun 11–5, Thu 11–8
Hans und Sophie School Platz 1
Tel +49 731 161 4360
www.kunsthalle-weishaupt.de
Kunsthalle Weishaupt features the private collection of entrepreneur Siegfried Weishaupt that is focused mainly on fifties' and sixties' artists. Designed by architect Wolfram Wöhr, a pupil of Richard Meier, the Kunsthalle opened in November 2007. The Kunsthalle continues to collect and Markus Oehlen, Liam Gillick, and Wolfgang Laib are all part of the collection.

Ulmer Museum

Marktplatz 9
Tue–Sun 11–5, Thu 11–8
Tel +49 731 161 4330
www.museum.ulm.de
Ulmer Museum since 1999 features a new extension that houses contemporary

art from the Fried Collection, including work by Frank Stella, Gerhard Richter, and Günther Uecker. The museum is known for its historical collections.

Selected solo exhibitions Niki de Saint Phalle, Jean Tinguely

Waldenbuch

Museum Ritter
Sammlung Marli Hoppe-Ritter
Alfred Ritter Strasse 27
Tue–Sun 11–6
Tel +49 71 5753 5110
www.museum-ritter.de

Museum Ritter was designed by Max Dudler and is set next to the Ritter chocolate factory. Based on the modernist collections of Marli Hoppe-Ritter, the museum also features works by Imi Knoebel and François Morellet. Opened in 2005, the museum's exhibits draw on the collection and related themes.

Weil am Rhein

Weil am Rhein Events
2010
VitraHaus opens, architects Herzog + de Meuron

Vitra Design Museum
How to get there Vitra is located a short bus ride from Switzerland's Basel Badischer Bahnhof (bus 55).
Charles Eames Strasse 1
Daily 10–6, Wed 10–8,
architectural tours daily 12 and 2
Tel +49 7621 702 3200
www.design-museum.de
(German and English)

Exhibitions & Collections The Vitra collection is devoted to modern design and ranges from works by Charles and Ray Eames to Le Corbusier. Exhibitions frequently draw on the collection as well as focus on major figures in the world of

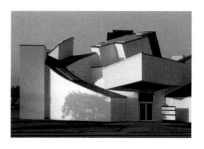

architecture and design. No permanent collection is on view as the museum operates on a Kunsthalle system. The museum was formerly located in Berlin.

Building Designed by Frank Gehry in 1989, the Vitra Design Museum is striking amidst the rolling hills of southern Germany. Pre-figuring Gehry's subsequent museum designs, Vitra offers twisted shapes and oblique angles to create exhibition spaces of note. Also on site are buildings by Tadao Ando, Zaha Hadid, Nicholas Grimshaw, and Álvaro Siza, although these are accessible via tour only. In 2010, the Vitra Haus designed by Herzog + de Meuron will open as a showroom and visitors center and will be joined by a new storage and assembly factory building by SANAA that will only be accessible on the architecture tour.

Selected solo exhibitions Le Corbusier, Luis Barragán, Jean Prouvé

Weimar

Weimar Events
May
Lange Nacht der Museen

Neues Museum Weimar
Weimarplatz
April–Oct Tue–Sun 11–6,
Nov–March Tue–Sun 11–4
Tel +49 36 43 5460
www.klassik-stiftung.de

Neues Museum Weimar opened in 1999

in a neo-renaissance building designed by Josef Vítek in 1863–69. This is the first museum dedicated to contemporary art opened in former East Germany and it was meant to house the collection of Cologne dealer Paul Maenz who in 2004 announced he wished to withdraw his collection due to bad management in Weimar. The Neues Museum has several site-specific pieces by Sol LeWitt, Daniel Buren, and Robert Barry as well as being strong in works from the sixties. The building itself formerly housed the Grand-Ducal collections prior to 1918 then was subsequently the Landesmuseum until damage in Second World War reduced the building to a ruin.
Selected solo exhibition Candida Höfer

Wiesbaden

Museum Wiesbaden
Friedrich Ebert Allee 2
Tue 10–8, Wed–Sun 10–5
Tel +49 611 3 3521
www.museum-wiesbaden.de
Museum Wiesbaden originally opened in 1915 in a building designed by Theodor Fischer, renovations were accomplished in 1997 and continue to this day. The collection ranges from historical art to contemporary with a particularly strong collection of modernism. Contemporary works from Thomas Bayrle, Rebecca Horn, and Gerhard Richter are featured.

Wolfsburg

Kunstmuseum Wolfsburg
How to get there The headquarters of Volkswagen, Wolfsburg is 1 hour via train from Berlin.
Porschestrasse 53
Tel +49 53 612 6690
Wed–Sun 11–6, Tue 11–8
www.kunstmuseum-wolfsburg.de
(German and English)

Exhibitions & Collections Opened in 1994, the Kunstmuseum Wolfsburg concentrates on post-1969 contemporary art and has been in the process of collection building since its inception. There is no permanent exhibition, instead the museum relies on temporary exhibits drawn from their permanent collection as well as hosting traveling shows.

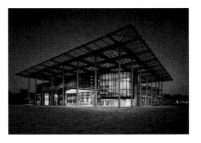

Building Peter Schweger designed the Kunstmuseum Wolfsburg with a glass cube at its heart and a glazed roof. The museum evidences the concern with transparency and openness which some have identified as a distinct trait of German post-war architecture.
Director Markus Brüderlin 2006–
Selected solo exhibition Neo Rauch

Wuppertal

Von der Heydt-Museum
Turmhof 8
Tue–Sun 11–6, Thu 11–8
Tel +49 202 563 6231
www.von-der-heydt-musuem.de
Founded in the late nineteenth century by the banking Von der Heydt family, the Von der Heydt-Museum Wuppertal still bears their name and the collections feature works by primarily modern artists although contemporary art is exhibited. The Kunsthalle Barmen is used for temporary exhibits and this is located in the adjacent municipality of Barmen.

Dominating the cultural field in Greece, the state attentions to antiquity and its related offshoots has left Greece bereft of a contemporary arts infrastructure. Only comparatively recently has contemporary art begun to assert itself, mainly through the efforts of private collectors and foundations. It is indicative of this change that only Athens warrants any extended visit for the contemporary art enthusiast.

Greece Resources

www.greece-museums.com
English-language museum information
ATOPOS, www.atopos.gr
organizes projects internationally

Athens

The center of the Greek culture industry, Athens has begun to emerge from the rapid urbanization of the fifties and sixties to become a contemporary metropolis. Through the efforts of private collectors, gallery owners, and foundations, Athens has begun to attract a diverse range of arts professionals. While this is encouraging, Athens still lags behind most of Western Europe in venues for contemporary art.

Athens Resources

www.athensartmap.net
Greek and English-language exhibition information
www.itys.org
Institute for Contemporary Art and Thought, organizes events and exhibits in Athens
www.artbox.gr
founded in 1999 to curate and organize contemporary art projects

Athens Events

May
Art Athina fair
2009
National Museum of Contemporary Art opens; 2nd Athens Biennial (15 June–4 Oct); Athens Video Art Festival 09, annual event
TBD: Goulandris Foundation, architect I. M. Pei

Benaki Museum—Pireos St. Annexe

138 Pireos Street
Wed–Thu, Fri–Sat 10–10,
Sun 10–6

Tel +30 210 345 3111
www.benaki.gr (in Greek only)
Benaki Museum—Pireos St. Annexe was opened in 2004 as the contemporary arts and architecture branch of the Benaki Museum. The space designed by Maria Kokkinos and Andreas Kourkoulas is a monolithic building and is striking in this busy industrial section of the city. The Benaki Museum was founded by the mid-twentieth-century donation to the state of the collection of Antonis Benakis, part of the wealthy Benaki family.

DESTE Foundation

How to get there Located in Nea Ionia, north of the city center, DESTE can be reached via metro stop N. Ionia and then a 10 minute walk (directions on website).
11 Filellinon & E. Pappa St.
Fri 4–8, Sat 11–4,
and by appointment Mon–Thu 10–6
Tel +30 210 275 8490
www.deste.gr
(Greek and English)

Exhibitions & Collections Noted collector Dakis Joannou established the DESTE Foundation in 1983 to promote arts and culture in Greece. The international level of Joannou's collection and his use of outside curators such as Jeffrey Deitch and Dan Cameron to present exhibitions at DESTE gives the institution a central role in the arts in Athens. Unfortunately, the collection is not always on view as the

foundation operates on a Kunsthalle system.

Building Designed by New York architect Christopher Hubert, the DESTE Foundation's permanent home opened in 1998 and used to be a factory. The design is uniquely suited to present contemporary art as well as housing a library and other facilities. The center was formerly located in Neo Psychico.

Director Xenia Kalpaktsoglou –2007

National Museum of Contemporary Art
www.emst.gr

The long-running saga of the creation of the National Museum of Contemporary Art is emblematic of the difficulties inherent in promoting Greek contemporary art. Founded in 1977, the Museum is controlled by the Ministry of Culture and has faced numerous challenges due to political circumstances. In a singular move, the museum began operations and mounting exhibitions in 2000 with neither a building nor a collection. This has since abated and the museum is now concentrating on opening their new building in 2009. The new building will be located in the renovated Fix brewery building, built in 1893 by Takis Zenetos, and is being renovated by I. Moulakis & Associates.

Goulandris Foundation

The Goulandris Foundation announced in 2007 that I. M. Pei will design a new contemporary art museum for the foundation on the site of the former Athens airport in Hellenikon Park. Pei's design draws on classical motifs and the museum will have four floors with spaces for the permanent collection as well as temporary exhibits. The Goulandris Foundation itself was established by Basil Goulandris and originally planned to build the museum in 1993 but the site in central Athens uncovered the remains of the

ancient lyceum and had to be abandoned.

Athens Art Areas

The densely packed Psyrri area features many of the more engaged contemporary art galleries in Athens. In this area of abandoned factories and a traditional working class flavor, galleries, design studios, and lofts now proliferate.

Hora, Andros

Museum of Contemporary Art
Nov–March Sat–Mon 10–2
April–May and Sept–Oct Daily 10–2
Tel +30 22820 22444
www.moca-andros.gr

On the most northerly of the Cycladic Islands, Andros, the Museum of Contemporary Art was founded in 1979 by the Basil and Elise Goulandris Foundation, a foundation that was established by ship magnate and art collector Basil Goulandris. Joining with a museum in Athens devoted to Cycladic art, the museum of contemporary art hosts temporary exhibits as well as selections from the collection featuring artists such as Anselm Kiefer, Hundertwasser, and Jannis Kounellis. The museum itself was designed by Greek architect Stamos Papadakis with an extension by Christos Kontovounisios in 1986.

Syros Island

Metro-Net installation

Martin Kippenberger's *Metro-Net* installation (part of imaginary international urban subway system) located at collector Michel Würthle's residence was constructed in 1993 at this private location. Spending six summers at the island, Kippenberger made many plans for works here including his Museum of Modern Art Syros that would have been located

in an old meat-packing facility. Other metro stations were constructed in different parts of the globe, including at Documenta, and were meant to symbolize a global metro system.

Thessaloniki

Greek State Museum of
Contemporary Art
21 Kolokotroni str.
Daily 10–6
Tel +30 2310 5891 4042
www.greekstatemuseum.com
The Greek State Museum of Contemporary Art was established in 1997 and is located in a wing of the Moni Lazariston Complex. The museum's collections predominately feature Russian and Greek modernism with temporary contemporary exhibits being held at the Warehouse B1-Provlita A building of CACT. Plans are under way to move to the entire institution to the industrial building YFANET.

CACT
Contemporary Art Center
of Thessaloniki
Warehouse B1
Tue–Sun 11–7
Tel +30 2310 546 683
www.cact.gr
CACT—Contemporary Art Center of Thessaloniki opened in 2005 as a branch of State Museum and presents eclectic exhibitions of video and new media art.

Facing many of the cultural issues that plague other former Eastern Bloc states, Hungary has yet to fully emerge on the international contemporary art stage. With Budapest a major center for cultural tourism, there have emerged a few museums that are engaging on an international level although commitment to this is sporadic and dominated by government support. As yet, the art market is still to make an impact in this region, so galleries are not as prevalent as in other areas.

Hungary

Budapest

A city long known for its beauty as well as being a bustling metropolis that has been the scene of much turmoil in the Cold War, especially during the 1956 Hungarian Revolution. It is Budapest that is the scene for all that is contemporary in Hungary, with several museums providing a platform for international art exhibits.

Budapest Resources

Index / Places of Art
monthly guide to contemporary museums and galleries in Hungarian
Artpool, www.artpool.hu
alternative arts institution founded in 1979 and today open to the public as archives

Budapest Events

June
Múzeumok Éjszakája, Museum Night

LUMÚ, Ludwig Múzeum
Museum of Contemporary Art

Palace of Arts, Komor Marcell u. 1
Tue–Sun 10–8, last Sat of month 10–10
Tel +36 1 555 3444
www.ludwigmuseum.hu

Located in southern Budapest, LUMÚ, Ludwig Múzeum, Museum of Contemporary Art was founded in 1989 with the donation of a part of the collections of German mega collectors Irene and Peter Ludwig. Inaugurated in 2005 in the Palace of Arts as part of the Millennium City Centre project and designed by Zoboki Demeter and Associates, the museum is somewhat eclectic in its collection that spans the entire twentieth century although works by Georg Baselitz, Chuck Close, and Arnulf Rainer are included.
Selected solo exhibitions Ákos Birkás, Chi Peng, László Fehér

Mucsarnok Kunsthalle Budapest

Hosok tere, Dózsa György út. 37
Tue–Wed, Thu 12–8,
Fri–Sun 10–6
Tel +36 1 460 7000
www.mucsarnok.hu
Mucsarnok Kunsthalle Budapest is located in a 1896 neoclassical building that was designed by Albert Schikedanz and renovated in 1995 for contemporary art. The Mucsarnok, or art hall, hosts temporary exhibits and is a publicly run institution that also controls the Ernst Múzeum
Selected solo exhibitions Luc Tuymans, Deimantas Narkevicius, Markéta Othová

Ernst Múzeum

Nagymezo utca 8
Tue–Sun 11–7
Tel +36 1 413 1310
www.ernstmuzeum.hu
Ernst Múzeum was founded in 1912 by Lajos Ernst to house his private collection and presents exhibits on a Kunsthalle system with its sister institution, the Dorottya Gallery, both of which are controlled by the Mucsarnok organization that also runs the Kunsthalle. Gyula Fodor designed the building of the Ernst.
Selected solo exhibitions Wim Delvoye, Andreas Fogarasi

WAX, Winkler Art X-perience

József Attila u. 4–6
Tue–Sun 11–6

Tel +36 1 272 0876

www.waxbudapest.com

In the industrial area of Ujpest, the WAX, Winkler Art X-perience is set in a former nineteenth-century tannery with a new building designed by István Bényei of In-archi Architecture Studio. The center is the brainchild of the art dealer Lajos Kovats who, together with Maron Winkler, initiate the project. Originally when completed in 2001 it was called the MEO Contemporary Art Collection. The current status of the center is not clear therefore the website should be consulted for current exhibition information.

Trafo House of Contemporary Arts

Lillom Str 41

Mon–Fri 2–8, Sat–Sun 5–8

Tel +36 1 456 2040

www.trafo.hu

A multi-use cultural center, the Trafo House of Contemporary Arts was built in 1909 as an electric transformer station and re-opened in 1998 as a concert, theater, and exhibition venue.

Selected solo exhibition Šejla Kameric

Dunaújváros

Institute of Contemporary Art

Vasmu ut. 12

Mon–Sat 10–6

Tel +36 2 541 2220

www.ica-d.hu

In this industrial city formerly known as Stalin City, the Institute of Contemporary Art opened in 2007 to support emerging artists of the region.

Pécs

Pécs Events

2011

Pécs European Capital of Culture

Iceland

Isolated from continental Europe, this Northern Atlantic island between Europe and Greenland offers stunning volcanic vistas and a more limited engagement with international art, which is to be expected based on its relative size and geographic location. Due to the financial crisis of 2008, it is unclear what impact this will have on the cultural sector.

Iceland Resources
www.cia.is
program that offers grants and events
in Iceland, section on museums and
galleries, in English
www.artnews.is
web magazine published every two
months in English
Sjónauki, www.sjonauki.is
Icelandic contemporary arts magazine in
Icelandic and English launched in 2007

Reykjavik

Reykjavik Events
May
Reykjavik Arts Festival

The Reykjavik Art Museum
Hafnarhúsið–Tryggvagata 17,
Kjarvalsstadir–Flokagata 105
Daily 10–5
Tel +354 590 1200
www.artmuseum.is
The Reykjavik Art Museum was found-
ed in 1973 and today has three separate
buildings including Hafnarhusio, which
is a former warehouse in the port area.
Focus here is on Nordic, especially Ice-
landic, art as well as administering a col-
lection of outdoor sculptures that in-
cludes work by Richard Serra.
Selected solo exhibitions Roni Horn,
Hreinn Friðfinnson

National Gallery of Iceland
Fríkirkjuvegi 7
Mon–Fri 9–12 & 1–3
Tel +354 515 9600
www.listasafn.is
Established in the nineteenth century
when the country was under Danish rule,
the National Gallery of Iceland opened in
a purpose-built building in 1951. This
served the museum until new premises
were built in 1987 in a former factory de-
signed by Garoar Halldorsson in 1916.

While heavily concentrating on nine-
teenth- and twentieth-century Icelandic
art, there are also works on view by con-
temporary artists, although the empha-
sis is on regional art.
Selected solo exhibitions Kristjan
Davidsson, Steíngrimur Eyfjörð

Kling & Bang Gallery
Laugavegur 23
Thur–Sun 2–6
Tel +354 696 2209
www.this.is/klingobang
Kling & Bang Gallery opened in 2003 as
an artist-run exhibition center in order to
present temporary exhibitions by both
international and regional artists.

Garðabær

Garðabær Events
2010
The Icelandic Museum of Design and Ap-
plied Art MUDESA opens, PK Arkitek-
tar; due to open in 2010 the Icelandic
Museum of Design and Applied Art,
founded in 1998, features a new build-
ing designed by PK Arkitektar. The brief
here is to create a unique site that will at-
tract visitors from the center of Reykja-
vik, which lies nearby.

Stykkishólmur

Vatnasafn/Library of Water
Bokhlooustigur 17
May–Aug Daily 11–5
www.libraryofwater.is
This permanent installation by American
Minimalist and frequent Icelandic visitor
Roni Horn, the Vatnasafn/Library of
Water is set in a former library on the
west coast of the country. Glass and wa-
ter here fuse into a unique statement on
light and nature. Artangel, the well-re-
garded British art projects firm, manages
the installation itself.

Divided since 1922, the Irish Republic in the twenty-first century has enjoyed prosperity due to the advantages of EU membership while the north continues to be plagued by the residue of the troubles that afflicted it for much of the prior century. The contemporary art situation has flourished in Dublin as the republic has seen itself emerge on the international stage.

Ireland & Northern Ireland

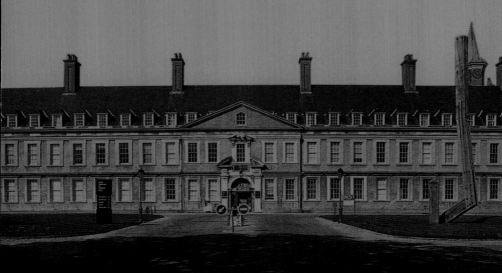

Ireland Resources

Circa, www.recirca.com
Irish contemporary art magazine
seasonal

Dublin

Unrecognizable from the capital that
would have greeted visitors twenty years
ago, Dublin today boasts a wide range of
art institutions that are engaged with pre-
senting art on an international level. In
many ways, the city has managed to forge
an identity that is no longer in the shad-
ow of London.

Dublin Events

September
Culture Night, Dublin

Irish Museum of Modern Art IMMA

Royal Hospital Military
Road Kilmainham
Tue–Sat 10–5:50, Wed 10:30–5:30,
Sun 12–5:30
Tel +353 1 612 9900
www.modernart.ie

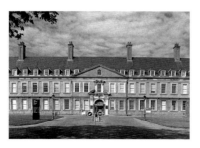

Established in 1991, the Irish Museum
of Modern Art IMMA is to be found at the
seventeenth-century Royal Hospital Kil-
mainham that was renovated for the pre-
sentation of contemporary and modern
art. The accent here is on Irish art, al-
though frequent exhibits by internation-
al artists are included in the program. The
museum is managed by the government
and its opening was a significant event in
the recent history of cultural heritage in
Ireland.
Director Enrique Juncosa, senior curator
Rachel Thomas
Selected solo exhibitions James Cole-
man, Lucian Freud, Shahzia Sikander,
Alex Katz, Thomas Demand

Dublin City Gallery The Hugh Lane

Charlemont House Parnell Square
North
Tue–Thu 10–6, Fri & Sat 10–5,
Sun 11–5
Tel +353 1 222 5550
www.hughlane.ie
Dublin City Gallery The Hugh Lane was
formed in 1908 and since 1933 is set
in the eighteenth-century Charlemont
House. The founding donation of collec-
tor Hugh Lane is heavy on nineteenth-
century French art, and acquisitions con-
tinue of which artist Francis Bacon's
studio, removed here following his death,
was a major coup for the institution.
Director Barbara Dawson
Selected solo exhibitions Adam
Chodzko, Ellen Gallagher, Tacita Dean,
Brian Doherty/Patrick Ireland

The Douglas Hyde Gallery

Trinity College
Mon–Fri 11–6, Thu 11–7,
Sat 11–4:45
Tel +353 1 896 1116
www.douglashydegallery.com
The Douglas Hyde Gallery is the exhibi-
tion space of Trinity College and holds
international quality contemporary art
exhibits. The gallery was opened in 1978
and is located in a purpose-built struc-
ture by Paul Koralek. A further space by
McCullough-Mulvin opened in 2001.
Selected solo exhibitions Willie
Doherty, Thomas Nozkowski, Trisha
Donnelly

Project Arts Centre
39 East Essex Street Temple Bar
Mon–Sat 11–8
Tel +353 1 881 9613
www.project.ie
A multi-use cultural facility hosting exhibits, dance, and theater, the Project Arts Centre opened in 1967 with a new space designed by Shay Cleary Architects inaugurated in 2000. Exhibits here are geared towards emerging regional artists.

Four
119 Capel Street
Tue–Fri 11–5, Thu 11–7, Sat 12–5
Tel +353 0 86 365 1256
www.fourdublin.com
Four is a space presenting four to six yearly temporary exhibits by international and Irish artists.

Limerick

Limerick Events
Spring
ev+a, annual exhibit
(14 March– 24 May, 09)

Limerick City Gallery of Art
Carnegie Building, Pery Square
Mon–Fri 10–6, Thu 10–7,
Sat 10–5, Sun 2–5
www.limerickcity.ie/LCGA
Housing a collection of modern and contemporary Irish art, the Limerick City Gallery of Art is to be found at the historic Carnegie Building. Exhibitions focus on contemporary art, including the juried annual ev+a show.
Selected solo exhibitions Nick Miller, Joe Duggan

Skibbereen, West Cork

Liss Ard
www.lissardgarden.com
A resort and garden retreat, Liss Ard was

created by former gallerist Veith Turske and includes a crater designed by James Turrell. The location is noted for its beauty and the two-hundred-acre estate can be visited although this is a commercial venture.

Sligo

Sligo Resources
Sligoarts.ie

The Model Arts & Niland Gallery
The Mall
Tue–Sat 10–5:30, Sun 11–4
Tel +353 71 914 1405
www.modelart.ie
Currently closed for redevelopment by architects Sheridan Woods, The Model Arts & Niland Gallery opened in 2000 as a multi-use facility in the Model School building originally built in 1862. Featuring the Niland Collection, which is the Sligo Municipal Art Collection formed by Nora Niland and that is based on Irish artists. During the redevelopment that is due to be completed in 2009, the center will present off-site projects.
Director Seamus Kealy

County Waterford

Lismore Castle Arts
late May–September 11–4:45
Tel +353 585 4061
www.lismorecastlearts.ie
In the once derelict west wing of the twelfth-century castle, Lismore Castle Arts opened in 2005 to present temporary exhibits during the summer months. As well as exhibits, there is a private collection of contemporary sculpture on the grounds of the castle owned by the Devonshire family. Sculptures include works by Antony Gormley, Davis Nash, and Franz West.
Selected solo exhibition Richard Long

Belfast, Northern Ireland

Belfast Events
2011
Museum Arts Centre opens,
Hackett & Hall architects

Museum Arts Centre
Announced in 2007, the Museum Arts
Centre will join the current Old Museum
Arts Centre as an exhibition venue in the
center of the city. The Belfast-based ar-
chitects Hackett and Hall will design this
multi use facility on St. Anne's Square
that is projected to open in 2011.

With a long tradition of engaged contemporary galleries, as well as a large collector base, Italy is a country that has been known as the poorest rich country in Europe. This is in part due to the concentration on preservation and restoration of existing monuments. Key to any visit to contemporary art institutions in Italy is an evaluation of time management as frequently museums and institutions are sited outside of main cities. There are several important fairs in Italy as well as the major event La Biennale di Venezia which is a significant feature of the international art calendar.

Italy

Italy Resources

www.artshow.it
Italian-language guide to exhibitions
www.artxworld.com
Italian and English-language art portal
www.exibart.com
Italian-language exhibition guide
www.italianarea.it
Italian and English-language arts
database
www.moussemagazine.it
Milan-based English/Italian-language
arts magazine
www.undo.net
Italian-language art information
Art Diary Italia
yearly guide published by *Flash Art
International*
Abitare, www.abitare.it
monthly architecture and visual arts
magazine based in Milan

Benevento

ARCOS Museo d'arte Contemporanea Sannio
Corso Garibaldi 1
Tue–Fri 4:30–8:30,
Sat–Sun 10–2, 4:30–9:30
Tel +39 824 31 2465
www.museoarcos.it

ARCOS Museo d'arte Contemporanea Sannio is located in the prefecture place in this town that holds many important structures from antiquity. The palace itself was constructed in the early twentieth century and was renovated to house a contemporary art collection in 2005.

Bergamo

GAMeC, Galleria d'arte Moderna e Contemporanea
Via San Tomaso 52
Tue–Sun 10–7, Thu 10–10
Tel +39 035 27 0272
www.gamec.it

With a collection heavily reliant on Italian modernism, the GAMeC, Galleria d'arte Moderna e Contemporanea opened in 1991 in a renovated building formerly housing the Order of Servites which was renovated by Gregotti Associati. **Selected solo exhibitions** Jan Fabre, Pietro Roccasalva, Paolo Ghilardi, Vanessa Beecroft

Biella

Fondazione Pistoletto Cittadellarte
Via Serralunga 27
Fri 4–8, Sat–Sun 11–2,
1:30–6:30
Tel +39 01 52 8400
www.cittadellarte.it

Northeast of Turin in the province of Piedmont, the Fondazione Pistoletto, Cittadellarte was founded in 1998 and stands in a former textile mill. Michelangelo Pistoletto, one of the leaders of the Arte Povera movement, began the center as part of his Progetto Arte program that intends to unify the creative and social economic spheres. The role of the foundation is to be a University of Ideas, or UNIDEE, and to this end hosts artists' residencies and workshops as well as presenting group exhibitions on social themes.

Bologna

Bologna Events
January
ArteFiera Art First, art fair; Art White Night

MAMbo
Museo d'arte Moderna di Bologna
How to get there Near the center of Bologna, MAMbo is accessible via bus 35 from the central station.
Via Don Minzoni 14
Tue–Sun 10–6, Thu 10–10

Tel +39 51 649 6611
www.mambo-bologna.org
(Italian and English)
Exhibitions & Collections Building on
the eighteenth-century to 1945 collec-
tion of the Galleria d'arte Moderna di
Bologna, of which MAMbo is a part,
MAMbo's brief is to collect emerging Ital-
ian art. Formed in 1936, the Galleria be-
gan to outgrow its premises in the sixties
and slowly an initiative was developed to
find new premises for the display of con-
temporary work. MAMbo opened in
2007 and will feature challenging con-
temporary art exhibits.
Building Following Bologna's tenure as
European Capital of Culture in 2000,
funds were available to renovate the for-
mer bread-bakery building in order to
house MAMbo.

Director Gianfranco Maraniello
Selected solo exhibitions Christopher
Williams, Markus Schinwald, Giovanni
Anselmo, Jay Chung, Q Takeki Maeda

Bolzano

Bolzano Events
May
KunStart fair

**MUSEION, Museo d'arte moderna
e contemporanea**
Via Dante 6
Daily 10–8, Thu 10–10

Tel +39 0471 22 3411
www.museion.it
Opened in a new building for the Mani-
festa in 2008, MUSEION, Museo d'arte
moderna e contemporanea has existed

since 1985 and originally was dedicated
to post-1900 modern art but has since re-
focused to the contemporary. With the
new building designed by the Berlin
based KSV Architects, there is a clear in-
tention to provide contemporary art with
an international focus. During its initial
year, the museum was beset by contro-
versy that eventually saw the director re-
moved. Currently, the institution is in
the process of building its collection.
Selected solo exhibitions Günter Brus,
Elmgreen & Dragset

Cagliari, Sardinia

Cagliari Events
TBD: Nuragic and Contemporary Arts
Centre, architect: Zaha Hadid

Nuragic and Contemporary Arts Centre
To be set near the sea on the island of Sar-
dinia, the spectacular new Zaha Hadid-
designed museum, Nuragic and Contem-
porary Arts Centre, was announced in
2006. With a brief to present both the
history of the Neolithic Nuragic culture
of Sardinia and contemporary art exhib-
its, this presents unique issues of organi-
zation to Hadid whose sinuous struc-

tures and forms that echo a sensual modernism will be stretched here to maximum effect.

Caraglio

CESAC, Centro Sperimentale per le arti Contemporanea
Via Cappuccini 29
Mon–Fri 9–12 & 2:30–5:30
Tel +39 171 61 8260
www.cesac.caraglio.com
In the province of Cuneo near the border with France in Piedmont lies the CESAC, Centro Sperimentale per le arti Contemporanea that opened in 1996 in a former Capuchin convent from the seventeenth century. Exhibits and collection here are focused on regional artists.

Codroipo

Villa Manin, Centro d'Arte Contemporanea
Piazza Manin 10, Passariano
Tel +39 432 90 6509
www.villamanincontemporanea.it
Closed in January 2009, this was one of the more impressive sites for contemporary art. The Villa Manin, Centro d'Arte Contemporanea was housed in the historic sixteenth-century villa of Antonio Manin. The Palladian-influenced design of the villa is accompanied by extensive gardens at which today can be found works by artists such as Damian Ortega, Piotr Uklanski, and Paweł Althamer. With a brief to host temporary exhibits, the center has no permanent collection. To reach the center it is necessary to take either taxi or bus from the station of Codroipo, consult the website for further information.
Artistic director Francesco Bonami, curator Sarah Cosulich Canarutto
Selected solo exhibition Hiroshi Sugimoto

Ferrara

Padiglione d'Arte Contemporanea
Palazzo Massari, Corso Porta Mare 5
Tue–Sun 9–1 and 3–6
Tel +39 5 32 24 4949
www.artecultura.fe.it
Padiglione d'Arte Contemporanea is set in the historic Palazzo Massari from the fourteen hundreds and holds temporary exhibitions by contemporary artists.
Selected solo exhibitions Olaf Nicolai, Jessica Stockholder

Florence

Florence Events
2009
Florence Biennale, Biennale Internazionale dell'arte Contemporanea

Genoa

Villa Croce, museo d'arte contemporanea
Via J. Ruffini 3
Tue–Fri 9–6:30, Sat–Sun 10–6:30
Tel +39 010 58 0069
www.museovillacroce.it
Villa Croce, museo d'arte contemporanea opened in 1985 to display the Cernuschi Ghiringhelli Collection of abstraction. The museum is set in a historic villa from the nineteenth century that is located in the center of park. While the collection is focused on modernism, exhibits regularly feature contemporary art.
Selected solo exhibition Allan Kaprow

Gibellina, Sicily

Alberto Burri's Il Grande Cretto
One of the more somber and haunting of contemporary public art works, Alberto Burri's *Il Grande Cretto* was created in 1984 on the ruins of Gibellina that was destroyed in an earthquake in 1968. Cov-

ering the city in a layer of white cement, Burri follows the traditional lanes and streets of the destroyed town. The area around the ruins houses works by Arnaldo Pomodoro and other Italian artists. Currently, there are plans to restore the *Grande Cretto,* a work that places particular demands on conservation.

Grottaferrata

Grottaferrata Events
2009
DEPART Foundation Museum, Grand Traiano Art Complex opens in 2012, Johnston Marklee Architects

DEPART Foundation Museum
Tel +39 06 945 8066
www.departfoundation.org
In the southeast environs of Rome, Grottaferata's DEPART Foundation Museum will open in 2009 as part of the Grand Traiano Art Complex being designed by California-based architects Johnston Marklee. With a focus on Chinese and American contemporary artists the DEPART collection also includes works by Jake & Dinos Chapman, Roxy Paine, and Darren Almond. The center, when completed in 2012, will offer artist residencies.

La Spezia

CAMeC, Centro arte Moderna e Contemporanea della Spezia
Piazza Cesare Battisti 1
Tue–Sat 10–1 & 3–7, Sun 11–7
Tel +39 187 73 4593
www.comune.sp.it/citta/camec
CAMeC, Centro arte Moderna e Contemporanea della Spezia stands in this commercial harbor city in the Liguria region and is located in a former school from the early twentieth century. Renovated by Chiara Bramanti and opened in 2004, the center houses the Cozzani Collection that includes works from Arte Povera, land art, and other movements associated with late twentieth-century contemporary art.

Merano

Merano Arte
Laubengasse 163
Tue–Sun 10–6
Tel +39 473 21 2643
www.kunstmeranoarte.org
Presenting temporary exhibitions, Merano Arte opened in a modest space in the center of Merano in 2001. Set in a former bank, this is primarily a German-language institution due to its South Tyrolean location.
Selected solo exhibitions Donald Baechler, Robert Mapplethorpe

Milan

As a center of the Italian art and design worlds, Milan offers dozens of top-class galleries and exhibition spaces. A unique feature of Milan is the concentration on contemporary design and applied art, including architecture. This emphasis on galleries and design covers the lack of a major art museum, which is symptomatic of a general feature of the Italian cultural landscape. In the coming years, though, Milan will see opening a wealth of new museums and spaces devoted to contemporary art that will further stake Milan's claim to be the center of the Italian art world.

Milan Resources
www.start-mi-net
Italian and English-language gallery information
www.hellomilano.it
English-language guide to exhibitions

Milan Events
March/April

MiArt, Fiera Internazionale d'arte
Moderna e Contemporanea, Milan
September
Weekend in Galleria
2011
Ansaldo City of Cultures opens,
David Chipperfield architect; Museo
d'Arte Contemporanea opens, Daniel
Libeskind architect
2012
Fondazione Prada new location opens,
architect Rem Koolhaas
2014
Fiera Milano, architects: Daniel Libes-
kind, Zaha Hadid, Arata Isozaki, Pier
Paola Maggiora, museum by Libeskind
2015
Expo Milano 2015
TBD: Sesto S. Giovanni, Museum of Con-
temporary Art, architect: Renzo Piano

PAC—Padiglione d'Arte Contemporanea

Via Palestro 14
transport: Metro Line 1–Palestro,
Metro-Line 3–Turati, or tram 1, 2
Tue–Sun 9:30–7, Thu 9:30–9
Tel +39 276 00 9085
www.comune.milano.it/pac
PAC—Padiglione d'Arte Contemporanea
founded in 1947 is the city of Milan's
contemporary art institution and is oper-
ated as a Kunsthalle with no permanent
collection on view. Located in the ex-sta-
bles of the war-damaged Villa Belgioioso
opposite the Giardini Pubblici, the PAC
was renovated by architect Ignazio
Gardella and inaugurated in 1954. The
PAC underwent extensive renovations in
the seventies and then was virtually de-
stroyed by a Mafia bomb in 1993. Subse-
quently rebuilt by original architect
Gardella, the PAC re-opened in 1996.
Director of exhibitions Lucia Matino
Selected solo exhibitions Stephan
Balkenhol, Christian Boltanski, Kim
Soo Ja, Marina Abramovic

Triennale Bovisa

Via Lambruschini 31
transport: suburban railway from
Milano Stazione Nord to Bovisa,
tram 1/3, or Autobus 82/92)
Tue–Sun 11–midnight
Tel +39 236 57 7801
www.triennalebovisa.it
An off-shoot of the Triennale di Milano,
Triennale Bovisa is envisioned as an
ephemeral space due to last only from its
opening in 2006 until 2010. Located in
an industrial neighborhood north of Mi-
lan, Bovisa presents contemporary art
and architecture exhibitions as well as
providing space for lectures and events.
The spaces by Pierluggi Cerri are con-
ceived as sheds and designed to empha-
size their temporary nature.
Selected solo exhibitions Victor Vasa-
rely, Hans Hartung

Triennale di Milano

Viale Alemagna 6
transport: Metro Line 1/2–Cadorna
or bus 61
Tue–Sun 10:30–8:30
Tel +39 2 72 4341
www.triennale.it

Opened in 1933, the Triennale di Mila-
no is located in Giovanni Muzio's land-
mark 1933 Palazzo dell'Arte in the Parco
Sempione. The Triennale was conceived
in Monza in 1923 before its move to Mi-
lan and was planned as a center of mod-

ern decorative and industrial art. As an institution devoted to exhibitions of design and applied art, the Triennale also houses a permanent design collection that has been installed in the new Design Museum located on site. The flexible container design of Muzio has been updated by exhibition spaces conceived by Gae Aulenti and a restructuring of the common areas by Michele De Lucci who also conceived the new Design Museum that opened in December 2007.
Selected solo exhibitions David Lynch, Renzo Piano, Jean Michel Basquiat

Fondazione Arnaldo Pomodoro
Via Andrea Solari 35
Wed–Sun 11–6,
Thu 11–10
Tel +39 289 07 5394
www.fondazionearnaldopomodoro.it
The Fondazione Arnaldo Pomodoro is dedicated to the work of Italian sculptor Arnaldo Pomodoro, part of the Continuita group and heavily influenced by modern sculptors such as David Smith and Alberto Giacometti. Opened in 2005, the foundation offers a prize for young sculptors as well as mounting exhibits on contemporary themes. Set in a former hydraulic lifts factory in the Ansaldo area, the foundation has featured the work of Enzo Cucchi, Jannis Kounellis, Michelangelo Pistoletto, and Alighiero e Boetti.

Fondazione Nicola Trussardi
Piazza della Scala 5
Tel +39 028 06 8821
www.fondazionenicolatrussardi.com
Fondazione Nicola Trussardi founded by Beatrice Trussardi, opened in 1996 in Palazzo Marino alla Scala and since leaving that space in 2003 now has no fixed address. Led by international curator Massimiliano Gioni the foundation has a deserved reputation for the quality of its programming.

Artistic director Massimiliano Gioni
Selected solo exhibitions Paola Pivi, Pawel Althamer, Martin Creed, Anri Sala, Urs Fischer, John Bock

Fondazione Prada
Via Fogazzaro 36
Tue–Sun 10–8
Tel +39 254 67 0515
www.fondazioneprada.org

Run by the Italian fashion house Prada, Fondazione Prada opened in 1995 in a former industrial space to present special projects by international artists, including a project by Thomas Demand at the 2007 Venice Biennale. Plans were announced in March 2008 for the foundation to move to a location in the south of Milan in a building to be designed by Rem Koolhaas.
Artistic director Germano Celant
Selected solo exhibitions Tom Sachs, Tobias Rehberger, Francesco Vezzoli, Steve McQueen

Isola Art Center
Tel +39 34 639 98571
www.isolartcenter.org
Torn down by the city in 2008, the Isola Art Center was founded out of the Isola Art Projects in this suburb of Milan. Opening in 2005 in the Stecca building, the center began a long struggle with the government who wished to turn the property over for real estate development,

eventually losing their struggle. Currently, the center organizes art projects, or interventions, throughout Isola while a more permanent home is sought.

Hangar Bicocca
Via Chiese & viale Sarca
Tue–Sun 11–7, Thu 2:30–10
Tel +39 273 95 0962
www.hangarbicocca.it

In a former industrial factory for manufacturing train motors in the industrial Bicocca district of Milan, Hangar Bicocca presents temporary focused exhibits on contemporary art. The area itself is undergoing tremendous changes as traditional industries move out and gentrification begins.

Selected solo exhibitions Marina Abramovic, Mark Wallinger, Anselm Kiefer

The new **Museo d'Arte Contemporanea** is a project of the city of Milan signifying the city's commitment to the contemporary. Probably the last major European city to build a contemporary art museum, Milan has engaged starchitect Daniel Libeskind who has recently clashed with Prime Minister Silvio Berlusconi over the relative manliness of a curving skyscraper project of the architect's in Milan. This is indicative of the issues facing major architects as they work for the state in areas without a broad commitment to innovation and the contemporary. Early designs for the museum that is located in the old Milan Fair area show a circular structure with five floors and it is due to be completed in 2011. The project is part of a larger master plan for the area to be designed by Libeskind, with collaborators Zaha Hadid, Arata Isozaki, and Pier Paolo Maggiora. The area of the Fiera Milano will include offices, retail, and commercial space, as well Libeskind's contemporary art museum.

A project that in some senses clashes with Libeskind's proposed new museum, a Museo d'Arte Contemporanea, is being planned by the province of Milan in the area of Sesto San Giovanni. To be designed by Renzo Piano, this museum will be housed in the Falck steelworks factory in what is part of a larger rehabilitation effort by Piano of the surrounding industrial area. It waits to be seen if this project can be realized in the light of the announcement of Libeskind's museum.

The Ansaldo industrial area near Porta Genova is the scene for a project under development by David Chipperfield, the English architect much in favor by the museum world of late. The **Ansaldo City of Cultures** will house a wide variety of institutions, from the historical collections of the Castello Sforzesco and the Archaeological Museum to a film school and a center for the study of visual art. Originally housing the Ferrari manufacturing plant, the Ansaldo is part of the industrial heritage that is a feature of Northern Italy. This project is due to be completed in 2011.

Viafarini
Fabbrica del Vapore, Via Procaccini 4
Tue–Sat 3–7
Tel +39 02 668 04473
www.viafarini.org

Viafarini was founded in 1991 and modeled on the German Kunstverein concept of presenting emerging artists as well as residencies. In 2008 Viafarini inaugurated a new space with Careof (Tue–Sat 3–7, Fabbrica del Vapore, Via Procaccini 4, tel +39 02 331 5800, www.careof.org), an organization founded in 1987 to work on special projects. Both can be reached via tram 12 & 14 Bramante/Monumentale stop, tram 29/30 & 33, bus 94 stop Procaccini/Messina or MM2 stop Porta Garibaldi.

Milan (Cinisello Balsamo)

Museo di Fotografia Contemporanea
Villa Ghirlanda, Via Frova 10
Tue–Sun 10–7, Thu 10–11
Tel +39 02 660 5661
www.museofotografia
contemporanea.org
Museo di Fotografia Contemporanea hous-
es several collections of both historic and
contemporary photography and, since
opening in 2005 in the seventeenth-cen-
tury Villa Ghirlandia, has focused as well
on temporary contemporary exhibits. Ci-
nisello Balsamo is located 10 km north of
the center of Milan.
Selected solo exhibition Victor Burgin

Milan Art Areas
In the north of Milan, Via Ventura has
emerged as center for art galleries, design
studios as well as bookstores and lofts.
This area began to be frequented by inno-
vative design firms in 2001 and has bee
dubbed the "Italian Chelsea."

Modena

Modena Resources
www.comune.modena.it/gioarte
Italian-language information on arts
in Modena

Galleria Civica di Modena
Palazzina dei Giardini, Corso Canal-
grande & Palazzo Santa Margherita,
Corso Canalgrande 103
Tue–Fri 10–1 & 3:30–6:30,
Sat–Sun 10:30–6:30
Tel +39 592 03 2911
www.comune.mo.it/galleria
Galleria Civica di Modena opened in
1963 at the Palazzina dei Giardini in the
public gardens as a venue for art exhibi-
tions. In 1983 the Palazzina began con-
centrating solely on contemporary art
and has since produced a string of high-

quality international art exhibitions. The
Palazzo Santa Margherita was added as a
sister venue in 1997 in order to focus on
international photography.
Director Angela Vettese
Selected solo exhibitions Katharina
Fritsch, Lewis Baltz, Mimmo Paladino,
Yayoi Kusama, Ugo Rondinone

Monfalcone

**Galleria Comunale d'arte
Contemporanea**
Piazza Cavour
Mon–Fri 9:30–11:30,
Mon & Wed 3:30–5:30
Tel +39 481 49 4365
www.comune.monfalcone.go.it
Near the Slovenian border in the province
of Gorizia is the Galleria Comunale d'arte
Contemporanea that opened in 2002 in a
former market hall to present both collec-
tions and exhibits that focus regional art.

Naples

This capital of the Campagna region has
developed a reputation for the quality of
its private collections, galleries, and art
museums. While the city has had a diffi-
cult time coping with its sub standard in-
frastructure, including massive issues re-
garding refuse collection, there has been
a marked increase in the liveliness of its
art scene evidenced by the wealth of con-
temporary art institutions located in pal-
aces throughout the city.

**MADRe, Museo d'Arte
Contemporanea Donna Regina**
Via Settembrini 79
Mon, Wed–Thu, Sun 10–9,
Fri–Sat 10–midnight
Tel +39 815 62 4561
www.museomadre.it
Sensitively restored by Portuguese archi-
tect Álvaro Siza, the seventeenth-century

Donna Regina palace houses the MADRe, Museo d'Arte Contemporanea Donna Regina that opened in 2005 to wide acclaim. The museum houses a first-rate collection that includes Francesco Clemente, Jeff Koons, and Richard Serra. **Chief curator** Mario Codognato

Selected solo exhibitions Mimmo Paladino, Jannis Kounellis

Museo di Capodimonte
Via Miano 2 Porta Piccola,
Via Capodimonte
Tue–Sun 8:30–7:30,
Tel +39 848 80 0288
www.capodimonte.spmn.remuna.org
The Bourbon-era palazzo is today the setting for the Museo di Capodimonte that features the Farnese Collection as well as containing a selection of contemporary work. Inaugurated as a museum in 1957 this is the city's main museum.

PAN Palazzo delle Arti
Via dei Mille 60
Wed, Thu, Fri, Mon 9:30–7:30
Tel +39 81 795 8605
www.palazzoartinapoli.net
PAN Palazzo delle Arti is located in the eighteenth-century Palazzo Roccella and that was opened in 2005 by the city of Naples to present contemporary exhibitions. This is the setting for the documentary center for contemporary art established by the city.

Fondazione Morra Greco
Largo Avellino 17
Mon–Fri 10–1:30
Tel +39 081 21 0690
www.fondazionemorragreco.com
Fondazione Morra Greco located in former palace and featuring collection of Maurizio Morra Greco. Boasting works by Candace Breitz, Mark Dion, and Gabriel Orozco, amongst others, this is one of the more impressive of contemporary collections of young international artists.

Selected solo exhibitions Eric Wesley, Gregor Schneider, Tue Greenfort, Jimmie Durham

Piazza del Plebiscito
During the winter months the nineteenth-century Piazza del Plebiscito hosts an annual outdoor sculpture series that has featured Anish Kapoor, Mimmo Paladino, Sol LeWitt, and Rebecca Horn.

**Museo Archivio Laboratorio
Hermann Nitsch**
Vico Lungo Pontecorvo 29/d
Wed–Mon 10–7
Tel +39 081 442 0923
www.museonitsch.org
Opened in September 2008, the Museo Archivio Laboratorio Hermann Nitsch features a photographic archive, objects, and a permanent exhibition on the Orgies Mysteries Theater of the noted Austrian actionist artist.

Nuoro

MAN
Museo d'arte Della Provincia di Nuoro
Via Satta 15
Tue–Sun 10–1 & 4:30–8:30
Tel +39 784 25 2110
www.museoman.it
While housing collections of this province in central Sardinia, the MAN, Museo d'arte Della Provincia di Nuoro also presents contemporary exhibits since 1999 in a renovated nineteenth-century palace.
Director Cristina Collu
Solo exhibitions Aligi Sassu, Ugo Mulas, Erwin Olaf

Padua

Padua Events
November
Arte Padova, modern
and contemporary fair

Fondazione March
Via Armistizio 49
Mon–Fri 10–6
Tel +39 49 880 8331
www.fondazionemarch.org
Intending to engage with international artists, the Fondazione March opened in March 2007 to present temporary exhibits as well as offering residencies and education services. The accent here will be on artists from the Balkans and Eastern Europe.
Selected solo exhibitions Daniel Knorr, Artur Zmijewski

Pesaro

Centro Arte Visive Pescheria
Via Corso XI Settembre 184
Tue–Sun 5:30–7:30
Tel +39 721 38 7651
www.centroartivisivepescheria.it
Devoted to temporary exhibitions, the Centro Arte Visive Pescheria opened in 1996 in a former fish market that was built in the nineteenth century.
Selected solo exhibitions Alfredo Pirri, Annalisa Sonzogni

Pisa

Fondazione Teseco
Via Carlo Ludovico Ragghianti 12
Mon–Fri 2:30–6
www.fondazione.teseco.it
The foundation of the energy firm Gruppo Teseco, the Fondazione Teseco per l'Arte is located in an industrial area and presents cutting-edge exhibits as well as selections from its collection.

Prato

Prato Events
2010
Centro per l'Arte Contemporanea Luigi Pecci extension by Maurice Nio

Centro per l'Arte Contemporanea Luigi Pecci
Via della Repubblica 277, LAM bus 8 from center, 7 from station
Thu–Tue 10–7
Tel +39 574 53 1842
www.museopecci.it
Centro per l'Arte Contemporanea Luigi Pecci is located in an industrial area in the southern suburbs of Prato. The noted Prato industrialist Enrico Pecci founded the institution in memory of his late son, Luigi, to collect and exhibit contemporary art. With a building designed by Florentine rationalist Italo Gamberini the center opened in 1988 and has become a magnet for contemporary art in this region, which is dominated by the historical tourism market. In late 2007 plans were announced for the museum to double in size through a new extension to be designed by Dutch architect

Maurice Nio. Completion is scheduled for 2010.

Artistic director Marco Bazzini
Selected solo exhibitions Anastastia Khoroshilova, Daniel Spoerri, Robert Morris, Flavio Favelli

Reggio Emilia

Collezione Maramotti
Via Fratelli Cervi 66
by appointment
Tel +39 522 38 2484
www.collezionemaramotti.org
Collezione Maramotti houses the collection of the founder of the clothing firm MaxMara, Achille Maramotti, and stands in the former headquarters of MaxMara. The building designed in 1957 by Pastorini and Salvarani opened as an art space in June 2007. Based on artists from post 1945 to today, the collection includes works by Tony Cragg, Luigi Ontani, and Philip Taaffe. MaxMara also founded the MaxMara Art Prize for Women, which is handled in conjunction with London's Whitechapel Gallery.

Rome

Long in the shadow of the northern cities of Milan and Turin, the contemporary art scene in Rome is currently undergoing revitalization with two major museums under constructions as well as new galleries opening. While the city has tremendous problems with finances, as does the rest of Italy, what this means for the arts is unclear although the well-known museum night was canceled in 2008 by the Mayor due to lack of funds.

Rome Events
April
Roma Contemporary art fair, Rome, Italy
October
Roma Art Weekend

January 2010
MAXXI, Museo Nazionale delle Arti del XXI Secolo, architect Zaha Hadid
2012
16a Quadriennale d'arte di Roma, Palazzo delle Esposizioni
TBD: MACRO Museo d'arte Contemporanea Roma extension, architect Odile Decq

GNAM
Galleria Nazionale
d'arte Moderna e Contemporanea
Viale delle Belle Arti 131
Tue–Sun 8:30–7:30
Tel +39 063 22 8221
www.gnam.arti.beniculturali.it
With the construction of the new MAXXI museum, the GNAM, Galleria Nazionale d'arte Moderna e Contemporanea, which houses Italian nineteenth- and twentieth-century works, will see its role in the contemporary diminished, although it will continue to feature work from artists such as Michelangelo Pistoletto, Jannis Kounellis, and Francesco Clemente. Located in an early twentieth-century building designed by Cesar Bazzani the museum was founded in 1833 and represents the emergence of the idea of an Italian nation known as the Risorgimento.

MAXXI
Museo nazionale delle Arti
del XXI Secolo
Via Guido Reni 2–6
Tue–Sun 9–7
Tel +39 658 43 4800
www.maxximuseo.org
A spectacular addition to the city's contemporary scene, the MAXXI, Museo nazionale delle Arti del XXI Secolo is located in a former military barracks and was partially opened in 2002. The new building designed by Zaha Hadid will house two separate institutions devoted to art and architecture respectively, with a col-

lection that features Alessandro Pessoli, Shahzia Sikander, and Anish Kapoor. Envisioned as a national museum for the contemporary, the new museum is a complex design of Hadid featuring interlocking forms and the expressive forms for which she is well known and is due to completely open in January 2010.

Selected solo exhibitions Rosemarie Trockel, Francesco Clemente, Carlo Mollino, Gilbert & George

MACRO
Museo d'arte Contemporanea Roma
Via Regglio Emilia 54
Tue–Sun 9–7
Tel +39 6 671 07 0400
www.macro.roma.museum

The city's contemporary institution, MACRO, Museo d'arte Contemporanea Roma stands in a former industrial complex that housed the early-twentieth-century Peroni brewery and opened as an art center in 2002. MACRO then engaged French architect Odile Decq in 2001 to expand into a site behind the current museum which will be set in a former nineteenth-century slaughterhouse that is an impressive example of industrial architecture. The project has faced numerous delays and an exact deadline for the project has not been determined. The museum's collections are based on post-war Italian art.

Director Danilo Eccher
Selected solo exhibitions Atelier van Lieshout, Ghada Amer, Paolo Canevari, Pedro Cabrita Reis, Erwin Wurm

Palazzo delle Esposizioni
Via Nazionale 194
Tue–Sun 10–8, Fri–Sat 10–10:30
Tel +39 639 96 7500
www.palazzoesposizioni.it
Palazzo delle Esposizioni is a municipal organization that was closed in 2002 for restoration that then stopped in 2004 after the ceiling collapsed. Reopened in late 2007, the palace of expositions, with restoration by Michele de Lucchi of the eighteen-eighties' Pio Placentini-designed palace, the venue hosts traveling exhibitions as well as the Quadrennial of Rome art exhibition.
Selected solo exhibitions Mark Rothko, Gregory Crewdson, Marco Cerolli

Museo Carlo Bilotti
Viale Fiorello La Guardia,
Villa Borghese
Tue–Sun 9–7
Tel +39 060 608
www.en.museocarlobilotti.it
Located in the orangery on the sumptuous grounds of the Villa Borghese that was home to the princely Borghese family, the Museo Carlo Bilotti opened in 2007 to present the donations of collector Carlo Bilotti. Included in the collection are works by Larry Rivers, Andy Warhol, and others, with exhibits geared to contemporary work.

Contemporary Arts Society
Via del Babuino 127
Tel +39 06 699 0832
www.contemporarartssociety.com
Contemporary Arts Society opened in 2006 as a global network of curators and artists and that organizes exhibits in Rome. Check website for current plans.

Fondazione Guastalla
Viale Regina Margherita 262
Tel +39 06 454 21343
www.fondazioneguastalla.com
Fondazione Guastalla opened space for collection in 2008 and is initiative of Giovanni Guastalla. The foundation, whose base is in Milan, includes works by Francesco Vezzoli, Vanessa Beecroft, and Shirin Neshat in its collection.

Rovereto

MART
Museo di Arte Moderna e Contemporanea di Trento e Rovereto
How to get there Within walking distance of the train station at Rovereto, MART is situated 45 minutes from Verona via train or 1 hour from Milan.
Corso Bettini 43
Tue–Sun 10–6, Fri 10–9
Tel +39 424 60 0435
www.mart.trento.it
(Italian, English, and German)

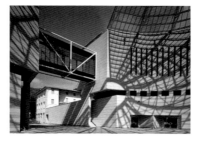

Exhibitions & Collections The MART collections are particularly strong in Futurism and in American Pop Art while also having an emphasis on modernist and contemporary design. Italian artists such as Mario Merz and Alighierro e Boetti augment the American minimalist holdings of a portion of the Panza Collection.
Building Opened in 2003 to a design by Mario Botta, MART evidences many of the stylistic elements of Botta's work such as horizontal rows of stone and a circular plaza. Encompassing a city library, auditorium, as well as a museum, MART was a fusion of the two existing museums in the Trentino region.
Director Gabriella Belli
Selected solo exhibitions Luca Vitone, Gea Casolaro, Douglas Gordon, Luigi Russolo, Chen Zhen, Kendell Geers, Alighiero Boetti

Santomato di Pistoia

Fattoria di Celle
The Gori Collection
Via Montalese 7
sculpture park open by appointment only on weekdays from mid-April to September
Tel +39 573 47 9907
One of the first locations in the world to feature site-specific contemporary art projects, the Fattoria di Celle—The Gori Collection was begun in 1982 by collector Giuliano Gori and today houses works by Magdalena Abakanowicz, Joseph Kosuth, Sol LeWitt, and Richard Long, amongst others. A villa from the late sixteen hundreds, the Fattoria is set in the Tuscan hills near Pistoia and visits can be arranged by emailing goricoll@tin.it.

Seggiano

Il Giardino di Daniel Spoerri
by appointment only April–Oct
Tue–Sun 11–9
Tel +39 564 85 0805
www.danielspoerri.org
In southern Tuscany, the Il Giardino di Daniel Spoerri was created by the Swiss artist Spoerri and opened in 1997. Here can be found works by Dani Karavan, Nam June Paik, Jean Tinguely, and Not Vital, as well as many of Spoerri's own assemblage and object-based artworks.

Siena

SMS Contemporanea
Piazza Duomo 1–2
Tue–Sun 11–7
Tel +39 057 72 2071
www.papesse.org
SMS Contemporanea was located in the Palazzo Piccolomini built in fifteenth century and known as the Palazzo delle Papese Centro Arte Contemporanea until 2008. The center moved in 2008 to the former hospital Santa Maria della Scala in front of the cathedral of Siena where it will continue to house international quality temporary art exhibits.
Director Marco Pierini, curator Lorenzo Fusi
Selected solo exhibitions Leonardo Drew, Nari Ward, Anya Gallaccio, Elisa Sighicelli

Siracusa, Sicily

Galleria Civica d'arte Contemporanea
Via S. Lucia alla Badia 1
Mon 4–8, Tue–Fri 9–1 & 4–8,
Sat–Sun 9–1 & 5–9
Tel +39 093 12 4902
www.montevergini.com
The modest Galleria Civica d'arte Contemporanea is set in a restored monastery complex and presents mainly emerging artists.

Trento

Galleria Civica di Arte Contemporanea
Via Belenzani 46
Tue–Sun 10–6
Tel +39 461 98 5511
www.workartonline.net
Galleria Civica di Arte Contemporanea holds exhibits in various locations around Trento as well as organizing exhibits in a space opened in 1989.
Artistic director Fabio Cavallucci
Selected solo exhibitions Gillian

Wearing, Aernout Mik, Santiago Sierra, Diego Mazzonelli

Turin

Turin has a wide range of contemporary arts institutions and galleries and as such is one of the more rewarding visits for the art traveler. Long a center for contemporary art, Turin has a pedigree and reputation that is emphasized by the annual art fair as well as the Turin Triennale. As with most Italian cities, institutions are located outside the historic center and require planning as regards to travel time.

Turin Resources
www.torinoartgalleries.net
Italian-language gallery listing

Turin Events
November
Artissima International Fair of Contemporary Art in Turin; Night of Contemporary Arts

Turin (Rivoli)

Castello Di Rivoli
Museum of Contemporary Art
How to get there The Castello is 40–60 minutes from the Turin Central Station. A shuttle bus operated by GTT runs from Metro station Fermi to the Castello (5 times per day). Otherwise, bus 36 runs to the hill below the Castello. Be advised the bus route is not well marked. Further information on the website.
Castello Di Rivoli,
Piazza Malfalda di Savoia
Tue–Thu 10–5, Fri–Sun 10–9
Tel +39 119 56 5222.
www.castellodirivoli.org
(Italian and English)
Exhibitions & Collection The collection, while based on Italian artists, is hetero-

geneous with a wide selection of world-class international artists represented. An active collection policy is instituted and elements of the collection are constantly on view with works by Alighiero e Boetti, Bruce Nauman, and Giuseppe Penone. Exhibitions are diverse, ranging from decorative and applied art to cutting-edge contemporary. Due to the exhibition schedule some parts of the complex are closed during installation, so check the website before visiting.

Building Set in a stunning location at the foot of the Alps, the House of Savoy's eighteenth-century Castello was principally conceived by Filippo Juvarra and executed in a haphazard fashion owing to political circumstances. After falling into disrepair during the twentieth century, Andrea Bruno in 1978 began a renovation that brought out the historical significance of the castle while also making it suitable for contemporary art. In 1998 the project was completed with the unique restoration of the Manica Lunga building.

Director Ida Gianelli 1990–, curator Carolyn Christov-Bakargiev
Selected solo exhibitions Gilbert & George, Claes Oldenburg and Coosje van Bruggen, Candice Breitz, Mario Merz, William Kentridge, Pierre Huyghe

Fondazione Sandretto Re Rebaudengo
Via Modane 16

Tue 12–11, Wed–Sun 12–8
closed in August
Tel +39 11 379 7600
www.fondsrr.org

Fondazione Sandretto Re Rebaudengo opened in 2002 with a building designed by Claudio Silvestrin. Patrizia Sandretto Re Rebaudengo's foundation is devoted to exhibiting challenging art by young artists.
Artistic director Francesco Bonami, curator Ilaria Bonacossa

GAM
Via Magenta 31
Tue–Sun 10–6
Tel +39 114 42 9610
www.gamtorino.it

Since 1959 the GAM or Galleria Civica d'Arte Moderna e Contemporanea has housed the municipal modern art collections, which have their roots in Turin's Museo Civico, the first public collection of modern art in Italy. While especially strong in nineteenth-century work as well as with substantial holdings of European modernism, GAM also has prime examples of Arte Povera and Italian analytical painting from the seventies. The building itself is a post-war modernist icon constructed by Carlo Bassi and Goffredo Boschetti.
Director Danilo Eccher
Selected solo exhibitions Mario Merz, Massimo Barotlini

Fondazione Merz

Via Limone 24
Tue–Sun 11–7
Tel +39 1 119 71 9437
www.fondazionemerz.org

One of the major figures of post-war Italian art, the Arte Povera artist Mario Merz's Fondazione Merz is located in a former heating plant and installed with works of the artist who passed away in 2003. Since 2005 the foundation has presented exhibits as well as a permanent collection.

Selected solo exhibitions Mario Merz, Gino De Dominicis, Marzia Migliora

Rivara (Turin)

Castello di Rivara

Piazza Sillano 2
Tel +39 012 43 1122
www.castellodirivara.it

With its setting 30 km from Turin, the Castello di Rivara and its historic neo-Baroque castle opened in 1985 a center for contemporary art. This is a spectacular venue and exhibits have featured emerging international and Italian artists.

Selected solo exhibitions Tino Stefanoni, Alessandro Giorgi, Giorgio Moiso

Varese

Villa Menafoglio Litta Panza

Piazza Litta 1
Feb–mid-Dec Tue–Sun 10–6
Tel +39 332 28 3960
www.fondoambiente.it

Home to the collection of Count Giuseppe Panza, the Villa Menafoglio Litta Panza is located about 50 km north of Milan holds many site specific works by artists such as James Turrell, Maria Nordman, and Robert Irwin. The Panza Collection was begun in the fifties and eventually acquired by the Guggenheim Museum who have permanently loaned the installation works at the Villa to the FAI, Fondo per l'Ambiente Italiano in 1996. The villa itself, located on the Biumo Superiore overlooking Varese, was constructed in the eighteenth century with the main areas stemming from the subsequent designs of Luigi Canonica in 1823. This is a spectacular location and the dialogue between the works remaining on site and the villa architecture is particularly rewarding.

Venice

Venice Events

March
Fresh Venice! Contemporary Art Fair
2009
La Biennale di Venezia, 53rd edition (June–November); Pinault Collection, Customs House opens (June), architect Tadao Ando
2010
12th Venice Architecture Biennale
2011
La Biennale di Venezia, 54th edition (7 June–22 Nov)

Palazzo Grassi

How to get there In the center of Venice, Palazzo Grassi is near the Vaporetto stop of San Samuele.

Camp San Samuele 3231
Daily 10–7, closed Tuesday
from July to November
Tel +39 424 46 4191
www.palazzograssi.it
(Italian, French, and English)

Exhibitions & Collections Purchased in 2005 by French businessman and collector François Pinault (the owner of Christie's and many luxury brands), the Palazzo Grassi exhibits a wide range of contemporary art from the bountiful collection of Pinault. Originally meant to be housed in a purpose-built museum on the Île Seguin in Paris, the collection was

moved to Venice by Pinault due to the lack of support from the French authorities. The collection of upwards of 3,000 works includes pieces by Jeff Koons, Mike Kelley, and Takashi Murakami.

Building Since its construction in 1772 for the Grassi family the Palazzo Grassi has served a variety of functions and has undergone many successive restorations and alterations. Originally built, it is thought, by Venetian architect Giorgio Massari, the Palazzo became the site for the post-Second World War Centro Internazionale Delli Arti e Del Costume which held international quality modern art exhibitions. In 1984 the Palazzo was bought by Gianni Agnelli of Fiat who brought in Gae Aulenti to renovate the space in order to present contemporary art and themed art exhibitions. Pinault's purchase brought in Tadao Ando to further renovate the space in keeping with the innovative nature of the holdings of Pinault.

Director Jean-Jacques Aillagon 2005–
Selected exhibition *Where are we going? Selections from the Pinault Collection, Pinault Collection: A Post Pop Selection Sequence 1*

Punta della Dogana
Dorsoduro 1
Tel +39 415 231 680
A further project of Pinault's, in addition to his Palazzo Grassi, is the renovation of the former customs house, the seven-

teenth-century Punta della Dogana, into a contemporary art center. With a loan of 141 works from his collection to the city of Venice, the center is expected to open in June 2009 with renovations being undertaken by Tadao Ando. Originally the site was intended to be used by the Guggenheim Museum although funds could not be raised for the project.

La Biennale di Venezia
Tel +39 041 521 8711
www.labiennale.org
La Biennale di Venezia is one of the most important events on the international art calendar. Drawing visitors from throughout the art world, the Biennale was first organized in 1895 and is held in odd-numbered years. With curated national pavilions joining an overall structure managed by a major international curator, such as recent editions by Robert Storr and Francesco Bonami, the Biennale is noted for

the controversies and dialogues it engenders. Main exhibits are based at the Giardini with the emerging art exhibition, the Aperto, held at the Arsenale. In addition to the Biennale events are staged throughout the city during the period of the exhibition (usually June to November).

Fondazione Bevilacqua La Masa
Piazza San Marco 71/c
Tel +39 41 523 7819
www.bevilacqualamasa.it

Fondazione Bevilacqua La Masa founded in 1898 by Felicita Bevilacqua who was the widow of General La Masa, and stands in the family palace of Cà Pesaro. The foundation is committed to supporting young artists and to this end offers studios and prizes to emerging artists.

Peggy Guggenheim Collection
Palazzo Venier del Leoni
Wed–Mon 10–6
Tel +39 41 240 5411
www.guggenheim-venice.it
The eclectic Peggy Guggenheim Collection opened in 1951 in the home of noted American modern art champion Peggy Guggenheim. While the focus here is on the modern, the contemporary is occasionally featured in exhibits.
Director Philip Rylands
Selected solo exhibitons Richard Pousette-Dart, Lucio Fontana, Luigi Ontani

Verona

Verona Events
October
Art Verona, Fiera d'Arte Moderna e Contemporanea

Verzegnis

Art Park Parco di Arte Contemporanea Villa di Verzegnis
visits by appointment
Tel +39 433 2344
www.museiprovinciaud.it
Initiated by collector Egidio Marzona, the Art Park Parco di Arte Contemporanea, Villa di Verzegnis houses works by Bruce Nauman, Richard Long, Sol LeWitt, and Dan Graham, amongst others. Set in the hills of the province of Udine, the center opened in 1989 and can be visited by appointment only.

Since joining the European Union in 2004 Latvia has begun, along with the other Baltic Republics, to stake its own identity in the post-Soviet era. This is signified by the ministry of culture's decision to fund the construction of the new Museum of Contemporary Art being designed by Rem Koolhaas. The first major art museum in Latvia in over one hundred years this is a significant development in the country's cultural life.

Riga

Riga Resources
RIXC, www.rixc.lv
electronic art and media center that orga-
nizes projects throughout Europe

Riga Events
2011
Museum of Contemporary Art opens,
architects Rem Koolhaas/OMA

Latvian National Museum of Art
10a K. Valdemara Street
Wed–Mon 11–5, April–Sept Thu 11–7
Tel +371 6732 5051
www.vmm.lv
The Latvian National Museum of Art was
designed by V. Neumann in 1905 as a
purpose-built museum construction and
contains mainly historical art with a con-
centration on Russian and Baltic region-
al artists. Also with an additional location
at Arsenals Exhibition Hall at 1 Torna
Street, the museum is at present the ma-
jor site for temporary exhibits that occa-
sionally feature contemporary work.

Riga Art Space
Kungu Street 3
Tue–Sun 12–7:30
Tel +371 671 81 330
www.artspace.riga.lv

Riga Art Space opened in 2008 in the
underground area of the Town Hall and
presents mainly artists from the Baltic
area in temporary exhibits.

Museum of Contemporary Art
The Rem Koolhaas-designed Museum
of Contemporary Art is due to open in
2011 and incorporates the existing pow-
er plant from 1905 which will be con-
verted into spaces for contemporary ex-
hibits. While the museum is being
funded through private and public
means, this is still a major development
in Latvian culture although the exact
programming and form of the institu-
tion is yet to be announced.

Liechtenstein

Although recently identified as the largest museum buyer in the world, the Royal Family of Liechtenstein does not participate in the contemporary art collections of Vaduz instead relying on purchasing historical art pieces that are shown in the family's palace in Vienna. This is symptomatic of a country that is more known as a tax haven than as a center of culture. Although this situation has been somewhat alleviated by the inauguration of the Kunstmusuem Liechtenstein in 2000.

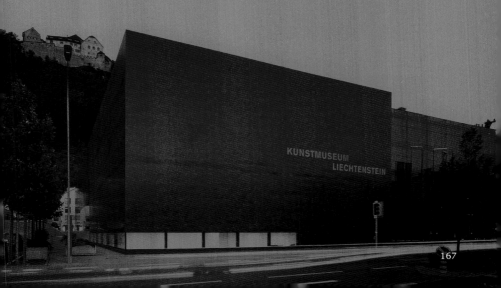

Vaduz

Kunstmuseum Liechtenstein
Städtle 32
Tue–Sun 10–5, Thu 10–8
Tel +423 235 0300
www.kunstmuseum.li

Opened in 2000, the Kunstmuseum Liechtenstein is the only major institution devoted to contemporary art in Liechtenstein. Set in the heart of Vaduz, the black concrete-and-basalt box hides an interior that is basically a white cube. This design by Meinhard Morger, Heinrich Degelo, and Christian Kerez, is well suited to the exhibition program, of changing exhibits that highlight the collection's especially rich Arte Povera works as well as traditional art from the state collections. Vaduz is accessible via bus from the Swiss rail stations of Sargans and Buchs or the Austrian rail station of Feldkirch.

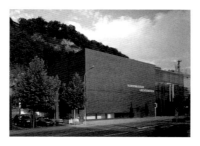

Director Friedemann Malsch 2000–
Selected solo exhibitions Sean Scully, Monika Sosnowska, Jannis Kounellis, Fred Sandback

Lithuania

As with the other Baltic countries, Latvia and Estonia, Lithuania has emerged from the decades under Soviet control with a renewed energy and commitment to forging a dialogue with the rest of the European community. To this end, the country entered into an agreement in 2008 to build a major outlet of the Guggenheim, the Guggenheim Hermitage Vilnius, in the capital city. It is hoped that this project will vault the country into the international art circuit, much in the way that Bilbao did for the Basque region of Spain.

Vilnius

With the designation of European Capital of Culture in 2009, Vilnius will see investment in the cultural sector, as evidenced by the decision in 2008 to construct a branch of the Guggenheim in the country.

Vilnius Events

2009
Vilnius European Capital of Culture; International Contemporary Art Triennial: Urban Stories (June–Aug 09); Art in Unusual Places, Vilnius, Lithuania (19–27 Sept)
2013
Guggenheim Hermitage Vilnius opens, Zaha Hadid architect

Guggenheim Hermitage Vilnius
The Guggenheim Hermitage Vilnius project, due to be completed in 2013, will be designed by noted architect Zaha Hadid and is structured as a mythical ship hovering about a landing strip in what will be a stunning addition to the cultural landscape. The museum itself will house new media art, Fluxus collections, and exhibits by Anthology Film Archives founder and Lithuanian-born filmmaker Jonas Mekas. Also featuring exhibits from Russia's Hermitage Museum, the exact program is still under discussion.

CAC Contemporary Art Centre
Vokieciu 2
Tue–Sun 12–7:30
Tel +370 5 212 1945
www.cac.lt
An independent institution since 1992, the CAC Contemporary Art Centre is the largest space for contemporary art in the Baltic States. Opened in 1968 as Art Exhibition Palace and formerly run as a branch of the Lithuanian State Museum, the center presents temporary exhibits with an accent on artists from the Baltic region.
Selected solo exhibitions Zilvinas Kempinas, Deimantas Narkevicius

Jonas Mekas Visual Arts Center
Konstitucijos pr. 3, 906 kab.
Tel +85 211 2377
www.mekas.lt
Housing a collection of over 2,600 works from the Fluxus movement, the Jonas Mekas Visual Arts Center opened in early 2007 and will, once constructed, move into the new Guggenheim Hermitage Vilnius museum. Born in Lithuania in 1922, the New York City-based Jonas Mekas is considered by many to be the father of American avant-garde cinema.

Vilnius region

Europos Parkas
Joneikiskiu k
Daily 10–sunset
Tel +370 5 2377
www.europosparkas.lt
The outdoor sculpture park, the Europos Parkas was founded in 1991 and houses works by Magdalena Abakanowicz, Sol LeWitt, and Dennis Oppenheim, amongst others. The park was conceived by Lithuanian sculptor Gintaras Karosas and is located a twenty minutes' drive from Vilnius.

Luxembourg

Bordered by Belgium, France, and Germany, Luxembourg's cultural outlook is colored by its position at the center of the European Union. An important banking and finance center, the country has until recently shown little inclination to fund contemporary art. This has changed somewhat with the construction of the new contemporary art museum in Luxembourg City.

Luxembourg Luxembourg City

Luxembourg Resources
www.statemuseen.lu

Luxembourg City

Luxembourg Events
October
La Nuit des Musées

Musée d'Art Moderne Grand-Duc Jean
How to get there Placed on the plateau of Kirchberg overlooking the old town of Luxembourg, the museum can be accessed via bus 16, 125, 192, 194, and 222 from the center.
Park Dräi Eechelon 3
Tel +352 45 378 5960
Wed 11–8, Thu–Mon 11–6
www.mudam.lu (French and English)

Exhibitions & Collections Discussions began in the early nineteen hundreds to construct a contemporary museum to showcase international contemporary art. While the museum had neither collection nor exhibition programme prior to its conception, it has been engaged in building the quality of its program through exhibits by the likes of Wim Delvoye, Glenn Ligon, and Michel Majerus.
Building Built by I. M. Pei with neither collection nor exhibition brief the museum exemplifies the American humanist style of Pei and fits the international outlook of Luxembourg City. Constructed on the ruins of Vauban's 1832 Fort Thüngen (demolished in 1867), the museum is busily carving out an identity for itself.
Director Marie-Claude Beaud 2000–
Selected solo exhibitions Glenn Ligon, Michel Majerus

Casino Luxembourg
Forum d'art contemporain
41 rue Notre Dame
Mon, Wed, Fri 11–7, Thu 11–8, Sat–Sun 11–6
Tel +352 22 5045
www.casino-luxembourg.lu
Casino Luxembourg, Forum d'art contemporain operates on a Kunsthalle system and is located in a building from 1882 known as the Casino Bourgeois. Converted by Urs Raussmüller in 1995 to spaces for art the center hosts a focused program of contemporary exhibits.
Selected solo exhibitions Wim Delvoye, Su-Mei Tse, Luca Vitone

Independent from the former Yugoslavia since 1991, Macedonia has faced issues with a struggling economy and residual fallout from the Balkan conflicts. While facing many issues familiar to other former socialist states, Macedonia has yet to fully engage with the contemporary.

Macedonia

Skopje

MoCA Museum of Contemporary Art Skopje

Samoilova bb
Tue–Sat 10–5, Sun 9–1
Tel +389 2 311 7734
www.msuskopje.org.mk

MoCA Museum of Contemporary Art Skopje originally opened in 1964 and has been located since 1970 in a purpose-built building with renovations continuing until late 2007. Here can be found mainly regional art, although the permanent collection has the occasional international artist such as Georg Baselitz in the collection.

Malta

An independent microstate in the Mediterranean Sea, Malta has enjoyed a rich history due to its strategic location between Europe and Africa. As for the contemporary, there has been little engagement although plans are underway for a Mediterranean Art Project that would bring contemporary art in the form of outdoor sculpture and artists' residencies to the former fortresses of Valletta and Floriana.

Set in the small town of Marsa in southern Malta, Malta Contempoary Art (8 Off Racecourse Street, Tue–Fri 4–8, Sat–Sun 11–6, Tel +356 21 22 6414, www.maltacontemporaryart.com) is the first dedicated contemporary art space on the island and opened in 2008 to present temporary exhibits, films, and performances.

Montenegro

Only recently independent from Serbia, Montenegro is bordered by many of the states of the former Yugoslavia and has a limited commitment to current art as is to be expected of this nascent republic.

In the capital city of Podgorica, the Contemporary Art Centre of Montenegro (Krusevac bb, Tel +81 225 043, www.csucg.cg.yu) was established in 1995 in the nine-teenth-century building complex of Krusevac park. Regional art is stressed here and the Palace of Petrovic houses exhibits as well as a permanent collection.

For a country of its size, the
Netherlands has a varied art
scene with major institutions in all regions and a
lively gallery scene centered in Amsterdam. What
has been of note in recent times is the shifting of
the traditional center of contemporary art in the
Netherlands from Amsterdam to Rotterdam, Eindhoven,
and Groningen. This stasis in the Dutch art scene,
emphasized by Amsterdam's fall from eminence, is
particularly odd considering the history of engagement
in the Netherlands with the contemporary. Funding
for the arts in the Netherlands has also been significantly
reduced in recent times leading to a lack of venues
promoting new and emerging art.

Netherlands Resources

www.galeries.nl
Dutch-language exhibition guide
www.kunstenpubliekeruimte.nl
Dutch-language on-line guide
to public art
www.skor.nl
Dutch/English-language website,
organizes art projects in public spaces
Architecture in Nederland, Jaarboek, NAi
published yearly

Amsterdam

Due to renovations of the existing major institutions, the Stedelijk and Rijksmuseum, Amsterdam has lost much of its traditional vanguard role in the Netherlands arts scene. Galleries and nonprofits, though, have filled the gap, and combined with the particular Dutch emphasis on bold architecture and design, make Amsterdam a unique spot for the art traveler.

Amsterdam Resources

www.akka.nl/agenda
Dutch/English-language listings of exhibitions, AKKA Foundation

Amsterdam Events

May
Art Amsterdam (art fair)
November
Museumnacht; The Vincent Award,
Stedelijk Museum Amsterdam, annual
award
2009
Stedelijk Museum re-opens, Benthem
Crouwel architects
2010
Kunstvlaai A.I.P., biannual festival of
emerging art

Stedelijk Museum

How to get there Due to re-open at the end of 2009, the Stedelijk was located for several years on the 2nd floor of the Post CS Building next to the Centraal Station. As the museum only rented the facility for a limited time this means the museum has no public presence from October 1, 2008 until the new museum opens.
Museumplein
Daily 10–6 (closed until end of 2009)
Tel +31 20 573 2911
www.stedelijk.nl
(Dutch and English)

Exhibitions & Collections The Stedelijk collection is one of the foremost modernist and contemporary collections in Europe although due to the protracted renovations of their building on the Museumplein most of this remains in storage. Since the vibrancy of William Sandberg's post-war directorship, the Stedelijk has lost much of its luster and the drawn-out process of their renovation is systematic of this fact. Exhibits, though, are generally well curated with an international array of artists presented. A satellite space, Stedelijk Museum Bureau (Rozenstraat 59, Tue–Sun 11–5, tel +31 20 422 0471, www.smba.nl) offers challenging art in a rotating exhibition calendar.

Building Designed in 1895 by A. W. Weissman, the Stedelijk is an emblem of fin de siècle Dutch architecture. In 1954 a hugely controversial new wing was opened to show contemporary art, and the wing has since become a casualty of

the Stedelijk's design issues. As of this date the new Stedelijk, to be designed by Dutch architects Benthem Crouwel, is under construction with a proposed completion date of the end of 2009.
Director Gijs van Tuyl 2004–
Curators Jelle Bouwhuis Stedelijk Museum Bureau 2006–
Selected solo exhibitions Ryan Gander, Saskia Olde Wolbers, Eberhard Havekost, Shirin Neshat
Selected solo exhibitions SM Bureau Rosa Barba, Gert Jan Kocken, Nina Fischer / Maroan el Sani, Guido van der Werve

de Appel
Tel +31 20 625 5651
www.deappel.nl
de Appel is an alternative space that exhibits cutting-edge emerging artists in a space in the center of Amsterdam. Well-known internationally for their curatorial program, de Appel is one of the liveliest parts of the Amsterdam cultural scene. Recent efforts to find a new expanded home have not come to fruition.
Director Ann Demeester 2006–
Selected solo exhibitions Richard Hawkins, Alberto de Michele, Jonathan Meese, Steven Shearer, Erik Parker, Melik Ohanian

Huis Marseille
Keizersgracht 401
Tue–Sun 11–6
Tel +31 20 531 8989
www.huismarseille.nl
Benthem Crouwel's restoration of seventeenth-century canal house for the Museum of Photography, Huis Marseille opened in 1999 and is a project of the De Pont Tilburg.

ARCAM
Prins Hendrikkade 600
Tue–Sat 1–5
Tel +31 20 620 4878
www.arcam.nl
René van Zuuk's striking ARCAM is a leading center for architectural publications and exhibitions since being established in 2003.

FOAM
Keizersgracht 609
Daily 10–6, Thu–Fri 10–9
Tel +31 20 551 6500
www.foam.nl
A center for photography exhibitions, Benthem Crouwel-designed FOAM is located on the former premises of the Netherlands Design Institute and since 2002 has presented a wide array of photography.

Netherlands Media Art Institute Montevideo / Time Based Arts
Keizersgracht 264
Tue–Sat, 1st Sun of months 1–6
Tel +31 20 623 7101
www.nimk.nl
Founded in 1978 the Netherlands Media Art Institute Montevideo / Time Based Arts has an extensive archive of media art as well as organizing events and projects at the space in the center of Amsterdam. The Montevideo and Time Based Arts were two separate media art centers that merged in 1993 and have located at the present site since 1997.

Almere

Museum de Paviljoens
Odeonstraat 3–5
Wed & Sat 12–5, Thu–Fri 12–9,
Sun 10–5
Tel +31 3654 50400
www.depaviljoens.nl
Museum de Paviljoens, in the seventies-era town of Almere, exists in the historic Aue Pavilions designed for documenta 9 in 1992 by Paul Robbrecht and Hilda

Daem. The five pavilions were moved to Almere in 1994 after the exhibit in Kassel where works by Luc Tuymans, Gerhard Richter, and others were shown. An unfortunate decision was taken in early 2007 by the right-wing municipal government to destroy the pavilions in 2008 and downgrade the institution to an educational center. Currently, though, the center remains open.

Selected solo exhibition Barbara Visser

Eindhoven

Van Abbemuseum

How to get there Eindhoven is 1 1/2 hours via train from Amsterdam and the Van Abbemuseum is a 10-minute walk from the station.
Bilderdijklaan 10
Tue–Sun 11–5, Thurs 11–9, closed during Carnival
Tel +31 40 238 1000
www.vanabbemuseum.nl
(Dutch and English)

Exhibitions & Collections While focusing on Dutch art, the Van Abbemuseum has a wide selection of European modernism and contemporary art. Established in 1936, the Van Abbemuseum has come to the fore in the post-war period to now be one of the leading, if not the leading, Dutch contemporary art institution. Exhibitions are routinely of interest and focus on international trends

in contemporary art. Led by a succession of energetic museum directors, the institution has forged a reputation for curatorial excellence.

Building Constructed in 1936 by the conservative Delft School architect J. Kropholler, the museum has since come to be highly regarded for its use of light and space. In 1998 an extension by Abel Cahen was opened after several years of attempts by the museum to realize various designs.

Director Charles Esche 2004–, curator Annie Fletcher 2007–

Selected solo exhibitions Dan Perjovschi, Lily van der Stokker, Allan Kaprow, Machteld Teekens, Lee Lozano, Lawrence Weiner

Emmen

The Broken Circle and Spiral Hill

150 Emmerhoutstraat, accessible via bus line 42, stop: Emmerhoutstraat, approximately 15 minutes from Emmen Station
Mon–Fri 9–5

Robert Smithson's *The Broken Circle* and *Spiral Hill* is one of the major land-art projects accomplished by the artist and was created for the Sonsbeek 71 exhibition centered in Arnhem. Located in a reclaimed sand quarry the work is a meditation on destruction and the role of art in everyday life, here worked through symmetry of opposites. After thirty years, the artwork has deteriorated but is still has the ability to impress. Visiting requires a considerable journey as Emmen is 2 1/2 hours by train from Amsterdam and then bus from the station.

Enschede

Rijksmuseum Twenthe

Lasondersingel 129–131
Tue–Sun 11–5

Tel +31 53 435 8675
www.rijksmuseumtwenthe.nl
Founded in 1927 in this center of Dutch textile manufacturing, the Rijksmuseum Twenthe was renovated in 1996 by UN Studio although in 2000 the massive fireworks explosion that caused so much damage to the city of Enschede did considerable harm to the building. Contemporary works are featured in the Depot VBVR that houses the collection of local gallery owners van Beijeren and van Ravenstijn and includes Barry Flanagan, Gilbert & George, and Richard Long.

Groningen

Groningen Resources
www.groningeruitburo.nl
Dutch-language listing of exhibitions and events

Groninger Museum
How to get there The capital of Friesland, Groningen is 2 1/2 hours from Amsterdam by train. The Groninger Museum is located directly opposite the railway station where the city moat once was.
Tue–Sun 10–5
Tel +31 50 366 6555
www.groningermuseum.nl
(Dutch and English)
Exhibitions & Collections The collection of the city of Groningen, the Groninger Museum contains contemporary art, archaeological objects, applied art, and various other items from the history of Groningen. While the permanent collection is geared towards a historical theme, the museum presents innovative contemporary art exhibitions that are uniquely suited to the daring museum design.
Building A unique example of post-modern museum architecture, the Groninger Museum opened in 1994 to a process orchestrated by Alessandro Mendini. Mendini's concept of pavilions to be designed by respectively Philippe Starck, Michele De Lucchi, and Coop Himmelb[l]au is meant to allow viewers to drop their preconceptions about art and reach their own, individual conclusions.

Director Kees van Twist 1999–
Selected solo exhibitions Mariko Mori, Peter Struycken,Osmo Rauhala, Marc Quinn

Video Pavilion
Bernard Tschumi's Video Pavilion (Hereplein) opened in 1990 as part of a music video festival and which also included pavilions by Rem Koolhaas, Zaha Hadid, and Peter Eisenman. The pavilion is not currently in use.

Den Haag (The Hague)

Gemeentemuseum
How to get there Located in the outskirts of Den Haag, the Gemeentemuseum can be reached via bus 24 or tram 17 from the Centraal Station.
Stadhouderslaan 41
Tue–Sun 11–5
Tel +31 70 338 1111
www.gemeentemuseum.nl
(Dutch and English)
Exhibitions & Collections The Gemeentemuseum is known for its outstanding collection of Dutch modernism, including Piet Mondrian's last unfinished paint-

ing for which the museum controversially paid a record sum. Its commitment to modernism notwithstanding, the museum also has frequent group shows of contemporary art although they are on a more modest scale than their modernist versions. Recent exhibits have featured Gunther Förg and Arnulf Rainer a well as regional Dutch art.

Building One of the seminal works of Dutch modernist architecture, H. P. Berlage's 1935 Gemeentemuseum exhibits many of the features that made Berlage's work so revolutionary. The lack of ornament and attention to detail are exemplary and echo other developments in Dutch modernism.

Sites nearby GEM, Museum of Contemporary Art

Director Wim van Krimpen 2001–

GEM
Museum of Contemporary Art
Stadhouderslaan 43
Tue–Sun 12–6
Tel +31 70 338 1133
www.gem-online.com

Next to the Gemeentemuseum is the GEM, Museum of Contemporary Art, developed by architects Bentham Crouwel in 2002, which showcases international artists such as Gavin Turk, Claude Closky, and Daniel Richter as well as artists from Den Haag. Its commitment to contemporary is in direct contrast to the Gemeentemuseum's more modernist bent. Also located in the complex is the Fotomuseum Den Haag (same hours).

Stroom Den Haag
Hogewaal 1–9
Wed–Sun 12–5
Tel +31 70 365 8985
www.stroom.nl

An independent foundation dedicated to promoting discourse on contemporary art and architecture, Stroom Den Haag is one of the most vital places in the Netherlands in which to see emerging art. Since its founding in 1989 Stroom Den Haag has built a reputation for the high quality of their exhibitions and events. **Selected solo exhibitions** Navid Nurr, Thom Vink, Christien Rijnsdorp, Sven 't Jolle, Toby Paterson

Haarlem

De Hallen Haarlem
Grote Markt 16
Thu–Sat 11–5, Sun 12–5
Tel +31 23 511 5775
www.dehallenhaarlem.nl

Featuring temporary exhibits as well as selections from the permanent collection of the Frans Hals Museum, De Hallen Haarlem opened in 1997 in the former nineteenth-century Verweyhal gentlemen's club and the renaissance-era Vleeshal.

Heerlen

Stadsgalerij Heerlen
Bongerd 18
Tue–Fri 11–5, Thu 11–8,
Sat–Sun 1–5
Tel +31 45 577 2210
www.stadsgalerijheerlen.nl

Stadsgalerij Heerlen focuses on Dutch contemporary art and has been located since 2003 in the historic thirties' Glaspaleis that was renovated by Jo Coenen. The gallery also collects contemporary and modern Dutch art, although this is not usually on view.

Maastricht

Maastricht Events
2010
B.A.C.A. Europe Prize,
BonnefantenMuseum Maastricht,
biannual award

Bonnefantenmuseum

How to get there From Amsterdam to Maastricht takes 2 1/2 hours via train to the heart of Limburg, the province wedged between Belgium and Germany.
Avenue Céramique 250
Tue–Sun 11–5
Tel +31 43 329 0190
www.bonnefanten.nl
(Dutch and English)

Exhibitions & Collections The Bonnefantenmuseum's collection ranges from medieval artifacts to contemporary work, with a particular emphasis paid to art from the Maas region. Contemporary art is represented by a wide range of artists from Marcel Broodthaers and Sol LeWitt to Atelier van Lieshout and Franz West. The biannual B.A.C.A. Europe Prize follows on the heels of The Vincent Award, which is now staged at the Stedelijk in Amsterdam.

Building Opened in 1995 to a design by Italian post-modernist Aldo Rossi, the Bonnefantenmuseum is situated on the River Maas in the area formerly occupied by a ceramics factory. Meant to house a large range of art styles and periods, the Bonnefanten incorporates references to other buildings and themes in its sophisticated design.
Director Alexander van Grevenstein, curator Paula van den Bosch
Selected solo exhibition
Mai-Thu Perret

NAi Maastricht

Avenue Céramique 226
Tue–Sun 11–5
Tel +31 43 350 3020
www.naimaastricht.nl

Opened in 2005, the NAi Maastricht is a branch of the Rotterdam-based Netherlands Architecture Institute and is dedicated to presenting exhibits focusing on architecture and urban design, especially of the Meuse region. Housed on the ground floor of the Wiebengahal, the NAi Maastricht is sited next to the Bonnefantenmuseum.

Otterlo

Kröller Müller Museum

How to get there Located in the Nationalpark de Hoge Veluwe, the Kröller Müller can be accessed via bus from Apeldoorn or Ede/Wageningen train stations. On weekends and holidays buses run reduced services so one is best advised to check the exact schedule at www.9292ov.nl.
Houtkampweg 6
Tue–Sun 10–5
Tel +31 31 859 1241
www.kmm.nl (Dutch and English)

Exhibitions & Collections While one of the most impressive collections of modernism in the Netherlands, the collection of turn-of-the-century philanthropists Anton and Helen Kröller Müller is noted for its unique sculpture garden that features seminal works of Gerrit Rietveld and Aldo van Eyck. Contemporary works are continually added to the collection and minimalism and conceptualism are particularly well represented by Richard Serra and Bruce Nauman.

Building Following a recent renovation, the 1938 modernist building by Henry Van de Velde has re-opened. The building is sensitive to its surroundings and has a justified reputation for providing one of the most unique experiences of

modern and contemporary art in nature. An addition in 1977 by Wim Quist added additional exhibition facilities.

Selected exhibitions *Inside Installations Parts I and II; Living Art: On the Edge of Europe*

Rotterdam

A center of international architectural discourse, Rotterdam boasts some of the most distinctive contemporary buildings in Europe as well as international quality museums and art centers. Sensitive to its secondary role to Amsterdam in the Dutch collective consciousness, Rotterdam has forged an identity that is rougher and more based on the new than its northern neighbor.

Rotterdam Resources

www.rotterdamsegaleries.nl
Dutch-language listing of exhibitions
Sculpture International Rotterdam,
www.sculptureinternationalrotterdam.nl
manages the public artworks of the city

Rotterdam Events

February
Art Rotterdam (art fair)
March
Rotterdamse Museumnacht
2009
4th International Architecture Biennale Rotterdam
2010
Museum Boijmans van Beuningen extension opens, architects MVRDV

Museum Boijmans van Beuningen

How to get there Sited in the Museumpark in the center of Rotterdam's Museum quarter.
Museumpark 18–20
Tue–Sun 11–5
Tel +31 10 441 9400
www.boijmans.nl

(Dutch and English)

Exhibitions & Collections Dedicated to a wide range of European art from the Middle Ages to the present, the Boijmans is one of the oldest museums in the Netherlands. The museum opened in 1849 with works donated by Jacob Otto Boijmans and christened the Museum Boijmans. Over the succeeding century and a half, the museum established a collection based not on masterpieces but on educational value. With the bequest of works from the collection of Daniel van Beuningen in 1958, the museum amended its name and began its current life. The contemporary section of the Boijmans has achieved renown over the years and includes work by Bruce Nauman, Matthew Barney, and Olafur Eliasson.

Building Although a conservative building at its inception, Andranus van der Steaur's 1935 Museum Boijmans has become a landmark in the Dutch cultural landscape. Successive additions by Hubert-Jan Henkert (1940), Alexander Bodun (1972), and Robbrecht & Daem (2003) have brought the museum additional facilities without blunting the museums visual impact. In July 2007 MVRDV was commissioned to design a new extension that will open in 2010.

Directors Director Sjarel Ex 2004–, director of exhibitions Cathy Jacob 2008–
Selected solo exhibition Andreas Slominski

Kunsthal

Museumpark Westzedijk 341
Tue–Sat 10–5, Sun 11–5
Tel +31 10 440 3010
www.kunsthal.nl

Rem Koolhaas/OMA's innovative 1993 Kunsthal was conceived with no specific exhibition program or with any idea to housing a permanent collection. Its striking elements and exhibition spaces have been widely studied and discussed in the architecture press. It is perhaps unfortunate that the direction of the institution has steered it away from contemporary art and into the realm of themed art historical traveling exhibitions. The Museumpark, of which the Kunsthal is an integral element, was also designed by OMA in accordance with an urban renewal project.

Director Wim Pijbes 2000–08
Selected solo exhibition Jean Tinguely

NAi

Museumpark 25
Tue–Sat 10–5, Sun 10–5
Tel +31 10 440 1200
www.nai.nl

The home of the history of Dutch architecture as well as current practice, the NAi (Netherlands Architecture Institute) opened in 1993 in a building designed by Jo Coenen. While controversially sited in Rotterdam (rather than Amsterdam) on the OMA redesigned Museumpark Rotterdam, the NAi engages with the current trends in architecture that is a feature of the city. Exhibitions at the NAi are uniformly ambitious and its role at the center of Dutch architectural discourse is crucial.

Director Ole Bouman 2007–

Witte de With

Witte de Withstraat 50
Tue–Sun 11–6
Tel +31 10 411 0144
www.wdw.nl

Witte de With is a contemporary arts center that has developed a reputation for creating innovative international art exhibitions. Since its founding in 1990, Witte de With has assumed a position as one of the leaders in the discourse concerning contemporary art in the Netherlands.

Director Nicolas Schafhausen 2006–, curator Florian Waldvogel 2006–
Selected solo exhibitions Liam Gillick, Isa Genzken, Margaret Salmon, Chloe Piene, Tue Greenfort

Rotterdam Public Sculpture

Paul McCarthy, *Santa Claus* (2001–05), Eendrachtsplein

's Hertogenbosch

SM's Stedelijk Museum

Magisratenlaan 100
Tue & Thu 1–9,
Wed, Fri–Sun 1–5
Tel +31 73 627 3680
www.sm-s.nl

Formerly known as Museum Het Kruithuis, the SM's Stedelijk Museum's-Hertogenbosch was originally founded in 1972 and presents international contemporary art focusing on emerging artists with an accent on design. Located in a temporary building near the railway station, the museum is currently in discussions to open a new space.

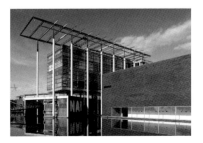

Sittard

Museum het Domein Sittard

Kapittelstraat 6
Tue–Sun 11–5
Tel +31 46 451 3460
www.hetdomein.nl
Located in a former nineteenth-century municipal school in this city near the German border, the Museum het Domein Sittard has forged a reputation for presenting a focused exhibition program of contemporary art.

Tilburg

Tilburg Events
2012
Lustwarande 12

DePont Museum for Contemporary Art
How to get there A textile and industrial center in the south of the Netherlands, Tilburg is 45 minutes via train from Rotterdam and 1 1/2 hours via train from Amsterdam and then via bus line 5 (Goirkestraat stop), bus line 6 (Kwaadeindstraat stop), or a 15–20 minute walk.
Tue–Sun 11–5
Tel +31 13 543 8300
www.depont.nl (Dutch and English)
Exhibitions & Collections Founded at the behest of industrialist Jan DePont in order to create a foundation to stimulate contemporary art. The DePont Foundation was established in 1987 with a limited brief to collect only a few prominent international artists. While this has continued to be the founding principle of the DePont the foundation has expanded into exhibiting a range of contemporary art. Among artists included in the collection are Giuseppe Penone, James Turrell, and Wolfgang Laib.
Building The 1993 opening of the DePont museum in a renovated wool-spinning mill is emblematic of the trend to reno-

vate existing factory structures to serve as art venues. The conversion by Benthem Crouwel here retains the original layout of the mill while allowing for a wide variety of uses.

Director Hendrik Driessen
Selected solo exhibitions Reinoud van Vught, Rene Daniels, Keith Tyson, Charlotte Dumas, Jan Andriesse, Angela Bulloch, Wolfgang Laib, Bill Viola

Utrecht

Utrecht Events
May
Utrecht Museumnacht

Centraal Museum
Nicolaaskerkhof 10, bus 2 from the train station or a 20-minute walk
Tue–Sun 12–5, Fri 12–9
Tel +31 30 236 2362
www.centraalmuseum.nl
Utrecht's Centraal Museum occupies a labyrinth-like building which in the past has housed a medieval cloister and then in succession an orphanage, military stable, and psychiatric hospital. The oldest municipal museum in the Netherlands, the Centraal Museum was founded in 1838 and has a collection that spans works from the medieval to today. Especially noted for their collection of modernist Gerrit Rietveld, the Centraal Museum has recently emerged as one of the

most challenging exhibition venues for contemporary art. The 1999 renovation by Stephane Beel, Lieven Achtergael, and Peter Versseput has brought the museum an up-to-date facility that retains elements from the past.

Director Pauline Terreehorst 2004–

BAK basis voor actuele kunst
Lange Nieuwstraat 4
Wed–Sat 12–6, Sun 1–6
Tel +31 30 231 6125
www.bak-utrecht.nl
An alternative arts institution to the major museums, BAK basis voor actuele kunst since its founding in 1989 has grown into one of the more cutting-edge centers for contemporary work in the Netherlands.

Venlo

Museum van Bommel van Dam
Deken van Oppensingel 6
Tue–Sun 11–5
Tel +31 77 351 3457
www.vanbommelvandam.nl
Opened in 1971, the Museum van Bommel van Dam is based on the highly variable collections of Maarten and Reina van Bommel van Dam. The museum has embarked on an exhibition program that engages with contemporary German art as well as regional Dutch work and will soon put on display elements from the collection.

Director Rick Vercauteren

Zwolle

Museum de Fundatie
Paleis a/d Biljmarkt, Biljmarkt 20
Tue–Sun 11–5
Tel +31 57 238 8177
www.museumdefundatie.nl
Set in a neoclassical building from the nineteenth century renovated by Gunnar

Daan, the Museum de Fundatie opened in 2005 to present the collections of former Boijmans Museum director Dirk Hannema. While the collection is composed of mostly historical art, there are frequent exhibitions of contemporary work.

Norway has in many areas never totally
broken free of tradition in the arts and
this can be seen in the relatively late entry of Norway
into the international contemporary art sphere.
What is currently propelling the arts forward in Norway
is the energy and drive of the Oslo-based Astrup
Fearnley Museum as well as a small but energetic art
scene in the capital.

Norway Resources

www.kulturnett.no
Norwegian-language exhibition and culture guide
www.koro.net
Public Art Norway is an official governmental organization that organizes public art projects

Oslo

Oslo is the center of the Norwegian art scene and its many museums and cultural institutions provide a reasonable variety of arts experiences. As well as the internationally prominent Astrup Fearnley Museum, the Office of Contemporary Art Norway offers artist support as well as hosting programs centered on contemporary art.

Oslo Events

September
Oslo Kulturnatt
2012
new Stenersen Museum opens, architects REX; new Astrup Fearnley Museum of Modern Art, architect Renzo Piano

Astrup Fearnley Museum of Modern Art

Dronningensgate 4
Tue–Fri 11–5, Thu 11–7,
Sat–Sun 12–5
Tel +47 2293 6060
www.afmuseet.no

Established by noted collector and head of ship broker firm Fearnleys Hans Rasmus Astrup, the privately run Astrup Fearnley Museum of Modern Art opened in 1993 and was built by LPO Architecture. The museum has become a destination on the international art circuit that will be furthered enhanced by the opening of the new museum in 2012 in the center of Oslo and that is being designed by Renzo Piano. Featuring the works of Caio Guo-Quiang, Jeff Koons, and Jason Rhoades, amongst others, in what is a growing international art collection.

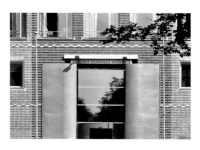

Director Gunnar B. Kvaran
Selected solo exhibitions Richard Prince, Charles Ray, Damien Hirst

National Museum of Art, Architecture and Design

Bankplassen 4
Tue–Fri 11–5, Thu 11–7, Sat–Sun 12–5
Tel +47 22 86 2210
www.nasjonalmuseet.no

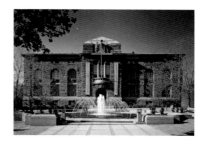

Since its establishment in 2003, the National Museum of Art, Architecture and Design, which incorporates the former National Museum of Contemporary Art that opened in 1990, has struggled to create a unique identity amongst its four separate functions. Set in a former bank from 1907, the contemporary museum also housed the architecture collection that moved to the now re-opened archi-

tecture museum. Included in the contemporary art collections are a large selection of Norwegian artists as well as international artists such as Richard Serra and Ilya Kabakov.

Senior curator Andrea Kroksnes 2001–
Selected solo exhibition Harun Farocki

Norwegian Museum of Architecture

Bankplassen 3
Tue–Wed, Fri 11–5, Thu 11–9,
Sat–Sun 12–5
Tel +47 21 98 2000
www.nationalmuseum.no

Re-opening in 2008, the Norwegian Museum of Architecture is an extension of the nineteenth-century bank building and is meant to house exhibitions on architecture and design. Designed by Pritzker Prize winner Sverre Fehn, the museum is based on a sensitive use of glass and concrete. The museum was originally founded in 1975 and was closed from 2005 to 2008.

Bærum Municipality (Oslo)

Henie Onstad Kunstsenter

Sonja Henies vei 31
Tue–Thu 11–7, Fri–Sun 11–5
Tel +47 67 80 4880
www.hok.no

Figure-kating legend Sonja Henie and Niels Onstad founded the Henie Onstad Kunstsenter in 1968 which houses a large modernist collection as well as works from the immediate post-war European context, with movements such as Cobra well represented. The building itself is a landmark of post-war Scandinavian architecture and was built by Jan Eikvar & Svein-Erik Engebretsen in a neo-Expressionist style.

Selected solo exhibitions Zdenka Rusova, Gunnar S. Gunderson, Victor Boullet

Kunstnernes Hus

Wergelandsvelen 17
Tue–Wed 11–4, Thu–Fri 11–6,
Sat–Sun 12–6
Tel +47 22 85 3410
www.kunstnerneshus.no

An artist-run exhibition space, the Kunstnernes Hus opened in a purpose-built structure in 1931 that has since been recognized as a landmark in Norwegian architecture. As well as showing mainly Norwegian artists in temporary exhibits the center is the home for the well-regarded Office of Contemporary Art Norway.

Stenersen Museum

Munkedamsveien 15
Tue–Sun 11–5, Thu 11–7
Tel +47 23 49 3600
www.stenersen.museum.no

Housing elements of the city of Oslo's art collection, the Stenersen Museum is based on the donations of three collectors, one of which was Rolf E. Stenersen. Opening in 1994, a new museum is currently being developed by REX to open in 2012. Exhibitions here focus on regional art.

Selected solo exhibitions
Rolf M. Aagaard, Sally Mann, Marita Dingus

Oslo Public Art

Norwegian Opera House

www.operautsmykking.no
opened in 2008 with site-specific works by artists such as Olafur Eliasson, Pae White, and from spring 2009, Monica Bonvicini.

Bergen

Bergen Events

September
Kulturnatt Bergen

Bergen Kunstmuseum

Rasmus Meyers allé 3, 7 & 9
Tue–Sun 11–5, May–Sept
Daily 11–5
Tel +47 55 56 8000
www.kunstmuseeneibergen.no

One of the largest museums in the Nordic countries, the Bergen Kunstmuseum houses a large collection of both historical and contemporary work. The museum is located in three separate buildings set aside the Lille Lungegård Lake, with the art collections housed in a neoclassical designed former power company building. Since opening in 2003 the museum has engaged with contemporary in shows in both the Tower Room and other areas of the museum.

Bergen Kunsthall

Rasmus Meyers allé 5
Tue–Sun 12–5
Tel +47 5555 9310
www.kunsthall.no

Bergen Kunsthall is located in three separate areas with a Kunsthall as the main space and a satellite space called No.
Selected solo exhibitions Aernout Mik, Gert & Uwe Tobias, Banks Violette, Rodney Graham

Horten

Preus Museum

Kulturparken Karljohansvern
Tue–Sun 12–5
Tel +47 33 03 1630
www.museumsnett.no

The national museum of photography, the Preus Museum is set in a former naval facility in this city on the southern coast of Norway. Originally a venture of the Preus family, the center was acquired by the government and moved into a Sverre Fehn-renovated building in 2001. The museum frequently presents exhibits by contemporary photographers such

as Ray Metzger, Joachim Koester, and Larry Clark.

Lillehammmer

Lillehammer Kunstmuseum

Stortorget 2
Tue–Sun 11–4, July–Aug Tue–Sun 11–5
Tel +47 61 05 4460
www.lillehammerartmuseum.com

Geared to exhibiting modernism and conservative art trends, the Lillehammer Kunstmuseum opened in 1994 in a building from 1963 designed by Erling Viksjø. The accent here is on Norwegian and regional art.
Selected solo exhibitions Vibeke Tandberg, Graham Nickson

Lofoten Islands

Lofoten Islands Events

2010
Lofoten International Art Festival

Nordland County

Artscape Nordland

Tel +47 75 65 0570
www.skulpturlandskap.no

Located in county in northern Norway, the Artscape Nordland outdoor-sculpture project opened in 1998 in thirty-three different municipalities. With artworks by Per Kirkeby, Antony Gormley, and Luciano Fabro, amongst others, this is an outdoor museum for a region that has no traditional museum structure.

Poland

Perhaps of all the former Eastern Bloc countries, Poland has emerged with the most energetic and committed of contemporary art scenes. Led by lively and focused art institutions located in Warsaw, including the important Foksal Gallery and Foundation, Poland has a dedicated field of contemporary curators, artists, and art professionals. A lack of infrastructure for the arts though, is the major obstacle to the growth of the contemporary scene in the country.

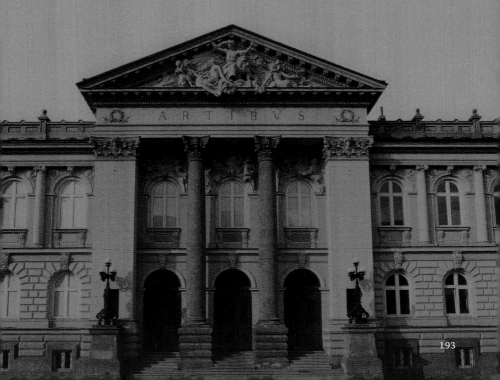

Poland Resources

www.poland-art.com
Polish-language gallery
and museum information
Arteon, www.arteon.pl
Polish-language art magazine
Artluk, www.artluk.pl
Polish-language art magazine

Warsaw

Having experienced an economic boom
in recent times, Warsaw has a variety of
institutions, galleries, and art spaces that
rewards an extended stay. With the tra-
dition of engagement with the contem-
porary emphasized in the Foksal Gallery
and the Zacheta, Warsaw has seen its rep-
utation rise amongst arts professionals
throughout Europe.

Warsaw Resources

*Informator, What's on in
Warsaw Galleries*
bi-monthly free publication

Warsaw Events

May
Museum Night
2009
Views, Deutsche Bank Foundation,
biannual award presented at Zacheta
TBD: Museum of Modern Art opens,
architect Christian Kerez

Zacheta National Gallery of Art

How to get there Set next to Saski Park
in the center of Warsaw, Zacheta is the
oldest exhibition site in Warsaw.
Pl. Małachowskiego 3
Tue–Sun 12–8
Tel +48 22 827 5854
www.zacheta.art.pl
(Polish and English)
Exhibitions & Collections Established
in 1860 by the Society for the Encourage-
ment of the Fine Arts, Zacheta occupies

a unique role in Polish culture. An inno-
vative institution that gradually became
conservative in the early twentieth cen-
tury, Zacheta saw the assassination on
its premises of Polish president Gabriel
Narutowicz in 1922. Following the Sec-
ond World War, the collections were
moved to the Narodny Gallery and the
Zacheta housed the Central Bureau of
Artistic Exhibitions. Following 1989 Za-
cheta became one of the driving forces for
innovative contemporary art in the for-
mer Eastern Bloc, showcasing artists
such as Paweł Althamer, Gustav Metzger,
and Bill Viola.

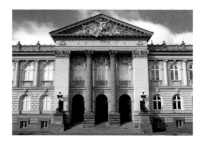

Building Built in 1900 by Stefan Szyller,
architect of many fin-de-siècle Warsaw
buildings, the Zacheta survived the Sec-
ond World War virtually intact.
Director Agnieszka Morawinska
Selected solo exhibition Piotr Wysocki

Centre for Contemporary Art (Centrum Sztuki Wspólczesnej Zamek Ujazdowski)

al. Ujazdowskie 6
Tue–Sun 11–7, Fri 11–9
Tel +48 22 6281 2713
csw.art.pl
The Centre for Contemporary Art (Cen-
trum Sztuki Wspólczesnej Zamek Ujaz-
dowski) is located south of the center
in the historic Ujazdowski Castle. Fea-
turing exhibitions, performances, and
events, the CCA is one of the liveliest

parts of the Polish art scene. The seventeenth-century castle built by Tylman z Gameren has undergone many subsequent renovations and since 1981 has housed the CCA.

Curator Milada Slizinska
Selected solo exhibitions Shirin Neshat, Darren Almond, Flor Garduño

Foksal Gallery Foundation
Górskiego 1A
Tel +48 22 826 5081
www.fgf.com.pl
Foksal Gallery Foundation founded in 1997 by leading Polish curators to be the non-profit arm of the Foksal Gallery, which is noted as one the most important centers for Eastern Bloc art since its establishment in 1966. In 2001 the gallery and foundation were formally separated with the foundation continuing to commission projects and organize exhibitions with an international focus. The Foundation is located in a building from the sixties that is used to stage exhibits and performances.

Director Andrzej Pryzwara
Selected solo exhibition Artur Zmijewski

Instytut Awangardy
Al. Solidarnosci 64, m. 118
by appointment only
Tel +48 22 826 5081
www.instytutawangardy.org
Instytut Awangardy, or the Avant-Garde Institute, opened in 2007 and was initiated by Joanna Mytkowska and Andrzej Przywara. The institute comprises the former studio of noted Polish artist Edward Krasinski that has been left intact since his death. The apartment also served as the studio for Foksal Gallery founder and modernist artist Henryk Stazewski. Set on the top floor of a Warsaw apartment building the studio is one of the more challenging attempts to safeguard an artist's legacy.

Muzeum Sztuki Nowoczesnej w Warszawie
ul. Panska 3
Daily 10–6
Tel +48 22 596 4010
www.artmuseum.pl
Part of a master plan of redevelopment for the center of Warsaw, the Museum of Modern Art, Muzeum Sztuki Nowoczesnej w Warszawie, will be situated between the Swietokrzyski Park and the new City Square. A project of the government, the museum will concentrate on Polish and international contemporary art and will be located in a building designed by Swiss architect Christian Kerez. The design itself rests on simplicity and has echoes of the more reduced forms of modernist design. In 2008 a temporary home was inaugurated across from the future home of the museum to present temporary exhibits. A former furniture store from the Communist era, the modernist space is intended to serve the museum until its projected opening.

Director Joanna Mytkowska

Gdansk

Wyspa Institute of Art
ul. Doki 1/145B
Tue–Sun 12–6
Tel +48 58 320 4446
www.wyspa.netstrefa.pl
Wyspa Institute of Art, Instytutu Sztuki Wyspa opened in 2004 and is located in the Gdansk Shipyard grounds in a former Shipbuilding School. The Wyspa, meaning island in Polish, is one of the more engaged contemporary institutions in Poland offering temporary exhibitions.

Director Aneta Szylak
Selected solo exhibitions Jeanne Susplugas, Artur Zmijewski

Centrum Sztuki Współczesnej Łaznia
ul. Jaskółcza 1

Tue–Sun 12–6
Tel +48 58 305 4050
www.laznia.pl
Situated in a former municipal bath
house from 1905, the Centrum Sztuki
Współczesnej Łaznia re-opened as an art
center in 1998. Exhibitions feature main-
ly regional artists.

Kraków

Kraków Events
May
Museums Night
2011
Museum of Contemporary Arts opens,
Claudio Nardi architect

Bunkier Sztuki Gallery
of Contemporary Art
Płac Szczepanski 3a
Tue–Sun 11–6, Thu 11–8
Tel +48 12 422 1052
www.bunkier.com.pl

Bunkier Sztuki Gallery of Contemporary
Art opened in 1965 in a purpose-built
Brutalist style exhibition building as part
of the BWA system. Renamed Bunkier
Sztuki in 1995 the center has a focused
program of contemporary art which in-
cludes leading Poland-based artists as
well as international art figures.
Director Maria Anna Potocka
Selected solo exhibitions Bogna Burska,
Adrian Paci, Alexis Hunter

Muzeum Narodni w Krakowie
3 Maja Avenue
Nov–April Tue,
Thu & Sun 10–3:30,
Wed, Fri & Sat 10–6,
May–Oct Tue–Sat 10–6, Sun 10–4
Tel +48 12 295 5500
www.muzeum.krakow.pl
Muzeum Narodni w Krakowie was found-
ed in 1883 as the municipal art collection
and had the honor of being the first Pol-
ish national collection of art. In 1950 the
museum absorbed additional collections
and now has eight branches in Kraków.
The contemporary collection is focused
on Polish art although in 2008 it an-
nounced that the Berlin and Cologne gal-
lerist Rafael Jablonka would loan the in-
stitution works from his collection for
display until 2018. This will mark the
first department of contemporary west-
ern art in a Polish national museum.

Museum of Contemporary Art
Announced in 2007, the new Museum of
Contemporary Art will be located in the
former factory of Oskar Schindler, the
German industrialist well known to the
public through Steven Spielberg's film.
To be designed by Claudio Nardi, the new
museum is a further sign of the commit-
ment in Poland to the contemporary and
will be a major addition to the cultural
scene in the country.

Łódz

Muzeum Sztuki
ul. Wieckowskiego 36
Tue 10–5, Wed 11–5, Thu 12–7,
Fri 11–5, Sat–Sun 10–4
Tel +48 42 633 9790
www.muzeumsztuki.lodz.pl
Muzeum Sztuki was founded in 1928 by
artists with the expressed aim of exhibit-
ing contemporary European modernism.
This collection of modernism remains at

the heart of the museum's holdings, although there has been a concerted effort to increase the breadth of the collection. Originally housed in the Łódz City Hall, the Muzeum Sztuki was relocated in 1946 to one of the Poznanski residences and was taken over by the state. Currently the museum offers highly engaging exhibits of contemporary art. In November 2008, the Museum inaugurated a new space the ms2 (Tue–Sun 10–7, Ogrodowa 19) for the display of the noteworthy collection of twentieth- and twenty-first-century art. The building is set in the former factory complex, Manufaktura, that now houses a shopping mall complex so emblematic of the new Poland.
Director Jaroslaw Lubiak

Oronsko

Centre of Polish Sculpture—Centrum Rzezby Polskiej
ul. Topołowa 1
April–Oct Tue–Fri 8–4, Sat–Sun 10–6, Nov–Mar Tue–Fri 7–3, Sat–Sun 8–4
Tel +48 48 618 4516
www.rzezba-oronsko.pl
Centre of Polish Sculpture—Centrum Rzezby Polskiej opened as a sculpture garden in the mid-sixties and, with the restoration in 1985 of a nineteenth-century manor complex, debuted in 1992 as a museum. With over six hundred works, the Centre also hosts temporary exhibits as well as a permanent installation by Magdalena Abakanowicz in the coach house.

Poznan

Poznan Events
2010
Mediations Biennale, 2nd edition

Art Stations Foundation
Połwiejska 42

Tel +48 61 859 6122
www.artstationsfoundation5050.com
Art Stations Foundation, an initative of local collector and brewery magnate Grazyna Kulczyk, is located in the shopping complex and former brewery the Stary Brower. The Foundation presents temporary exhibits and events since 2004 and has presented solo exhibitions by artist such as Eija-Liisa Ahtila.
Director Agnieszka Sumelka

Sopot

Sopot Public Art
Paweł Althamer and Jacek Adamas, *Two Men and a Wardrobe*, work installed in 2008 on beach location, information from State Art Gallery Sopot

Torun

Centre of Contemporary Art Znaki Czasu
13 Wały gen. Silkorskiego Street
Tue–Sun 10–6, Fri–Sat 10–8
Tel +48 56 657 6200
www.csw.torun.pl
Centre of Contemporary Art Znaki Czasu opened in June 2008 to a design by Edward Lach as part of an initiative of the Ministry of Culture. This is the first museum devoting itself solely to the contemporary to open in Poland.
Director Stefan Mucha

Wrocław

Wrocław Events
2009
WRO 09: Expanded City, XIII Media Art Biennale
TBD: new Museum of Architecture in Wrocław opens, architects M & A Domicz, begun 2005
TBD: Wrocław Contemporary Museum, architects Nizio Design International

WRO Art Center—Centrum Sztuki WRO

ul. Widok 7
Tue 2–6, Wed–Sat 10–6, Sun 12–4
Tel +48 71 344 8369
www.wrocenter.pl

WRO Art Center—Centrum Sztuki WRO focuses on media art. Inaugurated in 1988 and since February 2008 has been housed in a former coffee roasting plant where it presents temporary exhibitions as well as organizing the Biennale of Media Art. In its first year with a permanent home, the center has presented an exhibit of Nam June Paik.
Director Agnieszka Kubicka-Dziedszycka
Selected solo exhibition Nam June Paik

BWA Wrocław Galerie Sztuki Współczesnej

ul. Wita Stwosza 32
Tue–Sun 11–6
Tel +48 071 790 2582
www.bwa.wroc.pl

Part of the larger Bureau of Art Exhibitions that was created in the early sixties, the BWA Wrocław Galerie Sztuki Współczesnej presents temporary exhibitions by both international and regional artists in a historic house in the center of Wrocław.
Selected solo exhibition Katarzyna Kozyra

Museum of Architecture

ul. Bernardynska 5
Tue–Wed, Fri–Sat 10–4, Thu 12–6, Sun 11–5
Tel +48 71 344 82 78
www.ma.wro.pl

Opened in a fifteenth-century monastery, the Museum of Architecture in Wrocław is the only museum dedicated to architecture in Poland. With a new building to open by the Polish architecture practice of M & A Domicz the museum will receive a welcome update to its facility.

Wrocław Contemporary Museum

www.muzeumwspolczesne.pl

With a new museum to be designed by Nizio Design International, the new Wrocław Contemporary Museum will house a collection of contemporary art as well as hosting temporary exhibits.

Having shown a remarkable recovery
from the decades of stagnation under
the regime of Salazar, Portugal emerged in the last
decade as a force on the international art stage.
With private collectors, engaged galleries, and
a commitment to new museum design, Portugal
is a rewarding stop for the art traveler.

Portugal

Portugal Resources

L + arte

Portuguese-language monthly magazine devoted to contemporary art

Lisbon

Driven by private art collectors and funders, one of the first of which was Calouste Gulbenkian and whose ranks now include João Oliveira-Rendeiro and Jose Berardo, Lisbon's art scene is one of the more intriguing on the Iberian Peninsula.

Lisbon Resources

LisboArte, lisboarte.com gallery guide

Lisbon Events

November
Arte Lisboa, Feira de Arte Contemporânea

Museu do Chiado, Museu Nacional de arte Contemporânea

Rua Serpa Pinto 4
Tue–Sun 10–6
Tel +351 213 43 2148
www.museudochiado-ipmuseus.pt

Since its founding in 1911, the Museu do Chiado, Museu Nacional de arte Contemporânea has been housed in a former convent that underwent a renovation by Jean-Michel Wilmotte in 1994. Based on post-1850 art, the museum's collection concentrates on Portuguese and regional art forms as well as temporary exhibitions of both modern and contemporary art.

Exhibitions *Centre Pompidou: Novos Media 1965–2003*

CAMJAP

Fundação Calouste Gulbenkian, Centro de Arte Moderna

Rua Dr. Nicolau de Bettencourt

Tue–Sun 10–6
Tel +351 217 82 3474
www.camjap.gulbenkian.org

CAMJAP, Fundação Calouste Gulbenkian, Centro de Arte Moderna, José de Azeredo Pedrigão opened in 1983 to a design for Leslie Martin to present the modernist holdings of the well-regarded Gulbenkian Foundation, who remain a force for the promotion of Portuguese culture through their numerous funding activities. Gulbenkian himself was an Armenian who made a fortune in oil exploration and amassed a huge collection of modern and historical art and whose will, upon his death in 1955 in Lisbon, created the foundation. The foundation's museum, CAMJAP, continues to collect with British contemporary art a particular emphasis.

Director Jorge Molder

Selected solo exhibitions Patrick Faigenbaum, Fernando Calhau, Paulo Rego, Jose Pedro Croft

Alcoitão (Lisbon)

Ellipse Foundation Art Centre

Rua das Fisgas, Pedra Furada
Fri–Sun 11–6
Tel +351 214 69 1806
www.ellipsefoundation.com

In a former warehouse, the banker and mega-collector João Oliveira-Rendeiro's Ellipse Foundation Art Centre was converted to an art facility by Pedro Gadan-

ho in 2006. Set in a small village 20 km south of Lisbon, the Ellipse houses a superlative collection of contemporary art including works by Fischli & Weiss, Mona Hatoum, and Gabriel Orozco, amongst many others. Exhibitions regularly feature artists from the collection.

Fundação Carmona e Costa
Edifício de Espanha, Rua Soeiro Pereira Gomes, Lote 1–6
Wed–Fri 1–8
Tel +351 217 80 3004
www.fundacaocarmona.org.pt
Dedicated to Portuguese applied art, the Fundação Carmona e Costa was created in 1997 and also hosts temporary contemporary art exhibits.

Museu Colacção Berardo
Praça do Império
Daily 10–7
Tel +351 213 612 400
www.museuberardo.pt
Museu Colacção Berardo opened in 2006 and is located in the Exhibition Center of the Centro Cultural de Belém located on the western edge of the city in the Belém district. On permanent loan to the museum is the collection of José Berardo that includes artists such as Andy Warhol, Tony Cragg, and Robert Ryman.
Director Jean-Francois Chougnet

Coimbra

Centro de Artes Visuais
Pátio da Inquisição 10
Tue–Sun 2–7
Tel +351 239 836 930
www.cav.net4b.pt
Centro de Artes Visuais is dedicated to photography and stems from the photography festival held in the city throughout the eighties and nineties. Opened in 2003 the center has holdings of photography, new media art, and video as well

as presenting temporary exhibitions on related themes.

Elvas

MACE Museu de Arte Contemporânea de Elvas
Rua de Cadeia
Tue 2–6, Wed–Sun 10–1, 2–6
Tel +351 268 63 7150
www.cm-elvas.pt
Based on the collection of Antonio Cachola, the MACE Museu de Arte Contemporânea de Elvas was inaugurated in 2007 as the only permanent exhibition of contemporary art in a Portuguese museum. Set in is a former eighteenth-century hospital, the museum's main focus is on Portuguese and regional art.

Guimarães

Guimarães Events
2012
Guimarães European Capital of Culture

Madeira, Calheta

Centro das Artes Casa das Mudas
Val de Amores
Tue–Sun 10–7
Tel +351 291 82 2808
In the west of the island of Madeira in a spectacular location, the Centro das Artes Casa das Mudas was opened with a Paulo David-designed addition in 2005.

This joins the existing sixteenth-century mansion and the addition by David has won praise for its simple yet classical design in which temporary exhibits are featured as well as a collection of primarily modernist art.

Porto

Porto Events

TBD: Serralves 2 opens, architects SANAA

Museu Serralves

Rua D. João de Castro 210
Oct–Mar Tue–Sun 10–7, April–Sept
Tue–Fri 10–7, Sat–Sun 10–8
Tel +351 808 20 0543
www.serralves.pt

A major force on the European contemporary art stage, the Museu Serralves opened in 1999 to a design by Pritzker Prize-winner Álvaro Siza. Set in the Quinta de Serralves that is composed of a private residence and exhibition spaces from the thirties, the museum itself evidences the classical minimalism and attention to detail that is a hallmark of Siza's work. Exhibits here feature some of the more adventuresome artists in

lished in 1989 to focus on contemporary art and the environment. The foundation is currently constructing a facility in the Matosinhos district that will house storage of the contemporary collection as well as present exhibits. SANAA, the innovative Japanese architecture firm, is in charge of the project.

Director João Fernandes 2003–
Selected solo exhibitions Sol LeWitt, Robert Rauschenberg, Lucia Nogueira, Katharina Grosse, Silvia Bächli, Maria Nordman, Massimo Bartolini, Veit Stratmann

Sines

Centro de Artes de Sines

Rua Cândido dos Reis
Daily 2–8
Tel +351 269 86 0080
www.centrodeartesdesines.com.pt

Centro de Artes de Sines presents temporary exhibits on a wide variety of art, from modernism to contemporary to historically themed shows. Opened in 2000 and designed by Aires Mateus Architects the building itself has garnered praise for its approach to the urban context.

Europe and the level of curating is extremely high. There is no permanent collection on view at the Serralves, as the museum is the exhibiting arm of the larger Foundation Serralves which was established

With the state as the main actor in the Romanian contemporary art scene, especially in the creation of new institutions such as the MNAC in Bucharest, the arts in the country remain grounded in attitudes and traditions inherited from the Communist era. While the situation has improved with the founding of the well-regarded Bucharest Biennial, it remains to be seen how much energy the country devotes to furthering a conducive atmosphere in which the contemporary can flourish.

Romania

Romania Resources

Pavilion, www.pavilionmagazine.org,
Romania-based English-language arts
journal
ICCA—The International Center for Contemporary Art, www.icca.ro
successor to Soros Centre and organizes
projects in Romania
www.muzee.org
Romanian and English-language information on museums
www.artline.ro
English and Romanian-language information on arts

Bucharest

The main institutions and infrastructure
for contemporary art can be found in the
Romanian capital Bucharest. The city
hosts the Bucharest Biennial as well as
what has been a disappointing museum
of contemporary art. In many senses the
contemporary art scene has suffered from
lack of thoughtful investment from the
central government although this is alleviated somewhat by the dedicated art
practitioners found in the city.

Bucharest Events

May
Night of the Bucharest Museums
2010
BB4, Bucharest International Biennial of
Contemporary Art (21 May–20 June 2010)

MNAC National Museum
of Contemporary Art

Izvor St. 2–4, wing E4
Wed–Sun 10–6
Tel +4 021 318 9137
www.mnac.ro
MNAC National Museum of Contemporary Art was inaugurated in a new wing
of the eighties-era Palace of the Parliament in 2004. Expectations were high
with the opening of this state-run con-

temporary art institution although so far
only group thematic exhibitions have
been featured as the museum struggles
to find its own voice.

Galeria Noua

Str. Academiei 15
Wed–Sun 11–3 & 3:30–6
Tel +4 0765 273109
www.galerianoua.ro
Galeria Noua concentrates on photography and new media in temporary exhibits by mainly Romanian artists.

Pavilion UniCredit

Sos. Nicolae Titulescu nr. 1
Tue–Fri 12–7, Sat–Sun 2–9
Tel +4 031 103 4131
www.pavilionunicredit.ro
Established in February 2009, the Pavilion UniCredit will hold three to four exhibitions annually in the ground floor of
an apartment building that used to house
a bank. The space is run by *Pavilion*, the
magazine that organizes the Bucharest
Biennial.

Iasi

Iasi Events

2010
Periferic 9, Biennial for Contemporary Art

Sibiu

National Brukenthal Museum

Piata Mare 4–5
summer daily 10–6, winter daily 11–5
Tel +40 217 691
www.brukenthalmuseum.ro
Featuring the collections of eighteenth-century baron Samuel von Brukenthal,
the National Brukenthal Museum is located in a former Baroque palace. While
the accent here is on historical art traditions, there are some works from modern and contemporary Romanian artists.

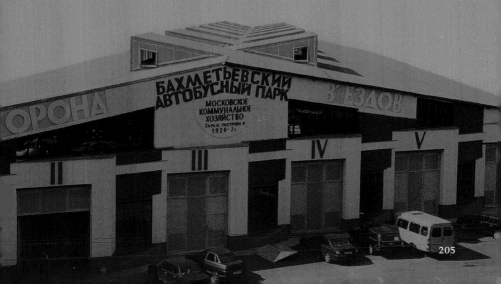

In many ways one of the more perplexing areas of the international art world, the Russian art scene is dominated by private collectors and institutions whose mandate and operating procedures defy scrutiny. As well as this, there are the intriguing Moscow Biennale, Art Moscow fair, and a gallery scene that is quickly gaining international quality galleries eager to capture the Russian market. The state continues to act as a shadowy figure, deeming some art not appropriate for exhibition and attempting to exert control at the periphery. This mixture has created an exciting atmosphere in which it seems anything may be possible.

Russia Resources

www.archcenter.org
the center of contemporary architecture based in Moscow
www.russianmuseums.info
English-language museum information
www.artchornika.ru
Russian and English-language website of the Russian arts magazine *ArtChronika*
newsletter.net.ru
twice yearly newsletter documenting the contemporary art scene
www.izo.com
Russian art blog by Matthew Bown

Moscow

Moscow has exploded onto the international art stage in the last several years with oligarchs opening foundations and art centers, galleries bustling with activity, a major biennial, and a lively art fair, all creating a mix that is stimulating and difficult to navigate for the outsider. The main driver of the art scene here is the private individual, although the Kremlin always remains as a player albeit for now in the background. Where the art scene goes from here is up for conjecture.

Moscow Events

May
Art Moscow (art fair)
December
Kandinsky Prize, annual award
2009
Third Moscow Biennial of Contemporary Art: Against Exclusion (24–29 Sept 2009)
2010
Stella Art Foundation new space opens

Art4.ru contemporary art museum

Moscow Hlinovsky tupik 4
Tue–Thu 11–8, Fri–Sat 11–midnight, Sun 11–8
Tel +7 660 1158
www.art4.ru

Art4.ru contemporary art museum focuses on contemporary Russian artists and was founded by Russian businessman Igor Markin in 2007. Located on the first floor of a central Moscow building the museum is noted for not having any labels for the artwork on view and for a rather idiosyncratic approach to exhibiting.

NCCA
National Centre for Contemporary Arts

ul. Zoologicheskaya 13
Tel +7 095 254 0674
www.ncca.ru

A government agency devoted to supporting the visual arts, the NCCA—National Centre for Contemporary Arts organizes exhibitions and presents events that span historical Soviet era art to contemporary European practice. The strategy here is not easily accessible and, with the website in Russian only, one takes one's chances at this venue. Located in the Polenov house at the back of the Moscow zoo since 2004, NCCA spent ten years in various facilities before moving to its current home.

Garage Centre for Contemporary Culture

Obraztsova st. 19
Tel +7 499 503 1038
www.garageccc.com

With a spectacular location in the Constructivist-era Bakhmetevsky Bus Garage built by Konstantin Melnikov in 1926, the Garage Centre for Contemporary Culture was inaugurated in 2008. Run by Dasha Zhukova, the daughter of the oligarch Aleksandr Zhukov, and partner of Roman Abramovich, this is one of the more exciting ventures of the dynamic art scene in Moscow. With lavish parties making the society pages as well as hiring Gagosian's Mollie Dent-Brocklehurst to design an exhibition program, there are also plans to develop a permanent collection.
Selected solo exhibition Ilya Kabakov

Moscow Museum of Modern Art

Petrovka St. 25.
Daily 12–8, closed last Monday
of every month
Tel +7 495 694 2890
www.mmoma.ru

Set in former neoclassical mansion of the Gubins, the Moscow Museum of Modern Art was founded to show the collections of Zurab Tsereteli which includes works by Armando, the Russian Oleg Kulik, and many modernist masters. In addition to this, in 2003 the museum inaugurated an exhibition hall at Yermolayevsky Pereulok 17 to display temporary exhibits. The focus here is firmly on Russian art of the post-Soviet era, as well as European modernism.

RuArts Foundation and Gallery of Contemporary Art

1 Zachatievskiy st. 10
Daily 11–7
Tel +7 495 637 4475
www.ruarts.ru

RuArts Foundation and Gallery of Contemporary Art opened in 2006 and primarily focuses on young Russian artists working in new media. Housed in a renovated sixteenth-century mansion, RuArts was founded by collector Marianna Sardarova.
Director Sabine Orudjeva

Ekaterina Foundation

21–5 Kuznetsky Most, porch 8, entrance
from Bolshaya Lubyanka Street
Tel +7 495 621 55 22
www.ekaterina-foundation.ru

The cultural organization Ekaterina Foundation was established in 2002 by collector Vladimir Semeninkhin to present special projects in Russia as well as the principality of Monaco, a favorite haunt for many wealthy Russians. Having opened a Moscow space in 2007 the organization concentrates on Russian art

as well as bringing artists such as Andreas Gursky to exhibit in Russia.

Art-center Winzavod

4-th Syromyatnicheskiy perelok 1, str. 6
Tel +7 495 917 4646
www.winzavod.com

Composed of seven buildings that comprised a former winery, the Art-center Winzavod was begun by collectors Roman and Sofia Trotsenko and houses galleries and collections. The complex is located behind the Kursk train station and is home to many leading Russian galleries as well as hosting events such as the newly established Kandinsky Prize ceremony.

Schusev State Museum of Architecture MUAR

Vozdvizhenka str. 5
Tue–Fri 11–7
Tel +7 095 291 2109
www.muar.ru

Schusev State Museum of Architecture MUAR, founded in 1934 by USSR architects, and formerly located in the Donskoi Monastery. The now museum is currently housed on an estate from the eighteenthe century of the Talyzin family. While exhibits here range over the entire history of Russian architecture, there is a particular emphasis on modernist-related trends. The museum is named for Aleksey Schusev who was an architect and co-founder of the museum.

Stella Art Foundation
Skaryatinski pereulok 7
Tel +7 495 691 3407
www.safmuseum.org

The non-profit Stella Art Foundation is a venture of oligarchette Stella Kesaeva to present primarily Russian art of the post-Soviet era with an accent on conceptualist tendencies. While in the process of collection building, the foundation currently organizes projects at spaces both in and outside Russia as well as developing plans to open a new site in 2010. The new site, announced in late 2008, will be in a bus garage built by Konstantin Melnikov in the nineteen-twenties and is near the Kazan Train Station.

Proekt Fabrika
18 Perevedenovsky passage
Tue–Sun 10–8
Tel +7 095 265 39 26
www.proektfabrika.ru

An independent organization devoted to contemporary art, Proekt Fabrika presents temporary exhibits as well as having a claim to be the first independent non-profit art space to open in Moscow in 2004. The former paper factory has hosted mainly Russian exhibits with the first Moscow biennial also being partly staged here.

Baibakov Art Projects
Bersenevskaya Naberezhnaya 6, 3rd floor
Mon–Thu, Sun 12–8, Fri–Sat 12–2
Tel +7 499 230 3930
baibakovartprojects.com

Opened in late 2008, Baibakov Art Projects presents temporary exhibits in the historic modernist Red October Chocolate Factory and is a venture of collector Maria Baibakova.

Perm

Perm State Art Gallery
Komosomolskyi Prospekt 4
Tel +7 3422 12 9524
www.gallery.permonline.ru
(in Russian only)

With a brief to be the most modern art museum in Russia, the new Perm State Art Gallery will be called Perm Museum XXI and has been the topic of an architectural competition that has lasted over a year. With the current museum hosting a wide-ranging collection, the new institution will have a program devoted to contemporary art in what is a city on the eastern perimeter of European Russia, near the Ural Mountains.

St. Petersburg

The State Hermitage Museum
Tue–Sat 10:30–6, Sun 10:30–5
Tel +7 812 710 9079
www.hermitagemuseum.org

One of the most impressive museums and collections in the world, The State Hermitage Museum has undergone dramatic upheavals since the Soviet era and has emerged with a program that has international scope. This is emphasized in the announcement that the London-based Saatchi Collection would present changing exhibits at the General Staff Building as part of the 20/21 project to update the Hermitage collections. Added to this, in early 2008 Rem Koolhaas was announced as designer for the collection display through the year 2014.

NCAA National Centre for Contemporary Art St. Petersburg Branch
Nevsky prospect 111/3
Tel +7 812 717 7967
www.ncca.spb.ru

A branch of the Moscow-based state-run NCAA National Centre for Contemporary Art St. Petersburg Branch provides support for the visual arts as well as organizing exhibitions.

Scotland

For centuries, Scotland has fought a battle with its richer southern neighbor England in an effort to control its own identity and culture. A rise in Scottish Nationalism over the last few decades has only increased a sense of the uniqueness of the Scottish condition that is reflected in the quality of the contemporary art institutions that are present in the country. With its own Art Council as well as other support bodies as well as innovative art galleries and a commitment to public art, Scotland has a distinct place in the contemporary art world.

Scotland Resources
Public Art Scotland,
www.publicartscotland.com
on-line resource for public art
www.24hourmuseum.org.uk
listings and articles on UK museums and
heritage sites

Aberdeen

Aberdeen Events
2010
Peacock Visual Arts new building,
architects Brisac Gonzalez

Peacock Visual Arts
21 Castle Street
Tue–Sat 9:30–5:30
Tel +44 122 463 9539
www.peacockvisualarts.com
Hosting temporary exhibitions, Peacock
Visual Arts opened in 1970 and is cur-
rently in the process of constructing a
new building to be designed by Brisac
Gonzalez. The center has a strong craft
basis with printmaking a focus.
Selected solo exhibitions Ursula
Biemann, Duncan Hart and De Geuzen

Balloch, Loch Lomond Shores

**Gateway Centre,
National Park**
Loch Lomond & The Trossachs
National Park
Tel +44 138 972 2600
www.lochlomond-trossachs.org
In the unique and striking Loch Lomond
and Trossachs area, the Gateway Centre,
National Park features site-specifics works
that were commissioned by Scottish Arts
Council in 2003. This area is one of the
largest parks in Britain and the works in
nature by Siobhan Hapaska, Olaf Nicolai,
and Donald Urquhart, amongst others,
are particularly well integrated into the
surrounding landscape.

Cumbria County, North Yorkshire

Sheepfolds
www.sheepfoldscumbria.co.uk
Began in 1996, Andy Goldsworthy's
Sheepfolds is composed of numerous
site-specific land art works that integrate
with nature and the Cumbrian tradition
of sheep farming, visualized in the sheep-
fold or sheep pen. Check the website for
accessibility and exact location of the var-
ious artworks.

Dundee

Dundee Contemporary Arts
152 Nethergate
Tue–Sat 10:30–5:30, Sun 12–5:30
Tel +44 138 290 9900
www.dca.org.uk

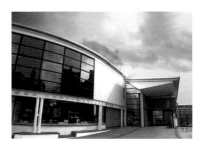

Dundee Contemporary Arts opened in
1999 with a strong regional focus in a
building designed by Richard Murphy
Architects. As with many UK institutions
there is a strong craft focus and, in addi-
tion to exhibitions, films and workshops
are offered.
Selected solo exhibitions Matthew
Buckingham, Elizabeth Oglivie, David
Claerbout

Dunsyre

Little Sparta
June–Oct Fri & Sun 2:30–5

www.littlesparta.org
In the Pentland Hills near Edinburgh is Ian Hamilton Finlay's Little Sparta which houses over 170 of his works in a unique garden setting. Hamilton Finlay was known for his conceptualist approach to history and sculpture that is best seen here, in what many feel is the definitive work of his career.

Edinburgh

The capital of Scotland, Edinburgh is host to major international venues as well as presenting art events in August during the Fringe theater festival.

Edinburgh Events
August
Edinburgh Art Festival

Scottish National Gallery of Modern Art
74 Belfort Road
Mon–Wed, Fri–Sun 10–5, Thu 10–7
Tel +44 131 624 6200
www.nationalgalleries.org
Scottish National Gallery of Modern Art opened in 1960 to house the national art collections in a neo-classical building from 1825 designed by William Burn. With a large sculpture garden landscaped by architectural critic Charles Jencks in 2002, the permanent collection also includes works by Antony Gormley, Damien Hirst, Tracey Emin, and Gilbert & George. The RSA Annual Exhibition is also held here.
Director Richard Calvocoressi –2007
Selected solo exhibitions Andy Warhol, Richard Long, Douglas Gordon, Robert Mapplethorpe

The Fruitmarket Gallery
45 Market Street
Mon–Sat 11–6, Sun 12–5
Tel +44 131 225 2383

www.fruitmarket.co.uk
Originally a fruit and vegetable market, The Fruitmarket Gallery opened in 1974 to present temporary exhibits by international artists. With renovations by Richard Murphy in 1993, the Fruitmarket has become one of the leading UK venues for contemporary art.

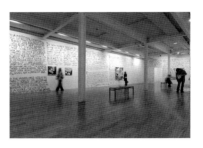

Director Fiona Bradley 2003–, Graeme Murray 1992–2003, Fiona Macleod 1988–1992, founding director Mark Francis 1974–87
Selected solo exhibitions Aernout Mik, Alex Hartley, Trenton Doyle Hancock, Fred Sandback, Marijke van Warmerdam, Callum Innes

Collective Gallery
22–28 Cockburn Street
Tue–Sat 12–5
Tel +44 0131 220 1260
www.collectivegallery.net
Collective Gallery organizes exhibitions, lectures, and events.
Selected solo exhibitions Paul Rooney, Artur Zmijewski

Glasgow

A grittier city than Edinburgh, Glasgow's art scene is also more varied with galleries, institutions, and an internationally renowned art academy adding to the cultural dynamic in what is the third largest city in the UK.

Glasgow Resources
The Common Guild,
www.thecommonguild.com
founded in 2006 and organizes projects,
lectures and events
www.glasgowgalleries.co.uk
gallery information updated every three
months

Glasgow Events
2009
The Briggait Building, renovation , archi-
tects Nicoll Russell Studios
2010
Glasgow International Festival of Con-
temporary Art, biannual event

Gallery of Modern Art GoMA
Royal Exchange Square
Mon–Wed 10–5, Thu 10–8, Sat 10–5,
Fri & Sun 11–5
Tel +44 141 204 5316
www.glasgowmuseums.com
Since 1966 the city-run Gallery of Mod-
ern Art GoMA has presented exhibits by
leading international contemporary art-
ists as well as developing a large collec-
tion of cutting-edge works. The gallery is
housed in a neoclassical building, with a
statue of the Duke of Wellington direct-
ly outside.
Selected solo exhibitions Jim Lambie,
Barbara Kruger

Tramway
25 Albert Drive
Tue–Sat 10–5, Sun 12–6
Tel +44 141 276 0950
www.tramway.org
Tramway is a multi-purpose cultural cen-
ter developed in 2001 and that is located
in a late-nineteenth-century main tram
terminus. Opened in 1988, Tramway has
developed a reputation for its curatorial
acumen and energetic programming.
Director Sarah Munro, Charles Esche
1994 – 97

Selected solo exhibitions Jonathan
Monk, Alex Frost, Lucy Orta

The Lighthouse, Scottish centre for architecture design and the city
11 Mitchell Lane
Mon, Wed–Sat 10:30–5,
Thu 11–5, Sun 12–5
Tel +44 141 221 6362
www.thelighthouse.co.uk
The Lighthouse, Scottish centre for archi-
tecture design and the city was founded
in 1999 with the conversion by Page Park
Architects of Scottish Art Deco master
Charles Rennie Mackinotosh's 1895
building. Exhibits here focus on architec-
ture and design.

CCA
The Centre for Contemporary Arts
350 Sauchiehall Street
Tue–Sat 11–6
Tel +44 141 352 4900
www.cca-glasgow.com
CCA, The Centre for Contemporary Arts
opened in 1992, with a further renova-
tion by Page Park Architects in 2002, to
present temporary exhibits as well as
films and music.

Briggait Building
In 2009, the Briggait Building, formerly
a nineteenth-century fish market, opens
as art facility with studios for artists and
exhibition spaces all of which are being
designed by Nicoll Russell Studios. This
project is being driven by the city who
envisions it as part of the larger Housing
the Visual Arts Strategy.

Isle of Bute

Mount Stuart
Mount Stuart
mid May–end Sept Daily 10–6
Tel +44 1 700 503 877
www.mountstuart.com

Mount Stuart is the ancestral home of the Stuart family, direct descendants of Robert the Bruce, and a major heritage site. The Victorian Gothic House is a significant tourist destination, and since 2001, the house also operates a visual artist program that has featured Anya Gallacio, Nathan Coley, and Thomas Joshua Cooper.

Orkney Islands, Stromness

The Pier Arts Centre
Victoria Street
Mon–Sat 10:30–5
Tel +44 185 685 0209
www.pierartscentre.com
The Pier Arts Centre was established in 1979 and recently re-opened in a purpose-built structure by Reiach and Hall Architects. The center presents mainly regional contemporary art.

Serbia

Following the break-up of Yugoslavia in the
nineties, Serbia entered into a period of turmoil
with the Balkan Wars and the Miloševic era signaling a
break from Western Europe and estrangement from
the international community. The arts in Serbia remain
influenced by the course of recent history and its isolation
from the larger European community.
While other areas of the Balkans flourish, Serbia remains
at the periphery of events on the Continent.

Serbia Resources

www.serbiancontemporaryart.info
Serbian and English-language art news
Remont Independent Art Assocation,
www.remont.co.yu
publishes magazine and engages with
contemporary Serbian art

Serbia Events

May
Noc Muzeja (Museum Night)

Belgrade

Belgrade is the center for the Serbian arts
community with the long-standing Oc-
tober Salon as well as a growing arts com-
munity. Following the NATO bombing
of the Serbian capital in 1999, the city has
attempted to disentangle itself from the
legacy of the Socialist era and the ensu-
ing decade of strife in the Balkans. This is
still very much a work in progress.

Belgrade Events

July/August
Belgrade Summer Festival
October
October Salon (2 Oct–15 Nov 09)

MoCAB Museum
of Contemporary Art Belgrade

Usce 10, Blok 15, Novi Beograd
Wed–Mon 10–5
Tel +381 11 311 5713
www.msub.org.yu

Re-opening in 2000, the MoCAB Muse-
um of Contemporary Art Belgrade was
originally founded in 1958 and was in-
augurated in 1965 in a building designed
by Ivan Antic and Ivanka Raspopovic.
The permanent collection features main-
ly Yugoslav-era artists from post 1900 al-
though the exhibition program is inter-
national in focus.

Novi Sad

Novi Sad Events

TBD: Museum of Contemporary Art,
architects Claiborne Markov Ruccolo

Museum of Contemporary Art
Vojvodina

Dunavska 37
Tel +381 21 661 3526
www.msuv.org
In the province of Vojvodina, the Muse-
um of Contemporary Art Vojvodina
opened in 1966 as the Gallery of Con-
temporary Art and only became museum
in 1996. While the museum concen-
trates on collecting and exhibiting arts
from the region, there are plans to enter
a different era with a new building in
the process of being designed by the
Canadian-Serbian architectural practice
Claiborne Markov Ruccolo.

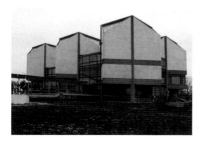

Since declaring independence from the **Slovakia**
Czech Republic in 1992 Slovakia has
been engaged in nation building which, at this stage,
has yet to feature a commitment to contemporary art and
instead has embarked on creating a unique Slovakian
identity embodied in the new extension for the Slovak
National Gallery set to open in 2009. As other former
Eastern Bloc countries have found, Slovakia has had to
deal with the legacy of the Communist era that affects
much of its approach to cultural policies.

Slovakia Resources

Slovak-language website on museums

Slovakia Events

May
Noc Múzeí a Galérií

Bratislava

Set on the Danube River near the Austrian border, Bratislava as the capital of Slovakia has a limited presence in the contemporary sphere. Its proximity to Vienna would seem to make this an ideal location for contemporary galleries and institutions, all of which are sorely lacking in the city.

Bratislava Events

2009
Slovak National Gallery extension, architects BKPŠ Kusý-Panák

Foundation—Center for Contemporary Arts

Kozia 11
Tel +421 2 5441 3316
www.ncsu.sk
Foundation—Center for Contemporary Arts was begun as part of the George Soros-funded Soros Centers for Contemporary Arts that were established throughout Eastern Europe following the collapse of Communism. Since Soros eliminated support for these centers in 1999, the foundation has struggled to maintain itself as a private-support arm for the arts in Slovakia.

Danubiana Meulensteen Art Museum

Bratislava-Cunovo-vodné dielo
May–Sept Tue–Sun 10–8, Oct–April
Tue–Sun 10–6
Tel +421 2 6252 8501
www.danubiana.sk
The personal museum of the Dutch entrepreneur and art collector Gerard H. Meulensteen, Danubiana Meulensteen Art Museum opened in 2000 to a design by Peter Zalman. With a collection based on Cobra artists as well as conservative commercial art, this is a very idiosyncratic institution.

Slovak National Gallery

Riecna 1
Tue–Sun 10–6
Tel +421 2 5443 2081
www.sng.sk
The new extension for the Slovak National Gallery to be designed by architects BKPŠ Kusý-Panák is scheduled to open in 2009. The Slovak National Gallery runs several institutions throughout the country and the Bratislava branch includes contemporary and modern Slovakian art in the collection. The gallery itself was established in 1949 and housed in the Esterházy Palace with an extension built in 1977.

Kosice

Kosice Events

2013
Kosice, European Capital of Culture

Medzilaborce

Andy Warhol Museum of Modern Art

A Warhol Street
Tel +421 939 31207
www.region.sk/warhol/index2.html
In northeastern Slovakia, Medzilaborce is the home of Andy Warhol's parents and now houses the Andy Warhol Museum of Modern Art that opened in 1991 and is devoted to Warhol and his family's origins. Included in this collection are twenty-three works by Warhol lent from the Foundation in New York, as well as memorabilia and paintings by Warhol's brother, Paul Warhola.

With many issues in common with
its Balkan neighbors, Slovenia has
nevertheless emerged as a strong part of the European
community with a commitment to the arts that has been
enhanced by the arrival of funds from the European
Union. Museums and cultural institutions have benefited
from this situation although the contemporary is yet to be
a focus for the government. A key figure in the Slovenian
art community, the noted late curator Igor Zabel was
the driving force behind many of the initiatives in the post-
Yugoslav era.

Ljubljana

The capital of Slovenia has a Mediterranean aspect as it is heavily influenced by Italian culture although this is tempered by its Central European heritage. A museum boom of sorts followed the joining of the European Union in 1984 although contemporary art institutions were not created at this time.

Ljubljana Events

TBD: Museum of Contemporary Art Metelkova, architects Groleger Arhitekti

Moderna Galerija Ljubljana
Museum of Modern Art
www.mg-li.si

Closed for renovation from 2007, the Moderna Galerija Ljubljana, Museum of Modern Art is housed in the former barracks of the Yugoslav Army. The Moderna Galerija collects mainly twentieth- and twenty-first-century Slovenian art and is the locus for Slovenia contemporary art. The genesis of the Moderna was in the need to create a home for contemporary art that did not fit into the Narodna Galerija and its collection of pre-twentieth century art. At the behest of noted collector Dr. Izidor Cankar, the architect Edvard Ravnikar designed the Moderna, which was partially completed before the Second World War interrupted work in 1941. In post-war Yugoslavia, the Moderna presented social realism as well as offering challenging contemporary art exhibitions. The Moderna also operates the Mala Galerija (Tue–Sun 10–6, Tue–Sun 10–6, Tomsiceva 14, Tel +386 1 241 6800) in the center of Ljubljana.

Museum of Contemporary Art Metelkova

A branch of the Moderna Galerija, the Museum of Contemporary Art Metelkova is located in the Slovenian capital's former nineteenth-century army barracks. Dubbed the "white cube" and designed by local architects Groleger Arhitekti this will be administered by the city's Moderna Galerija. For years, the former army barracks have been the scene for a nascent arts scene that was first initiated by squatters in 1993.

SCCA-Ljubljana
Metelkova 6
Tel +386 1 431 8385
www.scca-ljubljana.si
SCCA-Ljubljana organizes exhibitions and projects around the city since its founding in 1994.

Maribor

Maribor Events
2012
Maribor European Capital of Culture

With the rise of regional autonomous areas
following the end of the Franco regime,
culture became a primary component of raising the
profile of previously neglected cities. Bilbao, the capital
of the Basque province, being the most notable example
of this trend. Almost no city of size is without a newly
constructed contemporary art museum. A further
development has been the rise of foundations and
private organizations to fill the gap that exists between
regional institutions and the support of the federal
government. Spain's vibrant institutions are scattered
from Galicia to Catalunya and are a unique feature
of the European art scene.

MACBA Museu d'Art Contemporani de Barcelona

Spain Resources
www.masdearte.com
Spanish-language art guide
www.phedigital.com
Photo España site in Spanish with inter-
national photography news
www.arteinformado.com
Spanish-language art information
El Pais
Sunday supplement *Babelia*
ABCD, www.abc.es/abcd
supplement in *ABC* newspaper
El Cultural, www.elcultural.es
Friday supplement in *El Mundo*
newspaper

A Coruña

Fundación Caixa Galicia
Canton Grande 21–24
Mon–Sat 12–2 & 6–9,
Sun 12–2
Tel +34 981 18 5060
www.fundacioncaixagalicia.org
Fundación Caixa Galicia was designed by
English architect Nicholas Grimshaw to
house the headquarters of the banking
foundation. Since opening in 2006, the
foundation has presented temporary ex-
hibitions which feature modern and con-
temporary work.

**MACUF Museo Arte Contemporaneo
Union Fenosa**
Avenida de Arteixo 171
Tue–Sat 11–2 & 5–9:30,
Sun 11–2
Tel +34 981 91 1476
www.macuf.es
A contemporary art museum founded by
the Spanish energy firm Union Fenosa,
the MACUF, Museo Arte Contempora-
neo Union Fenosa opened in 2005 and
presents both regional and international
art exhibitions. The museum is set out-
side the center of the city near the main
train station.

Fundación Luis Seoane
San Francisco s/n
Tue–Sat 11–2, 5–8, Sun 11–2
Tel +34 981 21 6015
www.luisseoanefund.org
The Fundación Luis Seoane opened in
2003 in a location near the waterfront in
the historic district of A Coruña. The foun-
dation presents a wide range of exhibits
which regularly feature contemporary art
and culture and was founded by the art-
ist Luis Seoane in 1996 and includes
works by the artist in the collection.

Alicante

**MUA Museo de la Universidad
de Alicante**
San Vicente del Raspeig,
Apdo. Correos 99
Mon–Fri 10–8, Sat 10–2
Tel +34 965 90 9466
www.mua.ua.es
The museum of the local university, the
MUA Museo de la Universidad de Alican-
te was inaugurated in 1999 to a design by
Alfredo Payá Benedito and presents tem-
porary exhibitions by regional artists as
well as a wide ranging collection.
Selected solo exhibitions Riccardo
Cordero, Silvia Sempere

Andratx, Mallorca

Centro Cultural Andratx
Tue–Fri 10:30–7, Sun 10:30–4
Tel +34 971 13 7770
www.ccandratx.com
Founded by Danish gallery owners Jacob
and Patricia Asbæk, the Centro Cultural
Andratx presents changing exhibitions at
a site in the Tramontana Mountains thir-
ty minutes from Palma. Exhibitions here
focus on cutting-edge contemporary
work and the center is one of more chal-
lenging in Spain. Also located on site is
the Art Foundation Mallorca that orga-

nizes exhibits as well as an international-
ly regarded artist residency program. Exhi-
bitions have featured Cosima von Bonin,
Markus Oehlen, and Jittish Kallatt.

Avilés

Avilés Events
2010
Centro Cultural Internacional Oscar Nie-
meyer opens, Oscar Niemeyer architect

Centro Cultural Internacional Oscar Niemeyer
www.niemeyercenter.org
Set to open in 2010 in the Asturias town
of Avilés, the Centro Cultural Internacio-
nal Oscar Niemeyer is being designed by
Brazilian modernist and architectural
icon, Oscar Niemeyer. Part of an urban-
regeneration project, the center will fea-
ture exhibition spaces as well as other cul-
tural aspects including theater and film.

Badajoz

MEIAC, Museo Extremeño e Iberoamericano de Arte Contemporáneo
Virgen de Guadalupe 7
Tue–Sun 10–1:30 & 5–8
Tel +34 924 01 3060
www.meiac.org
Near the Portuguese border in the prov-
ince of Extremadura, the MEIAC, Museo
Extremeño e Iberoamericano de Arte
Contemporáneo is a unique building
that opened in 1995 to a design by José
Antonio Galea and that incorporates a pre-
exisiting prison. While exhibits here fo-
cus on Spanish, Portuguese, and Latin
American art, this is one of the more in-
triguing museum designs that emerged
from the post-Franco-era Spanish muse-
um boom.
Selected solo exhibitions Marta de
Menezes, Julio González Bravo

Barcelona

During the Franco regime Barcelona and
Catalunya were pushed to the margins
with the Catalan culture under constant
assault. The city has emerged from this
period with a wealth of contemporary
arts institutions that outshines Madrid
and the rest of Spain. A curious element
of this renewed vigor is that the gallery
scene has not kept pace and one must
look to Madrid, which is much richer in
galleries. In 2009, an announcement that
the Centre d'Art Santa Mónica will face
re-organization is a blow to the cultural
life in the city.

Barcelona Resources
www.artbarcelona.es
bi-monthly gallery guide
www.artmontjuic.cat
art guide to institutions
in Montjuïc area
wwww.galeriescatalunya.com
guide to art galleries
in Catalunya province

Barcelona Events
May
Swab Barcelona International Contem-
porary Art Fair; La Nit dels Museus
May/June
LOOP Barcelona (video art fair)
July
La Noche en Blanco
2009
Centre d'Art Santa Mónica closes;
Fundació Joan Miró– Joan Miró Prize

MACBA Museu d'art Contemporani
How to get there In the heart of the
seedy Raval area at Plaça dels Àngels 1.
Summer 24 June–24 Sept Mon & Wed
11–8, Thu–Fri 11–12, Sat 10–8,
Sun 10–3, Winter 25 Sept–23 June Mon,
Wed–Fri 11–7:30, Sat 10–8, Sun 10–3
Tel +34 934 12 0810

www.macba.es
(in Catalan, Castellano, and English)
Exhibitions & Collections MACBA has a well-deserved reputation for presenting engaging exhibitions by international art figures as well as a permanent collection of post-war art that, while heavy on Catalan and Spanish artists, does include work by the likes of Vito Acconci, Jean-Michel Basquiat, and Daniel Buren. **Building** Completed in 1995, the building by Richard Meier echoes many of his previous designs in its use of pristine white spaces illuminated by generous use of sunlight as well as a large central ramp and atrium. What mars the design is the treatment of the exhibition spaces, which allow for a cramped installation of the permanent collection and a focus more on the circulation areas than on the art spaces. Still, this is a striking building although its original intention of urban regeneration has not fully materialized yet. A satellite space in the church opposite the main building adds space for temporary exhibits.

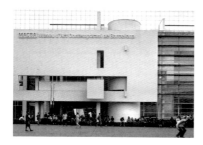

Director Manuel J. Borja-Villel 1998–2007, Bartomeu Mari 2008–, chief curator Chus Martinez 2008–
Selected solo exhibitions Joan Jonas, Carlos Pazos, Peter Friedl, Janet Cardiff & Georges Bures Miller, Pablo Palazuelo

Fundació Joan Miró
Parc de Montjuic

Oct–June Tue–Sat 10–7, Thu 10–9:30, Sun 10–2:30, July–Sept Tue–Sat 10–8, Thu 10–9:30, Sun 10–2:30
Tel +34 934 43 9470
www.bcn.fjmiro.cat
Fundació Joan Miró opened in 1975 on Montjuic to a design by noted modernist architect and friend of Miró, Josep Lluís Sert. The institution focuses on Miró and modernism but has a vigorous program of supporting international contemporary art, through the Espai 13 space as well as the presentation of the Joan Miró Prize for contemporary art.
Selected solo exhibitions Olafur Eliasson, Claes Oldenburg & Coosje van Bruggen, Sean Scully, Douglas Gordon

CaixaForum Fundació Catalunya
Avinguda Marques De Comillas 6–8
Tue–Sun 10–8, Sat 10–10
Tel +34 934 76 8600
www.fundacio.lacaixa.es
Opened in 2002 to house the CaixaForum Fundació Catalunya, the modernist Casa Ramon is, a textile factory designed by Josep Puig i Cadafalch that was converted by Arata Isozaki in 2002 to present art exhibits, concerts, lectures, and other cultural events. The striking use of brick by Puig I Cadafalch in this former mattress factory contrasts with the sleek contemporary work of Isozaki creating a forum for the exhibits hosted by the foundation of the Catalan savings bank La Caixa. Exhibits range from photo to film to contemporary art as well as historical themes.
Selected solo exhibition Candida Höfer

CCCB
Centre de Cultura Contemporània de Barcelona
Calle Montalegre 5
Tue–Sun 11–8, Thu 11–10
Tel +34 933 06 4100
www.cccb.org

Next to MACBA, the CCCB, Centre de Cultura Contemporània de Barcelona is located in the nineteenth-century Casa de la Caritat almshouse and furthered the urban renewal of the Raval area. With a new building and renovation carried out by Helio Piñon and Albert Viaplana, the center opened in 1994 with a brief to produce mainly group exhibitions on social themes. This has led to a more diffuse exhibition policy that does not foreground contemporary art but rather its relation to societal concerns.

Fundació Antoni Tàpies
Arago 255
Tue–Sun 10–8
Tel +34 934 87 0315
www.fundaciotapies.org
Dedicated to the work of the Catalan abstract painter Antoni Tàpies, the Fundació Antoni Tàpies opened in 1990 in a unique modernist Lluís Domènech i Montaner-designed building. While dedicated to the work of Tàpies in the form of a permanent exhibition, exhibits regularly feature contemporary art in the form of themed shows. During the first half of 2008 the foundation will close for needed renovation of the historic facility.
Director Rosa Maria Malet, director Manuel J. Borja-Villel 1990–98, chief curator Nuria Enguita Mayo

Centre d'Art Santa Mònica
La Rambla 7
Tue–Sat 11–8, Sun 11–3
Tel +34 933 16 2810
www.centredartsantamonica.net
With a tradition of presenting challenging exhibitions by international contemporary art figures the Centre d'Art Santa Mònica is located in a former Renaissance convent at the foot of the Ramblas and restored by Helio Piñon and Albert Viaplana in 1988. Operating on a Kunsthalle system, the center has forged a

unique identity within Barcelona and the wider art world. In early 2009 the center will be closed by the Catalan Ministry of Culture and will re-open as Arts Santa Monica (www.artssantamonica.cat) in April 2009.
Director Ferran Barenblit –2008
Selected solo exhibitions Dora García, Ceal Floyer, Christian Jankowski, Dave Hullfish Bailey, Fernando Sánchez, Jack Pierson, Francesc Ruíz

Bilbao

Guggenheim Bilbao
How to get there Set on the Nervión River, in an area formerly blighted by decay, the Guggenheim Bilbao is a spectacular landmark bisected by the Puente de la Salve Bridge.
Abandoibarra Et. 2
Tue–Sun 10–8, July–August
Daily 10–8
Tel +34 944 35 9080
www.guggenheim-bilbao.es
(Spanish, Euskara, French, and English)

Exhibitions & Collections Composed of the disparate collections of the Guggenheim in New York and Venice, the Guggenheim Bilbao has been actively engaged in creating an identity for itself through commissioned artworks by Jeff Koons, Francesco Clemente, and Richard Serra. Begun as an initiative in the early nineties by the Basque regional govern-

ment, the museum is a byword for the boom in international museum building and the disneyfication of the museum experience.

Building Built by Frank Gehry and orchestrated by museum director Thomas Krens, the Guggenheim Bilbao has become one of the most singular buildings of the twentieth century since its opening in 1997. With titanium forms enclosing oblique spaces, the museum is a triumph of engineering. The museum exists as part of a large urban-regeneration program by the Basque government and stands as a testimony to planning and architectural vision.

Director director-general Juan Ignacio Vidarte 1997–

Selected solo exhibition
Anselm Kiefer

Sala Rekalde

Alameda de Recalde 30
Tue–Sat 11–2 & 5–8:30, Sun 11–2
Tel +34 944 06 8755
www.salarekalde.bizkaia.net

Sala Rekalde opened in 1991 in a Bilbao storefront and is geared to emerging Spanish, with an accent on artists from the Basque region, as well as selected international art figures.

Director Pilar Mur

Selected solo exhibitions Lara Almárcegui, Erlea Maneros, Iñaki Imaz, Sean Snyder

Blanca

Blanca Events

TBD: MUCAB opens, architect Martin Lejarraga

MUCAB Museo y Centro de Arte de Blanca

An initiative of the Murcian province, MUCAB Museo y Centro de Arte de Blanca is opening in a building designed by

Martin Lejarraga with a focus on contemporary work and especially works on paper.

Burgos

CAB
Centro de Arte Caja de Burgos

Calle Saldaña s/n
Oct–April Tue–Fri 11:30–2 & 5:30–8:30, Sat 11–2:30 & 5–9, Sun 11–2:30, May–Sept Tue–Fri 11:30–2 & 5:30–8:30, Sat 11–2:30 & 5–9, Sun 11–2:30 & 5–8
Tel +34 947 25 6550
www.cabdeburgos.com

The former capital of Franco's Nationalist Spain during the Spanish Civil War, the historic town of Burgos houses the CAB Centro de Arte Caja de Burgos that presents and collects primarily Spanish artists. The center is run by the local banking firm, Caja de Burgos.

Selected solo exhibitions Florentino Diaz, Fernando Maquieira, David Shrigley, Marc Silver

Cáceres

Cáceres Events

2010
Centro de Artes Visuales Helga de Alvear opens, architects Mansilla + Tuñón

Museo Vostell Malpartida

Ctra. de los Barruecos,
s.n. Malpartida de Cáceres
21 Mar–20 June Tue–Sun 10–1:30 & 5–7:30, June Sun 10–2:30, 21 June–20 Sept Tue–Sun 10–1:30 & 5–8, July–Aug Sun 10–2:30, 21 Sept– 20 Mar Tue–Sun 10–1:30 & 4–6:30, Nov–Dec Sun 10–2:30
Tel +34 927 01 0812
www.museovostell.org

Featuring the sculptures of German artist Wolf Vostell, part of the Happening and Fluxus movements of the sixties, the Museo Vostell Malpartida opened in

1976 in the village of Malpartida that is a 15 minute drive from Caceres. Vostell is particularly well known for his sculptures with cars embedded in concrete and which deal with themes of destruction and decay. The center was founded by Vostell and features particularly photogenic vistas at the site of this former wool factory.

Centro de Artes Visuales Helga de Alvear

Due to open in 2010, the Centro de Artes Visuales Helga de Alvear will house the collections of Madrid dealer de Alvear. The historic building being renovated for contemporary art by Mansilla + Tuñón will house a portion of the extensive collections of de Alvear, who is a German-born gallerist and who represents many of the leading figures of the international contemporary scene such as Angela Bulloch, Imi Knoebel, and Santiago Sierra.

Cadiz

Cadiz Events
2012
Contemporary Art Centre opens

Contemporary Art Centre
An initiative of the municipality of Cadiz, the new Contemporary Art Centre will be housed in the eighteenth-century Carlos III military barracks and will feature the contemporary collection assembled by the city of Cadiz. The center is due to open in 2012.

Castelló

EACC Espai d'Art contemporani de Castelló
c/ Prim, s/n
Tue–Sun 10–8
Tel +34 964 72 3540
www.eacc.es

EACC Espai d'Art contemporani de Castelló was founded in 1999 to present temporary exhibitions featuring international artists and is one of the more engaged art centers in Spain.
Director Lorenza Barboni
Selected solo exhibitions Paul Sharits, Daniel Buren, Ulrike Ottinger

Ceuti

Ceuti Events
May 2009
La Conservera opens, Fernando de Retes architect

La Conservera
Opening in May 2009 in the province of Murcia, La Conservera is being designed by architect Fernando de Retes and will focus on international contemporary art with plans including exhibits by Banks Violette, Bjorn Dahlem, and Marilyn Minter.

Córdoba

Córdoba events
TBD: Espacio de Creación Artistica Contemporánea, architects Nieto Sobejano

Espacio de Creación Artistica Contemporánea
Currently under construction is Nieto Sobejano's Espacio de Creación Artistica Contemporánea that will focus on media art and is one of the more intriguing new art center designs of recent years.

Cuenca

Museo de Arte Abstracto Español
Casas Colgados
Tue–Fri 11–2 & 4–6, Sat 11–2 & 4–8, Sun 11–2:30
Tel +34 969 21 2983
www.march.es

Museo de Arte Abstracto Español is run by the Fundación Juan March and is set in a stunning location in the fifteenth-century hanging houses of Cuenca. Founded in 1980 with further renovations in 1994, the museum is based on the abstract-art collection of Fernando Zóbel which includes works by many leading Spanish artists of the fifties and sixties. **Selected solo exhibitions** Equipo Crónica, Gary Hill

Gijón

LABoral Centro de Arte y Creación Industrial
Los Prados 121
Daily 12–2 & 4–8
Tel +34 985 18 5577
www.laboralcentrodearte.org
Aiming to forge links between art and science, the LABoral Centro de Arte y Creación Industrial is set in a former vocational building designed by Luis Moya in the fifties and which opened as an art center in 2007. Exhibits here are temporary and designed to reflect the confluence of art, industry, and science and this one of the more engaged of new media art centers.
Director Rosina Gomez-Baeza Tinture

Granada

Centro José Guerrero
Calle oficios 8
Tue-Sat 10:30-2, 4-9, Sun 10:30–2
Tel +34 958 220 109
www.centroguerrero.org
Set in the heart of the city next to the cathedral, the Centro José Guerrero is dedicated to this local twentieth-century artist. Presenting temporary exhibits by international artists, the center also has a display of works by Guerrero on view. The former newspaper building itself was renovated by Anotnio Jimenez Tor-

recillas and opened in 2000.
Selected solo exhibition Martha Rosler

Huarte

Huarte—Centro de Arte Contemporáneo
Calle Zubiarte
Tue–Fri 11–2 & 4–8, Sat–Sun 11–8
Tel +34 948 36 1457
www.centrohuarte.es
Founded in 2007, the Huarte—Centro de Arte Contemporáneo is located in the province of Navarra and presents temporary exhibits in a building constructed by Spanish architects Franc Fernandez de Eduardo, Carlos Puig, and Xavier Vancells. An advisory council made up of international curators assists on exhibit planning.

Huesca

CDAN Centro de Arte y Naturaleza
Calle Doctor Artero, s/n
May–Sept Tue–Sat 11–2 & 5–9,
Sun 10–9, Oct–April Tue–Sat 11–2 &
5–8, Sun 10–2
Tel +34 974 239 893
www.cdan.es
CDAN Centro de Arte y Naturaleza was established as part of the Beulas Foundation whose aim is to integrate art and nature. With a permanent collection of outdoor works by Richard Long, Ulrich Rückriem, and David Nash, amongst others, and a building designed by Rafael Moneo Vallés, the center was founded in 2000 and was an initiative of the local collector José Beulas.

Las Palmas de Gran Canaria, Canary Islands

Centro Atlántico de Arte Moderno CAAM
Los Balcones 11–13

Tel +34 928 31 1800
www.caam.net
Centro Atlántico de Arte Moderno CAAM houses a collection of primarily modern and contemporary Spanish artists and was inaugurated in 1989. The center also organizes temporary exhibits.

Léon

MUSAC
Museo de Arte Contemporáneo de Castilla y Léon
How to get there Located outside the historic center of Léon, MUSAC can be accessed via bus 7, 11, or 12.
Avenida de los Reyes Leoneses 24
Tue–Sun 10–3 & 4–9
Tel +34 987 09 0000
www.musac.org.es
(Spanish and English)

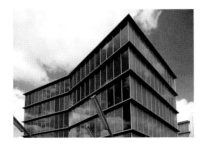

Exhibitions & Collections While in the process of collection building, MUSAC is dedicated to the art of the present, a museum for the twenty-first century. Exhibits focus on international contemporary art and present a dynamic vision of the role of the arts in Spain. Opened in 2005, MUSAC is emblematic of the Spanish trend towards innovative contemporary art museum building, while controversially neglecting infrastructure needs. In short, the Bilbao effect.
Building The design by Mansilla + Tuñón is one of the more bold and striking mu-

seums in recent years. Using colorful exterior panels, the museum is simple yet effective in its treatment of space.
Director Rafael Doctor Roncero, curator Agustin Pérez Rubio
Selected solo exhibitions Dora Garcia, Shirin Neshat, Enrique Marty, Pipilotti Rist, Daniel Verbis, Julie Mehretu

Lleida

Lleida Events
TBD: Fundacion Sorigué opens, architect: Richard Gluckman

Centre d'Art la Panera
Pl. de la Panera 2
Tue–Fri 10–2, 4–8, Sat 11–2, 4–8,
Sun 11–2
Tel +34 973 262 185
www.lapanera.cat
The Centre d'Art la Panera is set in former storehouse dating from the medieval era and presents temporary exhibits.

Fundacion Sorigué
Announced in 2008, the Fundacion Sorigué is a venture of the Gruppo Sorigué, the Catalanuya-based construction firm, and will feature the collections of the company which include works by Chuck Close, Antony Gormley, and Juan Munoz. It is anticipated that the noted American architect Richard Gluckman will be engaged to design the new museum in this northern Catalan city.

Madrid

Conservative in character, Madrid's cultural life is centered on the gallery scene that is the liveliest in Spain. Museums and institutions face governmental interference and it is hoped a more forward-looking political climate will allow its institutions to flourish. The annual ARCO fair and Noche Blanco are especially well

regarded events on the arts calendar and recent additions of off-spaces to the cultural scene have added vibrancy to the cultural matrix.

Madrid Resources

www.artemadrid.com
Spanish/English-language exhibition guide

Madrid Events

February
ARCO International Contemporary Art Fair Madrid
September
Noche Blanco, night of culture
2009
PhotoEspaña, annual event (3 June–26 July 09)

Museo Nacional Centro de Arte Reina Sofía

How to get there Located in the heart of Madrid near the Atocha Station, the Reina Sofía forms a museum mile of sorts with the Thyssen and the Prado just north.
Santa Isabel 52
Mon–Sat 10–9, Sun 10–2:30
Tel +34 917 74 1000
www.museoreinasofia.es
(Castellan and English)
Exhibitions & Collections Opened as Spain's modern art museum in 1992, the Reina Sofía houses a superlative collective of Spanish modernism, including Picasso's iconic *Guernica*. Meant to replace the Museo Español de Arte Contemporáneo, the Reina Sofía includes works in the collection by Equipo Crónica, Mario Merz, and Ellsworth Kelly. The central role of the government in the running of the museum places the Reina Sofía in an awkward and frequently controversial position.
Building Established in 1596 as a collection of Madrid hospices, what became known as the Hospital General was sub-

stantially rebuilt in the eighteenth century by Francesco Sabatini. Through many additions and alterations over the ensuing centuries, the Reina Sofía managed to endure and was then renovated in 1988 by Antonio Fernández Alba, José Luis Iñiguez de Onzoño, and Antonio Vázquez de Castro, as well as by Ian Ritchie. The contemporary art wing opened in 2005 to a design by Jean Nouvel that incorporates many of Nouvel's signature tropes, such as monumentality. While criticized by some as heavy-handed, the design deals with a difficult urban space while also adding needed exhibition spaces appropriate for contemporary art.
Directors Manuel Borja-Villel 2008–, chief curator Lynne Cooke 2008–
Selected solo exhibitions Andy Goldsworthy, Amy Cutler, Wolfgang Laib, Gordon Matta-Clark, Howard Hodgkin, Chuck Close

Centro de Arte Dos de Mayo

Tue–Sun 11–7
Tel +34 91 276 0213
www.madrid.org/centrodeartedosdemayo
The cultural complex Centro de Arte Dos de Mayo opened in May 2008 in the southwestern suburb of Móstoles and will house a collection of contemporary art as well as presenting exhibits by both international and Spanish artists. A project driven by the local Madrid govern-

ment as well as the tourism council this is further evidence of Madrid's commitment to the contemporary.

Director Farren Barenblit 2008–

Matadero Madrid
P. de la Chopera 14
Mon–Sat 11–9, Sun 10–3
Tel +34 91 517 7309
www.mataderomadrid.com

A former industrial slaughterhouse complex, Matadero Madrid is being refashioned by the Madrid city council as a multi-use cultural complex that includes spaces for temporary exhibits that have included artists such as Daniel Canogar.

Fundación Juan March
Castello 77, metro: Nuñez de Balboa
Mon–Sat 11–8
Tel +34 914 35 4240
www.march.es

Fundación Juan March is a family-run foundation established in 1955 to fund a wide range of activities in science and in the arts. The foundation organizes art exhibitions, conferences, lectures, and seminars and also runs art museums in Cuenca and Palma de Mallorca. Juan March Ordinas, a controversial financial figure, and one of the richest men in the world following the Second World War was the founder of the institution which today occupies a role in the vanguard of scientific research in Spain. Opened in 1975, the foundation's headquarters were designed by José Luis Picardo with the ground floor reserved for art exhibitions and lectures.

Selected solo exhibitions Roy Lichtenstein, Antonio Saura

CaixaForum
Paseo del Prado 36
Tue–Sun 10–8
Tel +91 330 7300
www.obrasocial.lacaixa.es

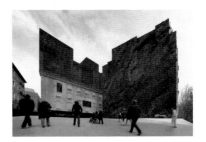

Opened in 2008, the CaixaForum is set in a former power plant, the Central Eléctrica del Mediodía, renovated by Swiss architects Herzog + de Meuron, a team familiar to the renovation of industrial architecture evidenced in their design for Tate Modern. An initiative of the banking firm La Caixa, this joins other spaces in Barcelona and Palma and will present temporary exhibitions as well as exhibitions curated from the bank's collections.

Fundación Telefónica
Fuencarral 1, Metro: Gran Via
Tue–Fri 10–2 & 5–8, Sat 11–8, Sun 11–2
Tel +91 522 6 645
www.fundacion.telefonica.com/
arte_tecno

The city telephone company's Fundación Telefónica is located in the twentieth-century icon Telefónica building. Created in 1998 by stockholders in order to increase social awareness throughout Latin America and the Iberian Peninsula, the Fundación has a collection of both modern and contemporary works by artists such as Nam June Paik and Antoni Tàpies.

Selected solo exhibitions Nam June Paik, Zhang Huan

La Casa Encendida
Ronda da Valencia 2
Daily 10–10
Tel +34 902 43 0322
www.lacasaencendida.com

The cultural center La Casa Encendida, funded by the bank Caja Madrid, offers a wide range of programs including theater and cinema. Located in a neo-Mudejar 1913 building and opened to the public in 2001, the center's exhibitions focus on emerging art.

Centro Cultural de Conde Duque
Museo de Arte Contemporáneo
Calle Conde Duque 9,
metro: noviciado/ventura Rodríguez
Tue–Sat 10–2 & 5:30–9,
Sun 10:30–2:30
Tel +34 915 88 5928
www.munimadrid.es/
museocontemporaneo

The municipal cultural center Conde Duque houses exhibitions, a theater, a library, and archives, as well as Madrid's contemporary art collection. Founded in 1980 and based on the collection of the financier José Lázaro Galdiano, the Museum is located in the former barracks of the Count Duke. The barracks were designed and built under Philip V's architect Pedro de Ribera and meant to guard the northern approaches into Madrid. The museum re-opened in 2004 after the barracks were substantially renovated. The collection itself varies greatly in quality and the hang emphasizes quantity over quality.

Selected solo exhibitions Lucio Muñoz, Eduardo Sala

Museo de Arte
Thyssen-Bornemisza
Paseo del Prado 8
Tue–Sun 10–7
Tel +34 913 69 0151
www.museothyssen.org

The superlative collection of old masters in the Museo de Arte Thyssen-Bornemisza is augmented by a unique collection of Pop Art as well as occasional exhibitions devoted to contemporary art.

Purchased by the Spanish government in 1993, the Baron Hans Heinrich Thyssen-Bornemisza's collection is housed in the Villahermosa Palace renovated and extended by Raphael Moneo in 1992. Originally in Lugano, the collection is a controversial legacy of the German industrialist Thyssen family. Renovated in 2004 by the Catalan firm BOPBAA to house the Baron's widow's collection, recent exhibits have focused on established post-war art figures.

Managing director Carlos Fernández de Henestrosa, chief curator Guillermo Solana

Selected solo exhibitions Richard Estes, Lynn Davis, Robert Rauschenberg

Museo Colecciones ICO
Zorilla 3
Tue–Sat 11–8, Sun 11–2
Tel +34 91 420 1242
www.ico.es

The Museo Colecciones ICO, located in the center of the city, presents temporary exhibits since 1996 and is controlled by the Instituto de Crédito Oficial that is an official branch of the Spanish economy and finance ministry. With a concentration on Spanish artists, the collection of the Museo is not on exhibit, although exhibits have been recently been held by Dominique Perrault and Dorothea Lange.

Málaga

CAC
Centro de Arte Contemporáneo
Calle Alemania 2
20 June–24 Sept Tue–Sun 10–2 & 5–9,
25 Sept–19 June Tue–Sun 10–8
Tel +34 925 12 0055
www.cacmalaga.org

CAC Centro de Arte Contemporáneo was founded in 2003 in a modernist market building from 1939 that was converted by Miguel Ángel Diaz. The collection fea-

tures international artists such as Tony Cragg, Cindy Sherman, and Thomas Struth and exhibits here are international in focus.

Selected solo exhibitions Juan Usle, Yoshitomo Nara + graf, Roni Horn, Jason Martin

Murcia

Murcia Events
2010
Manifesta 8

Espacio AV
Calle Santa Teresa, no. 14 bajo
Tue–Sat 10–2 & 5–9, Sun 10–2
Tel +34 968 930 206
www.espacioav.es

Espacio AV is run by province of Murcia and, known as the Espacio Artes Visuales, presents well regarded and focused exhibits of contemporary art. The space itself is part of a larger cultural agenda put forth by the province of Murcia. A further exhibition space Sala Veronicas (calle Veronica s/n) hosts additional exhibits.
Director Isabel Tejeda
Selected solo exhibitions Orlan, Francesca Woodman

Palma de Mallorca

ES Baluard Museu d'Art Modern i Contemporani de Palma
Plaça Porta Santa Catalina 10
Oct–15 June Tue–Sun 10–8,
16 June–Sept Tue–Sun 10–10
Tel +34 971 90 8200
www.esbaluard.org

With a large collection of modernist works, the ES Baluard Museu d'Art Modern i Contemporani de Palma was inaugurated in 2004 in a building designed by Jaime & Luis García Ruiz, Angel Sánchez-Cantalejo, and Vicente Tomás. Although the emphasis is on modernism, especial-

ly with Miró and Picasso, contemporary Spanish art is represented by artists such as Miguel Barceló and José María Sicilia.
Selected solo exhibitions Antonio Calvo Carrion, Santiago Calatrava, Andy Warhol

Fundación Juan March
Calle Sant Miquel 11
Mon–Fri 10–6:30, Sat 10:30–2
Tel +34 971 71 3515
www.march.es

Emphasizing Spanish artists of the twentieth century, the Museu d'art Espanyol Contemporani, Fundación Juan March opened in 1990 in an eighteenth-century building. Renovated in 2003, many of the exhibits travel to other March Foundation locations in Cuenca and Madrid.
Selected solo exhibitions Equipo Crónica, Esteban Vicente

CaixaForum Palma
Plaza Weyler 3
Mon–Sat 10–9, Sun 10–2
Tel +34 971 72 0111
www.obrasocial.lacaixa.es

Joining the system of art centers of the bank La Caixa, the CaixaForum Palma is set in the Grand Hotel built by modernist Lluís Domènech i Montaner in the early twentieth century. Exhibits here focus on a wide range of artistic themes and styles. As with other Caixa spaces, the buildings are more innovative than is the programming.
Selected solo exhibitions Chillida, Lee Friedlander

Portbou

Passagen
Dani Karavan's *Passagen, Homage to Walter Benjamin,* completed in 1994 pays tribute to the German philosopher who took his own life here while attempting to flee the Nazis. Set in a cem-

etery just outside the city, the monument is a moving work that uses themes familiar from Karavan's oeuvre such as history, loss, and displacement.

Salamanca

Da2, Domus Artium 2002 Salamanca

Avenida de la Aldehuela s/n
Tue–Fri 12–2:30, Sat –Sun 11–9
Tel +34 923 18 4916
www.salamancaciudaddecultura.org:81/
da2/

Da2, Domus Artium 2002 Salamanca is housed in a former jail from 1930 that was restored as an art center in 2002. Da2 focuses on Spanish art but does include in its collection works by Mona Hatoum and Candida Höfer, amongst others.

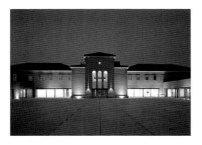

Selected solo exhibitions
ChristianMarclay, Gregory Crewdson, Nathan Carter, Franz Ackermann, Lee Bul

San Sebastián

Tabakalera

Duque de Mandas 52
Tel +34 943 011 311
www.tabakalera.eu

A former tobacco factory, Tabakalera is a multi.use cultural facility that is dedicated to visual arts. Renovated by Jon and Naiara Montero the center presents temporary art and architecture exhibits.

Santa Cruz de Tenerife, Canary Islands

TEA Tenerife Espacio de las Artes

Avenida de San Sebastian 10
Tue–Sun 10–8
Tel +34 922 8490 57
www.teatenerife.es

Originally named for local surrealist-influenced painter Óscar Domínguez and with a large collection of works by the artist, the TEA Tenerife Espacio de las Artes opened in October 2008 and houses an art gallery and cultural center. Designed by innovative architects Herzog + de Meuron, it is a unique addition to the contemporary art scene in the Canary Islands.

Espacio Cultural El Tanque

70 Paralela a la Avenida 3 de Mayo, Refineria, Tanque no. 69, Barrio de Buenos Aires
Tel +34 922 23 9596

Set at one stage for demolition, the Espacio Cultural El Tanque is located in a former warehouse of a local oil refinery. In the space, which is operated by the local government, temporary exhibits by regional artists are presented.

Santander

Santander Events

July
Art Santander fair
2009
Museo de Cantabria opens, architects Mansilla + Tuñón

Museo de Cantabria

A project that has faced difficulties, the Museo de Cantabria was the focus of an international architecture competition in 2002 that was won by innovative Spanish architects Mansilla + Tuñón. The museum has since faced pressures over the

structuring of the two halves of the institution, one which is devoted to history and one devoted to the arts. Whether the museum will actually be finished is due to conjecture as there is a lack of funds from the regional government.

Santiago de Compostela

CGAC, Centro Gallego de arte Contemporáneo
Villa Inclán s/n
Tue–Sun 11–8
Tel +34 981 54 6625
www.cgac.org

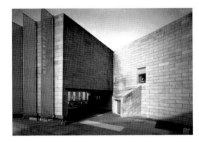

Designed by Álvaro Siza, the CGAC, Centro Gallego de arte Contemporáneo was inaugurated in 1993. The highly evocative modernist-inspired work of Siza combines with the cutting-edge art exhibits presented by the center. The collection concentrates on Galician artists although international artists are represented by artists such as Nam June Paik, Richard Long, and Andy Warhol.
Selected solo exhibitions Xavier Toubes, Jim Hodges

Segovia

Museo de Arte Contemporáneo Esteban Vicente
Plazuela de las Bellas Artes s/n
Tue–Wed 11–2 & 4–9, Thur–Fri 11–2 & 4–8, Sat 11–8, Sun 11–3

Tel +34 921 46 2010
www.museoestebanvicente.es
The works of Spanish abstract artist long based in the USA Esteban Vicente form the core of the Museo de Arte Contemporáneo Esteban Vicente which is set in a medieval palace that was restored by Jua Ariño. Presenting mainly historically themed shows that focus on modernism, the museum reflects a conservative trend in Spanish post-war art.

Sevilla

Sevilla Events
2010
Bienal Internacional de Arte Contemporáneo de Sevilla

CAAC, Centro Andaluz de Arte Contemporáneo
Monasterio de la Cartuja de Santa María de Las Cuevas
Oct–March Tue–Fri 10–8, Sat 11–8, Sun 10–3, April–Sept Tue–Fri 10–9, Sat 11–9, Sun 10–3
Tel +34 955 03 7070
www.juntadeandalucia.es/cultura/caac
In the Cartuja Monastery, the CAAC, Centro Andaluz de Arte Contemporáneo was founded in 1997 and houses a permanent collection devoted to artists such as Rebecca Horn, Louise Bourgeois, and Joseph Kosuth. Exhibits are international in focus and encompass modern and contemporary art trends.
Selected solo exhibitions Jesús Zurita, Mark Lewis, Equipo 57, Daido Moriyama

Valencia

Valencia Events
TBD: IVAM extension, architects SANAA

IVAM Institut Valencia d'art Modern
How to get there Guillem de Castro 118.
Tue–Sun 10–8

Tel +34 963 86 3000
www.ivam.es
(in Castilian, Valencian, and English)
Exhibitions & Collections The core of IVAM's holdings is the Julio Gonzáles collection as well as associated modernist movements. While various strands of post–war international art are collected what is mainly on view is Spanish art in all its regional variations. It is in exhibitions that the IVAM is most engaged with contemporary work and, if built, the new addition by SANAA will offer more space to present international level art.

Building IVAM opened in 1989 to design by Valencia-based architects Emilio Giménez and Carlos Salvadores, and thereafter remodeled in 2000 by Emilio Giménez and Julio Esteban. A truly remarkable design by SANAA was unveiled in 2005 would cover the entire museum in a transparent skin. To date, the museum has yet to begin what would be a stunning addition to the Spanish museum scene.
Director Juan Manuel Benet
Selected solo exhibitions Ana Peters, Equipo Crónica, Christopher Wool, Elizabeth Murray,

Valladolid

Patio Herreriano Museo de Arte Contemporáneo Español
Calle Jorge Guillén 6

Tue–Fri 11–8, Sat 10–8, Sun 10–3
Tel +34 983 36 2771
www.museopatioherreriano.org
Patio Herreriano Museo de Arte Contemporáneo Español is located in a former monastery converted by Juan Carlos Arnuncio, Clara Aizpún, and Javier Blanco to house a collection of Spanish art from 1918 to the present. Exhibits here feature mainly regional artists.

Vejer de la Frontera

Fundación NMAC
Dehesa Montenmedio, Ctra. A–48, old N–340, Km. 42,5
summer daily 10–2, 5–8:30,
winter daily 10:30–2:30 & 4–6
Tel +34 956 45 5134
www.fundacionnmac.com
Inaugurated in 2001, the Fundación NMAC features site-specific sculptures by Sol LeWitt, Roxy Paine, and Olafur Eliasson, amongst others. The rural setting on the grounds of the Dehesa Montenmedio near the scenic village of Vejer on the southern coast of Andalusia is a spectacular setting for contemporary art. Temporary projects by artists such as James Turrell join the permanent installations all of which deal with the integration of art and nature.
Director Jimena Blázquez Abascal

Vigo

Vigo Events
November
Feria Puro Arte (art fair)

MARCO, Museo de art Contemporánea de Vigo
Rúa Principe 54
Tue–Sat 11–9, Sun 11–3
Tel +34 986 11 3911
www.marcovigo.com
In the port city of Vigo, MARCO, Museo

de art Contemporánea de Vigo was established in a converted prison and courthouse and, since opening in 2002, has presented focused temporary exhibits featuring international artists such as Monica Bonvicini and Thomas Hirschhorn. The building is unique in that it visualizes the panopticon concept so important in postmodern critical theory.

Vitoria–Gasteiz

**Artium, Museo Vasco
de Arte Contemporáneo**
Calle Francia 24
Tue–Sun 11–8
Tel +34 945 20 9000
www.artium.org
With a large collection of Spanish twentieth and twenty-first-century art, Artium, Museo Vasco de Arte Contemporáneo opened in 2002, to a design by José Luis Caton. Exhibits range from international artists to regional Basque-based contemporary art.
Selected solo exhibitions Zhu Yi, Siah Armajani, Hannah Wilke, Jana Sterbak

**Centro Cultural Montehermoso
Kulturunea**
Calle Fray Zacarías 2
Tue–Fri 11–2 & 6–9, Sat 11–2 & 5–9,
Sun 11–2
Tel +34 945 16 1830
www.montehermoso.net
Centro Cultural Montehermoso Kulturunea was founded in 2007 in a sixteenth-century Renaissance palace by the city of Vitoria. Exhibits are thematic in nature and the center also offers yearly grants to curators and artists. With a stated brief to focus on issues of gender, the center is unique in the context of the Spanish contemporary scene.
Director Xabier Arakistain Ecenarro

Sweden

Not a member of the European Union,
Sweden has staked its independent
claim in both politics and culture which is reflected in
its art system which encompasses galleries, auctions,
art fairs as well as a museum and institution.
This system exists in many ways to promote Swedish
regional art but also engages with the wider art commu-
nity in the vibrant institutions centered in Stockholm
as well as in the southern part of the country.

Stockholm

A city renowned for its beauty, Stockholm is one of the major institutional centers of the European art world. With the well respected Magasin 3 Konsthall joining the oft troubled but nonetheless intriguing Moderna Museet and other institutions in the area as well as international-level galleries and a lively arts community all creating a matrix that offers the art traveler a range of experiences.

Stockholm Resources

www.gallerifurbundet.com
www.stockholmsmuseer.com
Swedish and English museum information

Stockholm Events

February
Market Stockholm Art Fair
August
Stockholms Kulturfestival
2010
Moderna Museet, The Moderna Exhibition 2010, Quadrennial

Bonniers Konsthall

Torsgaten 19, subway stop St. Eriksplan
Wed 11–8, Thu–Sun 11–5
Tel +46 8 736 4248
www.bonnierskonsthall.se

Bonniers Konsthall is a venue for promoting emerging Swedish and international artists that opened in 2005 and was founded by Jeanette Bonnier. The Swedish media conglomerate Bonnier Group operates the Konsthall on a non-profit basis. A triangular building on a difficult site was designed by Johan Celsing Arkitektkontor and presents the image of an office building rather than an art venue. There is a permanent installation on view by Pipilotti Rist.
Director Sara Arrhenius
Selected solo exhibitions Michael Beutler, Adrian Paci

Liljevalchs Konsthall

Djurgårdsvägen 60
Tue–Sun 11–5, Tue & Thu 11–7
Tel +46 8 5083 1330
www.liljevalchs.com
Opened in 1916 and run by the city of Stockholm, Liljevalchs Konsthall exhibits primarily Swedish contemporary art. The building by Carl Bengtsen was designed at the behest of Swedish industrialist Carl Frederik Liljevalchs.
Selected solo exhibitions Sophie Totti, Anders Widoff

Magasin 3 Stockholm Konsthall

Frihamnen-Gardet T-Bahnen
then bus 1 or bus 76
Thu 12–7, Fri–Sun 12–5
Tel +46 8 5456 8040
www.magasin3.com
An innovative privately run institution, Magasin 3 Stockholm Konsthall is located in a converted warehouse next to the Tallinn Terminal in the Freeport area of Stockholm. The Konsthall was founded in 1987 by Proventus AB, owners of a large toy firm amongst other concerns, with a mandate to collect and exhibit contemporary work that would challenge the Swedish art scene. A measure of their success is the leading role they play in Sweden in presenting international art.
Founding director David Neuman
Selected solo exhibitions Pipilotti Rist,

Gilbert & George, Paul Chan, Jake & Dinos Chapman

Moderna Museet & Arkitekturmuseet
How to get there Located on the Island of Skeppsholmen and a 10-minute walk from the center of Stockholm. Also reachable by bus 65.
Tue 10–8, Wed–Sun 10–6
Tel +46 8 5195 5289
www.modernamuseet.se
(Swedish and English)

Exhibitions & Collections Founded in 1958, the Moderna Museet's collection of art from 1900 to the present focuses on Swedish art but also branches out to include an impressive array of international modern and contemporary work. While the permanent collection is often re-hung, changing exhibits serve to enliven the spaces with such recent exhibits by Paul McCarthy, Janet Cardiff, and William Kentridge.
Building The museum complex designed by Spanish architect Rafael Moneo opened in 1998 and has been beset by controversy since its inception. While turmoil at the administrative level forced the museum into uncomfortable territory, the new building was found to be seriously compromised by weather conditions not taken into account by Moneo and his contractors. Closed from 2002 to 2004 to correct problems in design and materials, the Museum has begun to re-cover somewhat from this turbulent time.
Director Lars Nittve 2001–
Selected solo exhibitions Joachim Koester, Susan Hiller, Robert Rauschenberg, William Kentridge

Fargfabriken
Lovholmsbrinken 1
Thu–Sun 12–6
Tel +46 8 645 0707
www.fargfabriken.se
Fargfabriken opened in 1995 in the former Palmcrantz factory building set in the Liljeholmen district of southern Stockholm. Presenting temporary exhibits the center is currently undergoing restructuring and the website should be checked for current projects.
Selected solo exhibitions Jens Assur, Gavin Watson

Index—The Swedish Contemporary Art Foundation
Kungsbrostrand 19
Tue–Fri 12–4, Sat–Sun 12–5
Tel +46 8 5021 9838
www.indexfoundation.se
Dedicated to presenting exhibitions and projects by international artists, the independent Index—The Swedish Contemporary Art Foundation was founded in 1998 to foster dialogue in the field of contemporary art. The foundation has since 2006 had a new exhibitions space.
Selected solo exhibitions Matthew Buckingham, Ann Böttcher

Spånga (Stockholm)

Tensta Konsthall
Taxingegränd 10
Tue–Sun 12–5
Tel +46 8 36 0763
www.tenstakonsthall.se
In the northern borough of Spånga, the Tensta Konsthall was established in 1998

as part of the European Capital of Culture initiative. While the center organizes projects at off-site locations, one of its main focus is in educational outreach.

Selected solo exhibition Rainer Ganahl

Gävle

Gävle Konstcentrum
Kungsbäcksvägen 32
Tue–Fri 12–5, Sat–Sun 12–4
Tel +46 26 17 9424
www.gavle.se/konstcentrum

On the Baltic Sea in eastern central Sweden, the Gävle Konstcentrum was founded in 1961 to present temporary exhibitions by both international and regional artists.

Selected exhibition Oväntat Besök

Göteborg

Göteborg Events
October
Kulturnatta
Annual
Hasselblad Foundation International Award in Photography
2009
Göteborg International Biennial for Contemporary Art, 5th edition (5 Sept–15 Nov 09)

Göteborgs Konsthall
Götaplatsen
Tue–Thu 11–6, Wed 11–8,
Fri–Sun 11–5
Tel +46 31 368 3450
www.konsthallen.goteborg.se

In a modernist building from 1923, the Göteborgs Konsthall houses a collection of primarily Nordic historical art which includes works from contemporary artists such as Per Kirkeby, Olav Christopher Jensen, and Odd Nerdrum. Within the museum is the photography-based Hasselblad Center (same hours), which pres-

ents international contemporary photography since its founding in 1989.

Selected solo exhibitions Esther Shalev Gerz, Annica Karlsson Rixon

Helsingborg

Dunkers Kulturhus
Kungsgatan 11
Tue–Sun 10–5, Thu 10–8
Tel +46 42 10 7400
www.dunkerskulturhus.se

Dunkers Kulturhus was built by Kim Utzon and opened in 2002 to present both historical and contemporary themed exhibits. The center is named for Henry Dunker who was an industrialist and whose foundation financed the construction of the Kulturhus.

Kalmar

Kalmar Konstmuseum
Slottsvägen 1D
Daily 11–5, Tue 11–8
Tel +46 480 42 6282
www.kalmarkonstmuseum.se

Opened in 2008 in the Renaissance-era city of Kalmar, the Kalmar Konstmuseum was designed by Tham & Videgard Hansson as a four-story black cube and is one of the more interesting Nordic museum designs. The collection is primarily modernist-based but there are also selections of contemporary work from northeastern European artists.

Knislinge

Wanås Foundation
Wanås Castle
opening mid-May to mid-Oct
Tel +46 446 6071
www.wanas.se
One of the most renowned site-specific outdoor sculpture exhibition venues in the world, the Wanås Foundation opened in 1987 with a sculpture park on the grounds of Wanås Castle. With perma-

nent works situated in the park as well as yearly special exhibits during the summer months, this has become a major art destination. Marika Wachtmeister is the founder and director. Artists include Janine Antoni, Ann Hamilton, Allan McCollum, and Jason Rhoades.

Lidingö

Konsthallen Millesgården
Hererudsvägen 32
summer daily 11–5,
Oct–Mar Tue–Sun 12–5
Tel +46 8 446 7590
www.millesgarden.se
Konsthallen Millesgården was designed by Johan Celsing and was inaugurated in 1999 to present both modernist works as well as contemporary international and Swedish art. The Konsthall itself borders on the artist retreat established by Carl Milles in the early twentieth century.

Selected solo exhibitions Ulf Rollof, Carroll Dunham

Lund

Lund Events
September
Kulturnatten Lund

Lunds Konsthall
Mårtenstorget 3
Tue–Fri 12–5, Thu 12–8, Sat 10–5,
Sun 12–5
Tel +46 46 35 5295
www.lundskonsthall.se
Lunds Konsthall was founded in 1957 with a modernist building by Klas Anshelm. The Konsthall is in charge of the city collections of Lund as well as presenting international contemporary art exhibits.
Selected solo exhibitions Luca Frei, Cecilia Edefalk, Gustav Metzger

Skissernas Museum, Lund University
Finngaten 2
Tue–Sun 12–5, Wed 12–9
Tel +46 222 7283
www.adk.lu.se
Skissernas Museum, Lund University is a museum devoted to sketches for public art commissions and includes works by modernist masters as well as contemporary artists. With a contemporary art sculpture garden, the museum originally opened in 19411 and with an extension by Johan Celsing that was inaugurated in 2005.

Malmö

Malmö Events
September 2009
Moderna Museet Malmö opens in former Rooseum space

Malmö Konsthall
S:t Johannesgaten 7

Daily 11–5, Wed 11–9
Tel +46 4034 1293
www.konsthall.malmo.se
One of the more engaged Kunsthalles in Europe, the Malmö Konsthall opened in 1975 to a design by Klas Anshelm. The Konsthall also features the Schyl Collection of modern art which awaits the construction of a future museum home.

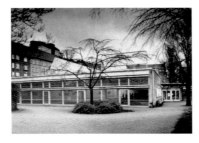

Director Lars Grambye –2007
Selected solo exhibitions William Kentridge, Elmgreen & Dragset, Sarah Sze

Malmö Konstmuseum
Malmoehusvagen
Sept–May daily 12–4,
June–Aug daily 10–4
Tel +46 40 34 1000
www.malmoe.se/kulturbibliotek/
malmokonstmuseum
Malmö Konstmuseum opened in 1925 to present the historical collections of the city and has an active acquisitions policy with artists such as Elmgreen & Dragset, Olafur Eliasson, and Ann Lislegaard included in the primarily Nordic-based collections. Exhibitions also feature contemporary art.

Rooseum Centre for Contemporary Art
Gasverksgaten 22
Founded by financier Fredrik Roos, the Rooseum Centre for Contemporary Art opened as an art space in 1988 in an early-twentieth-century power station. During

its two decades of operation the center had presented some of the more challenging exhibits in the Nordic countries and was led by a series of top quality curators. In 2007 the Swedish government took over the center and Stockholm's Moderna Museet announced plans to reopen the space as Moderna Museet Malmö in September 2009. In charge of renovating the spaces are the architects Tham & Videgard Hansson.
Former director Charles Esche 2000–04, former curator Lars Nittve 1986–90

Österlen

Kivik Art Centre
Tel +46 0733 900 182
www.kivikart.se
The southern Sweden-based Kivik Art Centre opened in 2006 as a project by museum director Sune Nordgren to present architecture and art pavilion projects. With future plans to build a larger exhibit hall, the center currently features pavilions designed by Antony Gormley and David Chipperfield and is only open during the summer months.

Skellefteå

Museum Anna Nordlander Konsthall
Nordanå
Tue–Thu 10–7, Fri–Sun 12–4
Tel +46 910 737 492
www.man.skelleftea.org
Established in 1995, the Museum Anna Nordlander Konsthall is home to works by nineteenth-century artist Anna Nordlander. In 2007 the Konsthall announced it will, in future, focus on gender issues and contemporary art.

Sundbyberg

Marabou Parken Annex
Esplanaden 13

Wed–Sun 12–5
Tel +46 8 29 4590
www.marabouparken.se
Marabou Parken Annex is located near the early-twentieth-century Marabou Park that was built by a local chocolate magnate for the recreational use of his employees. The former church on the site currently holds yearly exhibits by artists such as Edwin Wurm.

Tumba

Botkyrka Konsthall
Munkhattevagen 45
Daily 12–6, Thu 12–7,
Fri 12–3, Sun 11–3
Tel +46 85 306 1430
www.botkyrka.se/kultur-fritid/kultur/
botkyrkakonsthall
Botkyrka Konsthall features mainly re-gional artists in this nineteenth-century era city south of Stockholm.

Uppsala

Uppsala Konstmuseum
Uppsala Castle
Tue–Fri 12–4, Sat–Sun 11–5,
first Wed of month 12–8
Tel +46 18 727 2482
A historical collection in what is well known as a university town, the Uppsa-la Konstmuseum is situated in a former castle and has an engaged collections pol-icy that focuses on Nordic contemporary artists.

The Swiss art scene is dominated by
the annual ArtBasel, the premier art
fair for contemporary art, as well as the Zurich gallery
and museum scene, one of the foremost in Europe.
Switzerland stands outside the European Union in many
ways, one of which is the tax provisions on art work
that allows the art market to flourish here. This has led
a substantial number of major European galleries to
base their operations in Zurich, in particular. The Swiss
canton system as well as regional differences point up
the strength of the northern German-speaking regions,
along with Geneva, in setting the lead in engagement
with contemporary art.

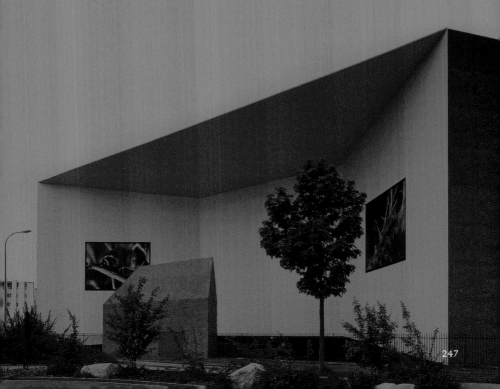

Switzerland Resources

www.myswitzerland.com
German and twelve languages-
information about Switzerland art
and architecture
www.kunstbulletin.ch
Zurich-based art information in German
www.go-east.ch
German-language information
on exhibitions in east Switzerland
www.swissart.net
on-line news and information in English,
German, and French versions
www.kunstverein.ch
Swiss Kunstverein organization with Ger-
man-language information on Swiss art
www.artgalleries.ch
Art Galleries of Switzerland site
in German, English, and French

Aarau

Aargauer KunstHaus
Aargauerplatz
Tue–Sun 10–5, Thu 10–8
Tel +41 62 835 2330
www.aargauerkunsthaus.ch
With an extension designed by Herzog +
de Meuron, the Aargauer KunstHaus
presents Swiss art from the eighteenth
century to the present. Established in
1956 by three Baden architects, the Aar-
gauer KunstHaus extension was complet-
ed in 2003 and includes an impressive re-
ception area as well as interiors designed
in collaboration with artist Remy Zaugg.
Director Beat Wismer
Selected solo exhibitions Dieter Roth,
Andreas Zybach, Thomas Virnich,
Roland Guignard

Basel

Basel is a major center of European art
that is emphasized by the annual ArtBa-
sel fair as well as its many satellite fairs all
of which are held in June. With much to
reward an extended visit, Basel has a
unique range of institutions devoted to
contemporary art as well as prime exam-
ples of contemporary Swiss architecture.
In addition, during ArtBasel institutions
and galleries extend their opening hours
and provide unique events for the art en-
thusiast.

Basel Resources

www.museenbasel.ch
information on museums in German,
English, French, and Italian
www.kunstinbasel.ch
exhibition information in German

Basel Events

January
Museumsnacht
June
ArtBasel; Baloise Art Prize, annual prize
given during ArtBasel; Liste, The Young
Art Fair in Basel; Scope International Con-
temporary Art Fair; Volta Show; bâlelati-
na, contemporary art fair; PrintBasel

Kunsthalle Basel
Steinenberg 7
Tue–Fri 11–6, Thu 11–8:30,
Sat–Sun 11–5
Tel +41 61 206 9900
www.kunsthallebasel.ch
The Kunsthalle Basel is located in the
center of Basel since its founding as a
Kunstverein in the nineteenth century.
Offering stimulating exhibitions by in-
ternational contemporary artists, this is
one of the major venues for temporary
exhibitions in Switzerland.
Director Adam Szymczyk 2003–
Selected solo exhibitions Minerva Cue-
vas, Micol Assaël, Bas Jan Ader, Peter
Peri

Swiss Architecture Museum
Tue–Fri 11–6, Thu 11–8:30,
Sat–Sun 11–5

Tel +41 61 261 14 13
www.sam-basel.ch
Housed in the same building as the Kunsthalle Basel since 1984, the Swiss Architecture Museum has changing exhibits on cutting-edge architecture themes.

Kunstmuseum Basel
St. Alban-Graben 16
Tue–Sun 10–5
Tel +41 61 206 6262
www.kunstmuseumbasel.ch
Kunstmuseum Basel houses the municipal collection of Basel and concentrates on historic art while also offering an ambitious program of contemporary art exhibits. With its origins in the eighteenth century, the Kunstmuseum Basel was constructed in 1936 by Rudolf Christ and Paul Bonatz as a purpose-built structure. While the collection is strong in Holbein and artists of the Upper Rhein region, contemporary art is also represented and recent acquisitions have included works by Pierre Huyghe and Simon Starling. The Museum für Gegenwartskunst branch was established to display only contemporary work.
Director Bernhard Bürgi 2001–
Selected solo exhibitions Andreas Gursky, Brice Marden

Museum für Gegenwartskunst
St. Alban-Rheinweg 60
Tue–Sun 11–5
Tel+41 61 206 6262
www.kunstmuseumbasel.ch
Museum für Gegenwartskunst is the contemporary art branch of the Kunstmuseum Basel. The museum exhibits established international artists while also showing a limited selection from the Emanuel Hoffmann Foundation's collection as well as containing the Christoph Merian Donation and works from the city of Basel's collections. Opened in 1980 to a design by Katharina and Wilfrid Steib,

the museum is located in a converted nineteenth-century paper mill.
Former director Theodora Vischer
Selected solo exhibitions Johanna Billing, Jean-Frederick Schnyder, Christian Philip Müller, Daniel Richter

Kunsthaus Baselland
St. Jakob Strasse 170
(tram 8, 20, 11 to Aeschenplatz and then tram 14 to Schaenzli)
Tue, Thu–Sun 11–5, Wed 2–8
Tel +41 61 312 8388
www.kunsthausbaselland.ch
Kunsthaus Baselland is a Kunstverein situated in industrial Muttenz area in the Baselland district, easily reachable by tram from the center of Basel. Established in 1997, the aims of the Kunsthaus Baselland are to present experimental art of a topical nature through an engagement with international contemporary art.
Director Sabine Schaschl
Selected solo exhibitions Nadja Solari, Jan Christensen, Renate Buser

Museum Tinguely
How to get there Situated on the north bank of the Rhine, Museum Tinguely can be reached from Basel SBB via tram line 2 to Wettsteinplatz and then bus 31 to Museum Tinguely.
Paul-Sacher Anlage 1
Tue–Sun 11–7
Tel +41 61 681 9320
www.tinguely.ch
(German, French, and English)
Exhibitions & Collections Works from the collection of longtime Tinguely companion and collaborator Niki de Saint Phalle as well as works from the collection of Paul Sacher form the basis for this museum dedicated to the work of Jean Tinguely. Tinguely's machine sculptures are the core of the collection but there are also exhibits on related art-historical themes.

Building Completed in 1996 by Swiss architect Mario Botta, the Tinguely has received criticism from the museum-architecture press as well as Tinguely's colleagues on the grounds that the museum fails to capture the iconoclastic nature of Tinguely and his work. A particular difficulty for the architect was the site located next to a major highway.

Schaulager
Ruchfeldstrasse 19
Tue–Fri 12–6, Thu 12–7, Sat–Sun 10–5
Tel +41 61 335 3232
www.schaulager.org

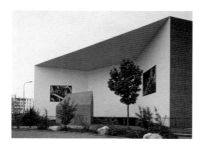

Schaulager opened in 2004 to an innovative design by Herzog + de Meuron and is a multi-function art-storage facility built primarily to house the Emanuel Hoffman Foundation and which is run by the Laurenz Foundation. Located in the Basel suburb of Münchenstein, Schaulager is open to the public during the summer for exhibitions.

Director Theodora Vischer 2003–
Selected solo exhibitions Robert Gober, Tacita Dean, Francis Alÿs, Jeff Wall, Dieter Roth

Fondation Beyeler
Baselstrasse 101
tram 6 from the center of Basel
Daily 10–6, Wed 10–8
Tel +41 61 645 9700
www.beyeler.com

Located in one of the most striking art buildings of recent times, the Fondation Beyeler is since 1997 home to the collection of gallery owner Ernst Beyeler and which focuses on modernism. Designed by Renzo Piano in the Riehen suburb of Basel, the Beyeler enters into a dialogue with nature through its unique approach to light and space. Universally acclaimed, the Beyeler, along with the Kröller Müller in the Netherlands and the Louisiana in Denmark, is one of the most sensitive and striking structures in which to present modern and contemporary art. The hiring of former ArtBasel chief Samuel Keller as director may bring the institution a cutting edge to its programming heretofore lacking.
Director Samuel Keller
Selected solo exhibitions Wolfgang Laib, Ellsworth Kelly, Jenny Holzer

Bellinzona

CACT
Centro d'Arte Contemporanea Ticino
via Taramo 3
Fri–Sun 2–6
Tel +41 91 825 4072
www.cacticino.net

CACT Centro d'Arte Contemporanea Ticino presents mainly regional artists in temporary exhibits in what is the least contemporary-focused of the Swiss regions. In 2010 the CACT will merge with the CAAC in Chiasso.

Bern

Bern Resources
www.museen-bern.ch
German, French, and English museum
information

Bern Events
March
Museumsnacht
2012
Kunstmuseum Bern extension opens,
Baserga & Mozzetti architects

Kunsthalle Bern
Helvetiaplatz 1, tram 3 or 5, bus 19 from
train station
Wed–Sun 10–5, Thu 10–7
Tel +41 31 350 0040
www.kunsthalle-bern.ch
Kunsthalle Bern has a focused program
of international contemporary art as well
as being in 1968 the first building that
was wrapped by Bulgarian-born artist
Christo. Opened in 1918, the Kunsthal-
le, run by the Berner Künstlerschaft, has
been headed by a succession of energetic
curatorial staffs which have imprinted
their vision on the Kunsthalle.
Director Philippe Pirotte 2005–
Selected solo exhibitions Marine Hu-
gonnier, Allen Kaprow, Jutta Koether,
Pavel Buechler

Kunstmuseum Bern
How to get there Set in the center of
Bern, the Kunstmuseum is a 5-minute
walk from the train station.
Hodlerstrasse 12
Tue 10–9, Wed–Sun 10–5
Tel +41 31 328 0944
www.kunstmuseumbern.ch
(German, French, and English)
Exhibitions & Collections The oldest
Swiss art museum with a permanent col-
lection since its founding in 1809, the
Kunstmuseum is especially strong in

modernism but also has significant con-
temporary holdings with artists such as
James Lee Byars, Franz Gertsch, and Sig-
mar Polke represented.
Building Constructed in 1878 by Eugen
Stettler, the Kunstmuseum Bern is a land-
mark building that has undergone succes-
sive extensions in 1936 and 1983. Cur-
rently there are plans to build a further
extension that will update the historic
building and make the spaces better suited
for the display of contemporary work.
Director Matthias Frehner 2002–
Selected solo exhibitions Werner Otto
Leuenberger, Üli Berger, Maria Eichhorn,
Louise Bourgeois, Suzan Frecon

Biel

Centre PasquArt
Seevorstadt 71–75
Wed–Fri 2–6, Sat–Sun 11–6
Tel +41 32 322 5586
www.pasquart.ch
Centre PasquArt is set in a building com-
plex composed of a nineteenth-century
hospital and a new building by Swiss
architects Diener + Diener and which
opened in 2000. Established in 1990,
the center has a collection that includes
Fischli & Weiss, Rebecca Horn, and
Markus Raetz.
Selected solo exhibitions Gian Pedretti,
Charles Sandison, Hervé Graumann

Burgdorf

Museum Franz Gertsch
Plantanenstrasse 3
Tue–Fri 10–6, Wed 10–7, Sat–Sun 10–5
Tel +41 34 421 4020
www.museum-franzgertsch.ch
The Museum Franz Gertsch is devoted to
Swiss contemporary artist and exponent
of realism Franz Gertsch. The museum is
based on the donations of collector Wil-
ly Michel and was inaugurated in a build-

ing designed by Jörg & Sturm in 2002. Gertsch is well respected throughout the artworld for his unique approach to realism.
Selected solo exhibitions Gregor Schneider, Dirk Skreber, Gert & Uwe Tobias

Chur

Bündner Kunstmuseum Chur
Postplatz
Tue–Sun 10–5
Tel +41 81 257 3868
www.buendner-kunstmuseum.ch
Set in the nineteenth-century neoclassic Villa Planta since 1990, the Bündner Kunstmuseum Chur focuses on artists from the Grisons region.
Curator Kathleen Bühler 2005–

Fribourg

Fri-Art Centre d'Art Contemporain
Petites-Rames 22
Tue–Fri 2–6, Sat–Sun 2–5
Tel +41 26 323 2351
www.fri-art.ch
Fri-Art Centre d'Art Contemporain opened in 1990 in a former night shelter and presents temporary exhibits by both established and emerging cutting-edge artists.
Director Corinne Charpentier
Selected solo exhibitions Amy O'Neill, Peter Coffin

Geneva

By tradition an international city, Geneva has a commitment to contemporary art in the BAC, Bâtiment d'art Contemporain, a project whose focus is to concentrate the city-supported arts institutions into one area, the Quartier des Bains. In late 2007 this plan fell apart with the Centre pour l'image Contemporain having to close and the Centre de la Photographie merging into CAC and MAMCO. This situation is symptomatic of both the position of smaller institutions in the wider art world and the fragility of funding.

Geneva Resources
www.geneve-art-contemporain.ch
French-language guide to exhibitions

Geneva Events
April
Genève Brille la Nuit
April/May
Euro'Art Geneva, International Art Fair
2009
13th BIM Biennial of Moving Images-Centre pour l'image contemporaine, Saint-Gervais

Centre d'Art Contemporain Genève
rue des Vieux-Grenadiers 10
Tue–Sun 11–6
Tel +41 22 329 1842
www.centre.ch
Originally the Geneva Kunsthalle, Centre d'Art Contemporain Genève was founded in 1974 as the first institution devoted to contemporary art in the French-speaking regions of Switzerland. Now located in the same building as MAMCO and part of the BAC group, the center's program focuses on engaging with current trends in international contemporary art. In late 2007 plans were announced to merge the Centre de la

Photographie with CAC and MAMCO.
Director Katya Garcia-Anton
Selected solo exhibitions Gary Webb,
George Shaw, Philippe Decrauzat

MAMCO
Musée d'Art Moderne
et Contemporain Genève
rue des Vieux-Grenadiers 10
Tue–Fri 12–6, Sat–Sun 11–6
Tel +41 22 320 6122
www.mamco.ch
MAMCO Musée d'Art Moderne et Con-
temporain Genève is the largest museum
of contemporary art in Switzerland. Lo-
cated in a renovated factory building,
MAMCO has since its opening in 1994
built a reputation for offering innovative
exhibitions and programs. The collection
focuses on work post-1960 and includes
work by Robert Filliou, Martin Kippen-
berger, and Franz Erhard Walthur. MAM-
CO is part of the umbrella BAC, bâtiment
d'art contemporain, which also includes
the Centre d'art Contemporain, and
which faces an uncertain future due to
closure of Centre pour l'image contem-
porain and the merging of the photogra-
phy center into CAC and MAMCO.
Director Christian Bernard.

Centre pour l'image contemporaine
5 rue du Temple Saint-Gervais
Tue–Sun 12–6
Tel +41 22 908 2000
www.centreimage.ch
Founded in 1985, the Centre pour l'image
contemporaine is geared to video and
multi-media work as well as organizing
the Biennial of Moving Images. The Cen-
tre also presents five to six solo shows a
year and announced it will have to close
in late 2008 therefore the website should
be consulted for its present status.
Selected solo exhibitions Thierry
Kuntzel, Elina Brotherus, Charles
Sandison

Giornico

La Congiunta
Tue–Mon 8–5
Set in a remote village in the canton of
Ticino, La Congiunta, or The Marriage,
houses the sculptural relief's of Swiss
artist Hans Josephson. The architecture
of Peter Märkli and Stefan Bellwalder
is one of the most discussed projects of
the nineties. Opening in 1992, it is min-
imalist and elemental in its structure,
with no heating or artificial lighting to

mediate the viewers' experience of Jo-
sephson's work. To visit takes a 40 min-
ute bus trip (bus stop: Giornico, S. An-
thony) from Bellinzona Train Station and
one must inquire for the keys to La Con-
giunta at Osteria Gironico on the main
street of Giornico.

Glarus

Kunsthaus Glarus
Im Volksgarten
Tue–Fri 2–6, Sat–Sun 11–5
Tel +41 55 640 2535
www.kunsthausglarus.ch
Kunsthaus Glarus was inaugurated in
1952 with a modernist building designed
by Hans Leuzinger. The collection focus-
es on Swiss art and includes works by
Olaf Breuning, Fabrice Hybert, and Daniel
Roth.
Director Nadia Schneider 2001–,

Beatrix Ruf 1998–2001
Selected solo exhibitions David Thorpe, Jeanne Faust, Peter Piller

Langenbruck

Stiftung Sculpture at Schönthal Monastery

accessible via bus,
exact details available on website
Fri 2–5, Sat 11–6, Sun 11–6
Tel +41 62 390 1160
www.schoenthal.ch

Set at the site of a Romanesque-era monastery in the Jura countryside near Basel, the Stiftung Sculpture at Schönthal Monastery is located in gardens of the monastery that re-opened as a cultural center in 2000. Presenting only sculpture the center includes works by artists such as Anish Kapoor, David Nash, Ulrich Rückriem, and Roman Signer.

Lausanne

Lausanne Resources

www.ggala.ch
French-languageguide to exhibitions
www.lausanne.ch/musees
French, German, Italian, and English-language guide to museums

Lausanne Events

September
Nuit des Musées
2012
new Musée Cantonal des Beaux Arts de Lausanne opens, architecture by Berrel Wüsler Kräutler

Musée Cantonal des Beaux Arts de Lausanne

Palais de Rumine, Place de la Riponne 6
Tue–Wed 11–6, Thu 11–8,
Fri–Sun 11–5
Tel +41 21 316 3445
www.beaux-arts.vd.ch

Musée Cantonal des Beaux Arts de Lausanne is housed in the 1904 Palais de Rumine and, in addition to its collection of historical art, has holdings of contemporary work by artists such as Bruce Nauman, Fabrice Gygi, and Alfredo Jaar. A new building to open in 2012 is to be designed by Berrel Wüsler Kräutler and will occupy a spectacular site on Lake Geneva.
Director Yves Aupetitallot
Selected solo exhibitions Albert Oehlen, Alfredo Jaar, Tom Burr

Lucerne

Kunstmuseum Luzern

Europlatz 1
Tue–Sun 10–5, Wed 10–8
Tel +41 41 226 7800
www.kunstmuseumluzern.ch

Kunstmuseum Luzern is housed on the 4th floor of Jean Nouvel's striking KKL (Culture and Congress Centre Lucerne) on the shores of Lake Lucerne. From 1933 to 1996 the museum was set in a purpose-built construction that was demolished to make way for the KKL. Since 2000 the museum exhibits contemporary art in spaces partially designed by artist Remy Zaugg and which focus on international contemporary art as well as presenting selections from its permanent collection of primarily Swiss art from the Renaissance to today. The collection includes work by Tony Cragg, Anton Henning, and Paul Thek.

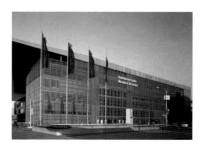

Selected solo exhibitions Annemarie
Öchslin, Robert Estermann, Werner
Meier

Lugano

Museo d'Arte Moderna
Riva Caccia 5
Tue–Fri 10–12 & 2–6,
Sat–Sun 11–6
Tel +41 58 866 6908
www.mdam.ch

Set in a picturesque location on Lake Lugano, the Museo d'Arte Moderna is the city of Lugano's venue for temporary exhibitions focusing on twentieth-century art. The Villa Malpensata was constructed in the eighteenth century but only opened as a museum in 1973 and further renovations brought it to its present condition in 1992. Exhibition strategy varies widely with modernism frequently taking precedence over contemporary and the permanent collection is focused on works from early twentieth-century regional artists.

Selected solo exhibitions Georg Baselitz, Christo and Jeanne-Claude, Jean-Michel Basquiat

Neuchâtel

CAN Centre d'art Neuchâtel
rue des Moulins 37
Wed–Sun 2–6
Tel +41 32 724 0160
www.can.ch

CAN Centre d'art Neuchâtel presents temporary exhibits by both regional and international artists.

Founding director Marc Olivier Wahler 1994–2001

Schaffhausen

Hallen für Neue Kunst
Baumgartenstrasse 23

Sat 3–5, Sun 11–5
Tel +41 52 625 2515
www.modern-art.ch

Opened by private collector Urs Raussmüller, the Hallen für Neue Kunst were established in 1984 in a former textile factory. The institution includes site-specific works by Joseph Beuys, Robert Ryman, and Mario Merz, as well as having a large selection of minimalist post-1965 works.

Selected solo exhibition Robert Mangold

Solothurn

Kunstmuseum Solothurn
Werkhofstrasse 30
Tue–Fri 11–5, Sat–Sun 10–5
Tel +41 32 624 4000
www.kunstmuseum-so.ch

Kunstmuseum Solothurn opened in 1902 and features historical art as well as a selection of works from contemporary Swiss artists such as Roman Signer, Markus Raetz, and Dieter Roth.

St. Gallen

St. Gallen Events
September
Museum Nacht

Kunst Halle Sankt Gallen
Davidstrasse 40
Tue–Fri 12–6, Sat–Sun 11–5
Tel +41 71 222 1014
www.k9000.ch

Inaugurated in 1993 the Kunst Halle Sankt Gallen exhibits emerging and challenging artists in a converted warehouse complex. The Kunst Halle is noted for its commitment to cutting-edge work and was formerly known as the Neue Kunst Halle St. Gallen.

Curator Giovanni Carmine
Selected solo exhibitions Gedi Sibony, David Lamelas

Kunstmuseum St. Gallen
Museumstrasse 32
Tue–Sun 10–5, Wed 10–8
Tel +41 71 242 0671
www.kunstmuseumsg.ch
Kunstmuseum St. Gallen is St. Gallen's main museum and was designed in 1877 by classicist architect Johann Christoph Kunkler. While the museum's collection starts in the late Middle Ages, there is also a significant contemporary section with works by Roland Signer, Pipilotti Rist, and Mario Merz.
Director Roland Wäspe
Selected solo exhibitions Emily Jacir, Nedko Solakov, Erwin Wurm, David Claerbout, Franz Ackermann, Bethan Huws

Stadtlounge
Schreinergasse 6
www.sanktgallen.ch/stadtlounge/
The stylish public living room, Stadtlounge, was designed by Pipilotti Rist and Carlos Martinez and opened in 2005. With red gadgets such as furniture, a fountain, and a Porsche this public square outside a bank's headquarters is a surreal aesthetic experience.

Thun

Kunstmuseum Thun
Hofstettenstrasse 14
Tue–Sun 10–5, Wed 10–9
Tel +41 33 225 8420
www.kunstmuseum-thun.ch
Kunstmuseum Thun is located since 1948 in the former Grand Hotel Thunerhof that was built in 1875. Although the permanent collection is not on view, temporary exhibitions regularly feature international artists.
Director Helen Hirsch
Selected solo exhibitions Aernout Mik, Mark Grotjahn, Simon Dybbroe Moller, Burkhard Hilty

Winterthur

Kunstmuseum Winterthur
How to get there Set 45 minutes north of Zurich, the Kunstmuseum Winterthur is located in the center of this industrial city.
Museumstrasse 52
Tel +41 52 267 5162
Tue 10–8, Wed–Sun 10–5
www.kmw.ch
(German)
Exhibitions & Collections Built by private collections, the Kunstmuseum is especially strong in Impressionism and European Modernism. A vigorous collection scheme for contemporary art has brought works by Brice Marden, Agnes Martin, and Mario Merz, amongst others, into the collection.
Building The neoclassical museum opened in 1916 to a design by Rittmeyer and Furrer. In the nineties it was decided to build a temporary (since made permanent) extension to house contemporary art exhibitions and this opened in 1995 to a design by Gigon + Guyer. The shed-like structure is deceptively simple and evidences Gigon + Guyer's noted concern for light and a modernist influenced simplicity.
Director Dieter Schwartz
Selected solo exhibitions Pia Fries, Mario Merz, Andro Wekua, Helmut Dorner

Fotomuseum Winterthur
Grüzenstrasse 44–45
Tue–Sun 11–6, Wed 11–8
Tel +41 52 234 1060
www.fotomuseum.ch
The Fotomuseum Winterthur was founded in 1993 and presents temporary exhibitions centered on photography. Also housing a permanent collection which is not on view, the museum has recently added the Jedermann Collection featur-

ing artists such as John Baldessari, Bernd & Hilla Becher, and Gordon Matta-Clark, to its substantial holdings.

Selected solo exhibitions Zoe Leonard, Shomei Tomatsu, Gregory Crewdson

Zug

Kunsthaus Zug
Dorfstrasse 27
Tue–Fri 12–6, Sat–Sun 10–5
Tel +41 41 725 3344
www.kunsthauszug.ch

Kunsthaus Zug presents temporary exhibits drawing on its collections of modern and contemporary art that includes works by Olafur Eliasson and Richard Tuttle. The Kunsthaus is located in sixteenth-century buildings renovated by Franz Füeg.

Selected solo exhibition Olafur Eliasson

Zurich

One of Europe's major art capitals and the center for much of the art business on the European continent, Zurich has a long history of engagement with contemporary art. With the opening of the former Löwenbräu brewery in 1996 as a center for galleries and institutions, Zurich began a phase of rapid expansion of the art gallery business that has been further enhanced by Switzerland's tax system and the benefits that come from purchasing art in the city.

Zurich Resources
www.museen-zuerich.ch
German, French and English-language museum information

Zurich Events
Roswitha Haftmann Award, annual award presented at Kunsthaus Zürich; Zurich Prize, annual award
September
Lange Nacht der Museen
October
Art International Zurich
November
Kunst Zurich—International Contemporary Art Fair
2011
Bau West, Löwenbräu complex, architects Gigon + Guyer
TBD: Kunsthaus Zürich extension, David Chipperfield architect

Kunsthalle Zürich
Tue–Fri 12–6, Thu 12–8, Sat–Sun 11–5
Tel +41 44 272 1515
www.kunsthallezurich.ch

Kunsthalle Zürich hosts temporary exhibitions of international contemporary art and is located in the former Löwenbräu brewery complex and reachable via tram 4 or 13 from the Hauptbahnhof. The Kunsthalle was founded in 1985 as a compliment to the Kunsthaus Zürich and moved to its current location in 1996.
Director Beatrix Ruf 2001–

Selected solo exhibitions Kai Althoff, Valentin Carron, Christopher Williams, Nicole Eisenman, General Idea, Terence Koh

Kunsthaus Zürich

How to get there The Kunsthaus Zürich lies in the center of Zurich at Heimplatz 1.
Tue–Thu 10–9, Fri–Sun 10–5
Tel +41 44 253 84 97
Website: www.kunsthaus.ch
(German, French, English)

Exhibitions & Collections One of the oldest still active private art associations in Europe, the Züricher Kunstgesellschaft began life in 1787. Originally collecting and exhibiting Swiss and German art only, the Kunstgesellschaft is based on democratic principles with the concept of bringing art to a wider public. Donated private collections form the basis of the museum's extensive holdings from the medieval period to today, which includes contemporary artists such as Cy Twombly, Georg Baselitz, and Bruce Nauman.
Building Opened in 1910, the Kunsthaus Zürich was designed by Swiss architect Karl Moser. The museum has undergone many extensions and alterations including one by Moser himself in 1925 as well as successive ones in 1976 by Erwin Müller and one recently completed in 2005. Plans are also underway to add a significant extension by David Chipperfield

that would enable the museum to show more of its collection.
Director Christoph Becker 2000–
Selected solo exhibitions Felix Valloton, Fischli & Weiss, Sigmar Polke, Miroslav Tichy

Migros Museum für Gegenwartskunst

Limmatstrasse, tram 4 or 13
from the Hauptbahnhof
Tue–Fri 12–6, Thu 12–8, Sat–Sun 11–5
Tel +41 44 277 2050
www.migrosmuseum.ch
The cultural branch of the Swiss supermarket and household goods chain Migros, Migros Museum für Gegenwartskunst offers contemporary art with a social dimension. Located since 1996 in the same Löwenbräu complex that houses the Kunsthalle, Migros has featured exhibits by leading international artists as well as developing a collection that is not on permanent view.
Director Heike Munder 2001–
Selected solo exhibitions Yoko Ono, Christoph Schlingensief, Mike Taanila, Robert Kusmirowski, Marc Camille Chaimowicz

Daros Collection

Löwenbrau Areal, Limmatstrasse 268
Thu–Sun 12–6
Tel +41 44 447 7000
www.daros.ch
Founded by Swiss entrepreneur Stephan Schmidheiny, the Daros Collection is one of the largest in Switzerland. Daros Exhibitions is the exhibiting arm of the collection and opened in 2001 in the former Löwenbräu factory with a concentration on Latin American art. The collection itself was guided by Swiss dealer Thomas Ammann and includes works by Hélio Oiticia, Bruce Nauman, and Cildo Meireles.
Director of Daros Latin America Collection Hans-Michael Herzog

Selected solo exhibitions Carlos Amorales, Guillermo Kuitca, Fabian Marcaccio

Haus Konstruktiv
Selnaustrasse 25
Tue–Fri 12–6, Wed 12–8, Sat–Sun 11–6
Tel +41 44 217 7080
www.hauskonstruktiv.ch
Haus Konstruktiv the Foundation for Constructive and Concrete Art is a private institution founded in 1986. In 2001 the institution moved into a new location at a former power station in the center of the city.
Director Dorothea Strauss
Selected solo exhibitions Gottfried Honegger, Carsten Nicolai, Günther Umberg

Shedhalle
Rote Fabrik Seestrasse 395
Wed–Fri 2–5, Thu 2–9,
Sat–Sun 2–8
Tel +41 44 481 5950
www.shedhalle.ch
Evolving from the Rote Fabrik alternative cultural center, the Shedhalle is situated in a former silk-weaving mill built in 1892 and since opening as an art center in 1986 has presented a wide range of events and exhibitions.
Co-directors Katharina Schlieben and Sonke Gau 2004–

Zurich Art Areas
Former brewery Löwenbräu Areal (270 Limmatstrasse) complex opened as an art venue in 1996 and houses major institutions and galleries and for many is the center of the Swiss art world. This has been the model for many subsequent renovations of factory complexes as arts venues. In October 2008 it was announced the complex will house Bau West, which will be an exhibition venue for shows from private collections as well as outside

curators and will open to a design by Gigon + Guyer in 2011.

The former red-light and industrial district, Zurich West, has seen over the past several years a major effort of urban regeneration that has included the opening of many galleries and alternative spaces. Here can be found the Löwenbräu Areal.

A secular state, Turkey is a country that
straddles the border between European
and Middle Eastern culture and this is reflected in its ap-
proach to the arts that is limited to the capital Istanbul
where a flourishing art scene has developed over the last
decade. The main drivers of the art scene in Turkey are
private individuals as the government has yet to fully
embrace the contemporary.

Turkey

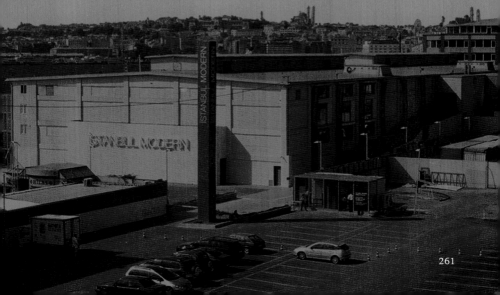

Istanbul

With the establishment of contemporary art centers, a well-regarded biennial, and an international art fair, Istanbul is fast outstripping other capitals in the region, such as Athens, in its commitment to the contemporary. While galleries are not as prominent here, there are museums and foundations that support the arts in a variety of ways.

Istanbul Events

December
Contemporary Istanbul art fair
2008
Platform Garanti Contemporary Art Center renovation, late 2008 (delayed)
2009
11th International Istanbul Biennial (12 Sept–8 Nov 09)
2010
Istanbul European Capital of Culture; Suna Kiraç Opera and Cultural Centre opens, architect Frank Gehry
2011
12th International Istanbul Biennial

Istanbul Modern

Meclis-i Mebusan Caddesi
Tue–Sun 10–6, Thu 10–8
Tel +90 212 334 7300
www.istanbulmodern.org

Istanbul Modern was founded in 2004 in a former government custom warehouse and exhibits and collects contemporary art. Set in the Tophane district, the Modern has developed a reputation for its commitment to the contemporary. The collection stresses Turkish artists although the exhibition program is more international in focus.
Director David Elliott
Selected solo exhibitions Ahmet Polat, Andreas Gursky

Platform Garanti Contemporary Art Center

Istiklal Cad. No.: 115A Beyoglu
Tue–Sat 10–6
Tel +90 212 293 2361
www.platform.garanti.com.tr
Platform Garanti Contemporary Art Center opened in 2001 and presents international artists in a Kunsthalle format. In 2007 a renovation was begun and the center is expected to re-open in late 2008. The center is known for presenting talks as well as offering artists' residencies.
Director Vasif Kortun

Proje4L Elgiz Museum of Contemporary Art

Harman Sokak, Harmanci Giz Plaza, Gultepe-Levent
Wed–Fri 10–6, Sat 10–4
Tel +90 212 281 5150
www.proje4l.org
Proje4L Elgiz Museum of Contemporary Art was established in 2001 to present works from the collection of Sensda and Can Elgiz. The exhibits and collection feature both Turkish and international contemporary art.

santralistanbul

Eski Silahtaraga Elekrik Santrali, Silahtar Mah. Kazim, Krabekir Caddesi No. 1
www.santralistanbul.com
santralistanbul is a cultural complex that opened in 2007 in the Eyup district in a

former power station that was the Otto-man Empire's first power station in 1914. Included in the complex is a museum de-voted to modern and contemporary art.

BM-Suma Contemporary Art Center
Voyvoda Cad. Yanikkapi Sokak No. 3
Kat. 2 Karakoy
Tel +90 212 361 5861
www.bmsuma.com
BM-Suma Contemporary Art Center originally opened in 1984 and is run by Beral Madra, a leading figure on the Turk-ish art scene. The center moved into a new space in 2007.

Suna Kiraç Opera and Cultural Centre
To open in 2010, the Frank Gehry-de-signed Suna Kiraç Opera and Cultural Centre will be located next to the current Pera Museum which is a venture of the Suna and Inan Kiraç Foundation. The site itself is part of a complex of buildings from the late nineteenth century de-signed by Achille Manoussos. From one of the richest families in Turkey and part of the Koc Group run by magnate Rahmi Koc, Suna Kiraç is creating this private cultural complex in which the exact na-ture of exhibitions is yet to be estab-lished.

Istanbul Art Areas
In the Tophane district, the Tütün Depo-su is a tobacco-storage building that was converted into galleries and studios be-ginning in 2007.

Ukraine

Following the collapse of the USSR in 1991, Ukraine became an independent state and has struggled to establish a national identity in the ensuing years. Ukraine has many of the same issues affecting it as does it neighbor Russia, such as a predatory oligarch-driven economy as well as authoritarian elements that attempt to control both culture and political life. The contemporary scene reflects this mixture with an art scene heavily dependent on support from the private sector.

Kiev

The center of the Ukrainian art world, contemporary art in Kiev is dominated by the presence of oligarch and mega collector Victor Pinchuk and his art center. As of yet, the municipal and state authorities have limited presence in the contemporary arena, leaving the field instead to private individuals like Pinchuk.

Contemporary Art Centre
vul. Skovorody 2
Tue–Sun 1–6
Tel +380 44 238 2446
www.cca.kiev.ua
Contemporary Art Centre was founded in 1993 and originally established by George Soros as part of the SCCA network. The institution faces an uncertain future as support from the Ukrainian state is virtually non-existent.

Pinchuk Art Centre
Tue–Sun 12–9, Arena 1/3–2,
A Block, Krasnoarmeyskaya/Basseynaya
St. Bessarabskiy Block
Tel +38 590 0858
www.pinchukartcentre.org

Pinchuk Art Centre opened by industrialist and oligarch Viktor Pinchuk in 2006 to a design by Philippe Chiambaretta that rehabilitates a twentieth-century building in the center of the city. Pinchuk is a major figure in the international art market and his collection of contemporary works is one of the strongest to be developed in recent years. With the recent appointment in 2008 of Austrian museum director Eckhard Schneider, well known from the Kunsthaus Bregenz, the center has further established its credentials as a cutting-edge venue.
Director Eckhard Schneider 2008–, president Peter Doroshenko 2006–
Selected solo exhibition Vik Muniz

Special Sections

Art Fairs

Art Fairs Resources
artfairsinternational.com
English-language art-fair information

January
ArteFiera Art First
Bologna, Italy (23–26 Jan 09), held at Bologna Exhibition Center, begun in 1976, one of the major European fairs
www.artefiera.bolognafiere.it

February
Art Rotterdam
Rotterdam, Netherlands (5–8 Feb 09) (4-7 Feb 10), held at the Cruise Terminal in Rotterdam, begun in 1999, this fair is quite conservative in outlook
www.artrotterdam.nl

ARCO 09
28th International Contemporary Art Fair
Madrid, Spain (11–16 Feb 09), held at the Feria de Madrid, one of the major European fairs that has grown in reputation in recent years. Director Lourdes Fernandez 2007–, director Rosina Gomez-Baeza – 2006
www.arco.ifema.es

Market Stockholm
Stockholm, Sweden (19–21 Feb 2010), held at the Royal Swedish Academy of Fine Arts, Nordic-centered fair
www.market-art.se

Art Innsbruck
Innsbruck, Austria (19–22 Feb 09), held at the Exhibition Hall
www.art-innsbruck.at

March
Art Karlsruhe
Internationale Messe für Klassische Moderne und Gegenwartskunst
Karlsruhe, Germany (5–8 Mar 09), held at the Karlsruhe Messe
www.art-karlsruhe.de

Fresh Venice! Contemporary Art Fair
Venice, Italy (12–15 Mar 09), held at Hotel Monaco & Grand Canal first edition in 2009
www.freshvenice.com

Art Paris
Foire d'art Moderne + Contemporain
Paris, France (19–23 March 09), held at the Grand Palais, begun in 1999, this is a more conservative fair than FIAC, Art Paris also holds a fall fair in Abu Dhabi
www.artparis.fr

April
Roma Contemporary
Rome, Italy (2–5 April 09), held at four different venues throughout Rome, begun in 2008, organized by Roberto Casiraghi
www.romacontemporary.it

MiArt 09
Fiera Internazionale d'arte Moderna e Contemporanea
Milan, Italy (17–20 April 09), held at Fieramilanocity, begun in 1995
www.miart.it

Art Cologne
42nd International Fair for Modern & Contemporary Art
Cologne, Germany (22–26 April 09), held at the Kölnmesse, international art fair that is one of the oldest in Europe, has in recent times undergone major upheavals, director Daniel Hug 2008–, Gerard A. Goodrow –2008
www.artcologne.de

Europ'Art Genève
18th International Art Fair

Geneva, Switzerland (22–26 April 09), held at Geneva Palexpo
www.europart.ch

**ARTBrussels
27th Contemporary
Art Fair**
Brussels, Belgium (24–27 April 09), held at the Brussels Expo Halls launched in 1968, this fair has in the last few years begun to assume increased importance
www.artbrussels.be

May
**Vienna Fair
The International Contemporary
Art Fair**
Vienna, Austria (7–10 May 09), held at Meesezentrum WienNeu, begun in 2004, focuses on modern and contemporary art from eastern and southeastern Europe
www.viennafair.at

Art 09 Amsterdam
Amsterdam, Netherlands (13–17 May 09), held at the RAI in Amsterdam, formerly known as KunstRai, the Thieme Art Award given to most promising young artist
www.kunstrai.nl

**Swab Barcelona International
Contemporary Art Fair**
Barcelona, Spain (14–17 May 09), held at former arsenal in center of Barcelona, begun in 2007
www.swab.es

KunStart 09
Bolzano, Italy (21–24 May 09), held at Exhibition Hall, began in 2000
www.kunstart.it

Art Athina
Athens, Greece (21–24 May 09), held at Faliro Pavilion, Faliro Bay Olympic Complex, restarted in 2007 after a several years' hiatus
www.art-athina.gr

LOOP 09
Barcelona, Spain (27–29 May 09), held at Catalonia Ramblas Hotel, begun in 2002, art fair devoted to video art with accompanying festival that has venues throughout the city
www.loop-barcelona.com

June
PrintBasel '09
Basel, Switzerland (8–14 June 09), held in the Volkshaus, begun in 2007, international fair for contemporary graphic works of art
www.printbasel.com

**Scope
International Contemporary
Art Fair**
Basel, Switzerland (8–14 June 09), held at the E-Halle, first Basel version in 2007, international art fairs held in New York, the Hamptons, London, Miami, and Basel, dedicated to emerging art, Alexis Hubshman director and founder
www.scope-art.com

Volta 5
Basel, Switzerland (9–13 June 09), held at the Markthalle, founded in 1985 by dealers Kavi Gupta, Ulrich Voges, and Friedrich Loock
www.voltashow.com

**Liste
The Young Art Fair in Basel**
Basel, Switzerland (9–14 June 09), held at the workshop community Warteck pp, begun in 1996, fair devoted to new galleries and emerging art, director Peter Blaeuer
www.liste.ch

bâlelatina
contemporary art fair
(10–14 June 09), held at Brasilea Foundation, begun in 2006, Latin-art fair
www.hot-art-fair.com

ART 40 Basel
Basel, Switzerland (10–14 June 09), held at the Messe Basel, the most important contemporary fair with a version also held as Art Basel Miami Beach in December, the Baloise Art Prize given during fair, Samuel Keller director 2000–07, Marc Spiegler 2008–, Cay Sophie Rabinowitz artistic director 2008 (resigned in May 08)
www.artbasel.com

July
Arte Santander
Santander, Spain (16–20 July 08), held in Congress and Exhibition Hall,
begun in 1991, focused on Spanish galleries
www.artesantander.com

July/August
Art Bodensee
Dornbirn, Austria (22–26 July 09), held at the Dornbirn Messe, begun in 2000, conservative fair
www.artbodensee.info

September
Docks Art Fair
Lyon, France (14–20 Sept 09), held in tent along Saône River, inaugural edition of biannual fair in 2007, emerging-art emphasis
www.docksartfair.com

Art Copenhagen
The Nordic Art Fair
Copenhagen, Denmark (18–20 Sept 09), held in the Forum Copenhagen, Nordic galleries predominate
www.artcopenhagen.dk

Art Moscow 2009
Moscow, Russia (23–27 Sept 09), held at the Central House of Artists, begun in 1997, director Vassily Bychkov
www.expopark.ru

Preview Berlin:
The Emerging Art Fair
Berlin, Germany, 4th fair, (23–27 Sept 09), held at Tempelhof Airport, satellite fair of art forum berlin, primarily German and Europe-based galleries, emphasizing Berlin artists
www.previewberlin.de

ABC
Art Berlin Contemporary
(24–27 Sept 09), held at Postbahnhof Gleisdreieck, inaugural edition 2008, director Michael Neff
www.artberlincontemporary.com

art forum berlin 13th edition
Berlin, Germany (24–27 Sept 09), held at the Messe, major European Art fair
www.messe-berlin.de

October
Bridge Art Fair
London, England (TBD Oct 09), held at the Trafalgar Hotel, inaugural fair in 2007, also held in Miami, Berlin, and New York and featuring emerging art. Director and founder Michael Workman, 2008 edition was canceled
www.bridgeartfair.com

Frieze Art Fair
London, England (15–18 Oct 09), held in Regent's Park, inaugural fair in 2003, one of the premier fairs in the world including approximately 150 of the most prominent galleries in the world, The Cartier Award is presented during fair. Directors Amanda Sharp and Matthew Slotover
www.friezeartfair.com

Scope London
(15–18 Oct 09), held at Lord's Cricket Ground, began in 2005
www.scopelondon.com

10th Art International Zurich
Zurich, Switzerland (16–18 Oct 09), held at Congresshall Zurich, devoted to twentieth- and twenty-first-century art
www.art-zurich.com

Art Verona
Fiera d'Arte Moderna e Contemporanea
Verona, Italy (17–21 Oct 09), held at the Verona Fiere, begun in 2005, this fair is dedicated to Italian galleries and focuses on modern and contemporary art with a special section on outsider art
www.artverona.it

Zoo Art Fair
London, England (17–20 Oct 08), held at the Royal Academy of Arts, satellite fair begun in 2003, devoted to emerging contemporary art with a UK focus. Champagne Perrier-Jouët Prize given during fair. Director Soraya Rodriguez
www.zooartfair.com

Show-Off
Paris, France (22–28 Oct 08), held at Espace Pierre Cardin, begun in 2006
www.showoffparis.com

FIAC
Foire Internationale d'art contemporain
Paris, France (22–25 Oct 09), held at the Grand Palais, the oldest European art fair after Cologne and Basel, a major international art fair, co-directors Martin Bethenod and Jennifer Flay
www.fiacparis.com

Art Élysées
Paris, France (22–26 Oct 09), held along the Champs-Élysées, launched in 2007

as Élysées de l'Art
www.artelysees.fr

Slick 09
Paris, France (23–26 Oct 09), held at Centquatre, begun in 2006, devoted to emerging galleries
www.slick-paris.com

The Affordable Art Fair
London, England (22–25 Oct 09), held at Battersea Park, launched in 1999
www.affordableartfair.com

October / November
Art.Fair 21
Fair for Twenty-First-Century Art
Cologne, Germany (29 Oct–1 Nov 09), held at Expo XXI, begun in 2002, geared to emerging art
www.art-fair.de

Bridge Art Fair
Berlin, Germany (30 Oct–2 Nov 08), held at Old Town Apartments on Schönhauser Allee, inaugural edition in Berlin in 2008, New York and London-based fair
www.bridgeartfair.com

November
Artissima A16
International Fair of Contemporary Art in Turin
Italy (6–8 Nov 09), held at the Lingotto Fiere, this is one of the most important contemporary art fairs, Illy Present Future Award given during fair. Director Andrea Bellini 2007–, director Roberto Casiraghi –2006
www.artissima.it

Arte Padova
20a Mostre Mercato d'Arte Moderna e Contemporanea
Padua, Italy (13–16 Nov 09), held at Padova Fiere
www.artepadova.com

Special Exhibitions

Paris Photo
Paris, France (19–22 Nov 09), held at
the Carrousel du Louvre, begun in 1997,
the BMW Photo Prize is given during the
fair, the major European photography
fair
www.parisphoto.fr

Kunst 09 Zurich
15th International Contemporary
Art Fair
Zurich, Switzerland (13–16 Nov 09),
held in former ABB factory buildings
www.kunstzuerich.ch

Arte Lisboa
Feira de Arte Contemporanea
Lisbon, Portugal (18–23 Nov 09), held in
the Parque das Nacoes, primarily Portu-
guese fair
www.artelisboa.fil.pt

St-art
14th European contemporary art fair
Strasbourg, France (26–30 Nov 09), held
at Parc des Expositions
www.st-art.fr

Feria Puro Arte
Vigo, Spain (15–19 Jan 09), held at the IF-
EVI, begun in 2006, devoted to Spanish
and Portuguese galleries
www.feriapuroarte.com

December
Contemporary Istanbul
Istanbul, Turkey (3–6 Dec 09), held at the
ICEC, begun in 2006
www.contemporaryistanbul.com

Special Exhibitions
Documenta, Biennials, Triennials

2009
Linz, Austria / Vilnius, Lithuania:
European Capitals of Culture
Linz: www.linz09.at
Vilnius: www.culturelive.lt

January 2009
Santiago Sierra, Death Clock,
Hiscox Building façade
London, 1 Great St. Helen's
(1 Jan–31 Dec 09)

HPF09, Helsinki Photography Festival
Helskini, Finland (21–24 Jan 09), festi-
val last held in 2005
www.hpf.fi

February 2009
Tate Triennial
New British Art, Tate Britain
London, England (3 Feb–26 April 09),
curator Nicolas Bourriaud

March 2009
VideoFormes
XXIVe manifestation internationale
d'art vidéo et nouveaux medias
Clermont-Ferrand, France (10–14 Mar 09)
www.nat.fr/videoformes

ev+a 2009
Limerick, Ireland (14 Mar–24 May 09),
annual culture and arts festival, curators:
Angelika Nollert and Yilmaz Dziewior
www.eva.ie

IMHE Project
Helsinki, Finland (20 Mar–13 April 09),
artist: Antony Gormley
www.proartefoundation.fi

Contour 2009–Fourth Biennial
for Video Art
Mechelen, Belgium (22 Mar–21 Jun 09)

April 2009

European Media Art Festival 2009
Osnabrück, Germany (22–26 April 09)
www.emaf.de

May 2009

WRO 09: Expanded City,
XIII Media Art Biennale
Wrocław, Poland (5–10 May 09)
www.wro09.wrocenter.pl

Festival of Regions: Normality
Linz (region), Austria (9 May–1 June 09)
www.fdr.at

Curated by Vienna 09
(6 May–6 June 09) at eighteen contemporary galleries
www.curatedby.at

Prague Biennale 4
Prague, Czech Republic (14 May–26 July 09)
www.praguebiennale.org

June 2009

International Contemporary Art
Triennial: Urban Stories
Vilnius, Lithuania (June–Sept 09)
www.culturelive.lt

PhotoEspaña
Madrid, Spain (3 June–26 July 09),
annual festival begun in 1998
www.phedigital.com/festival

Loire Estuary 2007 2009 2011
Nantes to Saint Nazaire
France (6 June–16 Aug 09)
www.estuaire.info

La Biennale di Venezia:
Making Worlds
Venice, Italy (7 June–22 Nov 09), 53rd
Biennale, curator Daniel Birnbaum
Held at Arsenale Corderie and Artiglierie,
Padiglione Italia at the Giardini. The Gol-
den Lion Awards are presented during fair
German Pavilion:
www.deutscher-pavilion.org
British Pavilion:
www.britishcouncil.org/biennale
Dutch Pavilion:
www.dutchpavilion.info
www.labiennale.org

2nd Athens Biennial:
Heaven
Athens, Greece (15 June–4 Oct 09),
curators Dimitris Papaioannou and
Zafos Xagoraris
www.athensbiennial.org

Royal Academy of Arts
Summer Exhibition
Royal Academy, London, England, 242nd
edition of annual show (8 June–16 Aug 09)
www.royalacademy.org.uk

July 2009

Serpentine Pavilion, SANAA
Serpentine Gallery
London, England (opens July)

Les Rencontres d'Arles Photographie
Arles, France (7 July–13 Sept 09)
www.rencontres-arles.com

August 2009

Kunstfest Weimar
(21 Aug–13 Sept 09)
www.kunstfest-weimar.de

September 2009

ARS Electronica
Linz, Austria, annual festival of art and
technology (3–8 Sept 09)
www.aec.at

Festival d'Automne à Paris
Paris, France, annual autumn festival of
visual arts, opera, music, etc., first held in
1972
www.festival-automne.com

Special Exhibitions

Château de Versailles:
Versailles Off
France, artist Xavier Veilhan
(Sept–Dec 09)

Göteborg International Biennial
for Contemporary Art, 5th edition
Göteborg, Sweden (5 Sept–15 Nov 09),
curators Celia Prado & Johan Pousette
www.rodasten.se

Biennale de Lyon
Lyon, France (16 Sept 09–3 Jan 10),
curator Hou Hanru
www.biennale-de-lyon.org

Art in Unusual Places
Vilnius, Lithuania (19–27 Sept 09)
www.culturelive.lt

4th International Architecture Biennale
Rotterdam, Netherlands (24 Sept 09–
10 Jan 10), curator Kees Christiaanse

Third Moscow Biennial of Contem-
porary Art: Against Exclusion
Moscow, Russia (24–29 Sept 09),
curator Jean-Hubert Martin
www.3rd.moscowbiennale.ru

October 2009
50th October Salon
Belgrade, Serbia
www.oktobarskisalon.org

November 2009
11th International Istanbul Biennial:
What Keeps Mankind Alive?
Istanbul, Turkey (12 Sept–8 Nov 09),
curators WHW What, How & for
Whom
www.iksv.org

World Architecture Festival
annual event launched in 2008,
Barcelona, Spain (4–6 Nov 09)
www.worldarchitecturefestival.com

December 2009
Florence Biennale, Biennale Inter-
nazionale dell'arte Contemporanea
Florence, Italy (5–13 Dec 09), this bien-
nale is geared to more conservative art-
ists and held at the Fortezza da Basso
www.florencebiennale.org

TBD 2009
Athens Video Art Festival 09
fifth edition of annual festival and held at
Technopolis
www.athensvideoartfestival.gr

Projekt Synagogue Stommeln
Cologne, Germany

Alt_Cph: Platform for Nordic
Non-Profit Art Spaces
Copenhagen, Denmark, held at Fabriken
for Kunst og Design, annual event begun
in 2006
www.altcph.dk

13th BIM Biennial of Moving Images
Centre pour l'image contemporaine
Saint-Gervais Geneva, Switzerland
www.centreimage.ch

Playground-Live Art Festival
STUK Kunstuncentrum
Leuven, Belgium, annual event first held
in 2007
www.playgroundfestival.be

Paris Triennial, Grand Palais
Paris, France
www.grandpalais.fr

2010
Essen, Germany / Pécs, Hungary /
Istanbul, Turkey: European Capitals
of Culture
Essen:
www.en.kulturhauptstadt-europas.de
Pecs: www.pecs2010.hu
Istanbul: www.istanbul2010.org

January 2010
Monumenta, Grand Palais
Paris, France, artist Christian Boltanski

Spring 2010
bb6 6th Berlin Biennial
Berlin, Germany (Spring 2010),
curator Kathrin Rhomberg
www.berlinbiennale.de

May 2010
Kunstvlaai A.I.P.
Amsterdam, Netherlands (May 2010),
biannual festival of emerging art
www.kunstvlaai.nl

BB4
Bucharest International Biennial
of Contemporary Art: Handlung:
On Producing Possibilities
Bucharest, Romania (21 May–20 June
2010) curator Felix Vogel
www.bucharestbiennale.org

June 2010
11. Triennale Kleinplastik 2010
Fellbach, Germany (June 2010–),
curator Ulrike Gross
www.triennale.de

Summer 2010
Serpentine Pavilion
Serpentine Gallery
London, England

Royal Academy of Arts
Summer Exhibition
Royal Academy, London, England,
242nd edition of annual show
www.royalacademy.org.uk

Fall 2010
Quadriennale
Düsseldorf, Germany (Nam June Paik at
Musuem Kunst Palast 4 Sept–21 Nov 10,
Joseph Beuys at K20, James Lee Byars at
Stiftung Schloss und Park Benrath and

other exhibits at venues throughout
Düsseldorf)
www.quadriennale-duesseldorf.de

September 2010
Festival d'Automne à Paris
Paris, France, annual autumn festival of
visual arts, opera, music, etc., first held
in 1972
www.festival-automne.com

October 2010
51st October Salon
Belgrade, Serbia (2 Oct–15 Nov)
www.oktobarskisalon.org

TBD 2010
Les Rencontres d'Arles Photographie
Arles, France
www.rencontres-arles.com

Athens Video Art Festival 10
sixth edition of annual festival and held
at Technopolis
www.athensvideoartfestival.gr

BAS7
The British Art Show
United Kingdom, traveling to three UK
venues

Brighton Photo Biennial
Brighton, England
www.bpb.org.uk

Brussels Biennial
Brussels, Belgium, 2nd edition
www.brusselsbiennial.org

VideoFormes
XXIVe manifestation internationale
d'art vidéo et nouveaux medias
Clermont-Ferrand, France
www.nat.fr/videoformes

Projekt Synagogue Stommeln
Cologne, Germany

Special Exhibitions

Alt_Cph, Platform for Nordic Non-Profit Art Spaces
Copenhagen, Denmark, held at Fabriken for Kunst og Design, annual event begun in 2006
www.altcph.dk

8th International Photo Triennial
Esslingen, Germany

Glasgow International Festival of Contemporary Art
Glasgow, Scotland

Periferic 9
Biennial for Contemporary Art
Iasi, Romania
www.periferic.org

Arts Le Havre 10
biennale d'art contemporain
Le Havre, France
www.artslehavre.com

ev+a 2010
Limerick, Ireland, annual culture and arts festival
www.eva.ie

ARS Electronica
Linz, Austria, annual festival of art and technology
www.aec.at

Liverpool Biennial 6th
Liverpool, England, curator Lorenzo Fusi
www.biennial.com

LIAF
Lofoten International Art Festival
Lofoten Islands, Norway, 6th edition
www.liaf.no

PhotoEspaña
Madrid, Spain, annual festival begun in 1998
www.phedigital.com/festival

Manifesta 8
Murcia, Spain
www.manifesta.org

European Media Art Festival 2009
Osnabrück, Germany
www.emaf.de
Monumenta, Grand Palais
Paris, France, annual exhibition

Mediations Biennale
Poznan, Poland, 2nd edition
www.mediations.pl

Bienal Internacional de Arte Contemporáneao de Sevilla
Seville, Spain
www.fundacionbiacs.com

Moderna Exhibition 2010
Moderna Museet Stockholm
Quadrennial of Swedish Art
Stockholm, Sweden

12th Venice Architecture Biennial
Venice, Italy
www.labiennale.org

Château de Versailles:
Versailles Off
France

ViennaBiennale
Vienna, Austria
www.viennabiennale.com

2011
Turku, Finland / Tallinn, Estonia:
European Capitals of Culture
Turku: www.turku2011.fi
Tallinn: www.tallinn2011.ee

June 2011
La Biennale di Venezia
Venice, Italy (June-November)
www.labiennale.org

October 2011
52nd October Salon
Belgrade, Serbia

TBD 2011
3rd Athens Biennial
Athens, Greece

Florence Biennale
Biennale Internazionale dell'arte
Contemporanea, Florence, Italy
www.florencebiennale.org

Folkestone Triennial
Folkestone, England

14th BIM
Biennial of Moving Images
Centre pour l'image
contemporaine
Saint-Gervais Geneva, Switzerland
www.centreimage.ch

Göteborg International Biennial
for Contemporary Art
6th edition
Göteborg, Sweden
www.rodasten.se

5. Triennale der Photographie
Hamburg, Germany

12th International Istanbul Biennial
Istanbul, Turkey

Loire Estuary 2007 2009 2011
Nantes to Saint Nazaire
France
www.estuaire.info

Biennale de Lyon
Lyon, France
www.biennale-de-lyon.org

Asia Triennial Manchester
Manchester, England
www.asiatriennialmanchester.com

Contour 2011
Fourth Biennial for Video Art
Mechelen, Belgium

Fourth Moscow Biennial
of Contemporary Art
Moscow, Russia

Prague Biennale 5
Prague, Czech Republic
www.praguebiennale.org

5th International Architecture Biennale
Rotterdam, Netherlands

T3 Torino Triennale
Turin, Italy
www.torinotriennale.it

WRO 11 XIV Media Art Biennale
Wrocław, Poland

2012
Guimarães, Portugal/Maribor, Slovenia:
European Capitals of Culture
Guimarães: www.guimaraes2012.com

June 2012
documenta 13
Kassel, Germany
(9 June–16 Sept 2012), curator Carolyn
Christov-Bakargiev
www.documenta.de

TBD 2012
Kunstvlaai A.I.P.
Amsterdam, Netherlands, biannual
festival of emerging art
www.kunstvlaai.nl

bb7 7th Berlin Biennial
Berlin, Germany
www.berlinbiennale.de

Brighton Photo Biennial
Brighton, England
www.bpb.org.uk

Brussels Biennial
Brussels, Belgium, 3rd edition
www.brusselsbiennial.org

**BB5 Bucharest International Biennial
of Contemporary Art**
Bucharest, Romania
www.bucharestbiennale.org

**U Turn
Quadrennial for Contemporary Art**
Copenhagen, Denmark

**Periferic 10
Biennial for Contemporary Art**
Iasi, Romania
www.periferic.org

Liverpool Biennial 7th
Liverpool, England
www.biennial.com

Mediations Biennale
Poznan, Poland, 3rd edition
www.mediations.pl

16a Quadriennale d'arte di Roma
Rome, Italy

**Bienal Internacional de Arte
Contemporáneao de Sevilla**
Seville, Spain
www.fundacionbiacs.com

Lustwarande 12
Tilburg, Netherlands, held at Park de
Oude Warande and first held in 2000
www.fundamentfoundaiton.nl

ViennaBiennale
Vienna, Austria
www.viennabiennale.com

2013
**Marseille, France /
Kosice, Slovakia:
European Capitals of Culture**

Contemporary Art Auctions

Auction Resources
www.auctionguide.com
English-language guide to all
manner of auctions
www.artfact.com
English-language art research
auction guide
www.artprice.com
fine-art market information in
five languages

Artcurial
Paris, France
Hôtel Dassault, 7 rond-point
des Champs-Elysées
Tel +33 1 42 99 2020
www.artcurial.com
Led by Francis Briest, contemporary art
expert Martin Guesnet; auctions held
at Hôtel Dassault and Hôtel Drouot,
Paris

BlindARTE Casa D'Aste
Naples, Italy
Via Caio Duilio 4 –10
Tel +39 081 239 5261
www.blindarte.com

Bloomsbury Auctions
24 Maddox Street
Tel +44 20 7495 9494
www.bloomsburyauctions.com

Bonhams
London, England
10 New Bond Street
Viewings Mon–Fri 9–5
Tel +44 207 447 7447
www.bonhams.com

Bukowskis
Stockholm, Sweden
Arsenalsgaten 4
Tel +46 8 614 0800
www.bukowskis.se

Christie's
London, England
8 King Street
Mon–Fri 9–5, Sat–Sun 12–5
Tel +44 20 7839 9060
85 Old Brompton Road
Mon 9–7:30, Tue–Fri 9–5
Sat–Sun 10–4
Tel +44 20 7930 6074
www.christies.com
London and New York leading contemporary auction house with branches throughout the world; King Street, department head Pilar Ordovas, South Kensington department head Lindsey Gallen

Cornette de Saint Cyr
Paris, France
46 avenue Kléber
Tel +33 1 47 27 11 24
www.auction.fr/cp/cornette/
Led by Pierre, Arnaud & Bertrand Cornette de Saint Cyr; auctions held at Drouot Richelieu and Drouot Montaigne

Dorotheum
Vienna, Austria
Palais Dorotheum,
Dorotheergasse 17
Auction viewings:
Mon–Fri 10–6, Sat 9–5
Tel +43 1 515 6000
www.dorotheum.com
Leading Viennese auction house, Modern and Contemporary Art Department; specialists Elke Königseder, Patricia Palffy

Drouot
Paris, France
9 rue Drouot
Mon–Sat 11–6
Tel +33 1 48 00 2020
www.drouot.com
One of oldest auction houses and composed of many disparate auctioneers who control interest in firm, Drouot Richelieu is main salesroom

Finarte–Semenzato
Milan, Italy
Tel +39 02 863561 (Milan)
www.finarte-semenzato.com
Established in 1959; offices and sales in Milan, Rome, and Venice

Galerie Fischer Auktionen AG
Lucerne, Switzerland
Haldenstrasse 19
Tel +41 41 418 1010
www.fischerauktionen.ch
Led by Kuno and Trude Fischer

Germann Auktionshaus
Zurich, Switzerland
Zeltweg 67
Mon–Fri 10–12:30, 2–6
Tel +41 44 251 8358
www.germannauktionen.ch
Auctions stress German and Swiss contemporary and modern art

Hauswedell & Nolte
Hamburg, Germany
Poeseldorfer Weg 1
Tel +49 40 413 2100
www.hauswedell-nolte.de
Also with New York and Los Angeles branches

Ketterer Kunst
Munich and Hamburg
Prinzregentenstrasse 61 (Munich)
Tel +49 89 55 2440
Am Messberg 1 (Hamburg)
www.kettererkunst.com
House founded in 1954

Koller
Zurich and Geneva, Switzerland
Hardturmstrasse 102
Tel +41 44 445 6363 (Zurich)
www.galeriekoller.ch

Kunst Auktionen im Kinsky
Vienna, Austria
Palais Kinsky, Reyung 4
Mon–Thu 10–6, Fri 9–1
Tel +43 1 532 4200
www.imkinsy.com
House founded in 1992

Kunsthaus Lempertz
Cologne, Germany
Neumarkt 3
Mon–Fri 10–1, 2–5:30, Sat 10–1
Tel +49 221 925 7290
www.lempertz.eu
Contemporary art experts Mechtild Potthoff and Benjamin Schumann

Lyon & Turnbull
Edinburgh, Scotland
33 Broughton Place
Tel +44 131 557 8844
www.lyonandturnbull.com
Also with London and Glasgow offices

Millon & Associés
Paris, France
5 avenue d'Eylau
Tel +33 1 47 27 95 34
19 rue de la Grange Batelière
Tel +33 1 48 00 99 44
www.millon-associes.com

Nagel Auktionen
Stuttgart, Germany
Neckarstrasse 189–91
Mon–Fri 9–5
tel +49 0711 649 690
www.auction.de

Pandolfini
Florence and Milan, Italy
Palazzo degli Albrizi 26
Tel +39 055 234 0888 (Florence)
www.pandolfini.com

Phillips de Pury & Company
www.phillipsdepury.com

New York-based auction house with branches in London, Paris, Munich, Berlin, and Geneva. Cologne office open from 2008-09 with specialist Gerard Goodrow. Sold to Russia-based Mercury Group in 2008. Worldwide Director Contemporary Art Michael McGinnis

Piasa
Paris, France
5 rue Drouot
Tel +33 153 34 1010
www.piasa.auction.fr
Founded by four auctioneers and with auctions at Drouot

Porro Art Consulting
Milan, Italy
Piazza Sant'Ambrogio 10
Tel +02 72 094 708
www.porroartconsulting.it
House founded in 2002

Sotheby's
London, England
34–35 New Bond Street
Tel +44 20 7293 5000
www.sothebys.com
London and New York leading contemporary auction house with branches throughout the world. New Bond Street board director Cheyenne Westphal, senior director Oliver Barker, director Isabelle Paagman

Stockholms Auktionsverk
Stockholm, Sweden
Nybrogatan 32
Mon–Fri 9–5, Sat–Sun during viewings 10–4
Tel +46 8 453 6750
www.auktionsverket.se

Dr. Andreas Sturies, Moderne Kunst & Auktionen
Düsseldorf, Germany
Blücherstrasse 69

Tel +49 211 514 1354
www.sturies.de
Website in German only

Tajan
Paris, France
37 rue des Mathurins
Mon–Fri 9–7
Tel +33 153 3030 55
www.tajan.com
French auction house holds seven annual contemporary art sales; two auctions yearly at L'Espace Tajan; one auction yearly at Monte Carlo; Specialists Julie Ralli and Paul-Arnaud Parsy, chairman M Jacques Tajan

Van Ham Kunstauktionen
Cologne, Germany
Schönhauser Strasse 10–16
Tel +49 221 92 58 620
www.van-ham.com

Villa Grisebach Auktionen
Berlin, Germany
Fasanenstrasse 25
Mon–Fri 10–6:30, Sat 11–4
Tel +49 30 885 9150
www.villa-grisebach.de

Wannenes, Art Casa d'Aste
Genoa, Italy
Palazzo del Melograno
Piazza Campetto 2
Tel +39 010 253 0097
www.asteart.com
Led by Guido Wannenes

Museum & Gallery Open Days

Resources
www.deutsche-museen.de/
museumsnacht.php
German-language information on museum nights in Germany
www.museums-naechte.de
German-language information on world wide museum nights

Monthly
TimeOut First Thursdays
East London Art Galleries and Museums
London, England
www.firstthursdays.co.uk

Light Night
Held at various venues throughout year
United Kingdom
www.lightnight.co.uk

January
Museumsnacht
Basel, Switzerland
www.museumsnacht.ch

Lange Nacht der Museen
Berlin, Germany
www.lange-nacht-der-museen.de

Art White Night
Bologna, Italy

March
Museumsnacht
Bern, Switzerland
www.museen-bern.ch

Museum Night Fever
Brussels, Belgium
www.museumnightfever.be

Rotterdamse Museumnacht
Rotterdam, Netherlands
www.rotterdamsemuseumnacht.nl

Museum & Gallery Open Days

April

Bielefelder Nacht der Museen, Kirchen und Galerien
Bielefeld, Germany
www.nachtansichten.de

Nacht Museen
Frankfurt, Germany
www.nacht-der-museen.de

Genève Brille la Nuit
Geneva, Switzerland
www.genevebrillelanuit.ch

Galerientage
Graz, Austria
www.aktuellekunst-graz.at

Nachtschicht
Leipziger Museumsnacht
Leipzig, Germany
www.nachtschicht-leipzig.de

Lange Nacht der Museen
Mannheim, Germany

Lange Nacht der Museen
Stuttgart, Germany
www.langenacht.de

Vienna Art Week
Vienna, Austria
www.viennaartweek.at

May

Internationaler Museumstag
www.museumstag.de

Architektur Tage
Austria
www.architekturtage.at

La Nit dels Museus
Barcelona, Spain
www.lanitdelsmuseus.cat

Le Printemps des Musées
Belgium
www.printempsdesmusees.cfwb.be

Gallery Weekend
Berlin, Germany
www.gallery-weekend-berlin.de

Museum Night Brno
Brno, Czech Republic

Night of the Bucharest Museums
Bucharest, Romania

Nuit des Musées
Clermont-Ferrand, France
www.clermont-ferrand.fr/
Musees_.html

Nacht der Museen
Düsseldorf, Germany
www.nacht-der-museen.de

Geraer Musemsnacht
Gera, Germany
www.museumsnacht-gera.de

Hallesche Museumsnacht
Halle, Germany
www.halle.de

Lange Nacht der Museen
Hamburg, Germany
www.langenacht.museumsdienst-hamburg.de

Museums Night
Kraków, Poland
www.muzeum.krakow.pl

Mainzer Museumsnacht
Mainz, Germany
www.museumsnacht.mainz.de

Kulturnacht in Neuss
Neuss, Germany
www.kulturnacht-neuss.de

Die Blaue Nacht
Nuremberg, Germany
www.kubiss.de/kulturreferat/
blauenacht

Nuit des Musées
Paris, France
www.nuitdesmusees.culture.fr

Reykjavik Arts Festival
Reykjavik, Iceland
www.artfest.is

Noc Muzeja
Serbia
www.nocmuzeja.rs

Noc Múzeí a Galérií
Slovakia
www.muzeum.sk/nocmuzeiagalerii

Nuit des Musées
Strasbourg, France
www.musees-strasbourg.org

Utrecht Museumnacht
Utrecht, Netherlands
www.culturelezondagen.nl

Museum Night
Warsaw, Poland

Lange Nacht der Museen
Weimar, Germany
www.weimar.de

May/June
Lange Nacht der Bremer Museen
Bremen, Germany

June
Lange Nacht der Kultur
Bremerhaven, Germany
www.lange-nacht-bremerhaven.de

Múzeumok Éjszakája
Museum Night

Budapest, Hungary
www.muzeumokejszakaja.hu

Fest der Innenhöfe und Museumsnächte
Freiburg, Germany
www.freiburg.de/museen

Nacht der Museen
Hannover, Germany
www.hannover.de

Prague Museum Night
Prague, Czech Republic
www.praha.muzejninoc.cz

Lange Nacht der Museen
Ulm, Germany

July
Braunschweiger Kulturnacht
Braunschweig, Germany
www.kulturnacht-braunschweig.de

Museums-Sommernacht Dresden
Dresden, Germany
www.dresden.de/museumsnacht

La Noche en Blanco
Barcelona, Spain

Karlsruher Museumsnacht
Karlsruhe, Germany
www.kamua.de

July/August
Belgrade Summer Festival
Belgrade, Serbia
www.belef.org

August
Lange Nacht der Museen
Aachen, Germany

Museumnacht
Antwerp, Belgium
www.museum.antwerpen.be/
museumnacht/

Museum & Gallery Open Days

Lange Nacht der Museen
Berlin, Germany
www.lange-nacht-der-museen.de

Edinburgh Art Festival
Edinburgh, Scotland
www.edinburghartfestival.com

Night of the Arts
Helsinki, Finland
www.helsinginjuhlaviikot.fi

Kieler Museumsnacht
Kiel, Germany
www.museumsnacht-kiel.de

Stockholms Kulturfestival
Stockholm, Sweden
www.kulturfestivalen.stockholm.se

September
European Heritage Days
Europe-wide initiative organized
by the Council of Europe
www.coe.int

Antwerp Art Weekend
Antwerp, Belgium
www.antwerpart.be

Kulturnatt Bergen
Bergen, Norway
www.kulturnatt-bergen.no

Lange Nacht der Museen
Darmstadt, Germany
www.langenachtdermuseen.de

DEW21-Museumsnacht
Dortmund, Germany
www.dev.museumsnacht.dortmund.de

Culture Night
Dublin, Ireland
www.cnci.ie

Kasseler Museumsnacht
Kassel, Germany
www.museumsnacht.de

Lange Nacht der Museen
Koblenz, Germany
www.touristik-koblenz.de

Nuit des Musees
Lausanne, Switzerland
www.lanuitdesmusees.ch

Kulturnatten Lund
Lund, Sweden
www.lund.se

Noche Blanco
Madrid, Spain
www.esmadrid.com/
lanocheenblanco

Weekend in Galleria
Milan, Italy
www.start-mi.net

Nacht der Museen und Galerien
Münster, Germany

Nacht der Museen
Oldenburg, Germany

Oslo Kulturnatt
Oslo, Norway
www.prosjekt-oslokulturnatt.oslo.
kommune.no

Night of Museums and Galleries
Plovdiv, Bulgaria
www.gallery-night.info

Museumsnacht
St. Gallen, Switzerland
www.museumsnachtsg.ch

Printemps de Septembre
Toulouse, France
www.printempsdeseptembre.com

Lange Nacht der Museen
Zurich, Switzerland
www.langenacht.ch

September / October
Tina B
The Prague Contemporary
Art Festival
www.tina-b.eu

October
KulturNat Aarhus
Aarhus, Denmark
www.kulturnataarhus.dk

Contemporary Day
Italy AMACI
www.amaci.org

Lange Nacht der Museen
Austria
www.langenacht.orf.at

Nuit Blanche
Brussels, Belgium
www.nuitblanchebrussels.be

Kulturnatten
Copenhagen, Denmark
www.kulturnatten.dk

Kulturnatta
Göteborg, Sweden
www.kulturnatta-goteborg.se

La Nuit des Musées
Luxembourg
www.museumsnacht.lu

Lange Nacht
der Münchner Museen
Munich, Germany
www.muenchner.de/museumsnacht

Nuit Blanche-contemporary art
Paris, France
www.paris.fr

Roma Art Weekend
Rome, Italy
www.romacontemporary.it

Lange Kunstnacht
Schwäbisch Hall, Germany

Stuttgarter Kulturnacht
Stuttgart, Germany
www.stuttgarter-kulturnacht.de

November
Museumnacht
Amsterdam, Netherlands
www.n8.nl

Lange Nacht der Kölner Museen
Cologne, Germany
www.museumsnacht-koeln.de

European Month of Photography
www.europeanmonthofphotography.eu

Night of Contemporary Arts
Turin, Italy
www.artissima.it

Vienna Art Week
Vienna, Austria
www.viennaartweek.at

December
Gent Museumnacht
Gentse Kunstweek
Ghent, Belgium
www.gent.be/museumnacht

Prizes

Andrew Doolan
Best Building Prize
Annual award (£ 25,000) given by Royal Incorporation of Architects in Scotland RIAS since 2001.

Architectural Review Awards for Emerging Architecture
Annual awards (£ 15,000) begun in 1999 and geared to discover emerging talent.

Arken Prize
Annual prize (kr 100,000) given by Arken Museum in Copenhagen to international artist and inaugurated in 2006.
www.arken.dk

Arnold-Bode-Preis
Annual prize (EUR 10,000) inaugurated in 1980 and given by city of Kassel, Germany to an international artist.

Ars Fennica Award
Annual award (EUR 35,000) given to Finnish artist and presented in exhibition at Kiasma Helsinki. Inaugurated in 1990.

Ars Viva
Annual awards given by Cultural Committee of German business in the Federal Republic (BDI) and presented at different institutions throughout Germany. Inaugural prize in 1952 and given to emerging artists.

Art Cologne Prize
Annual prize (EUR 10,000) given to museum/arts professional. Given during the Art Cologne fair.

Artes Mundi, Cardiff, Wales.
Biannual prize (£ 40,000) for emerging contemporary art presented at National Museum Cardiff, inaugural prize in 2004.
www.artesmundi.org

Art Fund Prize
formerly called The Gulbenkian Prize
Annual prize (£ 100,000) begun in 2003 given to museum or gallery in the United Kingdom.
www.thegulbenkianprize.org.uk

B.A.C.A. Europe
BonnefantenMuseum
Maastricht, Netherlands
Biannual prize (EUR 50,000) for contemporary art for artist between ages of thirty-five and forty-five first given in 2006.
www.bonnefanten.nl

Baloise Art Prize
Annual prize (CHF 25,000) launched in 1999 and given to two emerging artists during the ArtBasel fair. Works are donated to either the MMK in Vienna or the Hamburger Kunsthalle. Winners have included Tino Sehgal and Laura Owens.
www.baloise.com

Beck's Futures, ICA, London
Discontinued by ICA in 2007. Annual emerging-artist award (£ 20,000) inaugurated in 2000 given by Beck's and ICA and presented to a UK-based artist and originally given as a reaction to the Turner Prize. Winner was announced in spring after exhibition.
www.becksfutures.co.uk

Bernhard Heliger Award of Sculpture
Award (EUR 15,000) given every four years by Bernhard Heliger Stiftung, Germany and inaugurated in 1999.
www.bernhard-heliger-stiftung.de

BlueOrange
Juried by Kunstvereins in Germany and hosted by different institutions. Biannual prize (EUR 10,000) for contemporary art begun in 2004 endowed by two prominent German banks
www.blueorange.bvr.de

BMW Paris Photo Prize
Anual award (EUR 12,000) presented
during art fair and launched in 2004.

BNA Kubus
Annual prize given to Dutch architect(s)
by the Royal Institute of Dutch Archi-
tects.
www.bna.nl

**British Council, Young Visual
Entrepreneur Award**
Annual award established in 2008 for art
professionals in emerging markets.

Carnegie Art Award
Biannual prizes (skr 1,000,000, skr
600,000, skr 400,000) for Nordic con-
temporary painting and begun in 1998.
www.carnegieartaward.com

Carlsberg Architectural Prize
Awarded (£ 200,000) every three years
by Carlsberg Foundation, begun in 1992
and ended in 1998.

The Cartier Award
Annual prize (£ 10,000) for emerging
artists living outside the United Kingdom
and presented during the Frieze Art Fair.
www.friezeartfair.com

Celeste Art Prize
Annual prize (£ 10,000) for emerging art-
ist and student artist. Sister prize to Ital-
ian PrimoCeleste founded in 2003 and
German Celeste Kunstpreis founded in
2007.
www.celesteartprize.co.uk
www.premioceleste.it
www.celestekunstpreis.de

Central Art Award
Biannual award (EUR 75,000) to inter-
national artist by Central Health Insur-
ance Company with exhibit at Kölnisch-
er Kunstverein begun in 1996.

Champagne Perrier-Jouët Prize
Annual prize (US$ 17,000) given during
Zoo Art Fair in London.

**Charles Wollaston Award
Summer Exhibition
Royal Academy of Arts, London**
Annual exhibition and prize (£ 25,000)
for most distinguished work in show and
established in 1978.
www.royalacademy.org.uk

Council of Europe Museum Prize
Annual award based on recommendation
of European Museum Forum.
www.assembly.coe.int/museum/
PrixMuseeCE

**Coutts Contemporary Art Foundation
Awards**
Biannual awards for visual art presented
by Coutts Bank in Zurich Switzerland.
Discontinued in 2000.

**DaimlerChrysler Financial Services
Emerging Artist Award**
Yearly prize for contemporary art in part-
nership with Cranbrook Academy in USA.
www.daimlerchryslerservices.com

Deste Prize
Biannual contemporary art award (EUR
10,000) for Greek artist under forty and
inaugurated in 1999.
www.deste.gr

Deutsche Börse Photography Prize
Annual award (EUR 30,000) given by
Deutsche Börse to international photog-
rapher and inaugurated in 2005.
www.deutsche-boerse.com

Deutscher Architekturpreis
Biannual award (EUR 25,000) given by
E.ON Ruhrgas AG and the German As-
sociation of Architects since 1971.
www.architekturpreis.de

Prizes

Duveens Commission
Annual award (£ 3,000) for sculpture comes with exhibit on upper level of Tate Britain, London.

**Edvard Munch Award
for Contemporary Art**
Annual award (US$ 55,000) given to international artist, includes residency in Oslo, Norway, begun in 2005 by Office for Contemporary Art Norway.
www.oca.no

European Museum of the Year
Annual award given by the European Museum Forum and begun in 1977.
www.emya.org

5x5Castelló
Annual Award (EUR 60,000) organized from 2009 by the EACC in Castelló, Spain.

**Friederick Kiesler Prize
for Architecture and the Arts**
Biannual award (EUR 55,000) for international architect/artist and presented by Austrian government and city of Vienna. Inaugurated in 1998.
www.kiesler.org

Frieze Writer's Prize
Annual prize (£ 2,000) for art criticism begun in 2008.
www.frieze.com

The Golden Lion
Series of awards presented at the La Biennale di Venezia, Italy.

Guta Arte
Biannual art award presented by Basque government since 1982.

Hasselblad Foundation International Award in Photography
Annual award (kr 500,000) presented by Göteborg, Sweden-based Hasselblad Center and inaugurated in 1980.
www.hasselbladfoundation.org

Heinrich Tessenow Gold Medal
Annual prize begun in 1963 and given to architect by Alfred Töpfer Stiftung of Hamburg, Germany.

Hugo Boss Prize (USA)
Biannual prize (US$ 50,000) given by Guggenheim Museum in New York and founded in 1996.
www.hugobossprize.com

Igor Zabel Award for Culture and Theory
Annual award (EUR 40,000) for cultural protagonist and focus on Central and South Eastern Europe. Funded by Erste Bank and begun in 2008.

Jerwood Contemporary Painters
Annual exhibition and prize (£ 1,000 each for winners) sponsored by Jerwood Foundation in England since 1976.
www.jerwoodvisualarts.org

Joan Miró Prize
Biannual prize (EUR 70,000) for contemporary artist inaugurated in 2007 and given by the Fundació Joan Miró in Barcelona, Spain.
www.premijoanmiro.org

John Moores Prize
Biannual prize (£ 25,000) given to painter during exhibition at Walker Art Gallery, Liverpool, England. First held in 1957.
www.liverpoolmuseums.org.uk/walker/johnmoores/

Kaiserring
Annual award given to contemporary artist. Begun in 1974 with award to Henry Moore and presented by the city of Goslar, Germany.
www.kaiserring.net

Kandinsky Prize
Annual prize (EUR 40,000) given in
Moscow to contemporary Russian artist.
Sponsored by Deutsche Bank AG and the
ArtChronika Culture Foundation. Begun
in 2007.

**Kunstpreis der Landeshaupstadt
Düsseldorf**
Annual award (EUR 55,000) inaugurat-
ed in 2006 and given to international art-
ist by city of Düsseldorf, Germany.

Kurt-Schwitters-Preis
Biannual prize (EUR 25,000) given by
Niedersächsische Sparkassenstiftung
Hannover Germany to international art-
ist since 1982.
www.nsks.de/nsks/preise_stipendien/
schwitters_preis/

Liverpool Art Prize
Merseyside-based artists, contemporary
art prize, and inaugural edition 2007.
www.liverpoolartprize.com

**Lorenzo Bonaldi Prize
for Art-EnterPrize**
Annual prize for curators under the age
of thirty and presented by GAMeC Ber-
gamo Italy. Prize inaugurated in 2003.

Marcel Duchamp Prize
Annual prize (EUR 35,000) for contem-
porary art (announced during FIAC, Par-
is in October) inaugurated in 2001. Pre-
sented by ADIAF, a collectors group, and
given to an artist residing in France.
www.adiaf.com

**MaxMara Art Prize
for Women**
Biannual prize presented by Whitecha-
pel London and MaxMara Foundation,
launched at Venice Biennial, inaugural
prize 2006.
www.whitechapel.org

**Mies van der Rohe Award
European Union Prize for
Contemporary Architecture**
Biannual prize (EUR 50,000) given by
the European Union and the Fundació
Mies van der Rohe and begun in 2001.
www.miessbcn.com

Montana Enterprize
Annual award (kr 100,000) for Danish
artist and inaugurated in 2008.

Nam June Paik Award
Biannual prize (EUR 25,000) for media
art and presented by Kulturstiftung NRW
in Cologne and started in 2002.

Northern Art Prize
United Kingdom annual award (£ 16,500)
given by city of Leeds to artist working in
north of England. Inaugural award in
2008 and presented at Leeds Art Gal-
lery.
www.northernartprize.org.uk

Oskar-Kokoschka-Preis
Austrian biannual prize (EUR 20,000)
for international artist and presented at
University of Applied Arts in Vienna. Be-
gun in 1981.

Paul Hamlyn Foundation
United Kingdom-based organization
awarding (£ 45,000) yearly grants to vi-
sual artists and composers, recipients
have included Simon Starling, Jeremy
Deller, Ryan Gander.
www.phf.org.uk

Piepenbrock Preis für Skulptur
Biannual prize (EUR 50,000) given to
sculptor. German prize. Begun in 1988.
www.piepenbrock.de

**Preis der Nationalgalerie
für Junge Kunst**
Biannual young artist prize (EUR 50,000)

to artist residing in Germany under forty years of age and exhibit in Hamburger Bahnhof, Berlin, inaugurated in 2000, and given during art forum berlin, set up by Rolf and Erika Hoffmann in 2000.
www.freunde-der-nationalgalerie.org

Preis Peter C. Ruppert für Konkrete Kunst
Triannual prize (EUR 15,000) inaugurated in 2008 and presented to international artists associated with the Conrete Art movement and given in Wolfsburg Germany.

Premio Furla
Annual award presented by Fondazione Furla and begun in 2000 to help emerging Italian artists.

Principal Pinchuk Art Center Prize
Biannual prize (US$ 20,000) for Ukrainian artist under thirty-five and inaugurated in 2009.

Pritzker Architecture Prize
Annual prize (US$ 100,00) founded in 1979 and given to a living architect by The Hyatt Foundation in Chicago, USA, this is the most prestigious award in architecture.
www.pritzkerprize.com

Prix de l'Équerre d'Argent
Annual award, the silver T-square prize, sponsored by the journal *Le Moniteur* to recognize building on French soil.
www.prix.groupmoniteur.fr

Prix Fondation d'entreprise Ricard
Annual award (EUR 10,000) given to French artist under forty and presented during FIAC, Paris.
www.fondation-enterprise-ricard.com

Rolandpreis für Kunst im Öffentlichen Raum
Triannual prize awarded by the Stiftung Bremen, Germany, for art in public space.
www2.bremen.de/info/rolandpreis/

Roswitha Haftmann Award
Annual award (CHF 150,000) for international artist presented by foundation and at Kunsthaus Zürich, Switzerland. Begun in 2001.
www.roswithahaftmann-foundation.com

Rubens Prize
Award presented every five years by city of Siegen, Germany, to a European painter or graphic artist for lifetime achievement.

Stirling Prize
Annual prize (£ 20,000) given for Building of the Year by the Royal Institute of British Architects (RIBA), United Kingdom, and named in honor of James Stirling. First awarded in 2003.
www.architecture.com

Swiss Exhibition Award
Annual award (CHF 40,000) for best Swiss contemporary art exhibition and going to an institution. To begin in 2009, funded by Julius Baer Foundation.

Turner Prize
Tate Britain
Annual Exhibition and Award (£ 40,000) inaugurated in 1984 for UK-based artist under fifty and endowed by sponsorship. Exhibit at Tate Britain October–January. Winner announced in December.
www.tate.org.uk

Views
Deutsche Bank Foundation Award
Biannual prize (EUR 10,000) for emerging Polish artist presented at Zacheta in Warsaw, Poland.

The Vincent Award
Stedelijk Museum, Amsterdam
Biannual prize (EUR 50,000) for contemporary art, originally given in Maastricht at BonnefantenMuseum and inaugurated in 2000.
www.thevincentaward.eu

Wilhelm-Lehmbruck-Preis
Prize (EUR 25,000) awarded every five years by city of Duisburg, Germany and the Wilhelm Lehmbruck Museum.
www.lehmbruck.cynapsis.com/
museum/preise_stipendien

Wolfgang Hahn Preis
Annual prize (EUR 100,000) given by Gesellschaft für Moderne Kunst in the Museum Ludwig Cologne to international artist and named for Cologne collector Wolfgang Hahn.
www.gemoku.de/hahn-preis-koeln

Young Visual Artists Awards YVAA
Annual awards presented to Central and South Eastern Europe emerging artists by affiliate organizations since 1990.
www.yvaa.net

Zurich Prize
Annual prize (CHF 80,000) given by the Zürich Group and Haus Konstruktiv, Zurich, Switzerland, inaugurated in 2007 and given to young artists.

Upcoming Projects

2008
Istanbul, Turkey
Platform Garanti renovation

Manchester, England
FC MoCA Manchester
delayed from 2007

Zagreb, Croatia
Museum of Contemporary Art
Architect: Igor Franic; opens autumn 2007 (delayed)

2009
Aarhus, Denmark
AroS Aarhus Kunstmuseum
Himmelrummet extension; architect: Olafur Eliasson; opens in August/Sept 09

Amsterdam, Netherlands
Stedelijk Museum renovation
Architects: Bentham Crouwel; opens in late 2009

Athens, Greece
National Museum of Contemporary Art opens in autumn 2009

Bratislava, Slovakia
Slovak National Gallery
Architects: BKPŠ Kusý-Panák; 2005–2009

Ceuta, Spain
La Conservera
Architect: Fernando de Retes; opens May 2009

Glasgow, Scotland
Briggait Building renovation
Architects: Nicoll Russell Studios; announced September 2008

Linz, Austria
ARS Electronica Center, Museum

Upcoming Projects

of the Future new wing
Architects: Treusch Architektur; opens
2 January 09

London, England
Whitechapel Art Gallery expansion
Architects: Robbrecht en Daem; opens
5 April 09

Malmö, Sweden
Moderna Museet Malmö
Opens September 2009

Munich, Germany
Museum Brandhorst
Architects: Sauerbruch Hutton; opens
21 May 09

Nantes, France
Memorial to the Victims of Slavery
Artist: Krzysztof Wodiczko; opens in
autumn 2009

Nottingham, England
CCAN Centre for Contemporary Art
Nottingham
Architects: Caruso St. John; opens in
spring

Santander, Spain
Museo de Cantabria
Architects: Mansilla + Tuñón

Venice, Italy
Pinault Collection, Customs House
Architect: Tadao Ando; opens 4 June 09

2010
Aberdeen, Scotland
Peacock Visual Arts
Architects: Brisac Gonzalez;
begun 2007

Avilés, Spain
Centro Cultural Internactional
Oscar Niemeyer
Architect: Oscar Niemeyer

Berlin, Germany
MICAMOCA Collection
Architects: Kuehn Malvezzi; opens in
spring

Cáceres, Spain
Centro de Artes Visuales
Helga de Alvear
Architects: Mansilla + Tuñón

Duisburg, Germany
MMK
Museum Küppersmühle
für Moderne Kunst extension
Architects: Herzog + de Meuron;
begins construction in 2009

Essen, Germany
Museum Folkwang extension
Architect: David Chipperfield

Garðabær, Iceland
MUDESA
The Icelandic Museum of Design
and Applied Art
Architects: PK Arkitektur

Istanbul, Turkey
Suna Kiraç Opera and Cultural Centre
Architect: Frank Gehry

Lens, France
Louvre II
Architects: SANAA

London, England
David Roberts Art Foundation
Opens in Camden in 2010

Margate, Kent, England
Turner Contemporary Gallery
Architect: David Chipperfield

Metz, France
Centre Pompidou Metz
Architects: Shigeru Ban & Jean de
Gastines

Moscow, Russia
Stella Art Foundation new space

Paris, France
Fondation Louis-Vuitton
Architect: Frank Gehry

Paris, France
Centre Pompidou–Alma branch

Prato, Italy
Centro per l'Arte Contemporanea
Luigi Pecci
Architect: Maurice Nio

Rome, Italy
MAXXI
Museo Nazionale delle Arti
del XXI Secolo
Architect: Zaha Hadid; opens
Jan 10

Rotterdam, Netherlands
Museum Boijmans van Beuningen
Architects: MVRDV, extension

Sindelfingen, Germany
Senator Peter Schaufler Stiftung

Wakefield, England
The Hepworth
Architect: David Chipperfield; opens in
2010

Weil am Rhein, Germany
VitraHaus
Architects: Herzog + de Meuron

2011
Belfast, Northern Ireland
Museum Arts Centre
Architects: Hackett and Hall

Frankfurt, Germany
Das Städel extension
Architects: Schneider + Schumacher;
announced 2008

Krakow, Poland
Contemporary Arts Museum
Architect: Claudio Nardi; construction
starts in 2008

Milan, Italy
Museo dell'Arte Contemporanea
Architect: Daniel Libeskind

Milan, Italy
Ansaldo City of Cultures
Architect: David Chipperfield

Riga, Latvia
Museum of Contemporary Art
Architects: OMA

Tartu, Estonia
Estonian National Museum
Architects: Dorell, Ghotmeh & Tane;
competition in 2006

Zurich, Switzerland
Bau West, Löwenbräu complex
Architects: Gigon + Guyer

2012
Bern, Switzerland
Kunstmuseum Bern
Architects: Baserga & Mozzetti;
extension construction starts
in 2010

Cadiz, Spain
Contemporary Arts Centre

Grottaferrata, Italy
DEPART Foundation Museum,
Grand Traiano Art Complex
fully open in 2012,
Architects: Johnson Marklee
Architects

Lausanne, Switzerland
new Musée Cantonal des Beaux Arts
de Lausanne
Architects: Berrel Wüsler Kräutler

Upcoming Projects

London, England
Tate Modern extension
Architects: Herzog + de Meuron

London, England
Royal Academy of Arts, Burlington
annex renovation
Architect: David Chipperfield;
announced July 2008

Milan, Italy
Fondazione Prada new location
Architect: Rem Koolhaas; announced
March 2008

Oslo, Norway
Stenersen Museum new building
Architects: REX

Oslo, Norway
Astrup Fearnley Museum
of Modern Art
Architect: Renzo Piano

Santiago di Compostela Spain
Ciudad de la Cultura Galicia
Architect: Peter Eisenman; multi-
building project: museum, library,
archive, theater, etc. begun 2001

2013
Vilnius, Lithuania
Guggenheim Hermitage Vilnius
Architect: Zaha Hadid

2014
Milan, Italy
Fiera Milano
Architects: Daniel Libeskind,
Zaha Hadid, Arata Isozaki, Pier Paola
Maggiora; museum by Libeskind

TBD
Arles, France
Fondation Luma
Architect: Frank Gehry; plans
announced December 2007

Athens, Greece
Goulandris Foundation
Architect: I. M. Pei; announced
August 2007

Berlin, Germany
Sammlung Olbricht

Berlin, Germany
Humboldthafen
private contemporary art museum;
announced September 2008

Blanca, Spain
MUCAB
Architect Martin Lejarraga

Cagliari, Italy
Nuragic & Contemporary
Arts Centre
Architect: Zaha Hadid

Córdoba, Spain
Espacio de Creación Artistica
Contemporánea
Architects: Nieto Sobejano

Dunkerque, France
FRAC Nord Pas de Calais new building

Herning, Denmark
Herning Center for the Arts
Architect: Steven Holl; begun 2007

Ljubljana, Slovenia
Museum of Contemporary Art Metel-
kova
Architects: Groleger Arhitekti;
announced 2008

Lleida, Spain
Fundacion Sorigué
Architect: Richard Gluckman

Novi Sad, Serbia
Museum of Contemporary Art
Architects: Claiborne Markov Ruccolo

Paris, France
Contemporary European Creation center
project announced 2006 for Île Seguin

Perm, Russia
Perm Museum XXI
extension to existing museum; architectural competition announced in 2007

Porto, Portugal
Serralves 2
Architects: SANAA; announced 2009

Rome, Italy
MACRO Museo d'art
Contemporanea Rome
Architect: Odile Decq; begun 2001

Sarajevo, Bosnia and Herzegovina
ARS AEVI Museum of Contemporary Art
Architect: Renzo Piano

Sesto S. Giovanni (Milan), Italy
Museum of Contemporary Art
Architect: Renzo Piano

Valencia, Spain
IVAM extension
Architects: SANAA

Warsaw, Poland
Museum of Modern Art
Architect: Christian Kerez; begun 2007

Wrocław, Poland
Museum of Architecture
Architects: M & A Domicz; begun 2005

Wrocław, Poland
Wrocław Contemporary Museum
Architects: Nizio Design International;
announced October 2008

Zurich, Switzerland
Kunsthaus Zürich extension
Architect: David Chipperfield;
announced November 2008

The Printed Word & Media
Magazines

A10 New European Architecture
English-language periodical bi-monthly
(Amsterdam)
www.a10.eu

032c
Berlin-based biannual culture magazine
in German and English
www.032c.com

Abitare
monthly architecture and visual arts
magazine based in Milan
www.abitare.it

Afterall
art journal published in London and
devoted to contemporary art
www.afterall.org

Aperture
quarterly photography magazine
published in New York

A Prior
Belgium-based English-language-
journal on visual art
www.aprior.org

Architect Magazine
architecture news based in Washington DC
www.architectmagazine.com

The Architect's Newspaper
New York-based architecture news
www.archpaper.com

Architectural Design AD
UK-based architecture news
www.eu.wiley.com

Architectural Record
US-based architectural magazine
www.archrecord.construction.com

Archithese
Switzerland-based German-language
architecture news
www.archithese.ch

Archplus
German-language monthly
architecture information
www.archplus.net

Architektur. Aktuell
German/English periodical
bi-monthly (Vienna)
www.architektur-aktuell-freising.de

Arkkitehti
Finland-based architecture publication
focusing on Finland
www.ark.fi

ArtChronika
Russian monthly arts publication
www.artchornika.ru

Art + Auction
English-language auction magazine
www.artandauction.com

Art and Research
English-language quarterly journal
published in Glasgow
www.artandresearch.org.uk

Art
Das Kunstmagazin
German-language art magazine
www.art-magazin.de

art.es
Madrid-based international
art magazine in Spanish and English
www.art-es.es

Artforum
English-language contemporary
arts magazine
www.artforum.com

Art Investor
German-language magazine
for art collectors
www.artinvestor.de

Artist Kunstmagazin
German-language arts magazine
www.artist-kunstmagazin.de

Art Monthly
UK-based magazine on contemporary art

The Art Newspaper
English-language arts news
founded in 1990
www.theartnewspaper.com

Art Papers
Atlanta Georgia USA-based arts magazine
www.artpapers.org

Art Press
French/English-language art journal
based in France
www.artpress.com

Art Review
UK-based monthly arts magazine
www.art-review.com

Bauwelt
German-language architecture magazine
www.baunetz.de/arch/bauwelt

BeauxArts magazine
French-language arts magazine
www.beauxartsmagazine.com

Bomb
English-language art and culture
information-based in New York
www.bombsite.com

Cabinet
Brooklyn New York-based quarterly
magazine on arts and culture
www.cabinetmagazine.org

Camera Austria
German-language photography
magazine based in Graz
www.camera-austria.at

Circa
Irish contemporary art magazine seasonal
www.recirca.com

Contemporary
relaunched in 2002, monthly English-lan-
guage magazine. Also publishes annual.
www.contemporary-magazine.com

Connaissance des Arts
French-language art magazine
www.connaissancedesarts.com

Detail
Germany-based architectural magazine,
website in seven languages
www.detail.de

De Witte Raaf
Dutch-language art journal
www.dewitteraaf.stylelabs.com

Domus
Italy-based English/Italian
architecture magazine
www.domusweb.it

Eikon
Vienna-based quarterly magazine
in German and English dedicated to
photography and media art
www.eikon.at

El Croquis
Madrid-based Spanish and English-
language architecture publication
www.elcroquis.es

Esopus
New York City-based twice-a-year arts
magazine
www.esopusmag.com

European Photography
Berlin-based photography magazine
www.equivalence.com

Flash Art International
Italy-based arts publication, also pub-
lishes bi-yearly Art Diary International
and yearly Art Diary Italia
www.flashartonline.com

Framework
Finnish art review in English
www.framework.fi

Frieze
English-language contemporary
arts magazine, organizes annual art fair
www.frieze.com

Frog
French and English-language
art magazine published in Paris
www.frogmagazine.net

F. R. David
Netherlands-based twice-yearly publi-
cation of de Appel Amsterdam
www.deappel.nl

Grand Street
USA-based arts and writing coverage
published from 1981 to 2004

Grey Room
New York journal devoted to arts pub-
lished by MIT Press

Icon
UK-based architecture and design
magazine
www.icon-magazine.co.uk

Il Giornale dell'Arte
Italian-language version
of The Art Newspaper and founded
in 1983
www.ilgiornaledellarte.com

Janus
Brussels-based English-language
magazine covering art started by artist
Jan Fabre in 1999
www.janusonline.net

Kunstforum International
German-language bi-monthly arts
magazine
www.artcontent.de/kunstforum

L + arate
Portuguese-language contemporary
art magazine
www.l-arte.com,pt

Lapiz
Madrid-based Spanish and English-
language bi-monthly art coverage
www.revistalapiz.com

Le Journal des Arts
French-language art news
www.artclair.com

L'œil
French-language art magazine founded
in 1955
www.artclair,com/oeil

Mark
Netherlands-based English-language
architecture magazine
www.mark-magazine.com

Metropolis M
Netherlands contemporary-
art magazine in Dutch
www.metropolism.com

Modern Painters
UK-based art magazine
www.modernpainters.co.uk

Monopol, Magazin für Kunst und Leben
German-language art and living magazine
www.monopol-magazin.com

Obieg
Polish-language art publication based in
Warsaw
www.obieg.pl

October
US-based magazine on art theory and
culture

Øjeblikket
Danish art magazine
www.øjeblikket.net

Parkett
Swiss/New York-based influential pub-
lication on contemporary art, published
three times a year in German/English
www.parkettart.com

Pavilion
Romania-based English-language arts
journal
www.pavilionmagazine.org

Piktogram
Polish and English-language quarterly
art magazine
www.piktogram.pl

The Plan
Bi-monthly Italy-based architecture
magazine
www.theplan.it

Perspecta: The Yale Architecture Journal
USA-based
www.architecture.yale.edu

Rodeo
Italy-based magazine on art, fashion,
and culture
www.rodeomagazine.it

Sekcja magazyn artystyczny
Polish-language art magazine based
in Warsaw
www.sekcja.org

Sjónauki
Icelandic contemporary arts magazine
in Icelandic and English launched
in 2007
www.sjonauki.is

Spike Art Quarterly
Austria-based German/English-
language quarterly arts magazine
(website also featuring useful on-line
guide to Art in Eastern Europe)
www.spikeart.at

Springerin
German and English-language
quarterly art theory magazine based
in Vienna
www.springerin.at

Tate Etc.
quarterly arts journal published by
the Tate Gallery
www.tate.org.uk/tatetc/

Tema Celeste
Italian and English-language arts
publication based in Milan
www.temaceleste.com

Texte zur Kunst
Berlin-based German/English
magazine
www.textezurkunst.de

Third Text
London-based journal on visual art
www.tandf.co.uk/journals/
titles/09528822.html

Turps Banana
UK-based painting magazine
www.turpsbanana.com

Volume
Amsterdam-based architecture maga-
zine successor to Archis begun in 1929
www.archis.org

zingmagazine
NYC-based arts and culture
magazine
www.zingmagazine.com

Publishers

010 Publishers
Rotterdam Netherlands-based
architecture books
www.010publishers.nl

Abbeville Press
founded by Harry Abrams and
son in NYC
www.abbeville.com

Harry N. Abrams, Inc.
founded by Abrams in 1949
in NYC
www.hnabooks.com

Belser Verlag
based in Stuttgart

Benteli Verlag
Bern, Switzerland-based
www.benteliverlag.ch

Birkhäuser
Switzerland-based publishers
controlled by Springer
www.springer.com

Edition Braus (Wachter Verlag)
based in Heidelberg Germany
www.ediitonbraus.de

Charta
based in Milan
www.chartaartbooks.it

D.A.P.
book distribution for USA based in
New York
www.artbook.com art

Damiani
Bologna Italy-based
www.grafichedamiani.it

DuMont
based in Cologne
www.dumontliteratuundkunst.de

Ediciones Poligrafa
Barcelona-based publisher
www.poligrafa.net

Editorial Gutavo Gili
based in Barcelona
www.ggili.com

Gestalten Verlag
Berlin-based
www.die-gestalten.de

Hatje Cantz
based in Ostfildern, Germany
www.hatjecantz.de

Hirmer Verlag
Munich-based
www.hirmerverlag.de

Jovis Verlag
Berlin-based firm
www.jovis.de

JRP / Ringier
based in Zurich
www.jrp-ringier.com

Kehrer Verlag
based in Heidelberg German
www.kehrerverlag.com

Christopher Keller Editions
a division of JRP Ringier

Kerber Verlag
based in Bielefeld Germany
www.kerber-verlag.de

Knesebeck Verlag
based in Munich
www.knesebeck-verlag.de

Walther König
based in Cologne
www.buchhandlung-walther-koenig.de

Lars Müller Publishers
based in Baden, Switzerland
www.lars-mueller-publishers.com

Les Editions Gallimard
based in Paris
www.gallimard.fr

Marsilio
based in Venice
www.marsilioeditori.it

Gabriele Mazzotta
based in Milan
www.mazzotta.it/edizioni.php

Merrell
based in London and New York
www.merrellpublishers.com

Mondadori Electa
Milan-based
www.mondadori.it

Nicolaische Verlag
Berlin-based

Onestar Press
France-based producer of unedited
artists books since 2000
www.onestarpress.com

Phaidon
based in London
www.phaidon.com

Prestel
German, USA, and UK-based firm
www.prestel.net

Raina Lupa
Barcelona Spain-based publisher
of editions
www.rainalupa.com

Revolver
Frankfurt Germany-based producer
of artists' books
www.revolver-books.de

Richter Verlag
based in Dänischenhagen
www.richter-verlag.de

Rizzoli
based in New York
www.rizzoliusa.com

Scala
based in London
www.scalapublishers.com

Éditions Scali
based in France
www.scali.net

Scheidegger & Spiess
Zurich-based art book publisher
www.scheidegger-spiess.ch

Schirmer / Mosel Publishers
based in Munich
www.schirmer-mosel.com

Skira
Milan-based with offices in Paris
and London and founded in 1928
by Albert Skira
www.skira.net

Snoeck
Cologne-based art publisher
www.snoeck.de

Steidl
based in Göttingen Germany
www.steidlville.com

Swiridoff Verlag
based in Künzelsau, Germany
www.swiridoff.de

Taschen
based in Cologne
www.taschen.com

teNeues
based in Germany
www.teneues.de

Thames & Hudson
UK-based
www.thameshudson.com

Three Star Books
France-based artists' book publisher
www.threestarbooks.com

VFMK
Verlag für Moderne Kunst
Nürnberg
based in Nuremberg
www.vfmk.de

Wienand Verlag
based in Cologne
www.wienand-koeln.de

Free Publications

Art Absolument
French-language art magazine

Artefact-Kunst im Westen
German-language publication
covering the Rhineland

Artinside
Ausstellungen in der Region
Basel
German-language publication

Art Press
French/English art magazine

arttourist.com
international art tourism gazette

Das Museums Magazin
German-language publication
(Deutscher Museumsbund)

Gallery Guide
European edition, English-language
publication published out of NYC

I Love Museums
English/Italian-languages publication
(AMACI-Italy)

Kunstquartal
German-language world-wide gallery/
museum listings guide (highly useful)

Kunstmagazin Berlin
German and English-language Berlin
arts coverage
www.kunstmagazinberlin.de

Kunstzeitung
German newspaper published monthly

Mousse
Italian-language contemporary
art magazine

Museen Basel Magazin
German-language publication

Museo
English-language publication
(Finnish Museums Association)

Museo Mania
Spanish-language monthly publication

Museum Magazine
Dutch/German publication covering
Friesland and region

Museum Magazin Nord Brabant
Dutch-language publication

Museumskompass
German-language publication covering
Dutch/German border regions

Blogs & Web

www.40jahrevideokunst.de
on line project in German and English
to document history of video art

www.artforum.com/diary/
Artforum Diary

www.artsjournal.com
Arts Journal

www.e-flux.com
e-flux, subscriber service with arts list-
ings and announcements

www.specullector.com
market-oriented blog

www.worldarchitecturenews.com
architecture information

www.a-n.co.uk
The Artists Information Company, crit-
ical on-line artists-centered magazine
based in UK

www.archi-europe.com
architecture portal

www.archined.nl
Dutch-language architecture news

www.arcspace.com
architectural projects and information

www.art-agenda.com
international exhibition news

www.artasanasset.com
home to the Mei Moses art index that
tracks art prices

www.artfacts.net

www.artfagcity.com
USA-based web blog

www.artfairtraveler.com
organizes and plans trips to art fairs

www.artinfo
art news and information

www.artipedia.org
English-language art news

www.artistorganizedart.org
artist venture to organize own exhibits

www.artkrush.com
art news

www.artnet.com
art news with regional branches
(www.artnet.de) (www.artnet.dk)

www.artports.com
German-language exhibition informa-
tion and news

www.art-public.com
database of worldwide public art

www.artprice.com

www.arttactic.com
art-market information

www.artworldsalon.com
art news

www.dezeen.com
design blog

www.dutcharchitects.com
Dutch architecture news

www.galinsky.com
architectural information

www.european-art.net
connects European databases on con-
temporary art

www.grackleworld.com
online database of contemporary art
exhibitions available for tour

www.kunstaspekte.de
useful exhibition guide

www.kunstbulletin.ch
Switzerland-based exhibition and art
information, also hard copy

www.kunstmarkt.com
German-language information on art
market

www.kq-daily.de
International Art and Exhibitions

www.mimoa.eu
Dutch-based English-language website
with useful practical data on contempo-
rary architecture locations

www.photography-now.com
German-based website in six
languages covering photography
exhibits and news

www.postcommunist.de
German and English-language site deal-
ing with arts in former Eastern Bloc

www.teknedmedia.net
guide to Italian contemporary art, also
in English

www.thearchitectureroom.com
English-language website with resourc-
es on competitions and projects

www.vektor.at
Austrian based English-language Euro-
pean contemporary art archives

Selected Contemporary Art Bookstores

Austria
Klagenfurt
Buchhandlung Johannes Heyn
Kramergasse 2–4
Tel +43 463 54 24 92 6
Linz
Alex – Eine Buchhandlung
Hauptplatz 21
Tel +43 732 78 24 40-0
Salzburg
Galerie Welz
Sigmund-Haffner-Gasse 16
Tel +43 662 84 17 71-21
Museum der Moderne Salzburg
Rupertinum Museumshop
Wiener-Philharmoniker-Gasse 9
Tel +43 662 84 22 20
Vienna
Albertina Museumshop
Albertinaplatz 1
Tel +43 1 534 83 552
Buchhandlung Lia Wolf
Bäckerstr. 2
Tel +43 1 512 40 94
Buchhandlung Walther König
im Museumsquartier
Museumsplatz 1
Tel +43 1 512 85 88-0

Belgium
Antwerp
Fnac Antwerp
Gronenplaats
Tel +32 3 213 56 44
Copyright Antwerpen
Nationalestraat 28A
Tel +32 3 232 94 16
Brussels
Librairie Saint Hubert
2, Galerie du Roi
Tel +32 2 511 24 12
Museumshop
Museumstraat 9
Tel +32 2 508 32 84

Peinture Fraîche
10 Notarisstraat
Tel +32 2 537 11 05
Bozarshop
15, Rue Ravenstein
Tel +32 2 514 15 05
Cook & Book
Place du Temps Libre, 1
Tel +32 2 761 26 00
Filigranes
38, Avenue des Arts
Tel +32 2 511 90 15
Ghent
Copyright Artbookshop
Jakobijnenstraat 8
Tel +32 9 223 57 94

Croatia
Zagreb
Profil Megastore
Bogoviceva 7
Tel +38 514877325

Czech Republic
Prague
Palác Knih Luxor
Vaclávské námešti 41
Tel +42 221 111 364

Denmark
Aarhus
Aros Aarhus Kunstmuseum
Aros Allé 2
Tel +45 8730 6600
Copenhagen
Arnold Busck
International Boghandel
Købmagergade 49
Tel +45 3373 3500
Nikolaj, Copenhagen
Contemporary Arts Center
Nikolaj Plads
Tel +45 3393 1626
Humlebaek
Louisiana Museum Bookshop
Gl. Strandvej 13
Tel +45 4919 0719

Ishoj

Arken

Museum for Moderne Kunst

Skovvej 100

Tel +45 4354 0222

Ronde

Boggalleriet Niels Trangbek

Hovedgaden 6 B

Tel +45 8637 1035

Roskilde

Museet for Samtidskunst

Stændertorvet 3 D

Tel +45 4636 8874

Finland

Helsinki

Kiasma Store

Rosebud Books Oy

Mannerheiminaukio 2

Tel +35 8 917 336 505

Kulttuuritehdas Korjaamo

Töölönkatu 51 b

Tel +35 8 503 595 971

Stockmann Akateeminen

Keskuskatu 1

Tel +35 8 912 141

France

Lyon

Librairie Michel Descours

31, rue Auguste Comte

Tel +33 478426567

Paris

La Hune

170, boulevard Saint Germain

Tel +33 145483585

Librairie du Musée

d'Art Moderne

9, rue Gaston Saint Paul

Tel +33 153674045

Librairie du Palais de Tokyo

13, avenue du Président Wilson

Tel +33 149520204

Librairie Flammarion

du Centre Pompidou

19, rue Beaubourg

Tel +33 144784322

Rennes

Le Chercheur d'Art

1, rue Hoche

Tel +33 223201548

Toulouse

Librairie des Abattoirs

76, alleé Charles de Fitte

Tel +33 562485748

Germany

Berlin

Bücherbogen

am Savignyplatz

Stadtbahnbogen 593

Tel +49 30 3186950

Buchhandlung Walther König

Museum für Gegenwart

Invalidenstr. 50–51

Tel +49 30 39789870

Buchhandlung Walther König

an der Museumsinsel

Burgstr. 27

Tel +49 30 2576098-10

Buchhandlung Walther König

im Martin-Gropius-Bau

Niederkirchner Str. 7

Tel +49 30 23003470

Pro qm

Almstadtstr. 48–50

Tel +49 30 24728520

Cologne

Buchhandlung Walther König

Ehrenstr. 4

Tel +49 221 20596-27

Schaden.com

Albertusstr. 4

Tel +49 221 9252668

Darmstadt

Georg Büchner Buchladen

Antiquariat und Verlag

Lauteschlägerstr. 18

Tel +49 6151 77424

Dresden

Buchhandlung Walther König

Gemäldegalerie Alte Meister

Theaterplatz 1

Tel +49 351 4 86 17 29

Selected Contemporary Art Bookstores

Düsseldorf
Buchhandlung Walther König
in der Kunsthalle
Grabbeplatz 4
Tel +49 211 1362115
Frankfurt
Buchhandlung Walther König
Domstr. 6
Tel +49 69 296588
Kunst-Buch Dr. Bernd Kalusche
Römerberg 7
Tel +49 69 29988244
Hamburg
Buchhandlung im Haus
der Photographie
Deichtorstr. 2
Tel +49 40 32528704-06
Buchhandlung Sautter & Lackmann
Admiralitätstr. 71/72
Tel +49 40 373196
Hanover
Merz Kunstbuchhandlung
im Sprengel Museum
Kurt-Schwitters-Platz 1
Tel +49 511 884843
Leipzig
Kunst-Buch Dr.Bernd Kalusche
im Museum der bildenden Künste
Katharinenstr. 10
Tel +49 341 9938858
Lübeck
maKULaTUR
Hüxstr. 87
Tel +49 451 7079971
Munich
Buchhandlung L. Werner
Türkenstr. 30
Tel +49 89 2805448
Residenzstr. 18
Tel +49 89 225770
Buchhandlung Walther König
im Haus der Kunst
Prinzregentenstr. 1
Tel +49 89 25544498
Hans Goltz Buchhandlung
Türkenstr. 36
Tel +49 89 284906

Nuremberg
Buchhandlung Walther König
Neues Museum Nürnberg
Luitpoldstr. 5
Tel +49 911 2348808
CEDON MuseumShops
im Germanischen Nationalmuseum
Kornmarkt 1
Tel +49 911 1331177
Stuttgart
Buchhandlung Walther König
im Kunstmuseum Stuttgart
Kleiner Schlossplatz 1
Tel +49 711 22217-48
Lindemanns Buchhandlung
Nadlerstr. 4
Tel +49 711 24899977
Rita Limacher – Buchhandlung für
Architektur, Kunst und Design
Königstr. 28 (Königsbau)
Tel +49 711 292509

Great Britain
Gateshead
Baltic Museum Bookshop
Gateshead Quays, South Shore Road
Tel +44 191 478 1810
London
Artwords
65A Rivington Street
Tel +44 207 729 2000
Claire de Rouen
125 Charing Cross Road, 1st level
Tel +44 207 287 1813
Foyles
113–119 Charing Cross Road
Tel +44 207 437 5660
Koenig Books
at the Serpentine Gallery
Kensington Gardens
Tel +44 207 706 49 07
Magma
117–119 Clerkenwell Road
Tel +44 207 242 9503
Tate Shop
Tate Modern Bankside, level 1
Tel +44 207 401 5167

Greece

Alimos-Athens
Fnac Greece
63 Agiou Dimitriou
Tel +30 210 98 56 304
Athens
G.C.Eleftheroudakis
International Bookstore
17 Panepistimiou Str.
Tel +30 210 325 8287
National Museum of Contemporary Art
Bookshop
14 Am. Frantzi Str. Kallirios Ave.
Tel +30 210 924 2111
Papasotiriou
International Technical Bookstore
Stournara 35
Tel +30 138 04 39 78
Benaki Museum Bookshop
1 Koumbari Street
Tel +30 210 36 71 034

Iceland

Reykjavik
Penninn hf.-Media
Alfheimum 74
Tel +35 4 540 2077

Italy

Bologna
Il Leonardo Bookshop
Via Guerrazzi, 20
Tel +39 51 23 81 47
Milan
Carla Sozzani Editore Bookshop
Corso Como, 10
Tel +39 02 65 35 31
Electa/König
Piazza Duomo, 1
Tel +39 02 720 22 640
Libreria Bocca
Galleria Vittore Emanuele II, 12
Tel +39 02 86 46 23 21
or 58302093
Nuova Milano Libri
Via Giuseppe Verdi, 2
Tel +39 02 87 58 71 or 876394

Ulrico Hoepli
Via Hoepli, 5
Tel +39 02 86 54 46
Rivoli (TO)
Castello di Rivoli Museum Bookshop
Piazza Mafalda di Savoia
Tel +39 011 95 65 283
Turin
OOLP Out of London Press
Libreria Internazionale Bookshop
Via Principe Amedeo, 29
Tel +39 011 812 2782
Venice
Fondazione Solomon R. Guggenheim
Dorsoduro 701
Tel +39 041 2405432

Latvia

Riga
Gramatu nams Valters un Rapa
Aspazijas bulv. 24
Tel +37 6722 7482

Netherlands

Amsterdam
Athenaeum Boekhandel
Spui 14–16
Tel +31 20 5141468
Erasmus BV
Nieuwe Herengracht 123 A
Tel +31 20 6276952
Nijhof & Lee Boekhandel en Antiquariaat
Staalstraat 13 A
Tel +31 20 6203980
Robert Premsela
Van Baerlestraat 78
Tel +31 20 6624266
Selexyz Scheltema
Koningsplein 20
Tel +31 20 5231411
Deventer Boekhandel Praamstra
Kelzerstraat 2
Tel +31 57 0675925
Eindhoven
Motta
Bergstraat 35
Tel +31 40 2465087

Utrecht
Selexyz Broese
Stadhuisbrug 5
Tel +31 30 2335200
Rotterdam
Selexyz Donner
Lijnbaan 150
Tel +31 10 4132070

Norway
Oslo
ARK Egertorget
Øvre Slottsgade 23
Tel +47 22 47 32 00
Olaf Norlis
Bokhandel
Universitetsgaten 20–24
Tel +47 22 00 43 00
Tanum-Karl Johan
Sentrum
Karl Johansgate 37–41
Tel +47 22 41 11 00
Torpedo Kunstbokhandelen
Hausmannsgate 42
Tel +47 48 23 12 17

Poland
Warsaw
Top Mark Centre
ul. Emilii Plater 4
Tel +48 22 625 28 30

Portugal
Lisbon
Bulhosa Livreiros
Museu Cultural Belem
Campo Grande, 10-B
Tel +351 22 2076200
Fnac Portugal
Edifício Amoreiras Plaza
Rua Prof. Carlos Alb. Mota Pinto, 9, 6B
Tel +351 21 940 4775
B Shop
Museu Colecção Berardo
Centro Cultural de Belem
Praça de Império
Tel +351 22 615 51 95

RBMDC – Livros Arte
Trav. do Carvalho, 25
Tel +351 21 342 19 27
Porto
INC, Livros e edições de autor
Rua da Boa Nova, 164
Tel +351 22 617 1292

Russia
Moscow
Bookhunter
Krivokolenny Lane, 9
building 1
Tel +7 495 623 06 40
St. Petersburg
Anglia
Fontanka 38,
Turgenev House
Tel +7 812 579 82 84

Spain
Barcelona
Companyia Central Llibretera
Mallorca, 237
Tel +34 93 487 50 18
LAIE
Pau Claris, 85
Tel +34 93 318 17 39
Libreria Kowasa
Mallorca, 235
Tel +34 93 215 80 58
Llibreria Macba Botiga
Plaça dels Àngels, 1
Tel +34 93 481 38 86
Loring Art
Gravina 8
Tel +34 93 412 01 08
Bilbao
Museo Guggenheim Bilbao
Museum Bookshop
Avenida Abandoibarra, 2
Tel +34 94 435 90 00
Madrid
Fundación Collección Thyssen-
Bornemisza Museum Bookshop
Paseo del Prado, 8
Tel +34 91 420 39 44

Ivorypress Art + Books
Comandante Zorita, 48
Tel +34 91 449 09 61
Libreria Gaudi
Argensola 13
Tel +34 91 308 18 29
Panta Rhei XXI
C/ Hernán Cortés, 7
Tel +34 91 319 89 02

Sweden
Göteborg
Göteborgs Konstmuseum,
Bokhandel
Götaplatsen/Avenyn
Tel +41 31 368 35 10
Malmö
Malmö Konsthal
Bookstore
St Johannesgatan 7
Tel +46 40 341 29 3
Stockholm
Konst-ig
Åsögatan 124
Tel +46 8 20 45 20
Moderna Museet Bookshop
Skeppsholmen
Tel +46 85 195 52 21

Switzerland
Basel
Buchhandlung am Kunstmuseum
St. Alban-Graben 16
Tel +41 61 206 62 82
Buchhandlung Stampa
Spalenberg 2
Tel +41 61 261 79 10
DomusHaus
Pfluggässlein 3
Tel +41 61 262 04 90
Lucerne
Buchhandlung Alter Ego
Mariahilfgasse 3
Tel +41 41 412 00 99
Kunstmuseum Luzern Museumshop
Europaplatz 1
Tel +41 41 226 78 00

Riehen
Fondation Beyeler Art Shop
Baselstr. 101
Tel +41 61 645 97 09
St. Gallen
Rösslitor Bücher
Weberngasse 5
Tel +41 71 227 47 57
Zurich
Hochparterre Bücher
Gasometerstr. 28
Tel +41 44 271 25 00
Kunsthaus Zürich Museumsshop
Heimplatz 1
Tel +41 44 253 84 84
Orell Füssli Krauthammer
Marktgasse 12
Tel +41 44 253 65 82

Artists Residencies

Resources
www.resartis.org
worldwide listing of artists residencies
www.artquest.org.uk/international/
residencies/visual-arts-europe.htm

Acme
London-based charity formed by artists in 1972, offers working and living space in London, has international agency program

Akademie Schloss Solitude
Germany, based in Baroque castle outside of Stuttgart, Pawel Althamer, etc., artists under thirty-five, selected by jury

Art Scope
residency program funded by Daimler for emerging German and Japanese artists

Atelier Calder
Saché, France; six-month residence; program for international artists begun in 1988, alumni: Julian Opie, Mark Dion, Sarah Sze, Jessica Stockholder, Allan Sekula, Martin Puryear, David Claerbout

Bellagio Creative Arts Fellowships, Rockefeller Foundation
Lake Como, Italy; established in 2008, by invitation only, three-month residency, alumni: Mona Hatoum, Kofi Setordji, Shahzia Sikander

The British School at Rome
offers residencies in Rome to UK and Commonwealth artists, available via application, alumni: Julian Opie

Camden Arts Centre
London; provides residencies from six weeks to one year, by invitation, although artists can apply

CCA Andratx
Mallorca-based, artists residencies, alumni: Cosima von Bonin, Clegg & Guttmann, Gelatine

Civitella Ranieri Foundation
Umbria, Italy; provides international fellowships, by nomination, alumni: Allora & Calzadilla, El Anatsui, Petah Coyne, William Kentridge, etc.)

Cove Park
Scotland center for art residencies founded in 1999 by Eileen and Peter Jacobs, by invitation and application, located in west of Scotland and one hour from Glasgow on the Rosneath peninsula

DAAD
Germany, Deutscher Akademischer Austauschdienst, German Academic Exchange Program, Berlin version has four sections one of which is visual art, began 1965, Allora & Calzadilla, Phil Collins, Willem de Rooij, Anri Sala, etc., selected by jury

De Ateliers
Amsterdam-based since 1993, run by artists, focuses on emerging artists under thirty, by application

DIVA
Denmark-based residency program, begins residencies for international artist in 2009, three to six month residence provided
www.danishvisualarts.info

Domaine de Kerguehennec
Bignan France (museum offers yearly art and music residencies, alumni:
Steven Pippin)

Edith Russ Site
for Media Art
Oldenburg Germany-based exhibition

venue offers yearly stipends for artists, by application, Johan Grimonprez, Bernadette Corporation, etc.

Follow Fluxus–After Fluxus
grant of EUR 10,000 plus summer residency in Wiesbaden given to emerging artist whose ideas continue Fluxus legacy, first award in 2008

Foundation B.a.d.
Rotterdam, Netherlands, founded in 1987 by artists, studios and residencies, from two to six months

Gasworks
South London exhibition venue also includes studios for artists and offers non-UK-based artists three-month residencies, alumni: Mario Garcia Torres, Wang Wei, Hu Fang

Hangar
Barcelona-based in industrial building, four-month residency program, started in 1997

IAIRP
International Artists in Residence Programme
Guernsey, England; established in 1996, alumni: Antony Gormley

Iapsis
Swedish exchange program with residencies in Stockholm, Göteborg, and Malmö since 1996, by invitation only to international artists, Rikrit Tiravanija, Gerard Byrne, Marjetca Potrc, etc.

Irish Museum of Modern Art
Dublin; studio and residency program, by application

KulturKontakt Austria
Austria-based, cultural dialogue with eastern and south-east Europe, assists

with projects, three-month residency in Vienna

Künstlerhaus Bethanien
Berlin residency program, twenty-five studios, founded in 1974, twelve-month residencies, by invitation only, located in 1847 hospital, alumni: Mathieu Mercier, etc.

Künstlerhäuser Worpswede
Worpswede, Germany-based artists residencies, grants for six, nine, or twelve months, by application

Künstlerstätte
Schloss Bleckede
castle located in nature reserve near city of Lüneberg in northern Germany, residency program for emerging artists begun in 1979, by application, alumni: Katarina Sieverding, Hans-Christian Dany, etc.

La Maison Jaune
Gstaad Switzerland residency initiated by Patricia Low Contemporary in 2007, by application and then jury selection

Les Ateliers des Arques
Arques France residency program, website in French only

The London Consortium
London-based humanities and culture studies program, connected with ICA, Birkbeck College, etc.

Nosadella.due
Bologna Italy-based private foundation offers international artists and critics residencies, exhibits planned as well, alumni: Andres Güdes, Andreas Golinski

Office for Contemporary Art
Oslo, Norway; offers three-month residency to international artists, also assists

Norwegian artists in residencies outside Norway

Quartier21
Vienna, Austria; founded in 2003, five international artists per term of two-to-six-month stay, by application

Randolph Cliff
Edinburgh, Scotland; founded in 2007 by collectors Charles Asprey and Clémentine Deliss, three-month residency in Georgian apartment, by invitation, alumnus: Mark Wallinger

Rijksakademie van Beeldende Kunsten
Amsterdam, two-year residency, founded in 1870 by King Willem III, alumni include Torop and Mondrian, current alumni Ryan Gander 2001–02, Fiona Tan, de Rijke/de Rooij 1997–98, and Marijke van Warmerdam

Schloss Balmoral
Bad Ems Germany-based residencies since 1995, offers scholarships and residencies

Unidee
Città dell arte Italy, University of Ideas run by Michelangelo Pistoletto's foundation, run from July to October, open by submission and selection panel

Villa Massimo
Deutsche Akademie Rome
offers yearly residencies in Rome to German artists, notable attendees include Carsten Nicolai, Thomas Demand, and Thomas Ruff
www.villamassimo.de

Villa Romana
Florence, Italy, founded in 1905 by Alliance of German Artists and presents yearly fellowships to German-based artists, supported by Deutsche Bank, alumni: Baselitz, Lüpertz, Grosse, Schorr, etc.

ZKM
Institute for Visual Media
Karlsruhe, Germany, offers artist-in-residence program as well as grants for media-related art projects

Zuger Kulturstiftung
Landis & Gyr
Swiss Zug-based, founded in 1971, studio programs in London, Berlin, Zug, Budapest, and Bucharest

Art Schools

Amsterdam

Gerrit Rietveld Academie
located in Rietveld building from 1966,
alumni: Rineke Dijkstra 1981–86, Michael Raedecker 1985–90

Athens

Athens University of Fine Arts
established in 1837 and since 1843 as
School of the Arts, under current name
since 1940

Barcelona

Facultdad de Bellas Artes de Barcelona
part of Universidad de Barcelona founded in the fifteenth century

Belgrade

Academy of Fine Arts
founded in 1947 and brought together
previously existing art schools, part of
larger University of Arts Belgrade

Berlin

Hochschule für Bildende Kunste
and Akademie der Künste/Universität
der Künste
former Prussian Academy of Arts founded in 1696 and named Hochschule in
1896, name changed in 2001 from Hochschule to Universität, professors: Georg
Baselitz –2005, Tony Cragg –2006, Stan
Douglas 2004–06, Katharina Sieverding,
alumni: Tomma Abts 1989–95, Olaf
Metzel 1971–77

Brussels

Hogeschool Sint-Lukas Brussel
independent art school in Flanders,
Dutch-languagepredominates, founded
in 1880, Institut of Architecture Sint-Lucas since 1862, alumnus: Luc Tuymans

Copenhagen

Royal Danish Academy of Arts
Det Kongelige Danske Kunstakademie
formed in 1754, professor: Ann Lislegaard, alumnus: Olafur Eliasson 1989–
95

Dublin

National College of Art and Design
founded in 1746 as private drawing
school, controlled by London until 1924
and under present name since 1936

Düsseldorf

Kunstakademie Düsseldorf
founded 1762 and in 1819 as Prussian
Royal Academy, director Markus Lüpertz
since 1988, professors: Bernd Becher
1976–96, Joseph Beuys 1961–72, Tony
Cragg 1988–2001, Helmut Federle 1999–,
Hans Hollein 1965–67, Jörg Immendorff
1996–2007, Rita McBride, Albert Oehlen 2000– , Nam June Paik 1979–96,
Gerhard Richter 1971–93, Thomas Ruff,
Rosemarie Trockel, Günther Uecker
1973–95, alumni: Bjorn Dahlem 1994–
2000, Thomas Demand 1989–92, Katharina Fritsch 1977–84, Isa Genzken 1973–
77, Katharina Grosse 1982–90, Andreas
Gursky 1981–87, Lothar Hempel 1987–
92, Candida Höfer 1973–82, Imi Knoebel 1964–71, Markus Oehlen 1976–82,
Blinky Palermo 1962–67, Sigmar Polke
1961–67, Gerhard Richter 1961–63,
Thomas Ruff 1977–85, Thomas Schütte
1973–81, Dirk Skreber 1982–88, Thomas Struth 1973–78

Frankfurt

Städelschule
Staatliche Hochschule für Bildende Künste, founded by merchant Johann Friedrich Städel in 1817, Portikus is exhibition
space, professors: Ben van Berkel, Daniel
Birnbaum, Isabelle Graw, Michael Krebber, Tobias Rehberger, Willem de Rooij,
Simon Starling, Luc Tuymans, alumni:
Tue Greenfort 2000–03, Jeppe Hein
1999

Art Schools

Geneva
École supérieure des Beaux-Arts de Genève ESBA
founded in 1748, alumnus: John Armleder 1966–67

Glasgow
Glasgow School of Art
founded in 1845 as Glasgow Governmental School of Design, located since 1909 in landmark Mackintosh building, alumnus: Jonathan Monk

Hamburg
Hochschule für Bildende Künste
also Academie der Bildenden Künste, founded 1767 as a vocational school and then in 1896 as national college of arts and crafts, building from 1911–13, since 1955 is called by current name, professors: Hanne Darboven, Thomas Scheibitz, Andreas Slominski, Wim Wenders, Franz Erhard Walthur 1971–2005, alumni Franz Ackermann 1989–91, Stephen Balkenhol 1976–82, Ute Meta Bauer 1980–87, John Bock, Jeanne Faust 1993–98, Georg Herold 1977–78, Rebecca Horn, Martin Kippenberger 1972–76, Jonathan Meese 1993–98, Albert Oehlen, Santiago Sierra 1989–91

Helsinki
University of Art and Design Helsinki
founded in 1871 and is largest art university in Nordic countries

Leipzig
Hochschule für Grafik und Buchkunst
founded in 1764 by Saxon royalty, in 1835 became Academy of Fine Arts, reopened in 1947 under present name, professors: Astrid Klein, Neo Rauch 2005–, Arno Rink, alumnus: Neo Rauch

Lisbon, Portugal
Universidade de Lisboa, Faculty of Fine Arts
founded in 1836, since 1992 part of the University system that has origins in the thirteenth century

London
Chelsea College of Art and Design
Chelsea School of Art part of University of the Arts London, founded in 1895, Chelsea School of Art founded 1964, changed name to current in 1996, alumni: Richard Deacon, Peter Doig, Anish Kapoor 1973–78, Mariko Mori 1989, Steve McQueen, Chris Ofili 1988–91, Gavin Turk, Mark Wallinger, Gillian Wearing

London
Goldsmiths College, University of London
founded in 1891 as Goldsmiths Technical and Recreative Institute, located in south east London in 1844 building, acquired by University of London in 1904, alumni: Fiona Banner 1993, Angela Bulloch 1985–88, Matthew Collings, Thomas Demand 1993–94, Angus Fairhurst 1986–89, Ceal Floyer 1991–94, Anya Gallaccio 1985–88, Liam Gillick 1984–87, Antony Gormley seventies, Siobhan Hapaska 1990–92, Damien Hirst 1986–89, Gary Hume 1988, Sarah Lucas 1984–87, Steve McQueen 1993, Julian Opie 1979–82, Fiona Rae 1984–87, Michael Raedecker 1996–97, Sam Taylor–Wood 1990, Mark Wallinger, Gillian Wearing, Jane and Louise Wilson 1990–92

London
Royal College of Art
founded in 1837, in 1896 changed name to current form, alumni: Peter Blake, Victor Burgin 1962–65, Patrick Caulfield 1960–63, Jake & Dinos Chapman, Tony Cragg 1973–77, Richard Deacon 1974–77, Tracey Emin, David Hockney, Bethan Huws 1986–88, RB Kitaj, Malcolm Mor-

ley 1955–57, Chris Ofili 1991–93, Gavin Turk 1991, Alison Wilding 1970–73

London
Slade School of Art
University College London, founded in 1868 by Felix Slade, alumni: Cecily Brown 1989–93, Martin Creed 1986–90, Tacita Dean 1990–92, Douglas Gordon 1988–90, Antony Gormley 1977–79, Mona Hatoum 1979–81, Rachel Whiteread

London
Central St. Martins School of Art and Design
part of University of the Arts London, created in 1989 from St. Martins School of Art which was founded in 1854 and other schools, will move to new Camden location to open in 2011, professors: Anthony Caro, Barry Flanagan, alumni: Richard Deacon, Peter Doig, Cerith Wyn Evans 1984, Gilbert & George, Antony Gormley, Richard Long 1968

Madrid
Facultdad de Bellas Artes de Madrid
part of the Universidad Complutense de Madrid founded in 1840s with origins in the fifteenth century

Marseille
ESBAM, École supérieure des beaux-arts de Marseille
founded in 1752, moved to different location in 1874 and then to Luminy campus in 1969, alumnus: Jean Michel Alberola

Milan
Accademia di Brera
founded in 1776 by Maria Theresa of Hapsburg Empire, has preeminent museum of masterpieces, faculty: Luciano Fabro, Alberto Garrutti, alumni: Simone Berti, Patrick Tuttofuoco, Vanessa Beecroft

Moscow
V. Surikov Moscow State Academy Art Institute
part of Russian Academy of Arts organization, opened in 1939

Munich
Akademie der Bildenden Künste
founded 1808 by Maximilian I of Bavaria, name comes from 1953, previously known as Royal Academy, building from 1874 in neo-Renaissance style, added building by Coop Himmelb[l]au, professors: Gunther Förg, Jörg Immendorff 1984–85, Markus Oehlen, Eduardo Paolozzi 1981–89, alumni: Franz Ackermann 1984–88, Thomas Demand 1987–89, Gunther Förg 1973–79, Georg Herold 1973–76, Andreas Hofer 1991–97, Gerhard Merz 1969–73

Oslo
Oslo National Academy of the Arts KHIO
established in 1996 with joining of five separate institutions, National Academy founded in 1909

Paris
École Nationale Superieure des Beaux-arts
founded in 1648 by Charles Le Brun as Royal Academy, name changed in 1816, located in Palais des Beaux Arts since 1830, professors: Marina Abramovic, Jean-Michel Alberola, Christian Boltanski, Jean-Marc Bustamante, Claude Closky, Richard Deacon, Annette Messager, Jean-Luc Vilmouth, alumni: Annette Messager, Laurent Grasso

Paris
École Normale Superieure des Arts Décoratifs
ENSAD, founded in 1766 as Royal School, present name from 1927, alumni: Claude Closky, Pierre Huyghe 1982–85, Annette Messager

Art Schools

Southampton, England
Winchester School of Art
affiliated with University of Southampton and opened in 1863, alumni: Darren Almond, Brian Eno

Stockholm
Royal University College of Fine Arts KKH
founded in 1735 and part of Royal Academy until 1978, located on Skeppsholmen Island

St. Petersburg
I. Repin St. Petersburg State Academy Institute of Painting Sculpture and Architecture
part of Russian Academy of Arts organization, located in building from 1788, formerly known as St. Petersburg Academy of Arts and was Imperial Academy

Stuttgart
Merz Akademie
privately run applied-arts academy founded in 1918

Turin
Accademia Albertina delle Belle Arti, Torino
founded in 1678, royal academy since 1778

Venice
Italy-Universita IUAV di Venezia
founded as Venice University Institute of Architecture in 1926, directors have included Carlo Scarpa, also Arts & Design program, professors: Michele de Lucchi, Giorgio Agamben

Vienna
Akademie der Bildenden Künste Wien
founded 1692 as private academy, 1725 royal status, building by Theophil Hansen in 1877 on Ringstrasse, professors: Diedrich Diedrichsen, Harun Farocki, Bruno Gironcoli, Peter Sloterdijk, Heimo Zobernig, alumni: Elke Krystufek, Ugo Rondinone

Vienna
Universität für Angewandte Kunst Wien
University of Applied Arts, founded in 1867, professors: Zaha Hadid, Greg Lynn, Wolf Prix, Peter Weibel, Erwin Wurm, alumni: Hugo Markl, Walter Pichler 1955–59, Erwin Wurm 1979–82

Warsaw
Academy of Fine Arts in Warsaw
Akademia Sztuk Pieknych w Warszawie, founded as private institution in 1904 and nationalized in 1920, alumni: Pawel Althamer 1988–93, Miroslaw Balka, Krzystof Wodiczko

Zagreb
Croatia-Academy of Fine Arts, University of Zagreb
university founded in 1669 by royal decree with fine arts academy founded in 1907

Zurich
Zürcher Hochschule der Künste
created in 2000 from Schule für Gestaltung and other institutions, runs Museum für Gestaltung, alumnus: Thomas Hirschhorn

Selected Country Maps

England

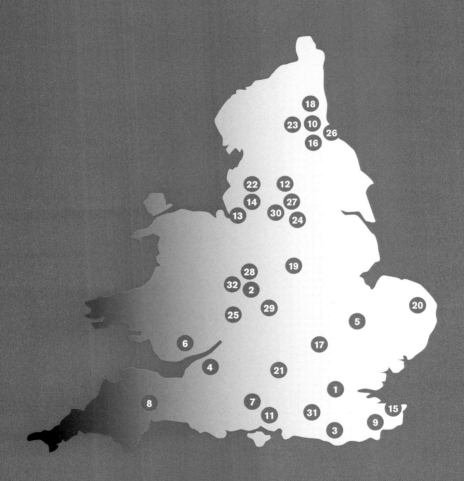

France

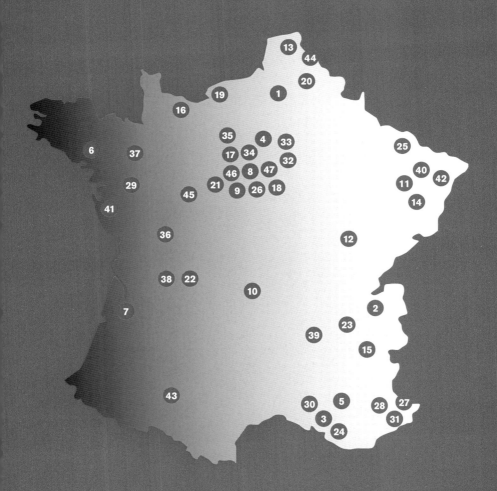

1	Amiens		25	Metz
2	Annecy		26	Milly-la-Forêt
3	Arles		27	Monaco
4	Aubervilliers		28	Mouans–Sartoux
5	Avignon		29	Nantes
6	Bignan		30	Nîmes
7	Bordeaux		31	Nice
8	Brétigny sur Orge		32	Noisiel
9	Chamarande, Essonne		33	Noisy-le-Sec (Paris)
10	Clermont-Ferrand		34	Paris
11	Delme		35	(Cergy) Pontoise
12	Dijon		36	Poitiers
13	Dunkerque		37	Rennes
14	Épinal		38	Rochechouart
15	Grenoble		39	Saint Étienne
16	Hérouville Saint-Clair		40	Saint-Louis
17	Île de Vassivière		41	Saint Nazaire
18	Ivry-sur-Seine		42	Starsbourg
19	Le Havre		43	Toulouse
20	Lens		44	Tourcoing
21	Les Mesnuls		45	Tours
22	Limoges		46	Versailles
23	Lyon		47	Vitry-sur-Seine (Paris)
24	Marseille			

Germany

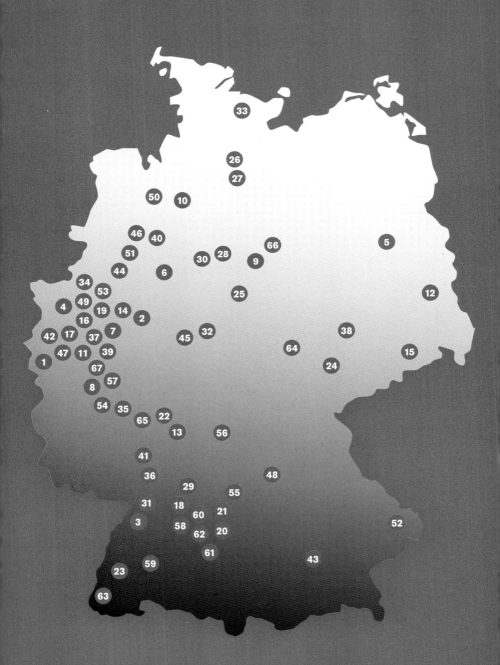

Germany

1	Aachen	35	Koblenz
2	Arnsberg	36	Kraichtal
3	Baden-Baden	37	Krefeld
4	Bedburg Hau	38	Leipzig
5	Berlin	39	Leverkusen
6	Bielefeld	40	Lingen
7	Bochum	41	Ludwigshafen am Rhein
8	Bonn	42	Mönchengladbach
9	Braunschweig (Brunswick)	43	Munich
10	Bremen	44	Münster
11	Cologne	45	Naumburg
12	Cottbus	46	Neuenkirchen
13	Darmstadt	47	Neuss
14	Dortmund	48	Nuremberg
15	Dresden	49	Oberhausen
16	Duisburg	50	Oldenburg
17	Düsseldorf	51	Osnabrück
18	Eberdingen-Nussdorf	52	Passau
19	Essen	53	Recklinghausen
20	Esslingen am Neckar	54	Rolandseck
21	Fellbach	55	Schwäbisch Hall
22	Frankfurt	56	Schweinfurt
23	Freiburg im Breisgau	57	Siegen
24	Gera	58	Sindelfingen
25	Goslar	59	St. Georgen
26	Hamburg	60	Stuttgart
27	Hamburg-Harburg	61	Ulm
28	Hanover	62	Waldenbuch
29	Heilbronn	63	Weil am Rhein
30	Herford	64	Weimar
31	Karlsruhe	65	Wiesbaden
32	Kassel	66	Wolfsburg
33	Kiel	67	Wuppertal
34	Kleve		

Italy

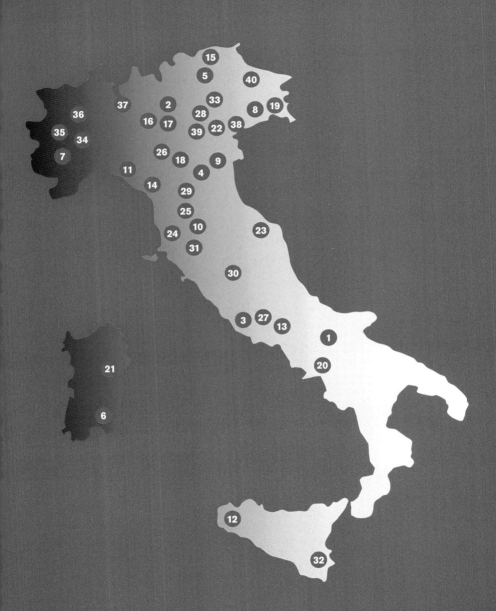

Italy

1	Benevento	21	Nuoro
2	Bergamo	22	Padua
3	Biella	23	Pesaro
4	Bologna	24	Pisa
5	Bolzano	25	Prato
6	Cagliari, Sardinia	26	Reggio Emilia
7	Caraglio	27	Rome
8	Codroipo	28	Rovereto
9	Ferrara	29	Santomato di Pistoia
10	Florence	30	Seggiano
11	Genoa	31	Siena
12	Gibellina, Sicily	32	Siracusa, Sicily
13	Grottaferrata	33	Trento
14	La Spezia	34	Turin
15	Merano	35	Turin (Rivoli)
16	Milan	36	Rivara (Turin)
17	Milan (Cinisello Balsamo)	37	Varese
18	Modena	38	Venice
19	Monfalcone	39	Verona
20	Naples	40	Verzegnis

Spain

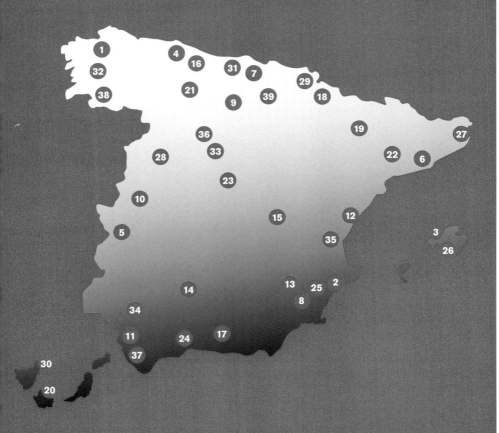

1 A Coruña
2 Alicante
3 Andratx, Mallorca
4 Avilés
5 Badajoz
6 Barcelona
7 Bilbao
8 Blanca
9 Burgos
10 Cáceres
11 Cadiz
12 Castelló
13 Ceuti
14 Córdoba
15 Cuenca
16 Gijón
17 Granada
18 Huarte
19 Huesca
20 Las Palmas de Gran
 Canaria, Canary Islands

21 Léon
22 Lleida
23 Madrid
24 Málaga
25 Murcia
26 Palma de Mallorca
27 Portbou
28 Salamanca
29 San Sebastián
30 Santa Cruz de Tenerife,
 Canary Islands
31 Santander
32 Santiago de Compostela
33 Segovia
34 Seville
35 Valencià
36 Valladolid
37 Vejer de la Frontera
38 Vigo
39 Vitoria-Gasteiz

Switzerland

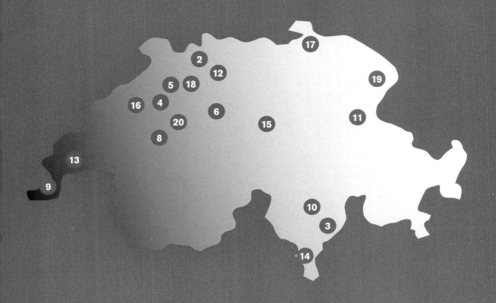

Cities & Institutions A–Z

B Cities & Institutions A–Z

C Cities & Institutions A–Z

F Cities & Institutions A–Z

The author wishes to thank:

Bundesministerium für Unterricht, Kunst und Kultur, Austria
Calouste Gulbenkian Foundation
Instytut Adama Mickiewicza
Pro Helvetia
SEACEX Socieded Estatal para la Acción Cultural Exterior
and the Spanish Government/MAEC/AECID

for their support of this project.

Pp. 7 & 12 Kunsthaus Bregenz, copyright Kunsthaus Bregenz. Photo: Thomas Riehle; p. 9 MU-MOK. Photo: Rupert Steiner; p. 13 Kunsthaus Graz. Photo: Zepp-Cam. 2004 / Graz, Austria; p. 14 Die Insel in der Mur, photo credit: GrazTourismus; p. 15 Sammlung Essl. Kunsthaus, copyright 2000 C. Richters; p. 16 Lentos Kunstmuseum Linz. Engelhardt / Selling Architekturfoto-grafie; pp. 19 & 22, credit Wiels; p. 23 Courtesy SMAK; pp. 27 & 28 Courtesy Sofia Art Gal-lery; p. 29 Olafur Eliasson and David Adjaye Your black horizon Art Pavilion Lopud, Croatia Thyssen-Bornemisza Art Contemporary. Photo: Michael Strasser / T-B A21, 2007; p. 34 Gal-erie Rudolfinum. Photo: Annelies Strba; p. 35 Courtesy Dox Center for Contemporary Art; pp. 37 & 38 Courtesy Arken; p. 40 Courtesy AroS Aarhus Kunstmuseum; p. 41 Louisiana Mu-seum of Modern Art, the South Wing seen from the Sculpture Park. Photo: Jens Frederiksen; pp. 43 & 45 Tate Modern. © Tate, London 2009; p. 48 Saatchi Gallery, Duke of York's HQ, Lon-don, 2008; p. 49 Photo: Stephen White. Courtesy Parasol unit foundation for contemporary art; p. 52 Baltic. Gateshead. Photo: Colin Davison; p. 53 Tate Liverpool. © Tate, London 2009; p. 54 A Foundation Liverpool. Photo: Jonathan Keenan; p. 55 mima 2008. Photograph: Gilmar Ribeiro, g2; p. 58 Isamu Noguchi at YSP, Underground Gallery, 2008. Photo: Jonty Wilde; pp. 61 & 62 Courtesy KUMU; pp. 63 & 64 Courtesy Kiasma; pp. 67 & 69 Centre Pompidou, copyright photos: Photos Philippe Migeat, Georges Méguerditchian Centre Pompidou; p. 70 Palais de Tokyo. Vue aérienne et façade sud: *Vues du Palais de Tokyo, site de création contemporaine,* Paris, May 2003, copyright Daniel Moulinet; p. 71 The building of the Fondation Cartier pour l'art contem-porain, Paris, 1994, architect: Jean Nouvel © Jean Nouvel. Photo: Philippe Ruault; p. 74 Law-rence Weiner DOWN AND OUT, OUT AND DOWN, DOWN AND OUT, OUT AND DOWN, 1971, installation view, Collection Lambert en Avignon. Photo: Franck Couvreur; p. 77 Courtesy Magasin; p. 77 Centre international d'art et du paysage built by Aldo Rossi and Xavier Fabre, copy-right Centre international d'art et du paysage de l'île de Vassivière. Photo: Marc Vulliez; p. 79 MAC_0986, copyright Bruno Amsellem and Blaise Adilon; p. 81 Courtesy Carré d'Art; p. 83 Musee d'art Moderne Saint-Etienne Métropole, copyright Didier Guichard, architecte DPLG. Photo: Yves Bresson pour le Musée d'Art Moderne de Saint-Etienne Métropole; p. 84 MAMCS. Photo: Mathieu Bertola; p. 84 Les Abattoirs Extérieur nuit 2, copyright Jean-Louis Monthier; pp. 87 & 120 Pinakothek der Moderne. Exterior view. Photo: Haydar Koyupinar 2004; p. 89 Hamburger Bahnhof. Photo: Christian Wurster; p. 90 Neue Nationalgalerie. Photo: Jessica Morhard; p. 91 Sammlung Boros. Photo: copyright Noshe; p. 94 Ludwig Forum. Photo: Andreas Herrmann; p. 95 Das Museum Frieder Burda in Baden-Baden, copyright Museum Frieder Bur-da; p. 98 Courtesy Weserburg; p. 99 Museum Ludwig seen from the southwest; p. 102 MKM Museum Küppersmühle für Moderne Kunst, extension as projected by Herzog & de Meuron, copyright Herzog & de Meuron; p. 104 K21 Kunstsammlung im Ständehaus, copyright Helke Rodemeier; K21 Kunstsammlung Nordrhein-Westfalen, Düsseldorf. Photo: Ralph Richter, Architekturphotos, Düsseldorf, 2008; p. 107 Museum für Moderne Kunst. Photo: Axel Schnei-der; p. 108 Copyright Schirn Kunsthalle Frankfurt, 2006. Photo: Norbert Miguletz; p. 110 Deichtorhallen. Photo: Wolfgang Neeb; p. 110 View of the Galerie der Gegenwart, new and old building with a view of the River Alster. Photo: Wolfgang Neeb; p. 112 Sprengel Museum, pho-to credit: Aline Gwose, Michael Herling; p. 113 View of MARTa Herford, copyright MARTa Herford. Photo: Thomas Mayer; p. 113 ZKM, photo credit ONUK; p. 116 Copyright Mu-seum of Fine Arts Leipzig. Photo: Harald Richter, Hamburg; p. 118 Städtisches Museum Abtei-berg. Photo: Ruth Kaiser; p. 119 Haus der Kunst. South façade. Photo: Wilfried Petzi; p. 120 Archi-tects: Herzog & De Meuron, Basel, courtesy Sammlung Goetz. Photo: Franz Wimmer, Munich; p. 120 Museum Brandhorst, copyright Museum Brandhorst. Photo: Andreas Lechtape, 2008; p. 122 Langen Foundation, Rakenstation Hombroich / Neuss. Architect: Tadao Ando, copyright Tomas Riehle/artur 2004; p. 122 Photo: Tomas Riehle, copyright Stiftung Insel Hombroich; p. 126 Copyright Kunstmuseum Stuttgart / Gonzalez; p. 124 Arp Museum. Photo: Horst Bern-hard; p. 125 Kunsthalle Würth; p. 125 Museum für Gegenwartskunst Siegen. Photo: Roman Mensing; p. 128 VitraDesign Museum, Frank Gehry, 1989, copyright Vitra Design Museum.

Edited by Mark Gordon, Copyediting: Ingrid Nina Bell
Design & Typesetting: Christian Wurster, Assistance: Jana Hiebsch
Production: Ines Sutter, Hatje Cantz
Reproductions: Weyhing, Ostfildern
Paper: LuxoArt Silk, 135 g/m²; Invercote Creato, 350 g/m²
Printing and binding: Kösel GmbH & Co. KG, Altusried

© 2009 Hatje Cantz Verlag, Ostfildern, and the author
© 2009 for reproduced works by the artists as well as photographers,
 and their legal successors

Published by
Hatje Cantz Verlag, Zeppelinstrasse 32, 73760 Ostfildern, Germany
Tel +49 711 4405-200, Fax +49 711 4405-220
www.hatjecantz.com

Hatje Cantz books are available internationally at selected bookstores.
For more information about our distribution partners, please visit our
homepage.

ISBN 978-3-7757-2336-7

Printed in Germany